Horror Film

BLOOMSBURY FILM GENRES SERIES

Edited by Mark Jancovich and Charles Acland

The *Film Genres* series presents accessible books on popular genres for students, scholars and fans alike. Each volume addresses key films, movements and periods by synthesizing existing literature and proposing new assessments.

PUBLISHED:

Teen Film: A Critical Introduction

Fantasy Film: A Critical Introduction

Science Fiction Film: A Critical Introduction

Historical Film: A Critical Introduction

Anime: A Critical Introduction

Film Noir: A Critical Introduction

Horror Film

A Critical Introduction

MURRAY LEEDER

BLOOMSBURY ACADEMIC

NEW YORK • LONDON • OXFORD • NEW DELHI • SYDNEY

BLOOMSBURY ACADEMIC
Bloomsbury Publishing Inc
1385 Broadway, New York, NY 10018, USA
50 Bedford Square, London, WC1B 3DP, UK
29 Earlsfort Terrace, Dublin 2, Ireland

BLOOMSBURY, BLOOMSBURY ACADEMIC and the Diana logo are trademarks
of Bloomsbury Publishing Inc

First published 2018
Reprinted 2018, 2019, 2020, 2021

© Murray Leeder, 2018

Cover design by Paul Burgess
Cover image: Still from *The Phantom of the Opera* (1925)
© Universal/The Kobal Collection/Faherty, Paul

Bloomsbury Publishing Inc does not have any control over, or responsibility for, any
third-party websites referred to or in this book. All internet addresses given in this
book were correct at the time of going to press. The author and publisher regret any
inconvenience caused if addresses have changed or sites have ceased to exist, but
can accept no responsibility for any such changes.

A catalog record for this book is available from the Library of Congress.

ISBN: HB: 978-1-5013-1442-1
PB: 978-1-5013-1443-8
ePDF: 978-1-5013-1446-9
eBook: 978-1-5013-1444-5

Series: Film Genres

Typeset by Deanta Global Publishing Services, Chennai, India

Printed and bound in the United States of America

To find out more about our authors and books visit www.bloomsbury.com
and sign up for our newsletters.

Contents

List of Images vi
Acknowledgements ix

Introduction 1

1 1895–1938: Horror's Process of Genrification 3

2 1939–1973: Horror and the Crisis of Rationality 31

3 1974 to Present: High and Low 61

4 What is Horror? 89

5 Mind and Body: The 'Why?' of Horror 113

6 Horror's Audiences, Critics and Censors 137

7 Shocking and Spooky Sounds 159

8 Colours of Fear 185

9 Digital Horrors 211

Bibliography 235
Index 256

List of Images

1.1 A depiction of the phantasmagoria that appeared in *L'Optique* by 'Fulgence Marion' (1869) 4

1.2 The speculative 'first monster movie' in *Matinee* (1993) 5

1.3 The abduction in *The Cabinet of Dr. Caligari* (1920) 11

1.4 Graf Orlak (Max Schreck) in *Nosferatu* (1921) 13

1.5 Erik (Lon Chaney) unmasked in *The Phantom of the Opera* (1925) 16

1.6 Béla Lugosi as the Count in *Dracula* (1931) 21

2.1 Darby Jones as Carrefour in *I Walked with a Zombie* (1943) 36

2.2 Vincent Price struggles with *The Tingler* (1959) 42

2.3 Christopher Lee in *Horror of Dracula* (1958) 47

2.4 Christiane's (Edith Scob) mask in *Eyes Without a Face* (1960) 52

3.1 Michael Myers watches Laurie (Jamie Lee Curtis) in *Halloween* (1978) 64

3.2 Bruce Campbell in *Evil Dead II* (1987), the new face of the horror hero 70

3.3 The emergence of Sadako in *Ring* (1998) 79

4.1 Louis Cyphre (Robert de Niro) reveals his Devilish true nature in *Angel Heart* (1987) 105

4.2 A mysterious closing image from *Angel Heart* (1987) 106

5.1 Dr Sneiderman (Ron Silver) psychoanalyses Carla Moran (Barbara Hershey) in *The Entity* (1982) 116

5.2 The repressed ape breaks free in *King Kong* (1933) 120

5.3 The haunted mirror in *Dead of Night* (1945) 124

5.4 A mirror image in Kubrick's *The Shining* (1980) 124

5.5 The archetypical 'Final Girl', Laurie Strode (Jamie Lee Curtis) in *Halloween* (1978) 128

5.6 The climax of *Sleepaway Camp* (1983) 131

6.1 Subcultures intersect in the comic book store in *The Lost Boys* (1987) 150

6.2 The sisters at the centre of *Ginger Snaps* (2000) 152

6.3 Romance competes with horror in *Bram Stoker's Dracula* (1992) 154

7.1 The cock crows at the end of *Nosferatu* (1922) 163

7.2 Imhotep (Boris Karloff) wakes in *The Mummy* (1932) 166

7.3 Mary (Candace Hilligoss) reacts to the sudden silence of her environment in *Carnival of Souls* (1962) 178

8.1 Buck (Charles Herbert) dons the ghost viewer in *13 Ghosts* (1960) 193

8.2 An advertisement from *The Sedalia Democrat*, 29 September 1960. *13 Ghosts*, © 1960, renewed 1988 Columbia Pictures Industries, Inc., All Rights Reserved. Courtesy of Columbia Pictures 193

8.3 An intertitle announcing the Phantom's arrival, *Phantom of the Opera* (1925) 196

8.4 The Red Death in the Black Room, *Masque of the Red Death* (1964) 201

8.5 Suzy's moment of realization in *Suspiria* (1977) 204

8.6 Blood leaks under the door in *The Leopard Man* (1943) 206

8.7 The monochromatic chic of Elina Löwensohn in *Nadja* (1994) 207

9.1 Pixelvision as vampire vision in *Nadja* (1994) 214

9.2 A digital ghost's eye view of Harue (Koyuki) in *Pulse* (2001) 223

9.3 The Universal Pictures logo 'glitchified' in *Unfriended* (2015) 226

9.4 A ghostly transmission in *Playback* (2012) 231

Acknowledgements

This book is in many ways a culmination of my professional and personal preoccupations, dating back decades. So many more people should be thanked than is possible here. First and foremost, I must thank the line editors of the *Film Genres* series, Mark Jancovich and Charles Acland, for their confidence and guidance, as well as the staff at Bloomsbury, including Katie Gallof and Susan Krogulski. I would also like to thank my anonymous outside reviewers.

Thanks should also go to my mentors and colleagues from the University of Calgary (including Charles Tepperman, Ryan Pierson, Lee Carruthers and Samantha Thrift), the University of Manitoba (including George Toles, David Annandale and Brenda-Austin Smith) and Carleton University (including Charles O'Brien, André Loiselle, Marc Furstenau, Mitsuyo Wada-Marciano and Chris Faulkner), as well as the broader community of academics I have interacted with and which has informed my thinking on the horror genre and its many strata. Special thanks must go to Adam Hart and Allison Whitney, my co-founders of the Horror Studies Special Interest Group (SIG) within the Society for Cinema and Media Studies, and all those who have participated in the SIG and its Facebook page. I would particularly like to thank Aalya Ahmad, Xavier Aldana Reyes, Drew Beard, Aviva Briefel, Kevin Chabot, S. J. Crompton, Dara Downey, Barry Keith Grant, Joan Hawkins, Alexandra Heller-Nicholas, Katharina Loew, Adam Lowenstein, Jeremy Maron, Cynthia J. Miller, Sean Moreland, Bernice M. Murphy, Marc Olivier, Gary D. Rhodes and Caelum Vatnsdal. Other friends and associates who helped me address certain specific matters arising from the writing of this book include Daniel Sheridan, Paul Jasen, Randolph Jordan, Mike Baker and Benjamin Wright.

Finally, thanks go to everyone in my family, especially my wife, Alana Conway, and our various and sundry offspring.

Introduction

Horror Film: A Critical Introduction provides an overview of the wide-ranging, protean and diverse genre of the horror film. As part of the Film Genres series, this book is designed first and foremost for a non-specialist reader, though it will hopefully have much value for the experienced horror scholar and the horror fan alike. It is structured as follows:

The first three chapters provide an overview of the history of the horror film, going as far back as the beginnings of cinema (and even before) and stretching up until the present day (roughly 2017). Though it cannot possibly be exhaustive in its coverage, I have attempted to balance industrial, national and aesthetic considerations of the genre, as well as such subjects as stardom, censorship, shifting generic parameters and the occasional availability of horror to cultural prestige. Horror is not a glassed-over relic but a living, dynamic genre, and even during the writing process I have found it a challenge to keep abreast of new developments; the book will inevitably become an artefact of the moment of its publication, but hopefully its insights will outlive its historical limitations.

The next three chapters cover major critical approaches to horror. They are divided by three interrogative pronouns: 'what', 'why' and 'who'. The fourth chapter addresses attempts to define horror and the difficulties presented by such definitions. The fifth covers attempts to address the contentious 'why' of horror – psychoanalytic, cognitive and affective. The sixth is the 'who' – who are horror's audiences and what is their stake in the genre?

The third set of chapters deals with the aesthetics and technologies of horror film and how horror films have manipulated the 'technological uncanny'. The three chapters deal, respectively, with film sound, colour and digital cinema, each time exploring special resonances these changes in film technology have had within the horror genre.

Horror Film: A Critical Introduction is just that, an introduction; the abused term 'scratching the surface' applies. For everything it covers, it excludes much, much more. While many national traditions of horror have been the subject of exciting and valuable scholarship in recent years (e.g. Bollywood horror (Sen 2017), Korean horror (Peirse and Martin 2013), Thai horror (Ancuta 2011), Turkish horror (Sahinturk 2016), Australian horror (Ryan 2018), Canadian horror (Vatnsdal 2014, Freitag and Loiselle 2016), etc.), *Horror Film: A Critical Introduction* offers a broadly Anglo-American-centred treatment of the horror genre and its history. However, other national traditions (German, Japanese, French, Canadian, etc.) are featured throughout as well.

1

1895–1938: Horror's Process of Genrification

What was the first horror film?

There is no easy answer to this question. The box for Kino International's DVD release of D. W. Griffith's *The Avenging Conscience* (1914) declares it to be 'The First Great American Horror Film,' and yet such terminology was not used when it was released. Similar claims are sometimes made of the German film *Der Student von Prag/ The Student of Prague* (1913) and the Edison Studios adaptation of *Frankenstein* (1910). But genres are not born with a single film. One could argue that the horror film is older: that it traces back to early cinema, or even could be stitched into a much longer narrative of uses of the projected image for frightening entertainment, dating back at least to the gloomy shows of the phantasmagoria that debuted in the late eighteenth century (see Castle 1995; Heard 2006). Originally exhibited in the darkness of an abandoned Capuchin monastery in Paris, phantasmagoria mixed magic lantern imagery, spooky music and layers of smoke, and favoured images of demons, skeletons and ghosts. Wrote the most famous pioneer of phantasmagoria, 'Robertson' (Étienne-Gaspard Robert), 'I am only satisfied if my spectators, shivering and shuddering, raise their hands or cover their eyes out of fear of ghosts and devils dashing towards them' (trans. in Elder 2008, 104). Still earlier, Leipzig illusionist and occultist Johann Georg Schröpfer used magic lanterns combined with other tricks to project ghosts, presenting himself not as a skilled magician but as

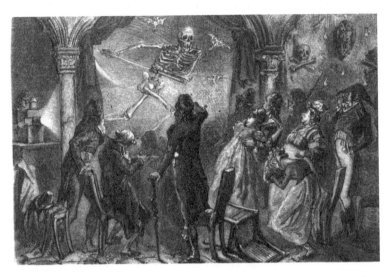

FIGURE 1.1 *A depiction of the phantasmagoria that appeared in* L'Optique *by 'Fulgence Marion' (1869).*

a legitimate necromancer who even purportedly put Prince Charles of Saxony in touch with his dead uncle. He committed suicide in 1774, reportedly driven mad by his own illusions. Should we regard Schröpfer as the first horror filmmaker?

But why stop there? Hypothetically, one can create a speculative narrative going back further, even into prehistory. In Joe Dante's film *Matinee* (1993), the fictional horror director Lawrence Woolsey (John Goodman) provides his own Allegory of the Cave. Visualized with animation of a brick wall, it involves a prehistoric man surviving an encounter with a mammoth and wanting to document the event as cave art: 'And he thinks, "People are coming to see this! Let's make it good! Let's make the teeth really long and the eyes really mean." Boom! The first monster movie.' Woolsey claims himself as the inheritor to a long line of benign monster-makers to bestow legitimacy upon his profession, and many scholars of horror have constructed extravagant lineages for a similar reason. Alternatively, you could say that the horror genre was not born until the early 1930s, when terms like 'horror film' came into general parlance. All these possible answers are correct from one perspective and shortsighted from all others.

FIGURE 1.2 *The speculative 'first monster movie' in* Matinee *(1993).*

Early cinema horror?

Some have suggested that horror in cinema, if necessarily not the horror genre, is exactly as old as cinema itself. On 28 December 1895, Auguste and Louis Lumière hosted the first public screening of their Cinématographe at the Salon Indien du Grand Café in Paris.[1] One particular film associated with this legendary event (although actually not screened until the following month) was *L'arrivée d'un train en gare de La Ciotat,* which simply depicts a train pulling into a station. In legend, it provoked a singular reaction: the audience screaming and jumping to their heels, maybe even running out of the room. The story was passed down unquestioned for decades. In all likelihood it never really happened, although it may reflect a kind of reality in terms of the jolting effects of an audience facing something foreign to its sensorial inventory (Bottomore 1999; Loiperdinger 2004).

But was *L'arrivée d'un train* also 'the first horror film'? It has been called so. Denis Gifford's *A Pictorial History of Horror Movies* (1973) states, 'Women had screamed the night cinema was born:

[1]In several senses, this mythical birthdate for cinema is inaccurate too; the first paid-for public display of the new invention, it was preceded by a variety of private demonstrations, and the term 'cinema' itself was not yet in use (see Gaudreault 2011).

a locomotive engine seemed to steam from the screen. Louis Lumière's innocent record of an everyday happening ... had shock in its realistic approach' (14). Gifford is far from the only scholar desiring to extend horror's lineage to the beginnings of cinema (Diffrient 2004, 59), one way or the other, as a strategy for asserting its importance and lineage.

Others look to another moment in early cinema associated with panic, from *The Great Train Robbery* (1903). *The Great Train Robbery* is considered significant as an early narrative short and an early Western (itself a misleading claim, as such a generic descriptor did not yet exist (Neale 1990, 52–5)), but for its moments of what Tom Gunning refers to as 'attractions' (1995), which breach the audience's sense of narrative absorption by confronting it directly. Notably it contains a shot of a bandit firing his pistol directly in the audience – today it is generally placed at the end of the film, but originally an exhibitor could choose its location. In *Horror in the Cinema* (1979), Ivan Butler wrote:

> It is quite possible that the famous pistol-firing close-up at the end (or the beginning, from choice) of *The Great Train Robbery* sent much the same thrill of terror through the unsophisticated audiences of 1903 as those of today are presumed to receive from the latest vampirical metamorphosis or planetary Thing which leaps or creeps at them from the contemporary screen. (15)

The documentary *Kingdom of Shadows: The Rise of the Horror Film* (1998) echoes Butler's claims as Rod Steiger's overripe narration intones 'Behold the face of horror – behold the birth of cinema' over the pistol shot.

Others look to the origins of cinematic horror in early cinema's trick films, especially those of Georges Méliès. This body of films eschew cinema's potential for representing reality in favour of its abilities to create artificial environments and events, often using film form to approximate tricks from the magical stage. There is a widespread impulse to anoint some of Méliès's early films, especially *Le Manoir du Diable* (1896, generally known in English as *The Devil's Castle*, *The Haunted Castle* or *House of the Devil*), as the first horror films. Gifford positions *Le Manoir du Diable* as

an ur-moment for the horror film: 'The big, black bat flew into the castle room. It circled slowly, flapping monstrous wings. Suddenly – it changed into the Devil! It was the eve of Christmas 1896; the horror had begun' (14). Carlos Clarens's *An Illustrated History of the Horror Film* (1967) similarly positions Méliès at the beginning of cinematic horror traditions by opening with a chapter on him (1–8). The canonization of *Le Manoir du Diable* is such that scholars have characterized it as 'undoubtedly the first horror film' (Hardy 1993, 16) and 'probably the first horror movie' (Kinnard 1995, 9), and casually cited it as the moment of horror cinema's commencement (Crane 2004, 150).

However, as Mark Jancovich rightly notes, 'It is not at all clear that [Méliès's] films were understood as horror films. Instead, it is more likely that they were seen as examples of the kinds of magical trick photography that Tom Gunning associates with the "cinema of attractions"' (2002, 7). Kim Newman observes that Méliès 'was more interested in the marvelous than the horrific, setting out to surprise rather than shock' (215). Even the use of Satanic imagery running through so many of Méliès's films is part of a tradition on the magical stage and relates more closely to Méliès's anti-clerical sensibilities (perhaps most blatant in *Le Diable au Convent/The Devil in a Convent* (1899)) than a desire to horrify people (Mangan 2007, 134–9). The uncertain generic boundaries between horror and fantasy (see Chapter 4) are an issue here.

All of the issues of locating examples of horror in early cinema are evident in the opening lines of Tony Magistrale's *Abject Terrors: Surveying the Modern and Postmodern Horror Film* (2005):

It is likely that the very first motion picture was a horror film. Out of the dark shadows cast by a flickering candle, exaggerated and magnified by mirrors and accompanied by the artificial introduction of smoke, Georges Méliès's *The Devil's Manor* (1896) was as much a magic trick as it was an effort to produce the first vampire film, where a bat flies into an ancient castle and transforms itself into the Devil. It is actually not that far a leap from Méliès's rudimentary experiments in blending science of German expressionism that informed the cinema of the 1920s. The environmental settings for the earliest motion pictures feature the essentials of the vampire

film: highly stylised sets and exaggerated use of makeup on the faces of actors provide *Nosferatu* [1922] and *The Cabinet of Dr. Caligari* [1920] with a highly psychological mise-en-scène. Lost in an angular, unnatural landscape, these early films emphasise the distortion of space and create an unsafe milieu that most resembles that of a nightmare. (xi)

Even if we ignore the fact that Magistrale seems to imply that *Le Manoir du Diable* was the first *film,* the collapse of decades of film history to blur Méliès's trick films and German expressionism illustrates the tendency to plug select examples of early cinema into a master narrative of horror's lineage. The common claim Magistrale repeats here, that *Le Manoir du Diable* is the first vampire film (see also Flynn 1992, 11–12; Stuart 1994, 218; Guiley 2005, 101; Joyce 2007, 105; Melton 2011, 448), bears particular examination. No figure in this Méliès's film – or any other – is clearly identifiable as a vampire, so this claim must be based on the film's bat-human transformation (along with a defensive cross, not originally unique to vampires). But the idea that vampires turn into bats did not yet exist. It would appear first in Bram Stoker's *Dracula* the year after.[2] Only in retrospect does *Le Manoir du Diable* become even abstractly readable as a vampire film, or as a horror film at all, so such claims necessarily take on an ahistorical quality.

What do we truly gain from regarding works from early cinema as the first horror films, be they actualities like *L'arrivée d'un train*, early narrative shorts like *The Great Train Robbery* or trick films like *Le Manoir du Diable*? Such a judgement requires wresting early cinema from its historical materiality and, once again, demoting it to a way station towards the generic traditions to emerge in the classical period. It is hardly surprising that scholars might look for the origins of the horror film in early cinema. It is undeniable that the formal vocabulary and thematic concerns of what would become known as horror film have a prehistory in early cinema. Certain early

[2]Thomas (2000) proposes that Stoker saw and was influenced by *Le Manoir du Diable* (303); this claim is obviously speculative but also difficult to disprove, since Stoker's earlier drafts did not contain references to bat transformations.

films would thus be potentially understood as part of what Thomas Schatz calls the 'experimental stage' of genre development, wherein generic conventions are present in a rudimentary form, but are not yet recognized as such (37). If there is horror in a generic sense in early cinema, it can only be described as such well in retrospect – as a kind of pre-phase to a pre-phase.

Mark Jancovich and Lincoln Geraghty note that 'one needs to be careful not to transfer one's own understandings of genre terms and their meanings back onto previous periods in which the terms and their meanings might have been very different' (3). The question 'What was the first horror film?' is thus less useful than one about genrification: just how did the recognizable and durable, and even versatile, genre called 'the horror film' emerge? The remainder of this chapter will address that question.

German expressionist cinema and horror's emergence

Several traditions of silent-era cinema are inextricably linked with the prehistory of the horror film, especially in Germany and the United States. Silent films produced elsewhere have also retrospectively been claimed as horror, notably Danish director Benjamin Christensen's *Häxan/Witchcraft Through the Ages* (1922) and *Kurutta Ippēji/A Page of Madness* (1926) by Japan's Teinosuke Kinugasa; these are inevitably less discussed because of their relative anomalousness. The major silent-era European tradition noted for contributing to the formal and thematic vocabulary of the horror film is German expressionism.

German expressionist cinema grew out of the broad artistic movement of the same name, which spanned a number of art forms (painting, architecture, sculpture, theatre, etc.) and included renowned painters Otto Dix, August Macke, Franz Marc and George Grosz. While this movement largely faded in the 1910s, many of its key players dying during the First World War, the cinematic movement is largely understood as a representative phenomenon of the postwar Weimar Republic. German Expressionist cinema

inherits the earlier movement's privileging of anti-realism and the graphic depictions of inner states, and is replete with relevant Weimar themes of paralysed masculinity, industrialization and modernity, death and mourning, enforced conformity and madness (Kaes 2009). German Expressionist cinema was about far more than horror: *Der letzte Mann/The Last Laugh* (1924) veers towards social realism (while maintaining a decided counter-realist aesthetic), while *Die Nibelungen* (1924) is a fantasy film derived from German legends and *Geheimnisse einer Seele/The Secrets of a Soul* (1926) is a Freudian allegory. Nevertheless, the links to horror are undeniable. The film generally agreed to be the first work of German Expressionist cinema is 1920's *Das Cabinet des Dr. Caligari/The Cabinet of Dr. Caligari*. Its disjointed narrative is framed by a young man named Francis (Friedrich Feher) explaining how he became an inmate in a mental asylum. He tells the story of a mountebank named Dr Caligari (Werner Krauss) and his somnambulist servant, Cesare (Conrad Veidt), whom he sends out to murder his enemies. However, after Cesare's failed attempt to abduct Francis's fiancée, Jane (Lil Dagover), it transpires that Caligari is actually the head of a local lunatic asylum, himself driven mad after studying a legendary mystic named Caligari. But there is a further twist. It transpires that the narrator himself is insane and Caligari is actually a benign asylum director, and the film ends with the apparently positive note that the narrator may soon be cured.

However, to discuss the plotline of *The Cabinet of Dr. Caligari* without reference to its form would be the real madness. Its artifice is everywhere on display. The town of Holstenwall is a funhouse of disorienting shapes and lines. Town clerks perch atop unnaturally high stools. Shadows are painted onto walls. A merry-go-round twirls at a wildly oblique angle. In a scene that anticipates a thousand monster-abducts-girl scenarios to follow, Cesare carries Jane over a distorted rooftop, where smokestacks point at disorienting angles towards the sky. The political and social implications of *The Cabinet of Dr. Caligari* have been much debated, especially given the little-loved final twist (see Kracauer 1947; Eisner 2008), but its immersion into a madman's dream cements its importance in cinematic history as still the go-to example of film formalism, shown in many introductory film classes worldwide.

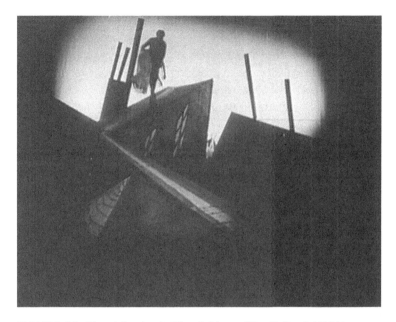

FIGURE 1.3 *The abduction in* The Cabinet of Dr. Caligari *(1920).*

But is it a horror film? The American critic Roger Ebert wrote, 'A case can be made that *Caligari* was the first true horror film.'[3] What makes earlier potential horror films 'untrue'? 'Their characters were inhabiting a recognizable world. *Caligari* creates a mindscape, a subjective psychological fantasy. In this world, unspeakable horror becomes possible' (2009, n.p.). Such criteria, of course, exist only in hindsight, but Ebert's assessment speaks to the mythological role that *The Cabinet of Dr. Caligari* has taken in the annals of horror films. The influence of its stagecraft, especially on the Golden Age of Horror Film, is pronounced and will be returned to later in this chapter.

Equally significant is *Nosferatu, eine Symphonie des Grauens* (henceforth *Nosferatu*), directed by F. W. Murnau. Older sources often characterize *Nosferatu* as the first adaptation of Stoker's *Dracula*; we now know that to be otherwise, since *Drakula halála*

[3]Compare Danny Peary's description of *The Cabinet of Dr. Caligari* as 'the first *horror* film of true, lasting distinction' (48, emphasis original).

(1921) had been produced in Hungary the year prior (Rhodes 2010). Both films were unauthorized adaptations, and Murnau changed the names of characters and reset the story in Germany in an unsuccessful attempt to avoid legal action by Stoker's widow. Though the film was never strictly unavailable in the United States (it ran for a few months at the Film Guild Cinema in New York City in 1929/1930), *Nosferatu* led a subterranean existence until it was widely rediscovered in the 1960s and 1970s. As such, its influence on the genrification process of horror was more minor than might otherwise have been the case. The concept that vampires are destroyed by sunlight, present neither in European folklore nor in the nineteenth-century vampire fiction of John Polidori, J. Sheridan Le Fanu or Stoker, was introduced by *Nosferatu* but would occasionally reappear before being firmly codified by *Horror of Dracula* (1958). Likewise, the depiction of the vampire, known in the original release as Graf Orlak (Max Schreck), as an obviously monstrous being with a chalk-white face, rat-like teeth and elongated fingers, would seldom be replicated before Tobe Hooper's miniseries *Salem's Lot* (1979) and Werner Herzog's *Nosferatu: Phantom der Nacht/Nosferatu the Vampyre* (1979) because of its limited availability.[4] *Nosferatu* serves as an example of how even a great film's influence can be forestalled by circumstance.

Other Expressionist films have dark supernatural and psychological themes. *Orlacs Hände/The Hands of Orlac* (1924) involves a pianist losing his hands in a train accident, having the hands of a murderer sewed on in their place and finding himself with homicidal urges. *Der Golem, wie er in die Welt kam/The Golem: How He Came into the World* (1920) builds on the ancient Jewish myth of a Frankensteinian creature animated from clay to protect a community, but which in a true monster-movie form becomes uncontrollable. In *Schatten – Eine nächtliche Halluzination/Warning Shadows* (1923), a magical trickster invades a party of nobles, steals their shadows and forces them to watch the inevitable consequences of their decadent behaviour play out. The anthology film *Das Wachsfigurenkabinett/Waxworks*

[4]Later films to pay homage to Orlak's design include *Subspecies* (1991), *What We Do in the Shadows* (2014) and even *Star Trek: Nemesis* (2002).

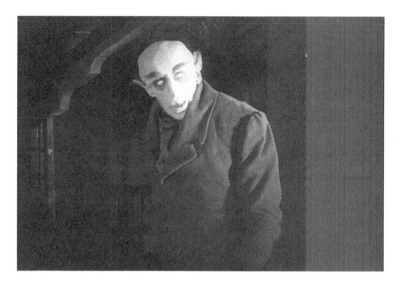

FIGURE 1.4 *Graf Orlak (Max Schreck) in* Nosferatu *(1921)*.

(1924) features a nightmarish depiction of Jack the Ripper, staged with multiple layers of superimpositions. And Fritz Lang's *Metropolis* (1927), a science fiction allegory taking place in a hyper-urban future, contributed immensely to the visual vocabulary of the mad scientist movie, with Rotwang (Rudolf Klein-Rogge) as an influential amalgam of alchemist and scientist; the creation of the Machine-Maria (Brigitte Helm) constitutes one of the most influential set pieces for the development of the horror film.

One need not resort to speculation to explain the influence of German expressionism on the Hollywood horror film of the 1930s. The draw of Hollywood and the fear of fascism drew some of the personnel who worked on the Expressionist films to the United States. Karl Freund, cinematographer of *The Golem* and *Metropolis*, emigrated in 1928, shot *Dracula* in 1931 and later directed *The Mummy* (1932) and *Mad Love* (1935), a remake of *The Hands of Orlac*; he ended out his career doing live cinematography for *I Love Lucy* (1951–7). Paul Leni, director of German Expressionist films including *Waxworks*, moved to Hollywood and made two films, shortly to be discussed, remembered as key works in the canon of American silent horror. While it is reductive to consider German

expressionism as merely a stage on the road to the American horror film (or, for that matter, film noir, similarly indebted to expressionism), it was certainly a key contributor to the genrification of the horror film that would more fully take shape in the United States in the 1930s. With the migration of Expressionist personnel came a certain taste for artistic experimentation, something traditionally more permissible in horror than in most other Hollywood genres.

Silent Hollywood horror

For all the mythological status D. W. Griffith holds as the 'Father of Film,' or more plausibly, the codifier of the classical Hollywood model, few anoint Griffith as a 'Father of Horror'. Yet, as already mentioned, some have identified his film *The Avenging Conscience* as an early horror film, and certainly the strange Poe-inspired work sports its share of nightmarish imagery (and a twist that somewhat anticipates *The Cabinet of Dr. Caligari*) alongside Griffithian staples like last-minute rescues. Even referring to silent Hollywood horror is anachronistic, since that terminology did not exist and most 'silent horror films' were received as melodramas.

The key figure of American silent horror was not a director but an actor: Lon Chaney, 'The Man of a Thousand Faces'. We belatedly refer to him as Lon Chaney Sr. to distinguish himself from his actor son (born Creighton Chaney, the son adopted the father's name only for career reasons), and also as America's first horror star, a label never used in his lifetime. Raised by two deaf parents, Chaney became an extraordinarily skilful pantomime performer. Working since his teens in the theatre, Chaney also honed his talents as a makeup artist, and from 1919 until his death in 1930, he was a bona fide movie star, specializing in playing disabled and disfigured characters. Chaney found his creative match in director Tod Browning, who had his own colourful circus/carnival background (Skal 1995) and an obsession with gloomy, melodramatic material. The two collaborated ten times, including the sensationally bizarre circus-set drama *The Unknown* (1927) and the early vampire film *London after Midnight* (1927), probably the most famous lost film of its era. Chaney played legless in *The Penalty* (1920), armless in *The Unknown*, wheelchair bound

in *West of Zanzibar* (1928), a criminal ventriloquist in both the silent and the sound version of *The Unholy Three* (1925, 1930), the title role in *The Hunchback of Notre Dame* (1923) and a gamut of other racial types and categories of disability. Many have interpreted the 1920s' striking obsession with disfigurement as a consequence of the mass context of disfigurement and injury following the First World War (Skal 2001, 71).

Probably the most famous Chaney film is *The Phantom of the Opera* (1925). It was a lavish, expensive production from Universal Pictures, based on the 1911 novel by French author Gaston Leroux, the rights to which were secured by producer Carl Laemmle as an ideal Chaney vehicle. Chaney plays Erik, the titular phantom, actually a flesh-and-blood mad genius, disfigured from birth. Erik haunts the bowels of the Paris Opera House, composing music, manipulating the opera's directors and secretly shepherding the career of the young ingénue Christine Daaé (Mary Philbin). Alongside the early Technicolor masquerade scene (see Chapter 8), the most famous scene in the film is the unmasking. Erik takes Christine to his subterranean lair. He sits at his organ, unaware that she is directly behind him, and her curiosity (and ours) builds over what hides behind his mask. After several false starts, she pulls it off, and the angle reverses to show us his disfigured, skull-like face. Even through all the makeup, Chaney clearly registers a terrifying mix of surprise, embarrassment and outrage. Christine rears back in shock and we switch to her point of view, a low angle of the domineering and terrifying Erik, a haze of fear blurring the screen. 'Feast your eyes,' an intertitle reads. 'Glut your soul on my accursed ugliness!' Audiences did just that, and the unmasking scene is reputed to have induced fainting in its original audiences. *The Phantom of the Opera* constructs a mix of sympathy and revulsion for the unfortunate Erik in large part through Chaney's performance. The inimitable Chaney would die of throat cancer in 1930 after making only one talkie, Browning's sound remake of their earlier film *The Unholy Three*, creating a talent vacuum at the beginning of the classic era of sound horror.

Robert Louis Stevenson's 1886 novella *The Strange Case of Dr. Jekyll and Mr. Hyde* was adapted many times in the silent era, both in Europe (Murnau's *Der Janus-Kopf* (1920), an unauthorized

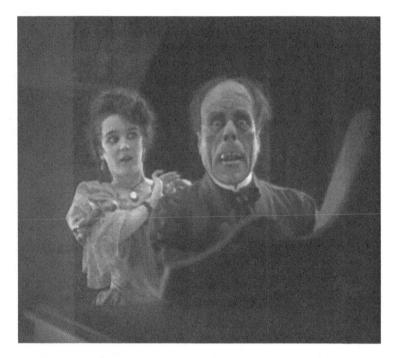

FIGURE 1.5 *Erik (Lon Chaney) unmasked in* The Phantom of the Opera *(1925).*

adaptation like *Nosferatu*) and in the United States. Before founding Universal Pictures, Carl Laemmle produced a version in 1913 for his earlier company, Independent Moving Pictures, and the previous year, the Thanhauser Company produced another version. The most famous, however, was Famous Players-Lasky's *Dr. Jekyll and Mr. Hyde* (1920),[5] with its subtle and powerful performance by John Barrymore representing an early example of a prestige star cast in horror material. Wrote *Moving Picture World*, 'Mr. Barrymore justifies the terrible repulsiveness of the character by the truth and power of his impersonation. It is worthy to rank along side the Mephistopheles of Henry Irving or the Berruccio of Edwin Booth. The screen has

[5]A different adaptation (the third, counting *Der Janus-Kopf*) was made in 1920 starring Sheldon Lewis.

never before known such great acting' (qtd. in Soister and Nicolella 2012, 154), although the *New York Times* held that 'high praise of the photoplay, however, must be limited to what Mr. Barrymore does it in' (ibid., 153). Prestige came to the nascent horror genre in scattered, qualified segments.

Separate to these serious-toned dramas about deformity and transformation, another cycle of silent Hollywood horror melded chills with comedy.[6] Epitomizing the comedic tradition is *The Cat and the Canary* (1927), directed by Paul Leni for Universal. It is based on the 1922 Broadway play of the same name by John Willard, concerning a group of family members descending on a creepy old mansion twenty years after the death of its patriarch Cyrus West, all seeking to claim his fortune. The virtuous protagonist, Annabelle West (Laura La Plante), is set to inherit it, but only provided she spends one night in the house and remain sane in the morning. Her sanity is sorely tested overnight, with a long-fingered hand reaching from secret panels in walls and a mysterious figure stalking the hallways. However, it transpires that these events are all being staged by one of Annabelle's cousins, scheming to drive her insane and claim the inheritance for himself.

This plot summary does not necessarily suggest a comedy, but *The Cat and the Canary* certainly is one, with the bumbling leading man Creighton Hale providing the broadest humour. Though *The Cat and the Canary* is the best remembered, it was neither the first nor the last of these Broadway-derived horror–comedy films. The 1909 play *The Ghost Breaker* was filmed in 1914 and 1922 (as well as in the sound era as *The Ghost Breakers* (1940) and *Scared Stiff* (1953)), the 1920 play *The Bat* was filmed several times (1926, 1956), the 1925 play *The Gorilla* was adapted in 1927, 1930 and 1939, and the 1922 play *The Monster* was adapted with Chaney in 1925. D. W. Griffith's

[6]In a sense, these pictures descend from the haunted hotel films of early cinema, where a weary traveller would check into a hotel only to comically find himself beset by invisible, playful forces, taking full advantage of cinema's potential for disappearances, sudden transpositions and sometimes motion animation. Méliès's *L'auberge ensorcelée/The Bewitched Inn* (1897), Edwin S. Porter's *Uncle Josh in a Spooky Hotel* (1900), J. Stuart Blackton's *The Haunted Hotel* (1907) and Segundo de Chomón's *La maison ensorcelée/ The House of Ghosts* (1908) are among the best examples.

One Exciting Night (1922) was a pastiche of *The Bat*. This cycle is often retrospectively referred to with the label 'old, dark house,' derived from the 1932 film *The Old Dark House*.

Owing to Leni's Expressionist roots, *The Cat and the Canary* is full of gorgeous chiaroscuro lighting, a complex interplay of light and shadow, and uses superimpositions throughout (Natale 2015). The opening shows the exterior of the mansion dissolving onto the spotlit wheelchair-bound Cyrus West, with the turrets of the house becoming medicine bottles towering all around him. Superimposed cats appear all around him and he rises and tries to fend them off with his hands, representing his descent into madness caused by his grasping relatives. Leni's film plays like a missing link between German expressionism and the American silent horror tradition.

The same can be said of Leni's subsequent feature for Universal, *The Man Who Laughs* (1928); Leni would direct one more film, a spiritual sequel to *The Cat and the Canary* called *The Last Warning* (1929), before dying of sepsis that year. Like *The Phantom of the Opera*, *The Man Who Laughs* was an expensive, lavish production based on a French novel (by Victor Hugo) and features a disfigured protagonist. Conrad Veidt, who played Cesare in *The Cabinet of Dr. Caligari*, portrayed Gwynplaine, mutilated as a child as punishment for his father's treason with a permanent grin carved into his features. Reputedly, the creators of Batman modelled the Joker on Veidt's makeup, designed by Jack Pierce. Though hideous, Gwynplaine is a gentle, tortured soul, and the story has a tragic structure, with psychosexual material underscored once again by Leni's Expressionist stylistics. Ian Conrich characterizes *The Hunchback of Notre Dame*, *The Phantom of the Opera* and *The Man Who Laughs* as 'Universal's trilogy of horror-spectaculars' (2004a, 54), but notes the financial failure of the latter – an expensive silent film released just as silents were becoming unfashionable.

The conversion to sound, in the history of the horror film as in so many other respects, thus creates a narrative of simultaneous continuity and rupture. The deaths of key figures like Leni and Chaney encourage the narrative of the newness of sound cinema, as does the demise of the costly horror-spectacular. However, the continued presence of many technicians (like Karl Freund, Jack Pierce and Charles D. Hall, art director of *The Man Who Laughs*, who would create the

look for most of the Universal horror films to follow) speaks to the continuities between Hollywood's silent and sound horror cycles.

The Golden Age: Universal and others, 1931–1936

We should be suspicious of narratives of a 'Golden Age'. This term derives from classical mythology. In the sixth century BCE, Hesiod wrote of an age when men

> lived like gods without sorrow of heart, remote and free from toil and grief: miserable age rested not on them; but with legs and arms never failing they made merry with feasting beyond the reach of all evils. When they died, it was as though they were overcome with sleep, and they had all good things; for the fruitful earth unforced bare them fruit abundantly and without stint. They dwelt in ease and peace upon their lands with many good things, rich in flocks and loved by the blessed gods. (4–5)

But a great civilization requires a great fall. Pandora's box unleashed all of the terrible things into the world, and they have been with us ever since.

Similar narratives exist in other mythologies (the Garden of Eden, the Satya Yuga in Hinduism, the gullaldr in Norse mythology) of a time of primal harmony when all was right in the world. Horror's so-called 'Golden Age' is rather more modest, and certainly falls much less spectacularly. It is understood as a period of unique fertility and the time when the recognition of the horror film as the horror film was established. Certainly, a person before 1931 might find the label 'horror film' vaguely legible – words like 'horror' had been used to characterize films for at least a decade in publicity materials and reviews. But by 1936, 'horror film' referred to something fairly concrete and recognizable to most, even those people without direct experience of it: a genre. The only question was if it would survive.

While the back end of this so-called 'Golden Age' of the American horror film is debatable, its beginning is less so: February 1931 with the release of Universal's *Dracula*. Adapted by Browning and based on the

play by Hamilton Deane and John L. Balderston, in turn adapted from Stoker's novel, it was an appealing prospect for a new sound film in ways that it might not have been for a silent one. *Dracula* was a troubled project (see Skal 2004; Rhodes 2015). When a long list of potential leads proved for naught, the studio resorted to casting the Hungarian actor who starred in the Broadway version, despite his relative lack of Hollywood experience and weak command of the English language: Béla Lugosi. Dracula became the first iconic sound-era movie monster, and Lugosi the first of a new breed of horror actors, all for a role in which he was top billed but poorly paid.

There is some fashion to dismiss *Dracula* today as a creaky curio, and the film certainly suffers from many of the teething problems of the conversion to sound period. At its best, its awkward and hollow soundscape actually enhances its atmosphere (see Chapter 7). At times, the Expressionist-tinged cinematography of Karl Freund conflicts with the film's stagy style to produce its own kind of strange expressiveness. But it is Lugosi's iconic star presence in the lead that cemented *Dracula*'s considerable legacy. A great example of his talents is in the drawing room scene where Dr Van Helsing (Edward van Sloane) holds out a cigarette case to confront the Count with his lack of reflection. Lugosi plays the smacking of the case from Van Helsing's hand as a violent impulse of revulsion. He takes one step backwards, and the camera pushes in on him to accentuate the static look of anger on his face, his shoulders held slightly back like an animal ready to pounce. And then we watch him slowly regain his composure, his blind rage turning to a mix of anger, embarrassment and even admiration for Van Helsing. Without a word, Lugosi sells the idea of Dracula as man and monster in one.

Lugosi would inherit Chaney's mantle as a horror star, and proved only the first of the type to emerge in the sound era. Lugosi's career may be the ultimate example of the mixed blessings of such stardom. While he would work steadily through to his death in 1956, Lugosi rarely escaped his typecasting within the horror genre. Exceptions like a small part as a Russian commissar opposite Greta Garbo in *Ninotchka* (1939) were few and far between, and Lugosi's dignity was tested by live engagements like strolling around with a man in a gorilla suit outside the Los Angeles premiere of *House of Wax* in 1953. He ended out his career with

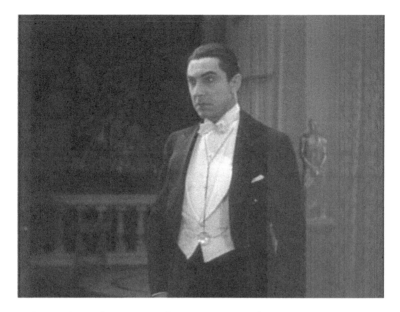

FIGURE 1.6 *Béla Lugosi as the Count in* Dracula *(1931).*

three films by independent director Edward D. Wood Jr. (*Glen or Glenda* (1953), *Bride of the Monster* (1955) and *Plan 9 from Outer Space* (1959), the endmost posthumously) – ultra-low-budget films that have been recuperated as cult classics (see Chapter 6). Lugosi's burial in his Dracula cape speaks to the inescapability of the part and his association with horror.

The unexpected success of *Dracula* motivated Universal to rush another adaptation of a venerable novel into production: *Frankenstein* (1931), directed by British expatriate James Whale (much later, the subject of Christopher Bram's novel *Father of Frankenstein* (1995) and its Oscar-winning adaptation, Bill Condon's *Gods and Monsters* (1998)). When Lugosi turned down the part of the monster, not interested in a non-speaking, makeup-heavy role, it went to a virtual unknown: an Englishman who used the stage name 'Boris Karloff'. Between Jack Pierce's iconic flat-topped, neck-bolted makeup and Karloff's powerful, expressive performance, Frankenstein's monster emerged as a sympathetic and tragic figure, and Karloff as a new star. Where one successful film was an anomaly, two made a trend, and Karloff was another instant star – the only actor except Garbo who

could be billed with a surname alone. By the end of 1931, the boom of the horror film was firmly on.

The American culture of the Great Depression provides an important context to this new cycle. David J. Skal (2001) treats the fact that the key year for the sound horror film was 1931, the worst year of the Depression, as extremely significant: the feelings of darkness and despair found a voice in the horror film, with the newly defined genre

> [serving] as a kind of populist surrealism, rearranging the human body and its processes, blurring the boundaries between Homo Sapiens and other species, responding uneasily to new and almost incomprehensible developments in science and the anxious challenges they posed to the familiar structure of society, religion, psychology, and perception. (114)

The process of genrification and its entanglement with the political and economic climate is amusingly confirmed by *Boo!*, a comic short that Universal released in 1932. It repurposes footage from *Frankenstein*, *The Cat Creeps* (1930) and *Nosferatu*, to which Universal held the North American distribution rights.[7] A comic narrator makes mock of the conventions that the studio was helping to solidify. It begins with a reference to the Depression: 'With times as tough as they are, we present our formula for cheapest kind of amusement: nightmares.' We watch a man reading Stoker's *Dracula* and trying to induce a nightmare by eating lobster and drinking milk before bed. The narration is laced with political jokes that allude to the 'horrific' character of the times; at one point we see Gustav von Wangenheim's Hutter in *Nosferatu* fleeing up a stairway only for the footage to be reversed and played forward again and again: 'He acts like Congress, and always ends up where he started.' Later the narrator tells us

[7] *Nosferatu*'s US exhibition was fairly small, so few watching *Boo!* would have recognized the footage's origins. Amid its period of relative unavailability, footage from *Nosferatu* would be repurposed in a number of interesting places, also including Jean Painlevé's *Le vampire* (1945), an experimental nature short in which the habits of vampire bats allegorize fascism.

that Dracula went back to his coffin to sleep for hundred years, 'until Congress decides to do something about the Depression'. Full of kitschy puns and unbridled silliness, *Boo!* tells us something about the new recognizability of these generic elements and the availability of horror themes to parody, as well as their repurposing for political and social commentary. *Boo!* helps us see that, far from being a sign of an exhausted genre, available only to mockery, parody can be a sign of a genre's vitality.

Boo!'s use of the term 'horror story' testifies to the increasing solidification of this terminology. Alison Peirse notes that while *Dracula* was marketed as a 'mystery picture', reviewers characterized it with terms like 'horror', 'blood-curdling' and 'eerie'. An administrator for the Production Code used the phrase 'horror pictures' in a letter to Paramount in 1931, and 'horror films' or 'horror pictures' began to appear in both the trade and the popular press in the early 1930s. A fairly firm consensus around what the genre included and excluded seemed to have been established by 1933 (6–8).

Universal continued to capitalize on its horror brand throughout the 1930s. *Dracula* and *Frankenstein* were followed by *The Mummy*, directed by Freund. While officially an original story influenced by the 1922 discovery of the tomb of King Tutankhamun, *The Mummy* also borrows heavily from *Dracula*, and even features actors Edward van Sloane and David Manners in similar parts. As the title character, Imhotep, a surprisingly sympathetic monster seeking the reincarnation of his lost love, Karloff is wrapped only in bandages in the terrifying opening sequence: the stereotypical shambling mummy stems from the subsequent Universal series, starting with *The Mummy's Hand* (1940). Universal's H. G. Wells adaptation *The Invisible Man* (1933) followed, directed by Whale with innovative special effects, adding Claude Rains to the canon of horror stars; like Peter Lorre and largely unlike Lugosi and Karloff, he would manage to alternate between horror leads and character roles in other types of films.[8] In 1935, Whale made Universal's first sequel, the inimitable *Bride of Frankenstein*.

[8] Other 'horror actors' who were largely supporting players include Dwight Frye, George Zucco and Lionel Atwill. Though there were certainly actresses who appeared in multiple horror films of the 1930s (including Fay Wray), the advent of the 'horror actress'

The centrepiece of *Bride of Frankenstein* is Frank-enstein's monster's friendship with a blind hermit, which walks a delicate line between not entirely ironic Christian imagery (Schubert's 'Ave Maria' on the soundtrack, a glimmering crucifix on the wall, a meal of bread and wine) and dry humour (the monster's newfound taste for cigars). Fast-paced, flashy (replete with low-angle shots and canted framings) and full of iconic scenes, *Bride of Frankenstein* is probably the most acclaimed of Universal's 1930s horror films. However, another strong candidate for that title is another sequel, the following year's *Dracula's Daughter* (1936), about the titular heiress (Gloria Holden) trying vainly to escape her heritage. Though *Bride of Frankenstein* is more comical and frolicsome and *Dracula's Daughter* is sombre, elegant and dreamlike, they are both noted for adult tones and queer themes (Benshoff 1997, 49–51). Between them, they seem to represent the full realization of Universal's horror style.

Universal's new successes inspired other studios to prepare horror films of their own. MGM recruited Tod Browning for a project that became *Freaks* (1932). Dipping into his carnival roots, Browning contrived a bizarre plotline starring many real-life freak show performers. The production of *Freaks,* which saw sideshow performers mixing with the players of an MGM back-lot, has become legendary, as has its strange release history: pulled by MGM during its initial engagement, cut heavily, repurposed for the exhibition circuit, frequently banned or suppressed, but then rediscovered in the 1960s and re-evaluated as a cult classic, praised for its sensitivity and nuance (though remaining controversial). For all the latter-day fascination and scholarship it has inspired (see Skal and Savada 1995, esp. 161–82, Brottman 2005, 15–49, Smith 2011, 82–118), *Freaks* was one of the few financial failures among Golden Age horror films, mostly due to MGM's lack of support.

MGM also produced *The Mask of Fu Manchu* (1932), Freund's *Mad Love* and two more Browning films, *Mark of the Vampire* (1935), a loose remake of *London after Midnight,* and *The Devil-Doll* (1936). Warner Bros. made two early Technicolor horror films: *Doctor X* (1932)

would largely not happen until the 1960s–1970s and actresses like Ingrid Pitt, Barbara Steele, Hazel Court and Jamie Lee Curtis.

and *Mystery of the Wax Museum* (1933). Columbia Pictures' ventures into horror remain fairly obscure, including *Night of Terror* (1933) and *Black Moon* (1934). Paramount had an early success with another literary property, the first sound adaptation of *Dr. Jekyll and Mr. Hyde* (1931), helmed by A-list director Rouben Mamoulian. It remains impressive for the spectacular transformation sequences and the narrative's frank sexual themes. Perhaps due to the still-uncertain genre lines, it attained a level of respectability undreamed of by other horror films in the period, earning a Best Actor Oscar for its lead, Fredric March. Paramount's next venture into the nascent horror film genre was another adaptation. *Island of Lost Souls* (1932), based on H. G. Wells's *The Island of Dr. Moreau* (1896), also had an impressive lead in Charles Laughton; one of the most vivid and disturbing films of its time, it was refused a release in Britain until 1958 (and then released in a cut version) due to its scenes of vivisection.

The European influence so often noted on these Golden Age Hollywood horror films did not come from nowhere. The migration of German talent led to the prominent and inexorable influence of expressionism on Hollywood horror. James Whale's films feel very English, especially in their dry sense of humour, and Whale often surrounded himself with British collaborators; *Bride of Frankenstein*, especially, almost qualifies as a British film made in exile (Hutchings 1993, 15). Other key directors were of continental origins: Mamoulian was Armenian Russian, Robert Florey (*Murders in the Rue Morgue* (1932)) was French, Michael Curtiz (*Mystery of the Wax Museum*, *Doctor X* and *The Walking Dead* (1936)) was Hungarian and Edgar G. Ulmer (*The Black Cat* (1934)) was Austrian.

Meanwhile, horror films continued to be produced across the Atlantic, but in nowhere near Hollywood's volume. In Britain, producer Michael Balcon brought Boris Karloff back to his homeland to star in *The Ghoul* (1933), and subsequent attempts to launch the UK horror film include *The Clairvoyant* (1935) with Rains and Fay Wray, and *The Man Who Changed His Mind* (1936) with Karloff. Despite borrowing Hollywood talent, none of them had more than minor success (Peirse 2013, 122–48). The film that perhaps best testifies to European allegiance of art cinema and horror material is Carl Theodor Dreyer's *Vampyr* (1932). While a sound film, *Vampyr* contains very little dialogue, and not for nothing is it subtitled *Der Traum des Allan Gray*,

'The Dream of Allan Gray'. It is a gauzy, disjointed, oneiric experience and is most famous for the sequence of its protagonist hallucinating his own funeral from inside the coffin, with the nightmarish image of the female vampire (Henriette Gérard) staring down at him from outside. Peirse writes, 'In its amalgamation of "high" art cinema and "low" horror culture, combined with its "incommunicable" nature, *Vampyr* remains slippery to demarcate, resistant to definition' (100). *Vampyr*'s place within the classical horror film, or even the vampire film, is hard to articulate due to its anomalousness; rather like the silent adaptations of *The Fall of the House of Usher* by Jean Epstein and James Sibley Watson (both 1928), it is seldom discussed in the generic context of horror.

Cinematic experimentation within the emerging generic space of horror was not unique to Europe. Mamoulian's *Dr. Jekyll and Mr. Hyde* is one of the most formally transgressive Hollywood films of the early sound period, with extensive use of first-person point-of-view shots, strange wipes and stunning, seamless transformation scenes. Some of Universal's Edgar Allan Poe adaptations, in particular, considerably foreground their avant-garde influences; 1932's *Murders in the Rue Morgue*, again shot by Freund, shows such expressionist influence that some sequences play like an unauthorized remake of *The Cabinet of Dr. Caligari*. Ulmer's *The Black Cat*, featuring Karloff and Lugosi, is noted for its modernist look, borrowing from the Bauhaus and Art Deco, quite distinct from the expressionism or surrealism influences on many Golden Age horror films.

Other inventive works came from Hollywood's margins. *White Zombie* (1932) testifies to another emerging phenomenon: independent horror. The first zombie film, *White Zombie* was directed and produced by the Halperin brothers, Edward and Victor, who rented out studio space on the Universal lot to take advantage of existing props and sets. They also hired Lugosi to play the villain, wonderfully named 'Murder Legendre'. With gorgeous matte work, interesting dissolves, wipes, superimpositions, split screens and instances of rack focusing, as well as a clever interplay of sound and silence, *White Zombie* is replete with low-budget innovation. Its success attested to the appeal of horror for independent producers, something that remains until this day. The Halperin brothers would then make *Supernatural* (1933) for Paramount, a rare horror ghost

film of the period and featuring uncharacteristic horror roles for Carole Lombard and Randolph Scott (see Chapter 7), before returning to independent status with the unofficial *White Zombie* sequel, *Revolt of the Zombies* (1936).

Another, considerably lower-grade example of independent horror from the period is the notorious *Maniac* (1934) by exploitation specialist Dwain Esper. Where the studios adapted respectable literary properties to dodge censorship, *Maniac*, despite its own citations of Poe, is the least respectable kind of film. Circulating in the exploitation circuit specifically designed to provide alternatives to the Hollywood studio system, it is full of sleaze, violence, nudity and sensationalism. Since it is putatively an educational film, Esper occasionally alternates the action with captions giving the dictionary definitions of mental illnesses. The most notorious sequence of the film sees a Poe-obsessed patient being given the wrong syringe and unleashing a resplendent burst of overacting, crying, 'Steeling through my body! Creeping through my veins! Pouring into my blood! Darts of fire in my brain! Stabbing me! Agony! I can't stand this torture! This torment! I can't stand it! I won't! I won't! I won't!' before degrading into animalistic grunts, ravishing a female zombie and then vanishing from the narrative altogether. The bizarre formal ineptitude of much of the film (an early scene fades out and back in on the same shot for no obvious reason) adds to its fascination. As would be proved again in the subsequent decades, horror could provide space for the expansion of cinema's formal vocabulary, through artistry or through incompetence (Sconce 2003).

Released in the middle of the Golden Age of the American horror film, no film attests to the vagaries of the genrification process better than RKO's *King Kong* (1933). As Cynthia Marie Erb has shown, it was not unequivocally considered part of the horror genre at the time, but rather was understood through the two genres for which its directors, Ernest B. Schoedsack and Merian C. Cooper, were known: travel documentaries and jungle adventure films (16). However, personnel on the film viewed some of the Universal films during its production and made reference to them as desirable models to emulate (47). Posterity, of course, recalls *King Kong* not only as a horror film, but as one of the most representative of the Depression era, a concentration of key horror themes, and particularly amenable to being read through

the central theme of repression (see Chapter 5). Yet to do so is, at least slightly, to pull the film out of its historical context. The fact that *King Kong* has ultimate been 'claimed' as a horror film, however, speaks to the label's increasing expansiveness.

Censorship and the end of an Era

When and why did this Golden Age cease? In the spring of 1936, Universal removed all horror productions from its schedule, and the other studios followed suit soon after. No Hollywood studio released a single new horror film in 1937 or 1938. Why this abandonment of the genre after such a stellar five years? Whatever the reason for this change might have been, it certainly was not a lack of public interest in horror: there was no single major flop that one can point out to explain this shift, and virtually every American horror film of the first half of the 1930s was profitable. *Bride of Frankenstein*, late in the cycle, was particularly so.

For many years, scholars blamed the studios' sudden lack of interest in producing horror films on the closing down of the lucrative British market: an outright ban on horror movies imposed by the British Commonwealth (Brunas, Brunas and Weaver 1990, 92). However, Alex Naylor's (2010) revisionist account demonstrates that there was never any such ban and that though the British censors were concerned about American horror films, most were passed for exhibition. Naylor shifts the emphasis towards internal factors in the American film industry, including the sale of Universal Pictures and the open hostility of the Production Code Administration (PCA), established in 1934, towards horror films, with which it now interfered from preproduction on. The PCA's tactics, Naylor shows, included pressing the line that this purported British ban would harm the profitability of any horror products. The increasing power of the PCA led to its insistence on substantial script changes to *The Walking Dead*, *The Devil-Doll* and *Dracula's Daughter*, uncoincidentally, the final three releases before horror film production dropped away in 1936.

If a narrative of a Golden Age requires a great fall, on this count the Golden Age of Horror falls short. It proved to be no more than a

hiatus. Late in 1938, Universal rereleased *Dracula* and *Frankenstein* in a very successful theatrical double bill, and quickly commissioned the well-budgeted *Son of Frankenstein* (1939), so the 'demise' of the horror film can easily be overstated.[9] A shift in priorities in the PCA at this time, away from censoring sex and violence and towards censoring political material, emboldened the studios to attempt horror films again. As Naylor notes, the studios' return to horror films demonstrates 'the limits of PCA influence when pitted against commercial cinema's ultimate and defining goal: profit' (n.p.).

The narrative of a single Golden Age is, of course, problematic, and can blind one to other fascinating eras of production, both before and after. But it cannot be denied that the years 1931 to 1936 were so fertile, so productive and so successful that they created or at least solidified the language and the rules of the horror genre that have been observed – or consciously broken – in the decades since.

[9]These re-releases were subject to the Production Code and experienced censorship as a consequence. In *Frankenstein*, Dr Frankenstein's (Colin Clive) line 'Now I know what it feels like to be God!' was cut, as was the accidental drowning of a young girl by the monster; the latter scene remains in the later version but is cut halfway through. Consequently, when the girl's body is brought into town later in the film, the audience lacks the knowledge that she died in a tragic accident, which suggests that the monster may have intentionally murdered her, or even molested her. It is a classic case of censorship making things worse.

2

1939–1973: Horror and the Crisis of Rationality

What does it mean to be a horror film in an age of horrors? Since the Second World War, horror films have regularly had to confront this question. The Holocaust and the atomic devastation of Japan ushered in a crisis of rationality that left the place of fictional horror uncertain, and in the subsequent decades it would alternatively work to sooth and enunciate this crisis – often both at once. Even in those seemingly pro-establishment films which conjure up monsters only to vanquish them, the ending is often haunted by the spectre of its own incompleteness, for one monster arising can mean another, and another, and another.

Monsters at war

The return of horror in 1939 was heralded by *Son of Frankenstein*'s release on 13 January of that year. It would be the last time Karloff played the monster and also added the memorable character of Igor, the broken-necked assistant, often regarded as Lugosi's second-best role. That year alone, Karloff also starred in *The Man They Could Not Hang* for Columbia and Lugosi in the British film *The Dark Eyes of London*, and the years 1939–1947 would see the production of horror films in an impressive volume. Universal would unveil another iconic monster in 1941's *The Wolf Man* and with it another horror star in Lon Chaney Jr. Coming off of portraying Lennie in *Of Mice and Men*

(1939), Chaney maintained an interesting double career of horror leads, often, like his father, under heavy makeup, and secondary parts in Westerns and crime films.

Where the previous decade had seen two successful sequels (*Bride of Frankenstein* and *Dracula's Daughter*), the 1940s saw Universal embracing franchising wholeheartedly. It produced four *Invisible Man* sequels/spinoffs, and followed 1940s. *The Mummy's Hand* with three further entries in the saga of Kharis the Mummy (a different mummy from the one played by Karloff in 1932), all but one with Chaney.[1] Chaney also played Frankenstein's Monster in *The Ghost of Frankenstein* (1942), the fourth entry in the series, as well as Dracula in *Son of Dracula* (1943).

Universal also launched a short-lived low-budget series built around Rondo Hatton, whose unusual appearance (with facial deformations resulting from acromegaly) allowed him to play heavies and monsters without makeup. Playing the menacing serial strangler 'the Creeper', Hatton starred in *House of Horrors* (1946) and *The Brute Man* (1946); however, he died two weeks after finishing the latter film in 1945. Fearing bad press for having worked an ill man to death, Universal sold both films to low-budget specialists Producers Releasing Corporation (PRC). In the 1940s, PRC and fellow 'Poverty Row' studios like Monogram and Republic benefitted enormously from horror's revival, often casting horror actors like Lugosi, Karloff and John Carradine in their pictures – bankable names who could be hired cheaply for short shoots.

Universal also experimented with merging series in 1943's *Frankenstein Meets the Wolf Man*, where Lugosi played the monster, the role he had rejected twelve years earlier. The fact that Frankenstein movies took place in the previous century and *The Wolf Man* in the present day is ignored to make the meeting work. Subsequently, Universal combined the Dracula, Frankenstein and Wolf Man franchises into the overcrowded but enjoyably silly *House of Frankenstein* (1944) and *House of Dracula* (1945), and later joined them with the famed comic duo for *Abbott and Costello Meet Frankenstein* (1948) (see Chapter 4).

[1] Tom Tyler played Kharis in *The Mummy's Hand.*

Most of these films are clearly targeted at a younger and perhaps less discriminating audience than most of those Universal produced in the 1930s. Yet there were still attempts to court mainstream audiences with prestige horror projects. MGM remade *Dr. Jekyll and Mr. Hyde* (1941) with Spencer Tracy, Ingrid Bergman and Lana Turner, largely using the same script as the 1931 Mamoulian film; this version received three Oscar nominations and was profitable despite weaker reviews than the earlier film. Universal remade *The Phantom of the Opera* (1943) as an expensive Technicolor spectacular, starring Claude Rains as a wronged composer seeking revenge after having his face scarred by acid. Musical stars Nelson Eddy and Susanna Foster were top billed and the horror elements thoroughly downplayed. *The Phantom of the Opera* was nominated for four Oscars, winning for its cinematography and art direction.

As Rick Worland writes,

> The traditional account contends that in the 1940s … the horrors of global war so far exceeded mere anxiety and the capacity of distanced metaphor that the genre ceased to command both wide audiences and critical respect. Put simply, real horror overwhelmed fake movie scares and made them irrelevant except as purely escapist, increasingly puerile entertainment. (47)

The striking absence of horrific ghost films during the Second World War and its aftermath is attributable to the need for the presentation of a positive afterlife, visible through the cycle of comic and romantic films about ghosts and angels that has been retrospectively dubbed 'film blanc' (Valenti 1978). Some of these explicitly involve the war (*A Guy Named Joe* (1943), *The Canterville Ghost* (1944), *A Matter of Life and Death* (1946), *It's a Wonderful Life* (1946)), but even those that do not often unfold against contexts of wounded masculinity, loss and mourning. Paramount's *The Uninvited* (1944) stands out as a rare serious haunted house film of its period, though it too balances its horror elements with romance and comedy.

Worland notes that the wartime context presents ample grounds for interest in some of the neglected horror films of the early 1940s. The Office of War Intelligence (OWI) cooperated with most of the studios of the time to ensure films were friendly to Allied interests.

Worland's research uncovers fascinating interventions. The OWI's Bureau of Motion Pictures persuaded Monogram to tone down the racism of the low-budget *Revenge of the Zombies* (1943) to avoid alienating African American servicemen, and influenced Universal to make some changes to *The Mummy's Ghost* (1944) to avoid offending Egyptian allies. Despite being fairly routine in most respects, Columbia's *The Return of the Vampire* (1943) stands out among war-era horror films for the directness of its commentary. It stars Béla Lugosi as a thinly veiled Dracula knock-off named 'Armand Tesla', a powerful vampire who was defeated in London during the First World War. Twenty-four years later, the Blitz accidentally reawakens him to renew his plans of conquest; his second destruction promises that of the resurgent Germany. Lugosi also starred in Monogram's *Black Dragons* (1942) as a Japanese mad scientist surgically altered to infiltrate the United States, his horror coding following him into a paranoid wartime crime drama. Even before the Pearl Harbour attack, *King of the Zombies* (1941), also from Monogram, had two American airmen and their black manservant Jefferson Jackson (Mantan Moreland) fighting evil Austrian spy/mad scientist Dr Miklos Sangre (Henry Victor), engaged in making zombies in the Caribbean; though he clearly works for some foreign government and is sending secret transmissions in German, Sangre is never quite clearly identified as a Nazi agent. For Hollywood's propagandists, stock horror imagery was readily available for repurposing to represent the Axis as human monsters.

But for all of the representative language that horror might have lent to the war effort, it is generally felt that the war era was deleterious to the horror film. This narrative is incomplete in part because of the shifting definitions of 'horror'. As reception studies like those conducted by Mark Jancovich (2009b, 2014) and Tim Snelson (2015) have found, in the 1940s terms like 'horror', 'thriller' and 'chiller' were not clearly delineated, and many of the films that we tend to locate within the retrospective constellations of film noir or the paranoid woman's film were closely linked with horror at the time. The fact that Orson Welles was received as a horror star during the 1940s (Jancovich 2009a) speaks to how differently the genre was conceived at the time relative to today.

Lewton, ambiguity and 'quality'

There is one major cycle that escapes the narrative of decline that is generally attributed to 1940s horror films: the nine films produced at RKO Pictures from 1942 to 1946 under the supervision of Val Lewton. An interesting example of a producer–auteur, Lewton was allowed relative artistic autonomy provided that he accepted RKO's titles, every film needed to be under seventy-five minutes and cost less than $150,000. The first was the remarkable *Cat People* (1942). While it is an exaggeration to characterize all American horror films of the 1930s as taking place in Europe or at least in a misty, Gothic non-place, it is a striking change that *Cat People* takes place in a generally realistic version of New York City. Rather like the emerging tradition of film noir (its director, Jacques Tourneur, would later direct the great noir *Out of the Past* (1947)), *Cat People*'s themes are deeply psychological and play out graphically through intricate mise en scène and low-key cinematography. It tells the tale of a deeply repressed Serbian immigrant, Irena (Simone Simon), who believes that she will transform into a murderous panther if sexually aroused by her husband (Kent Smith). Such transformations are implied rather than directly depicted. The film's most frightening moments depend on ambiguity, such as when romantic rival Alice (Jane Randolph) is trapped in a dimly lit swimming pool where every dark shadow might contain a stalking panther, and the subsequent 'bus scene' (see Chapter 7), regarded as containing cinema's first 'jump scare'.

The second Lewton film, also directed by Tourneur, is equally legendary. *I Walked with a Zombie* (1943) is set in the fictional Caribbean island of St. Sebastian, where a young Canadian nurse, Betsy (Frances Dee), comes to care for the catatonic wife of a local plantation owner. Betsy finds herself drawn into the complex family dynamic, exacerbated by the local community of voodoo practitioners. *I Walked with the Zombie* is the first film that is serious and semi-respectful about voodoo, and it deals with race relations with more nuance than most films of the period; if it doesn't quite stage a coherent critique of colonialism or an exploration of the long-term effects of slavery, it at least raises these matters and places emphasis on the white characters' ignorance of and complicity in continued

systems of exploitation. Like *Cat People, I Walked with a Zombie* is moody and atmospheric; Betsy's trip through the sugarcane fields at night – and the sudden discovery of the silent zombie Carrefour (Darby Jones) guarding the crossroads – is as spellbinding as any sequence in the whole of horror cinema.

Lewton's subsequent films are almost as interesting. *The Leopard Man* (1943) is a serial killer drama, and *The Seventh Victim* (1943) is a tale of New York Satanists that strikingly prefigures *Rosemary's Baby* (1968). *The Curse of the Cat People* (1944) may have the single most misleading title in a cycle full of them. A dreamlike fable about child psychology, it is a sequel to *Cat People* that has a young girl hallucinating the presence of Irena, her father's first wife. *The Body Snatcher* (1945) and *Isle of the Dead* (1945) gave Boris Karloff two of his best parts as, respectively, a Burke- and Hare-style 'resurrectionist' and a plague-stricken Greek general.

Lewton's films are often regarded as anomalies, islands of quality in the sea of mediocrity that is 1940s horror. This assessment ignores much, including how Lewton's films are very much of their time. Alexander Nemerov (2005) has provocatively linked them to the wartime context, identifying them as home-front war pictures that

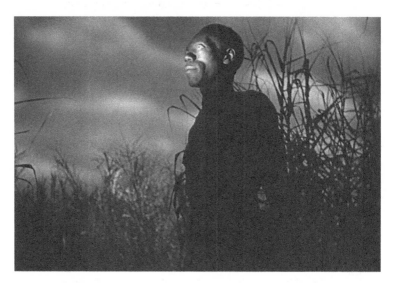

FIGURE 2.1 *Darby Jones as Carrefour in* I Walked with a Zombie *(1943).*

reflect the psychology of the war years. Seldom in Lewton's films do we find a glorification of traditional authority. The psychiatrist Dr Louis Judd in *Cat People* (Tom Conway) is not only fatally wrong in his assessment of Irena, but also a sexual predator who abuses his power. In *I Walked with a Zombie*, the white characters are almost all clueless about the realities of voodoo that the black characters grasp, and Mrs Rand (Edith Barrett) mixes voodoo and Christianity, magic and medicine, in her dual role as the local nurse and a voodoo practitioner. Lewton's fascinating body of work is awash with moral confusion and ambiguity, and his is a name often cited as a shorthand for subtle, ambiguous and thought-provoking horror.

Apocalypses, showy and subtle

The later years of the 1940s saw production of horror films dry up almost as strikingly as 1937–1938. This time there seems to be no cause but generic fatigue and dwindling audiences. But once again, the hiatus was short lived, and horror returned in full force in the 1950s, albeit often labelled as 'monster movies' or 'science fiction'. These genres, always tightly linked (see Chapter 4), drew remarkably closer in the 1950s. One could construct an extensive list of 1950s science fiction/horror films, with *The Thing from Another World* (1951), *Them!* (1954), *Invasion of the Body Snatchers* (1956), *Forbidden Planet* (1956), *The Blob* (1958), *The Incredible Shrinking Man* (1958), *I Married a Monster from Outer Space* (1958) and *The Fly* (1958) as only the best known. Traditional monsters were often 'scientifically' reconceived. *I Was a Teenage Werewolf* (1957) tethers its lycanthropy story to a mad scientist narrative, with its unfortunate protagonist's (Michael Landon) adolescent rage being transformed into werewolfry by the unscrupulous Dr Brandon (Whit Bissell).[2] Its

[2]Meanwhile, traditional monsters were recast as infiltrating bogies in the 1950s. *The Return of Dracula* (1958) has the Count attaching himself to a California family by posing as a long-lost European relative, while being pursued by international agents, Van Helsings for the Cold War. The horror narratives of previous eras were being repurposed to fit the fears of the time.

sister-film *Blood of Dracula* (1957) is a still odder mix of scientific and supernatural elements, with its female vampire created by the lesbian-coded science teacher/mad scientist Miss Branding (Louise Lewis) with both chemistry and a hypnotic amulet from the Carpathian Mountains. Excluded by the patriarchal scientific establishment, Branding has a bizarre motivation:

> I can release a destructive power in the human being that would make the split atom seem like a blessing. And after I've done that, after I've demonstrated clearly that there's more terrible power in us than man can create, scientists will give up their destructive experiments. They'll stop testing nuclear bombs. Nations will stop looking for new artificial weapons, because the natural ones, we the human race, will be too terrible to arouse. War will no longer be a calculated risk because it can only end in total destruction.

Branding means to turn her students into vampires in a plot to prevent atomic war!

Blood of Dracula is hardly the only film of the period to openly invoke atomic horror to add a dash of apocalyptic paranoia. The extent to which the 'giant monster' cycle of the period is all about atomic beasts can easily be overstated (in *The Giant Gila Monster* (1959), for example, no explanation is given for the eponymous reptile's size whatsoever), but generally reckless science is somehow responsible. In *Tarantula* (1955), the giant arachnid was created by experiments on animals with a radioactive isotope. In *The Beast from 20,000 Fathoms* (1953), the 'rhedosaurus' is accidentally freed by an atomic test, a convention that would be repeated in *Gojira* (1954). Though these films would conventionally end with the monster's defeat through military or quasi-military action and weapons of mass destruction (the tarantula is napalmed out of existence, the Gila monster is blown up with nitro-glycerine, the rhedosaurus shot full of a radioactive isotope), the restoration of order is often haunted by the awareness that the atomic genie cannot be put back into its bottle. *Gojira*, in its original Japanese version a grim, slow and thoughtful film, ends with the Oppenheimer-like Dr Serizawa (Akihiko Hirata) destroying the monster with a weapon of mass destruction, the Oxygen Destroyer, at the cost of his own life. The film ends with the warning that further

nuclear tests may produce a new Gojira, an admonition tellingly not retained in the film's American version, *Godzilla: King of the Monsters* (hybridized with newly shot footage in English).

The apocalypse wore a subtler garb in a different cycle of science fiction/horror films, based less on conspicuous display than on paranoia, infiltration and subversion. The most famous of these is *Invasion of the Body Snatchers*, in which aliens are replacing the inhabitants of a small California town one by one and threatening to spread far beyond it. Few films build paranoia more effectively. The film has proved fascinatingly available to simultaneous readings from the left and the right. On the one hand, it is readable as an anti-Soviet screed about infiltration and subversion; the aliens' lack of emotions and emphasis on pure rationality, as well as their compulsive desire to convert and expand, plays on Western stereotypes about communist de-individualization. This reading is encouraged by its studio-mandated frame narrative, which ends the film on a more hopeful and pro-authority note. Conversely, is the film an anti-McCarthyism fable about the rise of an American fascism under the guise of opposition to communism? Jancovich suggests that both readings shelter an indictment of the postwar American society of Fordism, corporatization and conformity: 'If the alien was at times identified with Soviet communism, it was also implied that this was only the logical conclusion of certain developments within American society itself' (1996, 26–7). The 1960 *The Twilight Zone* episode 'The Monsters Are Due on Maple Street' works similarly: strange happenings in an ordinary American neighbourhood produce paranoid witch hunts and then a violent riot, all rigged by aliens looking to turn humans against each other to ease planetary conquest.

In *Forbidden Planet*, the apocalypse occurred hundreds of thousands of years ago, destroying the ancient inhabitants of Altair IV, the Krell. When an Earth starship arrives, they find that the only survivors of a previous expedition are Dr Morbius (Walter Pidgeon) and his daughter, Altaira (Anne Francis), and that Morbius has been unlocking the secrets of the lost Krell civilization. But it transpires that the Krell's advanced logic and intellect created an unexpected by-product: 'monsters from the id' that destroyed them. Now, Morbius's own 'id monster' is attacking the starship crew, trying to keep them from Altaira because of her father's quasi-incestuous obsession with her. *Forbidden Planet* is a

science fiction classic but is often also discussed as horror because of its themes of repression and monstrosity. It fits well into the apocalypse-obsessed 1950s, even ending with an inglorious planetary destruction – the fate that many feared was now in store for planet Earth.

Spectacle and gimmickry

In spite of the apparent dominance of science fiction–horror hybrids, easily the most profitable horror film of the 1950s was not science fiction-inflected. This was *House of Wax* (1953), the first Hollywood studio picture released in 3D. Facing weak box office returns in the early 1950s, the Hollywood studios embraced ostentatious new theatrical techniques to restore prestige to the filmgoing experience itself and thus to compete with television. These included the widescreen formats Cinerama, CinemaScope and VistaVision, stereophonic sound and 3D. The first 3D feature was the successful indie *Bwana Devil*, released in November 1952, and Warner Bros. produced *House of Wax* as the first studio 3D release. Perhaps its best-remembered scene is an impressively reflexive one. As the new House of Wax within the diegesis is opening, a man carrying a pair of paddleballs entertains gawkers by bouncing balls close to their faces. Finally, he turns and looks at the camera and not only bounces the balls into the audience (through the miracle of 3D) but also speaks directly to it: 'There's someone with a bag of popcorn. Close your mouth, it's the bag I'm aiming at, not your tonsils.' Rarely has horror cinema's roots in sensational entertainment forms like the trick films of early cinema and carnival shows been more clearly on display.

The film itself, a remake of 1933's *Mystery of the Wax Museum*, is similarly reflexive, a tale of the making of horrors. *House of Wax* is the story of Henry Jarrod (Vincent Price), a designer of wax dummies. After a struggle with a business partner goes wrong, his museum burns down and he is himself badly injured (how badly, the film does not reveal until its climax). When he reopens it, it is as a house of horrors, abandoning tasteful historical recreations in favour of bloody and grotesque spectacles. But hidden beneath his dummies are corpses, and Jarrod is himself a charred wreck of a man beneath a clever disguise. The success of *House of Wax* was such

that, adjusted for inflation, it remains one of the two or three most profitable horror films ever made.

While Price had appeared in horror before (including Universal's *Tower of London* (1939) and *The Invisible Man Returns* (1940); he also made a cameo as the Invisible Man in *Abbott and Costello Meet Frankenstein*), it was *House of Wax* that established him as a horror star like Karloff and Lugosi. Much has been written of the queerness of Price's style and his status as a 'male diva' (Benshoff 2008); regardless of his own sexual preferences, he was certainly well in touch with the idea of camp. His ability to maintain commitment to playing his characters while maintaining a certain sardonic separation from the plot would make him ideal for playing diabolical figures in the horror genre, which he did with aplomb over the next several decades. Price's stage credentials and bearing of sophisticated perversity lent a sheen of prestige to a great many horror films of both low and high budgets.

Price's status as a horror icon would be secured later in the 1950s through his association with William Castle. Castle was a dependable Hollywood B-unit director, having directed more than forty films between 1943 and 1955: crime thrillers, Westerns, war films and the like. Observing the strong international box office of Henri-Georges Clouzot's French thriller *Les Diaboliques* (1955), famous for its shocking twist ending, he turned independent to make *Macabre* (1958). *Macabre* is best remembered for its advertising gimmick: a life insurance policy against death by fright. In the wake of *Macabre's* success, Castle remade himself as 'the Master of Gimmicks', a specialist in low-budget gimmickry that provided a DIY mirror of the studios' official innovations of the period. Also nicknamed 'the Living Trailer', Castle often appeared in the trailers and introductions to his films, playing himself as a kind of perverse director/carnival barker ballyhooing his latest products. He also did many personal appearances, often arriving in a hearse.

Castle recruited Price to star in his next two gimmick films: *House on Haunted Hill* (1959) and *The Tingler* (1959). The first was a modern variation on *The Cat and the Canary*, with a cast of characters locked into a spooky, possibly haunted house, promised a fortune if they survive the night. As the decadent millionaire Frederick Loren, Price is locked in a deadly struggle with his adulterous wife Annabelle

(Carol Ohmart), both deploying a set of quasi-cinematic devices in a sadomasochistic game designed to terrify each other and their guests. In the film's climax, Annabelle believes she has killed Frederick, but his skeleton returns to taunt her into falling into a pit of acid (it is actually a prop worked by her husband). Through a gimmick called 'Emergo', a skeleton was positioned to fly from the front of the theatre and hover over the audience, provoking a carnivalesque display among the child-dominated filmgoers (see Leeder 2011, 2016).

In *The Tingler*, Castle's most famous film, Price plays Warren Chapin, a pathologist engaged in an unorthodox study of the physiological effects of fear. Chapin discovers a parasite that lives inside the human spine that feeds on fear but is also subdued by screaming: the tingler. The major gimmick for *The Tingler* was 'Percepto': seats wired to vibrate at key moments in the film, stimulating audience members to believe that they are in danger from their own tinglers and thus need to scream and save themselves. The film contains a 'scream break' coordinated with the attack of a giant tingler on a movie theatre within the film, in which Price's voice commands, 'Scream for your lives!' to both internal and external audiences. In both films, there is an extensive slippage between Castle's own directorial authority and that of Price and his characters, who function as masters of ceremonies both of and not of the film's world – a perfect match for Price's signature style of wry detachment.

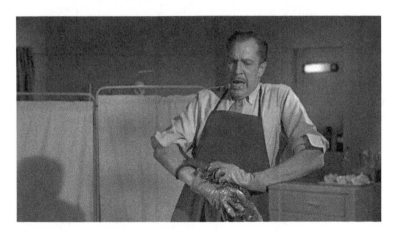

FIGURE 2.2 *Vincent Price struggles with* The Tingler *(1959)*.

Without Price, Castle would make more gimmick films. These included *13 Ghosts* (1960), with the colour process Illusion-O and a 'ghost viewer' (see Chapter 8), *Homicidal* (1961), with its 'fright break' to allow squeamish audience members to leave, and *Mr. Sardonicus* (1961), where the 'punishment poll' putatively allowed audiences to determine the villain's fate (in fact, only one ending was shot). In *Strait-Jacket* (1964), Castle replaced gimmickry with stunt casting, in this a widely unhinged Joan Crawford. Castle's later career (he died in 1977) is a mix of weak comedies, children's films, a few serious thrillers and the Marcel Marceau-starring silent film pastiche *Shanks* (1974), but he also made another major contribution to horror cinema as the producer of *Rosemary's Baby*, to be discussed below. The subsequent generation of directors, however, would look on Castle and in particular *The Tingler* with great fondness, including John Landis, John Waters, Robert Zemeckis and Joe Dante. Dante would pay tribute to Castle and the other independent horror filmmakers of the period in *Matinee*.

There were other gimmick filmmakers. The films of Ray Dennis Steckler, an independent director who acted in his films as 'Cash Flagg', made Castle's products look richly budgeted; the gimmick of the baffling *The Incredibly Strange Creatures Who Stopped Living and Became Mixed Up Zombies!!?* (1964) was 'Hallucinogenic Hypnovision', in which people with masks would occasionally run through the theatre. At the other scale of legitimacy was Alfred Hitchcock's *Psycho* (1960), in its own way a gimmick film; audiences were barred from entering after the film had started, and Hitchcock taped messages to be played in the lobby stating that a policeman was on duty to enforce this unusual policy (Kattelman 2011, 64). The cleverness of this advertising campaign worked to spread word of mouth and construct an aura of danger and transgression through this discipline (see Williams 2000). It has also been claimed, accurately or otherwise, that Hitchcock was inspired to make *Psycho* by seeing the success of Castle's low-budget films, especially *House on Haunted Hill* (Colavito 2008, 273).[3] Castle certainly borrowed from Hitchcock egregiously, especially in the *Psycho*-redolent *Homicidal,* but there

[3]While low by Hitchcock's standards, *Psycho*'s $800,000 was vastly higher than the $200,000 budget of *House on Haunted Hill* (1959) (Jancovich 2017).

may have been a slightly more reciprocal relationship between the Master of Suspense and the Master of Gimmicks.

Indeed, as masterful and impactful as it may be, *Psycho* should be viewed less as a singular work of auteurist genius than a logical outgrowth of developments in the American cinema, horror included. In particular, in locating its horror in a blandly commonplace American location (albeit with the Bates House standing for the Gothic's persistence within the everyday), *Psycho* echoes many previous horror films of the 1950s, including *I Was a Teenage Werewolf* and *Invasion of the Body Snatchers*. Nonetheless, it is hard to argue with Robin Wood's claim that *Psycho* 'conferred on the horror film something of the dignity that *Stagecoach* [1939] conferred on the western' (1979, 12) – effecting a revolution of taste and legitimation that belies its close relationship to less respectable phenomena like the gimmick films.

Monster culture and independent horror

Another crucial factor on 1950s horror was television. In 1957, Universal sold a package of fifty-two vintage films to TV stations, showing under the name 'Shock Theatre', and followed up the year after with 'Son of Shock'. For the younger generation, these represented a first exposure to these films, tipping off a new and very consequential wave of fascination with the classical horror film. Local horror hosts, often campy and pun-spouting, sprung up on television. The most famous of these were Vampira (Maila Nurmi) in Los Angeles and Zacherly (John Zacherle) in Philadelphia and New York, who spun their visibility into acting parts (Vampira famously appeared in *Plan 9 from Outer Space*) and novelty records. This new 'Monster Culture' produced such relics as the magazine *Famous Monsters of Filmland* (started in 1958) and Bobby 'Boris' Pickett's 'The Monster Mash' (a #1 billboard hit in October 1962). It also created the market for youth-oriented horror that filmmakers rushed to satisfy (Skal 2001, esp. 229–52).

Even more so than Castle, Roger Corman emerged as the quintessential American exploitation producer, whose product ranged from flimsy but engaging to lavish and impressive on modest budgets. Corman would ultimately direct almost five dozen films and produce

hundreds more: science fiction films, gangster films, motor racing films, biker films, Westerns, sex comedies and other exploitation staples, principally for American International Pictures (AIP). Yet it is likely as a horror filmmaker that he will always be best known. He was legendarily efficient and thrifty, known for making the witty *The Little Shop of Horrors* (1960) in two days, swiftly assembling a script that took advantage of sets left over from earlier productions. Similarly, the disjointed but still wonderfully atmospheric *The Terror* (1963) was hastily assembled to take advantage of existing sets from *The Raven* (1963) and a few days of work left on Boris Karloff's contract.

But alongside such zero-budget projects, Corman made more serious and costlier horror. Chief among these is the Poe series, each at least claiming to adapt the works of Edgar Allan Poe. The first was *The Fall of the House of Usher* (1960; also *House of Usher*), a canny choice as Poe's tale was read by mostly every American high school student; as with many of the Poe series, Corman fleshed it out to feature length with romantic subplots, innovative dream sequences with colour filters (see Chapter 7) and the conclusion-by-inferno that would characterize many of the following Poe films. These were *The Pit and the Pendulum* (1961), *The Premature Burial* (1962), the anthology film *Tales of Terror* (1962), *The Raven*, *The Haunted Palace* (1963), *The Masque of the Red Death* (1964) and *The Tomb of Ligeia* (1964). All but *The Premature Burial* starred Price. *The Haunted Palace* bears the title of a Poe poem but is in fact the first adaptation of an H. P. Lovecraft work, the short novel *The Case of Charles Dexter Ward*,[4] and others of the series have only a very tenuous relationship to the material they were putatively adapting, yet still traded on Poe's cultural respectability (Leeder 2017). The Corman Poe series boasted lavish production values for AIP, strong acting and literate screenplays by talented prose writers like Richard Matheson and Charles Beaumont.

Corman was a great nurturer of new talent, and a great many key Hollywood players of the following decades owe him their starts. Francis Ford Coppola worked as a dialogue director on Corman's

[4]Lovecraft did not pursue publication of this novel; it would be published posthumously in 1943.

Tower of London (1962) and *The Haunted Palace* and shot additional footage for the aforementioned *The Terror,* before directing *Dementia 13* (1963), produced by Corman. *The Raven* and *The Terror* both costarred Jack Nicholson, whose debut was Corman's crime film *The Cry Baby Killer* (1958). Other famous names to whom Corman granted early opportunities include Bruce Dern, Ron Howard, Martin Scorsese, James Cameron, Jonathan Demme and Peter Bogdanovich, to whom we shall return. Not for nothing is Corman sometimes characterized as the spiritual godfather of the New Hollywood generation, the directors of which benefitted not only from film school educations but also from the hands-on experience afforded them by producers like Corman.

Meanwhile, in Britain: Hammer and other British horrors

Many significant horror films had been produced away from the United States in the sound era (in the United Kingdom, these included the classic anthology film *Dead of Night* (1945) and Jacques Tourneur's *Night of the Demon* (1957)), but there were few sustained national cycles of production. This situation changed in Britain in the late 1950s, thanks to Hammer Film Productions. Hammer had existed since 1934, but only in the 1950s did its brand begin to shift towards horror. Hammer's turn towards horror was triggered by the films based on Nigel Kneale's BBC 1953 television serial *The Quatermass Experiment,* about an astronaut who returns to Earth infected by an alien entity and undergoes a terrifying transformation. The cinematic *The Quatermass Xperiment* (1955) wore its 'X' (restricted) certification as a badge of honour and became an unexpected hit. Looking to maintain this momentum, Hammer produced not only *Quatermass II* (1957) but also *The Curse of Frankenstein* (1957). Directed by Terence Fisher, the film needed to distinguish itself from Universal's film for legal reasons, which it did by downplaying emphasis on the monster in favour of the doctor himself and designing a very different look for its monster. *The Curse of Frankenstein* was also the first fully colour horror film made in Britain (see Chapter 8), and one of the most

graphic and gruesome to date. It takes a particular relish in throwing body parts onto the screen: heads, hands and eyes. It starred the talented stage-trained duo of Peter Cushing and Christopher Lee, soon both to become Hammer's quintessential actors and to join Vincent Price as the definitive horror stars of their time.

The Curse of Frankenstein was hugely successful and exported especially well, doing great business in the United States and Asia. The following year, Hammer put the same team on a new adaptation of *Dracula*, released domestically as *Dracula* and internationally as *Horror of Dracula*. Its revision is lean and efficient. Characters are dropped and others are reworked radically. The film's version of Jonathan Harker (John Van Eyssen) is an infiltrator to kill Dracula (Lee), and its Van Helsing (Cushing) is not the elderly polymath of the book, but a vocational vampire hunter and a daring man of action. Dracula himself, as embodied by Christopher Lee, alternates between a smooth aristocrat and a blood-dripping animal. Perhaps the most peculiar change is that *Horror of Dracula* is set neither in England nor in Transylvania. Everything takes place in a nebulously middle-European never-neverland, full of characters with German names and British accents; this would become a stock setting for many Hammer horrors. The first vampire film fully in colour, *Horror of Dracula*, wasted no time in filling the screen with blood; *The*

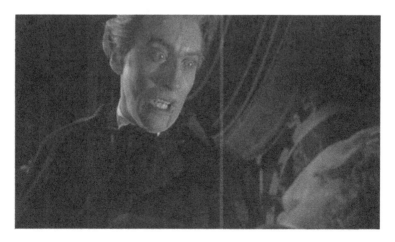

FIGURE 2.3 *Christopher Lee in* Horror of Dracula *(1958).*

Curse of Frankenstein and *Horror of Dracula* prepared audiences for increasingly sensationalistic horror films in the subsequent decade.

Hammer's product over the next several decades was fairly diverse, including black-and-white thrillers, comedies, science fiction films, caveman movies and Sherlock Holmes adaptations. But the Hammer *brand* was overwhelmingly horror. Like Universal before it, Hammer embraced series: seven Frankenstein movies, nine Dracula movies, three Mummy movies (although not narratively linked) and three films based on J. Sheridan Le Fanu's female vampire Carmilla Karnstein (from the 1872 novella *Carmilla*). Other familiar horror archetypes received Hammer treatments: *The Two Faces of Dr. Jekyll* (1960), *The Curse of the Werewolf* (1961), *The Phantom of the Opera* (1962), and so on. The films were well-made mid-budget offerings, with atmospheric sets and effective, largely restrained performances from stage-trained UK actors like Lee and Cushing.

Alongside the blood, another important element of Hammer's brand was sexuality. The heaving bosoms of the early films eventually became copious amounts of nudity, especially in the early 1970s, when some Hammer's films began to resemble soft pornography. This is especially true of the Karnstein trilogy of *The Vampire Lovers* (1971), *Lust for a Vampire* (1971) and *Twins of Evil* (1971); the third even starred Playboy models Mary and Madeleine Collinson. The Hammer horror films of the early 1970s are less popular than the studio's earlier horror output, but even then Hammer still managed to produce a number of very odd and hard-edged works. Since *Frankenstein*, few horror films have dared to kill children directly onscreen but *Vampire Circus* (1972) does so with abandon, in sequences with clear paedophile overtones. The declining popularity of Gothic horror films saw Hammer scrambling to stay relevant, shifting its last Dracula films to the present day (*Dracula A.D. 1972* (1972) moves the Count to Swinging London, summoned by hippie occultist Johnny Alucard (Christopher Neame)) and even attempted a Kung Fu film crossover with *The Legend of the 7 Golden Vampires* (1974), a co-production with Hong Kong's Shaw Brothers Studio. The last of the Dracula series, *The Satanic Rites of Dracula* (1973), even went unreleased in the United States for six years. Regarding the film's failure, Christopher Lee is supposed to have quipped, 'If you will forgive the pun, I think the vein is played out' (Holte 1997, 63).

Hammer's success created a market for other British studios. Perhaps the most successful of these was Amicus Productions, which set most of its films in the present day and often also hired Lee and Cushing. Amicus is best remembered for its anthology or portmanteau films: *Torture Garden* (1967), *The House That Dripped Blood* (1971), *Tales from the Crypt* (1972), *Asylum* (1972), *The Vault of Horror* (1973) and *From Beyond the Grave* (1974). Tigon British Film Productions also produced a few important horror films, including the eighteenth-century-set witchcraft film *The Blood on Satan's Claw* (1971) and two films made by Michael Reeves, *The Sorcerers* (1967) and *Witchfinder General* (1968), before his tragic drug-related death in 1969 at the age of twenty-five. *Witchfinder General*, starring Vincent Price in an uncharacteristically subdued performance as the historical seventeenth-century witch-hunter Matthew Hopkins, is a fascinating mix of historical drama and horror film. It was released in the United States as *The Conqueror Worm* and added a voiceover of Price reading Poe's poem of that title to create an impression of consistency with the Corman Poe franchise.[5]

The immediate wake of Hammer's success also saw a short cycle of horror films distributed by Anglo-Amalgamated Productions, the company most famous for the long-running *Carry On* comedy series. These include *Horrors of the Black Museum* (1959), *Peeping Tom* (1960) and *Circus of Horrors* (1960), which David Pirie links together as a loose 'Sadian Trilogy' (113–19) due to themes of sexualized violence and torture, much in contrast to the supernatural themes favoured by Hammer. All three are of interest. *Horrors of the Black Museum* has a shocking opening in which a woman's eyes impaled by knives hidden in a pair of binoculars, and its plotline, involving a crime journalist committing crimes so he can report on them, contains an interesting commentary on the public's appetite for

[5]Price starred in several other (often tenuously) Poe-related films made to benefit from the popularity of the Corman Poe series, including AIP's *City Under the Sea* (1965), better known as *War-Gods of the Deep* and featuring quotations from Poe's poem 'The City in the Sea', *The Oblong Box* (1969) (a loose adaptation of the Poe story) and *Cry of the Banshee* (1970) (maybe the most egregious case of all, using Poe's name on the poster and trailer but having nothing more to do with Poe than a tacked-on quotation from 'The Bells').

blood and depravity. But easily the most famous is *Peeping Tom*, directed by the legendary Michael Powell, having recently concluded his partnership with Emeric Pressburger. *Peeping Tom* is the story of Mark Lewis (Carl Boehm), a young photographer and serial killer. Himself subjected to inhuman experiments by his psychiatrist father, he combines voyeurism and sadism, dispatching young women with a custom knife-camera-mirror. The abused phrase 'ahead of its time' seems to apply to *Peeping Tom,* the outraged response to which 'virtually ended Michael Powell's career as a major director in Britain' (Christie 1994, 53); it has since been regarded as a classic film, and particularly as a key example of a 'horror metafilm' (Clover 1992, 169) due to its interest in the relationship of vision and fear. *Peeping Tom* has inspired voluminous scholarship, including on its cultural topicality (Lowenstein 2005, 55–82) and its status between horror and the art film (Hawkins 2000, esp. 26).

There was also a cycle of British 'quality horror' films that are often positioned against the sensationalistic fare of Hammer, Anglo-Amalgamated and Amicus (Wheatley 28), through their highbrow literary credentials, serious bearing and gorgeous black-and-white cinematography. Chief among these are *The Innocents* (1961), adapted from Henry James's *The Turn of the Screw* (1898) and *The Haunting* (1963), based on Shirley Jackson's *The Haunting of Hill House* (1959). These films are often regarded as logical successors to the Lewton tradition of subtlety, restraint and suggestion (*The Haunting* was directed by American Robert Wise, who directed Lewton's *The Body Snatcher* and *The Curse of the Cat People*), though, as Jancovich notes, they were not universally praised at the time, with some critics dismissing them as creaky and old fashioned (2015).

The cult favourite *The Wicker Man* (1973) is another major work of British horror, directed by Robin Hardy for British Lion Films. A product of the new wave of cultural interest in occultism and paganism, it concerns a deeply repressed Christian policeman, Sgt Howie (Edward Woodward), investigating a missing girl on a remote island of neopagans ruled by Lord Summerisle (Christopher Lee). Howie becomes convinced that the missing girl is intended as the sacrifice in a pagan ritual; it ultimately transpires, however, that an elaborate conspiracy has lured him to the island and that *he* is the

planned sacrifice. *The Wicker Man* is structurally unusual, revealing its horror elements only at the very end, and its anti-authoritarian bent is clear. The policeman is a blundering fool, and the lord is a deceptive manipulator. Each is absolutely possessed of moral and religious certainty in his actions, but neither paganism nor Christianity is shown to possess any real power.

The production of UK horror films neither started nor ended with Hammer's tenure, but was long defined by it. The horror films of that era were distinctly British yet also export friendly, exploitative yet classy, old fashioned and cutting edge. The recent revival of the long-dormant Hammer brand has had uncertain effects thus far, producing decent but generic horror films like *The Woman in Black* (2012) and *The Quiet Ones* (2014) (see Walker 2016, 109–30).

Continental horror

Horror also began to thrive in Europe in the 1960s, for perhaps the first time since the silent era.[6] Georges Franju's *Les yeux sans visage/Eyes Without a Face* (1960) caused a stir when it played at the 1960 Edinburgh Film Festival and reportedly resulted in seven audience members fainting during its gruesome surgery scene. *Eyes Without a Face* tells the story of Dr Génessier (Pierre Brasseur), a brilliant surgeon whose daughter, Christiane (Edith Scob), was disfigured in a car crash while he was at the wheel. Christiane is believed dead, but her father has secretly saved her and hopes to restore her appearance. Génessier kidnaps young women to graft their faces onto the beautiful but terrifying Christiane, who wears a featureless white mask and has slowly been going insane from isolation and guilt. The surrealist-influenced Franju mixes beauty with horror, in a film replete with echoes of both Nazi experiments and the institutionalized torture enacted by the French government in Algeria (Lowenstein 2005, 17–53); it is a paradigmatic example of the art film–horror hybrid (Hawkins 2000, esp. 65–85).

[6]For a thorough treatment of 'Euro-Horror', see Olney (2013).

FIGURE 2.4 *Christiane's (Edith Scob) mask in* Eyes Without a Face *(1960).*

The same year, Italian director Mario Bava directed *La maschera del demonio/Black Sunday* (1960), starring the emerging horror icon Barbara Steele. Though conceived as an adaptation of Nikolai Gogol's 1865 short story 'Viy', the film plays more as an elaborate, beautiful and chilling homage to classic Universal horrors. The story of a murdered witch returning centuries later to take vengeance and steal the identity of her descendant, *Black Sunday* became famous for shocking violence (brands burnt into flesh, spiked masks hammered into faces, burnt flesh peeling and a stake driven into an eyeball) coexisting with an eerie, beautiful ambience. AIP, the American distributor, trimmed it by three minutes, and the British censor rejected it altogether.

Bava went on to direct a slate of gruesome and stylish horror films. For films like *La frusta e il corpo/The Whip and the Body* (1963), *Sei donne per l'assassino/Blood and Black Lace* (1964) and *Ecologica del delitto/Bay of Blood* (1971; also *Twitch of the Death Nerve*), Bava is celebrated as an early master of the Italian horror/mystery subgenre labelled '*giallo*'. The name derives from the yellow covers of cheap paperback novels, and the *giallo* style conventionally mixes crime, violence and eroticism. There is some debate over what should be included under the heading of *giallo* film, but few would deny Bava a key place among its practitioners, alongside the

much younger Dario Argento. After writing screenplays during the late 1960s, including for Sergio Leone's 'spaghetti Western' *C'era una volta il West/Once Upon a Time in the West* (1968), Argento made his stunning directorial debut with *L'uccello dalle piume di cristallo/The Bird with Crystal Plumage* (1970). It swiftly established a signature audiovisual style typified by black gloves, knives, shards of broken glass and bold uses of colour and music, especially in his collaborations with the progressive rock group Goblin. Argento's masterpieces are generally held to be *Profondo rosso/Deep Red* (1975) and *Suspiria* (1977; see Chapter 7), and though he remains prolific, his output in recent decades (arguably since *Opera* (1987) or at the latest *La Sindrome di Stendhal/The Stendhal Syndrome* (1996)) has attracted little critical praise.

Other European cinemas produced interesting horror films in the 1960s and 1970s as well, benefitting from loosening censorship laws and increased audience tolerance for graphic and shocking material. In Spain, Uruguay-born Narciso Ibáñez Serrador made *La residencia* (1969), about strange goings-on at a nineteenth-century French boarding school. It was the first Spanish film directed in English, firmly aimed at the international market, and was promoted as the first Spanish horror film. AIP distributed it as *The House That Screamed* (Lázaro-Reboll 2012, 109–16). Ibáñez Serrador later made the tense and original *¿Quién puede matar a un niño?/Who Can Kill a Child?* (1976), about an island ruled by murderous children. Established European auteurs dallied with horror material, including Sweden's Ingmar Bergman with *Vargtimmen/The Hour of the Wolf* (1968) and Italy's Federico Fellini and France's Louis Malle and Roger Vadim with segments of *Histoires extraordinaires/Spirits of the Dead* (1968), an anthology film based on three Poe stories.

Following Hammer's example, vampire films would prove particularly appealing for European filmmakers, especially when they mixed horror and eroticism. In France, Vadim's *Et mourir de plaisir (Le sang et la rose)/Blood and Roses* (1960) drew on Le Fanu's *Carmilla* a decade before Hammer would, proving to be the most explicit lesbian vampire film to date. Later, Spanish director Jesús Franco would make a specialty in vampires, with films such as *El Conde Dracula* (1969) and *Vampyros Lesbos* (1970), as would Frenchman Jean Rollin with his lush, sensual and explicit films (*Le Viol du Vampire/The Rape of*

the Vampire (1968), *La vampire Nue/The Nude Vampire* (1970), etc.). In Belgium, Harry Kümel made the gorgeous and unusual *Le Rouge aux lèvres/Daughters of Darkness* (1971; see Chapter 8). One of the most unusual vampire films was West Germany's *Jonathon* (1970), a class parable set in an alternate history where the world is ruled by aristocratic vampires. The strange parody *Dance of the Vampires* (1967), also released as *The Fearless Vampire Killers, or Pardon Me, but Your Teeth Are in My Neck*, was a UK film with a European director and a European feel to suit its continental setting (it was partially shot in Italy). Its director was the Polish-born enfant terrible Roman Polanski, who had earlier directed the acclaimed psychological thriller *Repulsion* (1965) amid a string of successful art films. Polanski would shortly be bound to Hollywood to make one of the most significant horror films of all.

1968

1968 is a monumental year for horror films, principally because of two American films that, between them, seem to chart parallel directions forward for the genre: *Night of the Living Dead* and *Rosemary's Baby*. Costing just under $100,000, George A. Romero's *Night of the Living Dead* has few locations and a small, non-professional cast, telling an intimate version of a huge-scale story: the dead are coming back en masse to feast on the flesh of the living. The film has no faith in authority and depicts a world simply and inexplicably gone mad. No firm explanation is given for the dead's return, and no faith is placed in the ability of the living to intelligently resist them. In rural Pennsylvania, a desperate group comes together in an abandoned farmhouse to stay alive. But rather than being a story of resourceful strangers banding together successfully, *Night of the Living Dead* depicts them feuding and squabbling, and their inability to work together kills them all. The protagonist, Ben (Duane Jones), is a black man – a fact that the screenplay never references – who outlasts all of the other occupants of the farmhouse only to be shot accidentally by militiamen.

Rosemary's Baby, on the other hand, was based on Ira Levin's bestselling novel – a classic 'presold' property in contrast to Romero's sleeper hit. William Castle purchased the rights to the book, hoping

to direct himself, but reluctantly cut a deal with Paramount's Robert Evans that gave directorship to Polanski. Made with the lofty budget of three million, it starred Mia Farrow, then most famous as the wife of Frank Sinatra (he served her with divorce papers when she refused to leave *Rosemary's Baby* to work with him on *The Detective* (1968)), and a gallery of talented Hollywood character actors. Rosemary Wodehouse (Farrow) is the wife of a struggling stage actor, Guy (John Cassavetes), who falls in with a New York-based coven of witches who secretly impregnate her with the devil's spawn. A paranoid thriller with very understated supernatural elements, *Rosemary's Baby* takes place against the backdrop of a secularized, 'fallen' America, and it proved to be among the first horror films in which evil scores an unqualified victory. It proved a major success, the eighth highest grossing film of 1968, and triggered a cycle of Satanic-themed film, including *The Mephisto Waltz* (1971), *Asylum of Satan* (1971), *The Touch of Satan* (1971), *The Brotherhood of Satan* (1971), *Daughters of Satan* (1972), *Satan's School for Girls* (1973) and *To the Devil a Daughter* (1976) alongside the better-remembered *The Exorcist* (1973) and *The Omen* (1976).

Night of the Living Dead* and *Rosemary's Baby* are very different films. One is an independent, the other a major studio prestige picture (and nominated for two Academy Awards, winning Best Supporting Actress for Ruth Gordon). One is raw and monochromatic, the other glossy and colourful. One is cast with non-actors, the other recognizable stars. One is rural, the other urban. *Night* features shambling monsters, while *Rosemary's Baby*'s witches are seemingly ordinary New Yorkers. But as different as they are, *Night of the Living Dead* and *Rosemary's Baby* are united by an apocalyptic sensibility: the end is nigh, whether from zombies stalking the countryside or from Satanists plotting the rise of their dark lord. Both brim with Vietnam-era cynicism, depicting worlds where rationality has clearly failed. Between them, *Night of the Living Dead* and *Rosemary's Baby* chart the way forward in horror, either in prestige or in exploitation. Horror can be a promising route for an aspiring young independent filmmaker, or it can be the high-budgeted product of entrenched studio forces.

Another low-budget American film of 1968 offers a kind of eulogy for the classical horror film. In the late 1960s, film programmer and critic Peter Bogdanovich moved to Los Angeles, having decided to

become a director. Connecting with Corman, he was hired first as an assistant director and extra on *The Wild Angels* (1966), and then later to direct a quickie with Boris Karloff, who owed Corman two days of work from another project. Bogdanovich was also instructed to make use of existing footage from *The Terror*, but was otherwise given free rein. The film became *Targets* (1968), which intertwines the story of the elderly horror movie star Byron Orlok (Karloff) facing retirement with the emergence of a new, modern monster. Bobby Thompson (Tim O'Kelly), an unemployed Vietnam veteran and gun collector, suddenly murders his family and goes on a shooting spree. Orlok is upset that his films are derided as 'camp', and when a young director (Bogdanovich himself) pleads with him to act in his next film, he merely points to the atrocities reported in the local newspaper as evidence of his obsolescence.

The two plotlines converge at a drive-in theatre screening of *The Terror*. Orlok has reluctantly arrived to promote the film, and the Charles Whitman-esque Thompson has hidden himself behind the screen to start shooting up the audience through a small hole. AIP's films did great business in drive-ins, so Bogdanovich's staging of his grim climax in one is both appropriate and perverse. Orlok boldly apprehends Thompson, who cannot tell the difference between the Orlok on the screen and the one in the flesh. The legendary horror actor emerges as the hero. Towering over the cowering representation of 'middle-class conservative America gone wrong' (Speldewinde, n.p.), Orlok remarks, 'Is that what I was afraid of?' In addition to giving Karloff a last great part, *Targets* provides a thoughtful and reflexive meditation on the status of horror fiction amid contemporary violence, as well as a prescient anti-gun polemic. In *Targets,* as during the Second World War, a horrific world seems to promise to make fictional horror a relic. Ironically, it arrived just as horror was becoming perhaps more relevant than ever.

A second Golden Age?

What changed in the horror films of the 1960s? Andrew Tudor proposes that horror films can be divided into 'secure' and 'paranoid' world views. The 'secure' tradition 'presume[s] a world which is

ultimately subject to successful human intervention' (1989, 103), one where expertise, order and rationality ultimately tend to prevail. In the 'paranoid' counter-tradition, however, 'both the nature and course of the threat are out of human control, and ... disorder often emerges from *within* humans to potentially disrupt the whole ordered world' (ibid., original emphasis). While both 'secure' and 'paranoid' horror have always existed, Tudor proposes that the latter rise to the genre's dominant version in the 1960s and 1970s. This succession was surely a gradual process, but the twin successes of *Night of the Living Dead* and *Rosemary's Baby*, however differently both paranoid horror, played a large part in encouraging it. *Rosemary's Baby* triggered a Satanic chic that stretched well into the 1970s and produced some even more successful horror films. *Night of the Living Dead* proved once again the benefits of horror material to young independent filmmakers and horror's increasing iconoclastic appeal. Following Romero's lead, young directors like Wes Craven, John Carpenter, Brian De Palma, Larry Cohen, Tobe Hooper and David Cronenberg would all make their mark through low-budget horror films, which were becoming the kind of test of basic skill that Westerns once were. The (long) 1970s were perhaps as a much a Golden Age for American horror films as 1931–1936, thanks not only to independent films like *The Last House on the Left* (1972), *Sisters* (1973), *The Texas Chain Saw Massacre* (1974) and *Halloween* (1978), but also to high-budget studio productions like *The Exorcist*, *Jaws* (1975), *Carrie* (1976) and *The Omen*. The New Hollywood era, with its putatively director-driven, European-influenced sensibilities and increased inclusiveness for low-budget independent projects, as well as the new tolerance for onscreen violence prepared for by films like *Bonnie and Clyde* (1967), proved a fertile space for new developments in the horror genre.[7] On another front of independent cinema, African American filmmakers also formulated a distinctive, underappreciated brand of

[7]The term 'New Hollywood' is a contentious one, alternating with 'American New Wave', 'film brats' and 'Hollywood Renaissance' (see King (2002), Krämer (2013)). Names associated with both the New Hollywood and horror include Bogdanovich, De Palma, Coppola, Spielberg, Polanski and even Robert Altman (who directed the UK horror film *Images* (1972)).

horror; key entries in the Blaxploitation horror cycle included *Blacula* (1972) and *Scream, Blacula, Scream!* (1973), *Ganja and Hess* (1973), the possession film *Abby* (1974) and *Dr. Black, Mr. Hyde* (1976) (see Benshoff 2000, Coleman 2011, esp. 118–44).

Craven's *The Last House on the Left* is a particularly significant example of early 1970s independent horror; like *Targets,* it depicts violence emerging from everyday American life. The tale of two teenage girls being tortured and slain by a pack of Manson-esque maniacs, who are in turn brutally killed by the parents of one of the murdered girls, it mixes art film sensibilities (it is a remake of Ingmar Bergman's *Jungfrukällan/The Virgin Spring* (1970)) and low-budget sleaziness (it was apparently originally intended to contain hardcore sex scenes). Craven was a former humanities professor, and beneath its mad intensity, *The Last House on the Left* is an intelligent commentary on its times. The Love Generation is in tatters: the two girls are kidnapped on their way to a rock concert, lured with the promise of marijuana. A peace symbol necklace, taken from one of the girls as a trophy and recognized by the parents, triggers the cycle of revenge. A comic subplot has two bumbling cops continually delayed in their investigation, arriving just too late to prevent violence, further working to denigrate traditional authority. *The Last House on the Left* found success in part due to its innovative advertising campaign, including the repeated line 'Keep repeating: it's only a movie, it's only a movie ...' and the injunction 'Not recommended for persons over 30.'

However differently, *The Exorcist* was also invested in youthful rebellion. The story of a demonically possessed young girl and the priest who must overcome his loss of faith to save her, it keeps most of the William Peter Blatty's novel's most shocking moments: Regan (Linda Blair) shouting profanity, projectile vomiting, head rotating and violently masturbating with a crucifix. All of these would have been unimaginable in a major Hollywood studio feature short years before. Blatty was a devout Catholic who conceived the story as a reaffirmation of God's role in the modern world, and the film had several priests as consultants. On one level, *The Exorcist* promises resolution to the contemporary world's crisis of rationality through the return of religion – a very conservative parable on the importance of faith in a fallen world told through the prism of the horror film. But

to many filmgoers, its vulgarity and terror scene far outweighed any religious messages.

A full-blown cultural sensation, *The Exorcist* became one of the most profitable films of the 1970s and, adjusted for inflation, is still the highest grossing R-rated film of all time (Phillips 2005, 205). It was nominated for eight Academy Awards and won two, including for Blatty's screenplay. Both one of the highest earning and most laurelled horror films of all time, *The Exorcist* was 'the first true horror event movie' (Kattelman 2011, 69) and its first blockbuster. Beth A. Kattelman notes that the film's publicity engine played up deaths and accidents related to the film's production, creating the narrative that demonic forces attempted to prevent its completion. The studio even fabricated rumours that fourteen-year-old Blair was driven to a nervous breakdown by the strain of the role. Like *Eyes Without a Face*, it was purported to inspire profound physical reactions in its audience members, including fainting and vomiting, and even a miscarriage (ibid., 68–70). For all of its achievements, *The Exorcist* was as dependent on sensationalism and ballyhoo as a William Castle gimmick film.

Where the last chapter ended on a note of apparent failure and even extinction, this chapter ends with apparent triumph. Where 1938 saw little evidence that horror film would be more than a short-lived production cycle, by 1974, it was a firmly entrenched and perennial product of film industries in Hollywood and abroad. The genre had transformed countless times in those years, responding to different times, different places and different audiences.

3

1974 to Present: High and Low

The Exorcist would prove only the first in a line of horror blockbusters. Two years later, *Jaws*, an updated sea monster movie by New Hollywood wunderkind Steven Spielberg, shattered box office records. Probably the single film most associated with the dawn of the blockbuster age and the Hollywood studios' reconfiguration towards horizontal integration, *Jaws* can also be considered part of a 1970s cycle of American animal horror or 'revenge of nature' movies, regarded as an early wave of eco-horror (including *Willard* (1971), *Night of the Lepus* (1972), *Frogs* (1972), *Bug* (1975), *Grizzly* (1976), *Orca* (1977), *Piranha* (1978), *Prophecy* (1979) and *Alligator* (1980), itself somewhat anticipated by Universal's *Creature from the Black Lagoon* trilogy (1954–6). But where most of those films were relatively low budget and critically reviled or at least ignored, *Jaws* was a costly presold property (based on Peter Benchley's 1974 bestseller) and received four Oscar nominations, including Best Picture, winning for Best Sound Mixing, Best Score and Best Film Editing, though Spielberg himself was a conspicuous non-nominee.

In 1976, *The Omen* and *Carrie* both did tremendous business and received critical accolades. *Carrie*, the adaptation that made Stephen King a household name and brought De Palma his first major hit, received Oscar nominations for Sissy Spacek and Piper Laurie, and *The Omen* won for Jerry Goldsmith's score. Alongside these high-budget studio works, shocking low-budget horror in the mould of *Night of the Living Dead* and *The Last House on the Left* continued to

find audiences and acclaim. In 1974, Tobe Hooper's *The Texas Chain Saw Massacre* earned more than $30 million off a budget of less than $300,000, in spite or because of controversy over its intense, though almost bloodless, violence and its raw, unpolished tone. *The Texas Chain Saw Massacre* supplied a gallery of human ghouls with its murderous, cannibalistic unemployed slaughterhouse worker family, but the breakthrough character was the powerful but infantile Leatherface (Gunnar Hansen), clad in an apron and a human-skin mask and wielding the titular saw. He would be the first of a new pantheon of brutal and implacable horror villains. More than a decade would go by before *The Texas Chainsaw Massacre 2* (1986), and six other sequels, prequels and remakes would follow, with some iteration of Leatherface among the few consistent elements.

Perhaps as influential in the long run was Canada's *Black Christmas* (1974), directed by transplanted American Bob Clark. Building on a popular urban legend that would also inspire *When a Stranger Calls* (1979), it takes place largely in a sorority house that is receiving a series of lewd phone calls, which are actually being placed by a mysterious man hiding within the house itself. He murders his way through the sorority sisters one by one, but is never clearly seen and receives almost no characterization. As we shall see, *Black Christmas* proved an important predecessor to the 'slasher film'.

The 1970s Canada also saw the emergence of another key figure in the history of horror: David Cronenberg, nicknamed the 'Baron of Blood' and the 'King of Venereal Horror'. Cronenberg's early career included writing the book for the musical *Spellbound* with Canadian magician Doug Henning and directing two short underground features, *Stereo* (1969) and *Crimes of the Future* (1970), that introduced many of his preoccupations: mad science, strange institutes, provocative sexuality and radical bodily transformations. *Shivers* (1976; also released as *The Parasite Murders* and *They Came from Within*) brought him into the public eye, the story of an antiseptic Montréal apartment building being invaded by disgusting parasites, transmitted sexually, which produce a sort of fully liberated subject driven only by lust and a desire to spread the infection. The notoriety of *Shivers* was such that Toronto essayist Robert Fulford wrote a damning review targeting the fact that it had received funding from the Canadian Film Development Corporation, entitled 'You Should Know How Bad This

Film Is. After All, You Paid for It'; the controversy was even discussed in the Parliament. Heralded by some critics and lambasted by others, *Shivers* benefitted from this debate and Cronenberg emerged as an eloquent and thoughtful public figure, willing to debate his critics very publically (Mathijs 2008, 44–8). In the years that followed, Cronenberg would develop a distinctively visceral and intellectual brand of horror through films like *Rabid* (1977), *The Brood* (1979), *Scanners* (1981), *Videodrome* (1983), *The Fly* (1986), *Dead Ringers* (1988) and *Naked Lunch* (1991). Cronenberg's auteurist preoccupations, playing on the lines of art, exploitation, visceral horror and philosophy, largely survive into his more 'mainstream' films of the twenty-first century (including *A History of Violence* (2005), *Eastern Promises* (2007) and *Maps to the Stars* (2014)).

Cronenberg joined the ranks of North American horror specialists that included Wes Craven, who followed *The Last House on the Left* with *The Hills Have Eyes* (1977), the allegorical tale of a middle-American family stranded in the Nevada desert and facing off against a clan of cannibals. Also emerging in the 1970s was John Carpenter, the son of a music professor in Bowling Green, Kentucky, who ventured to Los Angeles to study film production at the University of Southern California. A cinephile whose veneration of Howard Hawks and Alfred Hitchcock led to a style perhaps more 'classical' than many of his peers, Carpenter would direct the cult science fiction comedy *Dark Star* (1974) and attract more notice with *Assault on Precinct 13* (1976). *Assault* transplants the formula of a Howard Hawks Western to contemporary Los Angeles, staging an intense siege on an undermanned police station by an enormous, hugely resourced gang (see Chapter 4). Carpenter drew on *Night of the Living Dead* in characterizing the gang as an implacable, unspeaking and unmotivated foe, leading to charges of being too in love with genre conventions to engage their ideological meanings and thus qualifying as reactionary (Wood 1979), though some have argued that, on the contrary, 'Carpenter does ... consistently engage with the socio-political dimension of his material in often quite subtle and unexpected ways' (Smith 2004, 40). Similar debates swirl around Carpenter's subsequent film, which forever enshrined him in the pantheon of horror directors and, some argue, triggered the end of the second Golden Age in American horror films.

Comes the slasher

The project that became *Halloween* (1978) was originated not by Carpenter but by the independent producer Irwin Yablans. Witnessing the success of *Black Christmas*, Yablans imagined an inexpensive horror film with an extreme economy of location and time, built around babysitting: *The Babysitter Murders*. Yablans approached Carpenter based on his burgeoning reputation as a skillful, innovative low-budget director. Carpenter negotiated considerable creative control provided he stayed on budget (little more than $300,000) and schedule. Yablans also decided to set it on a night with built-in interest and iconographies and to change the name accordingly. It is notable for its use of the gliding steadicam aesthetic afforded by a lightweight Panaglide camera, Carpenter's pulsing electronic score and its careful widescreen compositions that allowed unexpected intrusions of half-seen figures into the frame. *Halloween* evokes the mood of a grim American urban legend. Its foe, Michael Myers or 'the Shape' (Nick Castle), wears a white mask that strips him of humanity and he seems able to be anywhere and everywhere, lurking, looking, stalking. Opening to mixed reviews, *Halloween* soon became a classic sleeper hit, earning more than one hundred million dollars worldwide from its modest budget.

Halloween's success triggered a cycle of low-budget imitators, what would become known as 'slasher films'. This terminology won

FIGURE 3.1 *Michael Myers watches Laurie (Jamie Lee Curtis) in* Halloween *(1978).*

out over competitors like 'stalker' (Dika 1990); 'slash and gash' (Ryan and Kellner 1988); 'teenie kill pic' (Wood 1986); 'mainstream simulated snuff movie', or 'MSSM' (Rosenbaum 1979); and 'dead teenager pictures' (Ebert 1997). This low-budget cycle favoured simply motivated villains who, like *Halloween*'s Michael Myers, sported a distinctive look easily exploited by advertisement campaigns. What's more, they also conventionally had female protagonists, the type later dubbed 'the Final Girl' by Carol J. Clover (see Chapter 5). Some argue that, for all of its success, *Halloween* accidentally brought the curtain down on the second Golden Age of American horror films. This narrative is implicit in the third episode of Mark Gatiss's BBC documentary series *A History of Horror* (2010), 'The American Scream', which ends with *Halloween*. Gatiss asserts: '*Halloween* is the consummate slasher film [but] I'm not so enthusiastic about its legacy. A slough of lower-quality, increasingly gory serial killer outings that would overwhelm the genre for years to come, like horror's equivalent of Dutch Elm Disease.' Yablans himself would remark, 'They congratulated me, but I told them: "Fellas, it's over." ... When the studios see how much money you can make with this kind of film, they are going to want to get in on the action, and then you will be finished, and that's what happened' (Zinoman 2011, 189). If the claim is that the success of the slasher film precluded studios from bankrolling higher budget horror films, this is obviously not true; however, these competed with slasher films as the public face of the genre.

Richard Nowell's *Blood Money: A History of the First Teen Slasher Film Cycle* (2011) gives a detailed account of the development of the slasher film. Nowell delineates a set of stages for a film production cycle beginning with a Pioneer Production, followed by a Speculator Production (potentially becoming a Trailblazer Hit), which is in turn followed by Prospector Cash-ins, Reinforcing Hits that keep the cycle alive and finally the Carpetbagger Cash-ins that mark its dismal late stages. In this case, the Pioneer Production was *Black Christmas*, and *Halloween* was a Speculator Production turned Trailblazer Hit. The first wave of Prospector Cash-ins included *Friday the 13th* (1980), *Prom Night* (1980) and *Terror Train* (1980), some of which became Reinforcing Hits; these in turn motivated the production of films like *Hell Night* (1981), *My Bloody Valentine* (1981) and *Happy Birthday to Me* (1981). Most of these films had considerably higher body counts

and gorier kills than the earlier films, *Halloween* included. By the time Carpenter reluctantly agreed to write and produce *Halloween II* (1981), he found it necessary to personally add gratuitous kills after a more restrained and atmospheric first cut by director Rick Rosenthal, keeping up with the bloody times.

Innumerable in the early 1980s, the slasher film became a source of considerable cultural consternation. In 1980, American critics Gene Siskel and Roger Ebert devoted an episode of their PBS show *Sneak Previews* to 'Women in Danger', as they termed the trend. Both critics praised *Halloween* and positioned it as a 'good object' (mostly due to its sense of artistry and command of film style) against the slashers they lambasted as 'scumbucket films' made by 'sleaze merchants'. Much of Siskel and Ebert's vitriol was directed against Meir Zarchi's *I Spit on Your Grave* (1978) – not really a slasher film, but a strange, unpalatable mix of realist film aesthetics and exploitation explicitness. The story of a vacationing writer (Camille Keaton, granddaughter of Buster) repeatedly raped by locals only to re-emerge as a powerful figure of vengeance who mercilessly slaughters her attackers, *I Spit on Your Grave* would also land on Britain's infamous 'video nasty' list in the early 1980s. This colloquialism describes dozens of films that circulated principally on VHS, targeted by moral crusaders who attempted, with various levels of success, to enforce bans on them under obscenity laws. The video nasty list itself is a colourful patchwork of gory American, European and a few Canadian and Mexican films, many of which would be sublimely obscure if not for their 'nasty' status (see Chapter 6).

The slasher cycle lost steam as the 1980s proceeded but never vanished altogether, and was also rejuvenated by an unexpected success. This was Wes Craven's *A Nightmare on Elm Street* (1984), which wedded the slasher formula to the supernatural, triggering another long-running series centred around another iconic slasher: the scar-faced, razor-fingered child murderer and dream invader Freddy Krueger (Robert Englund). Englund would become a horror star principally associated with a single role; like Lugosi and Karloff before him, Englund has occasionally worked outside the genre since, but never as a star performer. The moral panic about the slasher seems quaint from a few decades' hindsight; it seems that the moral outrage they inspired did little to halt their production; rather, their decline

came from a more traditional sense of generic exhaustion. Indeed, it is possible to speculate that the bountiful free publicity provided by this outrage prolonged and not hindered the slasher cycle.

The gross and the nostalgic

Another towering horror work towards the end of the 1970s was George A. Romero's sequel to *Night of the Living Dead*, *Dawn of the Dead* (1978). A mix of gruesome horror film, war film, anti-consumerist social commentary and (often slapstick) comedy, *Dawn of the Dead* established the foundation for the post-classical zombie story even more so than its predecessor. *Dawn of the Dead* exists in a bewildering variety of cuts, including a trimmed European version edited by Dario Argento under the name *Zombi*. This release emboldened the Italian gore maestro Lucio Fulci to make an unofficial sequel called *Zombi 2* (1979), and the fact that the 'Living Dead' trademark belonged to early Romero collaborator John Russo allowed the parodic *The Return of the Living Dead* (1985) and its sequels. Romero would make the sequel *Day of the Dead* (1985) before a long hiatus, and then rode the wake of the revived zombie interest following the success of Danny Boyle's *28 Days Later* (2002) with the second trilogy of *Land of the Dead* (2005), *Diary of the Dead* (2007) and *Survival of the Dead* (2009). *Dawn of the Dead* casts a long shadow, cementing an entire subgenre that has thrived in films, games, comics and television (especially with the various versions of Robert Kirkman's *The Walking Dead*).

By the 1980s, as Phillip Brophy put it, horror was 'violently aware of itself as a saturated genre' (5), and responded to this saturation in a variety of ways. The most prominent horror film of the early 1980s, at least to posterity, was probably *The Shining* (1980), Stanley Kubrick's adaptation of Stephen King's 1977 novel. Years in the making and almost two and a half hours in length,[1] it had a mixed

[1]The European cut, which Kubrick apparently preferred, is about twenty-five minutes shorter.

critical reception and a disappointing box office performance, but has enjoyed a much stronger retrospective reputation. *The Shining* has been much analysed and much debated for all of its exacting details, riddles and mysteries (including the various theories presented in the documentary *Room 237* (2012), among them that *The Shining* is Kubrick's admission to having faked the moon landings). King famously disliked Kubrick's film, regarding it as a technical exercise that lacked soul and emotion (Bailey 1999, 105). Many have accused Kubrick of making a Kubrick film, an eccentric auteur work, rather than a horror film, or for making a horror film having too little knowledge of the genre, staging clichéd scenes without realizing it. Thought of only slightly differently, however, *The Shining* fits perfectly into a cycle of supernatural horror films that emphasized haunted domestic space and spousal abuse, including *Burnt Offerings* (1974) – which, like *The Shining*, ends with camera movement coming to rest on a mysterious photography – *The Amityville Horror* (1979) and *The Entity* (1982). Though *The Shining* has become a canonical horror film, even occasionally regarded as the scariest ever made (see Chapter 4), its initial reception was far more mixed; it even received two 'Razzie' (Golden Raspberry) Award nominations, including Worst Director for Kubrick.

But if *The Shining* was accused of feeling better than its genre, another cycle of American horror films in the 1980s operated from an awareness and love of the genre's history, yet updated it with newfangled special effects and hip comedy. John Landis's *An American Werewolf in London* (1981) and Joe Dante's *The Howling* (1981) were twin revivals of the dormant werewolf genre, both with state-of-the-art transformations and a lot of self-aware humour. The blockbuster comedy *Ghostbusters* (1984) was likewise a star- and effects-driven updating of madcap comic ghost films like *The Ghost Breakers, Scared Stiff* and *The Ghost and Mr. Chicken* (1966), and Dante's *Gremlins* (1984) proved another successful comic horror property. Tom Holland's *Fright Night* (1985) was a similarly reflexive vampire film allegorizing the subgenre's putative decline and promising its rejuvenation (Leeder 2009), with a subplot about an out-of-work horror actor and revue host named Peter Vincent (Roddy McDowall) – obviously referencing Vincent Price and Peter Cushing – putting his fictional experience to use against real vampires.

Somewhat earlier in this cycle, another high-budget film that walked the line between comedy and horror, *Poltergeist* (1982), became one of the ten most profitable films of the year. Like *The Amityville Horror* and *The Shining*, it is a haunted house story about domestic space, in this case a suburban home beset by angry spirits that manifest through their television. Its PG rating led many families to see it expecting another *E.T.: The Extra-Terrestrial* (1982); it is perhaps no surprise that in one study of phobias induced by horror films, *Poltergeist* was the single most referenced film (Canton 291) – phobias of clowns, television sets and trees. One of *Poltergeist*'s most striking features is its dividedness. Perhaps due to the competing authorial impulses of producer Steven Spielberg and director Tobe Hooper (the extent of each man's on-set involvement is still debated (see Buckland 2006, 154–73)), the film is at once cosy and jagged-edged, and tends simultaneously towards representing evanescence and abjection (Leeder 2008). The ghosts are envisioned with clean optical effects and generous doses of Spielbergian soft white light, emphasizing the wonder and beauty of the supernatural, while also being associated with bodily fluids, rotting food, mud, blood and corpses. *Poltergeist* plays as an uneasy allegiance between the family-oriented blockbuster and the rougher sensibilities of independent horror. It is simultaneously linked to the ghost films of old (*The Uninvited* is explicitly cited) and to the emerging 'splatter' or 'gross-out' film.

If the splatter film nominally traces back to the 1960s underground gore films of Herschell Gordon Lewis, it became more prominent in the 1970s and 1980s, with many of its entries ending up on the aforementioned 'video nasty' list. 'Splatter film' is a somewhat ill-defined term, sometimes describing serious-toned films replete with body horror (Clive Barker's *Hellraiser* (1987), Carpenter's *The Thing* (1982) and many of Cronenberg's films), but more often used to describe cheerfully irreverent and bloody films like Stuart Gordon's *Re-Animator* (1985), Peter Jackson's *Bad Taste* (1987) and *Braindead* (1992), and perhaps above all Sam Raimi's trilogy of *The Evil Dead* (1981), *Evil Dead II* (1987) and *Army of Darkness* (1992).[2] Gory special

[2] The vaguely cognate literary horror movement was 'splatterpunk', including authors like David J. Schow, Richard Christian Matheson and Joe R. Lansdale.

FIGURE 3.2 *Bruce Campbell in* Evil Dead II *(1987), the new face of the horror hero.*

effects are a major part of a splatter film's appeal, elevating makeup artists like Tom Savini, Stan Winston, Rob Bottin and Rick Baker to auteur status of sorts. Splatter films also yielded an interesting (shadow) star system of cult stars that, like the horror stars of the 1930s, rarely crossed over to mainstream pictures and remain relatively obscure to society at large. *Evil Dead*'s Bruce Campbell is, perhaps even more so than Robert Englund, the prototypical post-classical cult horror star: a fixture of low budget, often tongue-in-cheek horror films whose star image circulates through public appearances, comic books, autobiographies and so on, as clearly as through his acting roles (Hills 2013, 25). *Re-Animator*'s Jeffrey Combs has had a comparable career, though generally working as a character actor, often under heavy makeup (including many roles on *Star Trek* shows).

Quality and prestige

Jonathan Demme's *The Silence of the Lambs* (1991) earned something no horror film had before or has since: an Academy Award for Best Picture. That is, if one regards *The Silence of the Lambs* a horror film, its generic identification would indeed be a point of debate (Jancovich 2002b). Based on Thomas Harris's 1988 novel, it would make an iconic

human monster out of the brilliant psychiatrist, aesthete, serial killer and cannibal Hannibal Lecter, played here by Oscar-winner Anthony Hopkins (Lecter was previously played by Brian Cox in *Manhunter* (1986), adapted from Harris's earlier novel *Red Dragon*). In fact, *The Silence of the Lambs* became only the third film to sweep the 'top four' categories: Best Picture, Director, Actor and Actress (Jodie Foster as the fledgling FBI agent Clarice Starling). Horror's long-standing dalliances with official prestige and legitimation paid off both in the gold-plated britannium of the Oscar statuette and in box office gold: *The Silence of the Lambs* was the fifth-grossing film of its year.

The Silence of the Lambs went a decade before its sequel and prequel arrived, the disappointing *Hannibal* (2001) and the *Manhunter* remake *Red Dragon* (2002), reportedly because of Anthony Hopkins's reluctance to revive the part due to fears of copycat violence. There would be another, widely despised prequel, *Hannibal Rising* (2007), before the much better received NBC series *Hannibal* (2013–5). However, in the meantime it triggered an extensive cycle that marked the 1990s as the decade of the serial killer. Its followers include great films like David Fincher's *Seven* (1995) and Mary Harron's *American Psycho* (1999), an adaptation of Bret Easton Ellis's dark satire about a Reaganite stockbroker/murderer, as well as *Kalifornia* (1993), *Copycat* (1995), *Kiss the Girls* (1997), *The Bone Collector* (1999) and many others. It also played into the revival of the slasher film discussed below.

No doubt hoping to match *The Silence of the Lambs*'s financial success and prestige, another cycle in the American horror film followed in the early 1990s with pedigreed directors approaching classic horror material with lavish, expensive productions and star-studded casts. *Bram Stoker's Dracula* (1992) was neither Francis Ford Coppola's first horror movie (his first feature *Dementia 13*) nor his last (*Twixt* (2011)), but remains his best known. With Gary Oldman as Dracula, Hopkins as Van Helsing, Winona Ryder as Mina Murray and a stunningly miscast Keanu Reeves as Jonathan Harker, it is lavish and operatic in the extreme. The title is somewhat misleading, for while in certain respects it follows the plot of Stoker's novel more closely than other adaptations, it also introduces new elements and tonally its soaring romanticism is quite unlike Stoker. The title serves to foreground its status as a prestigious adaptation of a canonical literary work as a

strategy of genre gentrification. Coppola's film lists Leonard R. Wolf, author of *The Annotated Dracula* (1975), as a 'Historical Consultant', drawing scholarly credentials into its legitimation strategies.

Thomas Austin has called the cycle stemming from *Bram Stoker's Dracula* 'costume horror' (2002), though frames it slightly beyond period pieces to include *Wolf* (1994), a romantic werewolf film directed by Mike Nichols and starring Jack Nicholson and Michelle Pfeiffer. The most obvious successors of *Bram Stoker's Dracula* were *Mary Shelley's Frankenstein* (1994), produced by Coppola, directed by Kenneth Branagh and starring Branagh as Frankenstein and Robert de Niro as his creation, and Stephen Frears's *Mary Reilly* (1996), a reworking of the Jekyll and Hyde mythos with Julia Roberts and John Malkovich. There was also *Interview with the Vampire* (1994), the century-spanning literary adaptation of Anne Rice's modern classic, directed by Neil Jordan and starring bankable Hollywood stars Tom Cruise and Brad Pitt as the vampires Lestat de Lioncourt and Louis de Pointe du Lac.

This cycle is characterized by high production values (*Bram Stoker's Dracula* won Oscars for Best Costume Design, Sound Editing and Makeup and was nominated for Best Art Direction, as was *Interview with the Vampire*, and *Mary Shelley's Frankenstein* was nominated for Best Makeup), prestigious directors, long running times, stars not generally associated with the horror film and, some would say, a conspicuous lack of scares (see Chapter 6). Even as they strived, with varying degrees of success, to attract non-traditional viewers for horror films (women, especially), they alienated some horror fans with their appeals to taste and quality (Jancovich tags this cycle 'horror films for people who don't like horror' (2000, 31)). Composed of expensive, high-risk films, the cycle proved short lived due to the underperformance of *Mary Shelley's Frankenstein* and the disastrous flopping of *Mary Reilly*. Yet its decline unfolded against the commencement of another cycle that reshaped the face of the American horror film yet again.

Son of the slasher

The extent to which the slasher film ever died out is easily overstated. The *Halloween, Friday the 13th* and *Nightmare on Elm*

Street franchises lingered on into the 1990s, accompanied by a few memorable standalone works, like *Dr. Giggles* (1992). Also somewhat connected to the cycle was *Candyman* (1992). Based on a story by the acclaimed UK horror writer Clive Barker, it is about a white Chicago grad student (Virginia Madsen) investigating an urban legend circulating in the notorious Cabrini-Green housing project that proves to have a terrifying supernatural reality. As the hooked-handed and bee-bestrewn Candyman, the nearly two metre tall African American actor Tony Todd joined the canon of iconic horror stars, cemented by his presence in the *Final Destination* (2000–11) franchise and films like *Wishmaster* (1997) and *Minotaur* (2006). If *Candyman* has some links to the slasher film, it also reflects the increasing availability of horror to prestige, including a score by the acclaimed minimalist composer Phillip Glass (one of his first scores for a Hollywood feature).

New Nightmare (1994) saw Wes Craven returning the *Nightmare* franchise to relative seriousness. This cleverly reflexive Hollywood-set tale stars Craven, Heather Langenkamp (star of the original film), Robert Englund and others as themselves, discovering that Freddy Krueger is trying to break through to the real world. *New Nightmare* performed poorly despite strong reviews; it actually remains the lowest earning *Nightmare* film. But Craven would ˙come back strongly with his biggest hit, a much jokier slice of reflexive horror that inaugurated a new slasher cycle: *Scream* (1996). *Scream* was conceived by screenwriter Kevin Williamson under the title *Scary Movie* – eventually the title of its own parody (2000) – which speaks to its self-referential character. *Scream*'s distributer was Bob Weinstein's Dimension Films, launched to segregate genre pictures from Miramax's brand of Oscar-bait and art house films. Dimension would manage countless horror films in the subsequent decades.

Costing around $15,000,000, *Scream* was considerably better budgeted than the slasher films of the 1980s to which it pays homage. It stars recognizable actors, largely from television (Neve Campbell from *Party of Five* (1994–2000), Courteney Cox from *Friends* (1994–2004)), and sports a hip soundtrack and smoothly competent cinematography. But its most notable feature is its reflexivity: *Scream* is full of characters who know about horror movies, watch horror movies, know the conventions of horror movies and become cognizant of the fact that they're in one. Even the killers are horror

movie junkies, scheming to actualize the conventions they have internalized from fiction.

Scholarship has been split on whether *Scream*'s reflexive tendencies represented a productive postmodern approach to horror or simply evidence of a spent genre consigned to self-cannibalism (Schneider 2000; Hills 2005, 182–7; Wee 2005). Less debatable was its success; *Scream* grossed more than $100,000,000 at the domestic box office alone. Its success not only ensured its own sequels (1997, 2000, 2011) but also triggered a new cycle of production for slasher films, considerably glossier and better budgeted than the first cycle, and generally with less nudity and gore. One of the first was *I Know What You Did Last Summer* (1997). Starring Campbell's *Party of Five* costar Jennifer Love Hewitt and *Buffy the Vampire Slayer* (1997–2003) herself, Sarah Michelle Geller, it initially came billed as from the 'Creator of *Scream*' – meaning Williamson. Miramax successfully sued over the misleading implication that Craven was that 'creator'. These 'neo-slashers' followed many of the marketing cues of the original slasher cycle, including having a killer whose highly distinctive costuming lends itself to advertising. Original slashers arrived (the *Urban Legend* films (1998, 2000), *The Clown at Midnight* (1998), *Valentine* (2000)), as well as parodies (*Scary Movie, Behind the Mask: The Rise of Leslie Vernon* (2006)) and continuations of older franchises (*Halloween H20: 20 Years Later* (1998), *Bride of Chucky* (1998), *Jason X* (2001) and *Freddy vs. Jason* (2003), a multi-property mash-up in the tradition of *Frankenstein Meets the Wolf Man* and *King Kong vs. Godzilla* (1962) that became the highest earning film of both *Nightmare* and *Friday the 13th* franchises). Countless new remakes followed, too: *The Texas Chainsaw Massacre* (2003), *Black Christmas* (2006), *When a Stranger Calls* (2006), *The Hills Have Eyes* (2006), *Halloween* (2007), *Friday the 13th* (2009), *My Bloody Valentine 3-D* (2009), *The Last House on the Left* (2009), *I Spit on Your Grave* (2010), *A Nightmare on Elm Street* (2010) and more. Fans dismayed at the state of a putatively slasher- and remake-soaked Hollywood horror film often looked to independent cinema and to other countries' traditions in search of 'authentic' horror.

More analytic reworkings of the slasher and its 'Final Girl' accompanied the revived slasher film. *Cherry Falls* (2000) inverted the formula with a killer who kills only virgins. *You're Next* (2011) has

a Final Girl who surprises the villains by being a hyper-competent survivalist. Also somewhat classifiable as a slasher film satire was *The Cabin in the Woods* (2012). Written and produced by *Buffy the Vampire Slayer* and *Angel* (1999–2004) creator Joss Whedon and directed by his regular collaborator Drew Goddard, it mixes elements of the slasher formula, with Dana (Kristen Connolly) as its faux-virginal Final Girl, with the *Evil Dead*-style setting implied by the title and something else: a team of technicians arranging all of the horrific events as a sort of blood sport to appease ancient Lovecraftian god-monsters. *The Cabin in the Woods* stages a critique of horror films as static and morally bankrupt, and its ending, in which two characters deliberately allow the apocalypse in the spirit of 'maybe it's time for a change', hopes to herald a new dawn for the horror film, divested of its formulaic trappings. A popular film for its ironic sensibility and some effective scenes (none more so than the 'all Hell breaks loose' climax, which fills the screen with colourful monsters galore), *The Cabin in the Woods* divided fans on its merits for similar reasons too (see Chapter 6).

The twins of 1999

We take a step back to 1999. This was an extremely successful and consequential year for the horror film, thanks to two unlikely hits. One was *The Sixth Sense* (1999), an old-fashioned, restrained ghost film the success of which was anchored by its much-discussed twist. It became the second highest grossing film of 1999, after *Star Wars: Episode 1: The Phantom Menace* was nominated for six Academy Awards and introduced the oft-parodied phrase 'I see dead people' into the cultural lexicon. It was the second film by M. Night Shyamalan, the young Indian American director whose career trajectory demonstrates all the potential downsides of genre auteur status. Following *The Sixth Sense*, the media promoted him as a new Rod Serling, if not a new Spielberg. Shyamalan's follow-ups, *Unbreakable* (2000), *Signs* (2002) and *The Village* (2004) were all successful, but his critical stock declined with each film and plummeted with the self-indulgent flop *Lady in the Water* (2006). Shyamalan was lambasted as a one-trick pony (the parody show

Robot Chicken (2005–) had him continually popping up yelling, 'What a twist!'), and by *The Last Airbender* (2010) and *After Earth* (2013), his films weren't advertised with his name (somewhat working in his favour by insulating Shyamalan from their failure). More recently, *The Visit* (2015) and *Split* (2017) marked a tentative return to form; Shyamalan's critical reputation may yet be rescued, but it seems unlikely he will ever equal the success of *The Sixth Sense*.

Yet the return on investment of *The Sixth Sense* was dwarfed by that of *The Blair Witch Project* (1999), which earned $250,000,000 worldwide from a microscopic $60,000. The story of three young filmmakers making a film about an urban legend in rural Maryland only to find themselves lost in the woods and beset by mysterious, unseen forces, *The Blair Witch Project* was aided by an innovative online advertising campaign that cast doubt on its status as fiction. While far from the first identifiable 'found footage horror' film (see Chapter 9), it reinforced horror's potential as a lucrative field for ambitious independent filmmakers – and come the millennium, low budgets could be very low indeed.

Similar insofar as both are slow paced, suggestive and bloodless, *The Sixth Sense* and *The Blair Witch Project* have significant differences. *The Sixth Sense* stars a movie star (Bruce Willis), has polished, glossy cinematography and eventually shifts away from horror conventions towards a white-light-dominated mysticism akin to *Ghost* (1990) (Fowkes 1998), while *The Blair Witch Project* is deliberately cheap and shaky, and ends on a note of horrific suspension. *The Sixth Sense*'s smooth studio competence contrasts with *The Blair Witch Project*'s unpolished independent immediacy. They rather mirror the duality of *Rosemary's Baby* and *Night of the Living Dead* thirty-one years earlier.

Both proved influential. *The Sixth Sense* was followed by a cycle of well-crafted 'quality' ghost films with various degrees of success, including *What Lies Beneath* (2000), *The Others* (2001), *Gothika* (2002), *White Noise* (2005) and *El orfanato/The Orphanage* (2007), as well as the J-Horror remakes and the Blumhouse films to be discussed below. *The Blair Witch Project* seemed to be an interesting one-off for years (its 2000 sequel was quickly forgotten), before the explosion of found footage horror films in the latter half of the 2000s. With a diverse slate of films, ranging from

giant monster movies (*Cloverfield* (2008)) to zombie films (*REC* (2007) and its sequels) to science fiction horror (*Apollo 18* (2011)) to anthology films (*V/H/S* (2012)) to a great many supernatural tales, found footage would become almost the dominant mode of low-budget horror films, especially after the advent of Netflix and other streaming services. Easily the most successful was *Paranormal Activity* (2009), whose $200,000,000 worldwide gross off of a $15,000 initial budget makes it a strong candidate for the best return on investment of any film in history. Made by first-time director Oren Peli, shooting in his own home, this story of a demon-haunted married couple was picked up by DreamWorks/ Paramount for $300,000 and would become a huge success, with four sequels to date. Established directors like Romero (*Diary of the Dead*) and Shyamalan (*The Visit*) would attempt the found footage style as well. The dominance of found footage horror is somewhat wearying (in 2014 the *Washington Post* published an article called 'Enough with the found footage already' (O'Sullivan)) and the *Blair Witch, Cloverfield* and *REC* franchises broke with the format to various degrees), and the increasing migration of the found footage aesthetic to other genres like the superhero film (*Chronicle* (2014)) and the police drama (*End of Watch* (2012)) suggests that it may eventually be untethered from horror.[3]

J-Horror

In the decades since *Gojira*, Japanese horror fitfully circulated widely internationally, with stylish and beautiful films like *Kwaidan* (1964), *Onibaba* (1964) and *Kuroneko* (1968) finding admirers among European and North American critics and cinephiles. It was in the 1990s, however, that a full cycle of Japanese horror – often shortened and genericized to 'J-Horror' – became a major international force to be reckoned with, with a slate of daring, serious and disturbing films by directors like Hideo Nakata, Takashi Shimizu, Takashi Miike and

[3]See Heller-Nicholas (2014) for a thorough examination of the found footage cycle.

Kiyoshi Kurosawa. These films are often seen as allegorizing issues facing Japanese society in the period of economic decline.[4]

The key film for the internationalization of J-Horror was *Ring* (1998), distributed internationally by Miramax under the Japanized name *Ringu*. Based on a novel by Koji Suzuki, *Ring* involves a videotape haunted by Sadako, who emerges from television sets to kill those who fall under her curse. Sadako is an *onryō*, one of the angry and vengeful female ghosts of Japanese mythology, and has their traditional look: bloodless white skin, long black hair and white burial garb. *Ring* displays the influence of Western horror films like *Videodrome*, *Poltergeist* and *A Nightmare on Elm Street* but has plenty of culturally specific elements too: not only the lore of the *onryō*, but a backstory drawing on the controversial experiments on female clairvoyants by Dr Tomokichi Fukurai in the 1910s. Like many J-Horror films, *Ring* involves a single mother and a broken home, and it reflects concerns about the loss of the traditional family structure as a consequence of Japan's diminishing place in the global world economy during its 'Lost Decade', as well as the influence of new media.

Ring had numerous Japanese sequels and prequels, and was remade as *The Ring Virus* (1999) in Korea. However, its Hollywood remake, *The Ring* (2002), directed by Gore Verbinski, may have been its most consequential incarnation, if only due to the cycle of production it triggered. Remade due to a deal brokered by Roy Lee, the Korean-American producer who specializes in such deals (Heffernan 2014, 68–9), *The Ring* earned $250,000,000 worldwide. Nakata himself directed the disappointing Hollywood sequel *The Ring Two* (2005). Takashi Shimizu's *Ju-on* (2003), also about an *onryō*, was remade by Shimizu as *The Grudge* (2004) with Sarah Michelle Geller, the Hollywood film simplifying the original's complex and disorienting structure. Other Hollywood remakes of J-Horror films followed, most listing Lee as a producer and generally involving ghosts: *Kairo/Pulse* (2001; remake 2006), *Honogurai Mizu no soko kara/Dark Water* (2002; remake 2005) and *Chakushin Ari/One Missed Call* (2003; remake 2008), the poor performance of which spelt the end of the cycle of

[4]For sources on J-Horror and its remakes, see Wada-Marciano (2007), McRoy (2008) and Lim (2009, 190–244).

FIGURE 3.3 *The emergence of Sadako in* Ring *(1998).*

J-Horror remakes (the 2017 attempted revival, *Rings,* received poor reviews and middling box office).

A variety of horror films from other Asian cinemas received their own Hollywood remakes, again often with Lee involved. These include Hong Kong's *Gin gwai/The Eye* (2002; remake 2008), the Philippines' *Sigaw* (2004; remade as *The Echo* (2008)), South Korea's *Janghwa, Hongryeon/A Tale of Two Sisters* (2003; remade as *The Uninvited* (2009)), *Geoul sokeuro/Into the Mirror* (2003; remade as *Mirrors* (2008)) and Thailand's *Shutter* (2004; remake 2008). The Hollywood version of *Shutter* was directed by Japan's Masayuki Ochiai, likely to create an impression of consistency with the J-Horror brand.

The spate of remakes of Asian and, more rarely, European horror films exacerbated the 'crisis rhetoric' (Hantke 2007) on the part of critics and fans about the state of the American horror film, now constructed as a creatively bankrupt field desperate for new ideas. Some fans looked instead towards Asian films, especially those marked as part of Tartan Films' 'Asia Extreme' DVD series, though a brand of Orientalism was certainly in play:

The success of Tartan Asia Extreme reveals more about the Western perceptions and obsessions about the East Asian countries rather than what people or societies are like there. It is also notable that the language and approach used in Tartan Asia

Extreme's promotional campaigns, based on the discourses of difference and excess, fit comfortably into the widespread notion about the East. (Shin 2008, n.p.)

The slate of J-Horror films remade in Hollywood also created a somewhat misleading impression of Japanese horror as a whole. The long-running *Tomie* series (1999–2011), about an evil, immortal schoolgirl, remains obscure in the West. *Batoru Rowaiaru/Battle Royale* (2000), about children forced to fight to the death in an elaborate arena, was consigned to limited distribution in the West due to its premise (coloured by the recent Columbine school shootings) but attracted a cult following; its notoriety would increase due to the similarly themed *Hunger Games* franchise (2012–2015). Mitsuyo Wada-Marciano has noted that the label 'J-Horror' has swelled to encompass a slate of films, past and present, not initially regarded as horror films at all (20–4).

Another important figure, director Takashi Miike, has earned notoriety for grim, violent films like *Koroshiya Ichi/Ichi the Killer* (2001) and *Ōdishon/Audition* (1999); these stand starkly opposed to the relatively restrained supernatural-themed films that have attracted remakes. In 2006, Miike was invited to direct an episode of the American anthology series *Masters of Horror* (2005–2007), with assurances of creative freedom. However, the resulting episode 'Imprint' never aired in the United States, though it was released on DVD. The tale of a nineteenth-century American traveller (Billy Drago) searching for a lost lover in Japan, it is full of graphic torture and abortions by (literally) the bucketful. With a female ghost in addition to scenes of gore and unbearable torment, as well as patently absurd closing revelations, maybe 'Imprint' should be seen as a brutal J-Horror self-parody, and its suppression by *Masters of Horror*, perhaps, as its ultimate tribute.

New extremes on both sides of the Atlantic

The turn of the millennium saw 'the genre's centre … globally dispersed' (Hart 2014, 432), with various national traditions of horror

gaining prominence, mostly thanks to one or two breakthrough works. These included Canada (*Ginger Snaps* (2000), *Pontypool* (2008)), Britain (*28 Days Later*, *The Descent* (2005), *Kill List* (2011)), Australia (*Wolf Creek* (2005), *Lake Mungo* (2008), *The Babadook* (2014)), Germany (*Anatomie/Anatomy* (2000)), Sweden (*Låt den rätte komma in*/*Let the Right One In* (2008)), Norway (*Død snø*/*Dead Snow* (2009)), Finland (*Rare Exports* (2010)), Spain (the *REC* series, *El espinazo del Diablo*/*The Devil's Backbone* (2001), *The Others*, *The Orphanage*) and so on. Special mention should go to France for a slate of boundary-pushing horror films within the movement dubbed 'the New French Extremity' by James Quandt of *Artforum*, albeit in terms of criticism:

> A cinema suddenly determined to break every taboo, to wade in rivers of viscera and spumes of sperm, to fill each frame with flesh, nubile or gnarled, and subject it to all manner of penetration, mutilation, and defilement. Images and subjects once the provenance of splatter films, exploitation flicks, and porn – gang rapes, bashings and slashings and blindings, hard-ons and vulvas, cannibalism, sadomasochism and incest, fucking and fisting, sluices of cum and gore – proliferate in ... high-art environs. (127–8)

In certain respects, the New French Extremity appears to be the descendant of Franju's *Eyes Without a Face,* bridging horror and art cinema and constantly testing lines of taste with disturbing plotlines and extreme violence and gore.

The confines of the New French Extremity are somewhat unclear, though it seems certain to include works by directors like Catherine Breillat (*À ma sœur!*/*Fat Girl* (2001)), Claire Denis (*Trouble Every Day* (2001)), Bruno Dumont (*Twentynine Palms* (2003)), Xavier Gens (*Frontier(s)* (2007)), Gaspar Noé (*Irréversible* (2002)), Marina de Van (*Dans ma peau*/*In My Skin* (2002)) and Julien Maury and Alexander Butillo (*À l'intérieur*/*Inside* (2007)). One of the best examples is Pascal Laugier's France/Canada co-production *Martyrs* (2008), the story of a woman being tortured by a cult as an investigation into existence of the afterlife, for its balance of weighty philosophical themes and unspeakable brutality. Hollywood did not let this spate

of films pass unnoticed. One interesting case is France's Alexandre Aja, who came to prominence at the age of twenty-six with his first feature, the dazzling neo-slasher *Haute Tension/High Tension* (2003). Among its admirers was Wes Craven, who brought Aja to the United States to direct the 2006 remake of *The Hills Have Eyes*. Aja was subsequently hired to direct other horror remakes: the aforementioned *Mirrors* and *Piranha 3-D* (2010), a loose reworking of Joe Dante's cult favourite *Piranha*. Similarly, the directing team of Maury and Butillo has been attached to new *Halloween* and *Hellraiser* films, as yet unmade, and directed *The Texas Chainsaw Massacre* prequel *Leatherface* (2017).

If one extends the 'extreme' label beyond France, it becomes possible to include films by provocative and controversial European auteurs like Lars von Trier (*Antichrist* (2009)), Michael Haneke (the two versions of *Funny Games* (1997, 2007)), Fabrice du Welz (*Calvaire* (2004)) and Srđjan Spasojević (*Srpski film/A Serbian Film* (2010)). Conversely, Pedro Almodóvar's *La piel que habito/The Skin I Live In* (2011) has a Frankensteinian mad scientist narrative and shows the clear influence of *Eyes Without a Face*, but is conspicuously lacking in blood, violence or shock, a sort of horror film without horror. A cycle unto itself was *The Human Centipede* trilogy (2009, 2011, 2015) by Dutch director Tom Six, built on the excruciating mad science premise of oral-anal grafting. Six's trilogy cheerfully challenges all standards of taste and has earned bans in some countries (Jones 2013a).

Meanwhile, a somewhat similar cycle of films unfolding in American cinema also gained a label in semi-disgrace: 'torture porn'. In this case, the term came from a 2006 article by David Edelstein in *New York Magazine,* though Edelstein's formulation was sufficiently broad to place *The Passion of the Christ* (2004) next to *Irréversible, Saw* (2004) and *Hostel* (2005). This cycle was triggered by the unexpected success of James Wan's *Saw*, about a maniac who uses elaborate traps to test how far his victims are willing to go to survive. Redolent of *giallo* (especially Argento's *Deep Red*), *Seven, The Silence of the Lambs* and the Canadian science fiction thriller *Cube* (1997), *Saw* was certainly derivative. But there is no denying its success, earning back its modest $1,000,000 budget one hundred times over, and triggering

a lengthy series, with another *Saw* movie coming out at Halloween annually until 2010. Jigsaw (Tobin Bell) joined the pantheon of horror movie villains, with the creepy puppet 'Billy' providing an ad-ready 'face' of the franchise.

To return to Richard Nowell's terminology, if *Saw* was the Breakthrough Hit for the torture porn cycle, its first Reinforcer Hit was Eli Roth's *Hostel*. Produced by Quentin Tarantino, *Hostel* depicts some hapless American tourists visiting Slovakia in search of sexual adventures, but instead running afoul of a secret ring of rich degenerates who torture and murder tourists. Like many of the films of its cycle, *Hostel* seems to open itself up to both reactionary (the non-US world is full of decadence and violence) and progressive (Americans are bumblers abroad, and suffer from torture instead of inflicting it) readings; in any event it is as much an artefact of the age of Guantanamo and Abu Ghraib, when debates about torture were constantly in the news, as reflected in prestige pictures like *Rendition* (2007) and *Zero Dark Thirty* (2012). Symptomatic readings of the American torture porn cycle have emerged (Middleton 2010; Lowenstein 2011; Jones 2013a; Kerner 2015); certainly, we should not blindly accept the distinction between artistically provocative and politically radical European or Asian 'extreme' cinema and ideologically evacuated American 'torture porn'.[5]

The torture porn cycle inaugurated a series of new horror auteurs dubbed the 'splat pack', including Wan, Roth, Aja, Leigh Whannel, Rob Zombie, Darren Lynn Bousman and Greg McLean, many of whose films have been distributed by Lionsgate. Benefitting enormously from the DVD's potential for distributing multiple cuts with different ratings, the splat pack have been consciously positioned as the logical inheritors to post-classical horror auteurs like Hooper, Craven, Carpenter and Romero (Tompkins 2014; Bernard 2015). Their rough, unpolished work was positioned as an alternative to the star-driven gloss of the slasher revival – a narrative of (bloody) paradise lost and regained. Yet they too peddle a brand of nostalgia horror, tethered to notions about the lost 'purity' and 'legitimacy' of 1970s horror and its auteurs.

[5]For more on these cycles, see Horeck and Kendall (2011), Wilson (2015).

Newer trends

Through the 2010s, the most visible force in American horror has been Blumhouse Pictures, which scored big with the *Paranormal Activity* films. Founded by former Miramax executive Jason Blum in 2000, its model favours relatively modestly budgeted films, generally with bankable B-list actors willing to accept a back-end heavy pay structure, and then distribute them through the Hollywood studios (Murphy 2015). While Blumhouse's products range from the Dwayne Johnson-starring children's comedy *Tooth Fairy* (2010) to the Oscar-winning drama *Whiplash* (2014), horror has been its principal brand. Blumhouse recruited *Saw* director James Wan for the *Insidious* (2010, 2013) and *The Conjuring* (2013, 2016) films. Other than the violent alternate history franchise *The Purge* (2013, 2014, 2016), Blumhouse has favoured supernatural horror, also including the *Sinister* (2012, 2015) and *Ouija* films (2014, 2016), *Oculus* (2013) and *Unfriended* (2015; see Chapter 9), and especially haunted house films that play on recession-era anxieties about real estate (ibid.). Where other contemporary horror traditions combine aspects of high- and lowbrow culture, Blumhouse's brand is decidedly middlebrow.

Blumhouse's biggest hit to date has been *The Conjuring*, the highest grossing horror film of the twenty-first century thus far. *The Conjuring* and its sequel are openly nostalgic, explicitly referencing films like *The Exorcist*, *Poltergeist*, *The Changeling* (1980), *The Amityville Horror* and *Ghostwatch* (1992). Bearing the selectively worded tagline 'Based on the True Case Files of the Warrens', *The Conjuring* takes place in 1971 and purports to dramatize events in the careers of real-life paranormal investigators Ed (Patrick Wilson) and Lorraine Warren (Vera Farmiga); its sequel deals with their involvement with the 1977 'Enfield Poltergeist' case in London. In echoing the 'reality based' horror films of the 1970s and 1980s (including *The Amityville Horror*, *The Entity* and *Audrey Rose* (1977)), *The Conjuring* films join a recent cycle of films purporting similar factual bases (*The Exorcism of Emily Rose* (2005), *The Haunting in Connecticut* (2009), *The Rite* (2011), *When the Lights Went Out* (2012), *Deliver Us from Evil* (2014), *The Quiet Ones*, etc.), often misleadingly. While the credibility of the real Warrens has been widely questioned, the cinematic versions are full-blown demon-fighting heroes with God on their side, and *The*

Conjuring films can be seen as correctives to the moral ambiguities of so much post-classical horror. *The Conjuring* films have also craftily incorporated secondary villains to generate spinoffs: the possessed doll Annabelle (*Annabelle* (2014), *Annabelle 2* (2017)) and a ghostly nun (*The Nun* (2017)).

If Blumhouse has carved out a market for skilfully made but formulaic horror, innovation is coming from smaller independents. An important recent example is *The Babadook* by Australia's Jennifer Kent. Echoing films like *The Haunting, The Entity* and *Truly Madly Deeply* (1990) in its themes of motherhood, mourning and the haunting of domestic space, *The Babadook* also explicitly cites Méliès and other trick filmmakers (see Chapter 9), assembling its own interrogation of horror's history while adding a terrifying new top-hatted foe to the canon of movie monsters. Combining a sensitive character study with well-wrought scares, *The Babadook* has swiftly been canonized as a modern classic.

Kent is one of a number of female directors worldwide now working in horror, also including Canadians Jovanka Vuckovic and sisters Jen and Sylvia Soska, Belgian Hélène Cattet and Americans Karyn Kusama and Ana Lily Amirpour.[6] The latter is the director of the stunning black-and-white *A Girl Walks Home Alone at Night* (2014), billed with some justification as 'The First Iranian Vampire Western'. A Farsi-language film shot in California but set in Iran, Amirpour's film shares the slow, atmospheric qualities of the cycle of independent American vampire films of the 1990s (including *Nadja* (1994), *The Addiction* (1995) and *Habit* (1996)),[7] but is consistently original and provocative, complete with a vampire whose chador billows like a cape as she skateboards through the streets of Tehran.

Recent years have also seen a revival of the venerable horror anthology format, including the *V/H/S* found footage series (2012,

[6] Earlier woman-directed horror include Stephanie Rothman's *The Velvet Vampire* (1971), *Messiah of Evil* (1973), codirected by Gloria Katz, Amy Holden Jones's slasher parody *Slumber Party Massacre* (1983), Kathryn Bigelow's *Near Dark* (1987), Mary Lambert's *Pet Sematary* (1989), Marina Sarengti's *Mirror, Mirror* (1990) and Rachel Talalay's *Freddy's Dead: The Final Nightmare* (1991).

[7] For a study of the under-examined art house-vampire cycle of the 1990s, see Sexton (2012).

2013, 2014), *Trick 'r Treat* (2007), *Little Deaths* (2011), *Chillerama* (2011), *The ABCs of Death* (2012, produced by Drafthouse Picture, the production wing of the Alamo Drafthouse theatre chain) and the all-female-directed *XX* (2016). An ideal format for emerging directors seeking exposure, it thrives on Netflix and other streaming services, playing in cinemas more rarely.

In the past few years, the highest grossing horror films have included Blumhouse sequels, competent but unnecessary remakes (*Poltergeist*(2015)) and the nostalgia-driven YA adaptation *Goosebumps* (2015), yet the most praised horror films were innovative low-budget ones. The major innovation of *It Follows* (2014) lies in tethering the transmittable curses of *Night of the Demon* and *Ring* to sex, a death sentence that can only be forestalled by inflicting it on someone else through intercourse. The murderous entity in *It Follows* can look like anyone and appear anywhere at any time, less a character than an inexorable force walking towards the camera, framed with unnatural symmetry in the centre of the frame; as in *Halloween*, all camera movement becomes a source of unease, implying supernatural surveillance. The film's suburban Detroit is redolent of white flight and a social commentary is implicit in its white teenagers' inescapable confrontations with the Other puncturing their complacent lives.

The Witch (2015), on the other hand, peels back the United States to its puritan roots, dramatizing the disintegration of an English family settling in the backwoods of seventeenth-century New England. In exploring the colonial period as a time of isolation, repression and paranoia, *The Witch* evokes Teresa Goddu's observations about how American Gothic literature criticizes 'America's national myth of new-world innocence … the gothic tells of the historical horrors that make national identity possible yet must be repressed in order to sustain it' (10). Its finale presents embracing the monstrous as the only freedom the new world offers.

The Witch was widely acclaimed by professional critics and quite financially successful, making back its $1,000,000 budget forty times over. But its reception by horror fandom, who may not have expected such a slow and restrained film, was mixed enough to warrant coverage in the mainstream media. An article by Benjamin Lee in *The Guardian* asks, 'Did arthouse horror hit The Witch trick mainstream US audiences?' and reproduces comments like 'The

witch was the worst movie fucking made mad I wasted my money on that shit' (n.p.). Resistance to *The Witch* and other acclaimed recent independent horror films inspired Jason Coffman's critique of 'horror fandom's gatekeepers' (n.p.) as clinging to a too-narrow conception of the genre and discouraging new fans with their curmudgeonly tone (for more on horror fandom, see Chapter 6).

Only time will tell if the Trump era proves the same fertile ground for horror filmmakers as other conservative periods, but *Get Out* (2017) has provided a promising start. Written and directed by Jordan Peele, the sketch comedian best known for the TV series *Key & Peele* (2012–2015), *Get Out* was produced by Blumhouse and quickly became a breakthrough hit. It tells the story of a young black photographer meeting his white girlfriends' family. We slowly learn that they are part of a secret society that captures black men and women to auction their bodies for a kind of soul transference by ageing white elites. *Get Out* shows the inspiration of *Invasion of the Body Snatchers*, *Eyes Without a Face* and especially *The Stepford Wives* (1975); it also provides a dark variant on *Guess Who's Coming to Dinner* (1967), with the twist being that the white liberal parents, rather than being the ones invested with the power to solve racism, are monstrous exploiters behind their bland platitudes. *Get Out* is a topical issue picture but is also an effective paranoid horror film. The fact that Peele plans future horror films, and is committed to nurturing young black talent in genre filmmaking, provides reason enough to be hopeful for the future of the American horror film.

The future of an undead genre

A graveyard could be filled with tombstones declaring the death of horror. But what is the future of a genre that has bent and flowed so unexpectedly since its inception? Today, one may observe with dread the merging of horror with the action blockbuster (*I, Frankenstein* (2014), etc.) or declare that the *Twilight* franchise (2008–2012) has *ruined* vampires or that torture porn went too far, or decry the dominance of found footage horror, or lament that horror's moment of currency is long past and it is consigned now only to nostalgia and mindlessly reshuffling through the same few conventions again

and again. A version of this 'loss of legitimacy' narrative seems ever present in both fan and critical discourse (see Chapter 6). But if one thing the history of horror has demonstrated time again, it is the genre's flexibility, its ability to bend to new social and technological milieus. We cannot know if the future holds a new 'Golden Age' like the 1930s or 1970s. But works like *The Babadook, A Girl Walks Home Alone at Night, It Follows, The Witch* and *Get Out* indicate that there should be plenty of life – or unlife – left to the horror film.

4

What is Horror?

While identifying an individual horror film is often a commonsensical task, defining horror itself proves much more challenging. For example: Am I describing a horror film? It is New York City in the mid-1950s and our protagonist is a hardboiled, world-weary detective named Harry Angel (Mickey Rourke). He is hired by a rich, mysterious man to locate a missing crooner/soldier named Johnny Favorite, shell-shocked and hospitalized while serving in the Second World War, with whom he has an unfulfilled contract. The detective finds the case uninspiring but needs money, so he tracks Favorite to a mental hospital in upstate New York. There he finds that a doctor has been falsifying records for money and that Favorite has actually been missing for more than a decade. Shortly afterwards, the detective finds the doctor shot to death. Convinced to stay with the increasingly dangerous case after a hefty pay-raise by the mysterious man, the detective continues pursuing the case, which leads him to a group of voodoo practitioners in New Orleans, including Favorite's daughter, Epiphany Proudfoot (Lisa Bonet).

So far, little of this plot description suggests a horror film; it suggests a detective film, rather like the film noirs of the 1940s and 1950s. And indeed, the film, Alan Parker's *Angel Heart* (1987), pays homage to the aesthetic of film noir, with gorgeous low-contrast lighting and a mournful, jazz-laden score echoing the music of that classic cycle. Even the role of voodoo may suggest earlier crime films involving fraudulent cults, such as *Harper* (1966), or phony mediums, like *Fallen Angel* (1945), *Nightmare Alley* (1947) and *The Amazing Mr. X* (1948). However, other elements, including many of

the film's visuals, suggest a horror film instead. While noir is certainly a genre of violence, it is rarely one of gore. But *Angel Heart* is gory, increasingly so as the narrative progresses. An early image is a blood-splattered wall in a Harlem church, attributed to a suicide that seems to have no relationship to the rest of the plot. The image of the bloody wall recurs, seemingly because it haunts the main character Harry; a mysterious figure in black also keeps appearing at odd moments. We seem to slip in and out of Harry's mental spaces at intervals throughout the film and it is occasionally unclear whether we are seeing dream or reality.

And the rich man funding the investigation has the suspicious name 'Louis Cyphre' (Robert de Niro). If a viewer catches the pun on 'Lucifer', the question becomes: Is he literally the Devil, or is he simply using this name for some reason? Are the film's satanic allusions just allusions or are they to be taken literally? They manifest in the film's mise en scène: pentagrams appear regularly, and the film keeps returning to images of ventilation fans photographed to resemble pentagrams and swastikas. The generic confusion amplifies once the narrative moves to New Orleans. We witness an intense voodoo rite and an explicit sex scene between Harry and Epiphany, where blood leaks from the walls – real, or imaginary? The murders grow more gruesome and bizarre: a heart is removed from a body, one character is killed by being castrated and his penis shoved down his throat, and finally Epiphany is killed with a gun fired into her vagina.

The film's final twist is clearly supernatural in nature, and seems to push the film more clearly into the terrain of the horror genre. In the end, it is revealed that Johnny Favorite sold his soul to the Devil and later tried to use black magic to renege on the deal. He used a ritual, glimpsed in a few harrowing flashbacks, to sacrifice a random soldier and switch souls with him. That soldier was Harry Angel. Harry has been unwittingly looking for himself, and has also unwittingly committed incest. Louis Cyphre is the Devil himself, manipulating Harry's movements in order to retrieve the purloined soul (Harry has also been committing all the murders himself in a dissociated state, including that of his own daughter/lover). We will return to *Angel Heart* later, but observe for the moment that it poses an interesting case of a film that seems to not just permit but *demand* multiple generic identifications at once.

Defining genre, defining horror

As we have already seen, it has often been unclear at many points in history what is and is not a horror film. The label is often retrospectively applied to films that were not considered horror at the time, and conversely, some films understood by a contemporary audience as horror can lose that label. In the 1960s and 1970s, the first film genre subjected to substantial academic attention was the Western, but horror followed quickly behind. Important questions include: Have there always been horror films? *Must* there always be horror films? Who gets to decide if a given film is a horror film or not: filmmakers? Studios? Critics? The general audience? Fans? Is horror defined affectively, and if so, how do we distinguish 'a film that produces horror' from 'a horror film'? How does the generic category 'horror' relate to other categories like national cinema and authorship? How do we conceptualize horror's relationship to other genres (does thinking of a film as a horror film preclude thinking of it in terms of other genres)? And which horror films are most worthy of analysis?

It may be useful to take a step back and ask something basic: 'What is genre?' When flicking through TV channels, it often does not take more than a few seconds to recognize the genre of a television show or movie ... but how? Genres provide classifications to a diverse set of texts based around their similarities. These similarities can be formal/aesthetic, thematic, stylistic and so on. But different genres seem to be characterized in radically different ways: by presumed audience (signalled through terms like 'children's film', 'women's picture', 'family film', etc.), by setting (the Western, the war film, the jungle movie, etc.), by presumed emotional or affective reaction (thriller, 'weepie' melodrama, 'gross out' comedy, erotic film), by a certain tonal approach to the material (drama, comedy) and so on. Every genre has come about differently and seems to have slightly different (and shifting) parameters. So what can we reliably say about all genre films, all of the time?

As defined by Barry Keith Grant, genre films are 'those commercial feature films which, through repetition and variation, tell familiar stories with familiar characters in familiar situations'. Genre cinema, says Grant, is created by 'an industrial model based on mass

production' (1986, ix). Understood commercially/industrially, genres are categories that supply both producers and audiences with a set of expectations that a given film can either fulfil or (more rarely) depart from. Genres make individual texts comprehensible by referring to cultural shorthands that most audiences will grasp. By now, a great many people who have never watched a Western, a musical or a romantic comedy could likely give an account of what they would expect to see in such a film, because their conventions have reached a level of cultural osmosis.

However, the relationship of an individual genre film to the genre to which it is understood as belonging is often hard to articulate. The conventional category called 'the horror film' is logically an aggregate of the films within it, yet they often relate to the over-category in different and contradictory ways. So if one is studying the horror film, what films should one include and exclude – and doesn't a different set of choices subtly, or even dramatically, reshape our understanding of the genre itself? J. P. Telotte refers to this problem as

> the empiricist dilemma ... which poses the question of how we can ever determine what characteristics typify a genre without first determining what texts constitute the genre, even though that very decision about textual inclusiveness would logically seem to hinge upon prior decisions about the genre's identity or definition. (2001, 8)

This dilemma becomes less of a problem if you accept that, as Andrew Tudor writes, 'genre is what we collectively believe it to be' (1973, 139). It is true that genres are basically categories of consensus that exist only because we agree that they do. There cannot be a secret genre that we don't know about, but there probably are films and other texts right now that posterity will regard as belonging to a genre for which we do not yet have a name. And yet, this 'collective' understanding of genre does not always let us interrogate how and why this consensus exists.

Perhaps the central word for the study of genre is 'convention'. Genres are, by nature, conventional, and it is their conventions – formal, narrative, in terms of character types, and so on – that come together to define them. Conventions are more 'typical' of a genre

than they are 'vital'. For example, a saloon is a stock location in a Western, but it is easy to think of Westerns without them ... they clearly do not cease to be a Western as a consequence. Likewise, an old, dark house is a location in many horror films, but few would insist that a film *must* have one to quality for the 'horror' label. Likewise, a single convention may exist in multiple genres, but have different significance in each. In a melodrama, a single gun could wait patiently to be fired once in the climax, while a gun in a Western, action film or a war film is apt to be fired many times. Conventions are given meaning only by their adjacency to other conventions.

Genres involve the managing and fulfilment of audience expectations, but need to provide variations within those expectations (and potentially even carefully violate them on occasion) in order to avoid losing its audience due to stasis. They also frequently have to change with the times in order to stay current; for example, a Western of today ought not to present Native Americans as a faceless horde in the manner of *Stagecoach* because of an increased level of consciousness about the historical injustices against the indigenous peoples of the Americas. The mechanisms of genre evolution have been explained in a number of ways; Thomas Schatz influentially described 'patterns of increasing self-consciousness' in a four-stage process: experimental (not yet aware of itself as a genre), classical (an equilibrium is achieved, with conventions understood by audiences and filmmakers alike), refinement (increased stylistic experimentation and reflection on the genre's ideological underpinnings) and baroque (the embellishments of the refinement phase have accelerated to the point of being the substance of the work) (37–8). This formulation is useful to a point especially insofar as it foregrounds the fact that genres are simultaneously consistent and adaptable, but is hampered by a sense of predetermination, the seemingly preordained march from 'the not-yet-classical towards the no-longer-classical' (Walton 2009, 96). It also tends to encourage a rather selective reading of genre history, wherein films that support this narrative of increasing self-consciousness are canonized and other films are discarded.

Rick Altman's influential semantic/syntactic approach to film genres (1984) provides a useful vocabulary for discussing genre conventions. Borrowing language from linguistics, he proposes a distinction between semantic genre elements (the equivalent

of words or phonemes) and syntactic elements (the equivalent of grammar). Semantic elements can include stock character types, conventional settings, props and even familiar musical cues. Syntactic elements are structural and include things like character relationships and formula plots. By analogy, semantic elements are the building blocks and syntactic elements are what they come together to build. It is principally in the syntactic that cultural meaning can be located (however temporarily). So one could approach the Western through semantic elements (white-hatted cowboys, plains, saloons, black-hatted bad guys, etc.) or through syntactic elements (a stranger rides into town, a narrative builds to a shootout, etc.), but a robust account of a genre must take account of both.

But what is relatively easy to explain using the Western becomes somewhat harder to apply to the horror film and its diverse variations. What exactly holds together silent horror, Universal or Hammer's cycles, quiet horror, *giallo*, the slasher film, costume horror, J-horror, torture porn and found footage horror (etc., etc., etc.)? Some scholars have produced formulae that purport to allow us to identify horror films. Probably the most influential was Robin Wood, who in 1979 proposed a 'basic formula' for the horror film: 'Normality is threatened by the Monster' (14). Wood defines 'normality' as 'conformity to dominant social norms' that are often embodied in horror films by monogamous heterosexual couples and social institutions like the police, military and church. Wood notes that the Monster is defined generally enough to cover the range of 'a vampire, a giant gorilla, an extraterrestrial invader, an amorphous gooey mass, or a child possessed by the devil' (ibid.). As we shall see in the next chapter, Wood approaches the horror film from a radical perspective, premising his analysis on the confluence of Freud and Marx that characterized much of 1970s film theory.

Under Wood's definition, is *Angel Heart* a horror film? The film focuses on marginal social figures and non-standard sexuality, so 'normality' is depicted largely in its absence. Perhaps it qualifies through its depiction of religion; there is a commentary inherent in the fact that Cyphre seems comfortable in churches and at one point even admonishes Harry for using profanity in one. If we can understand the Devil as a monster, which seems something of a stretch, Cyphre does not seem to threaten normality but ironically

reinforces it. Or maybe Harry is the monster here, supernaturally carrying another man's soul and committing intolerable crimes like murder and incest due to the Devil's manipulations. However, neither he nor we realize this monstrosity until the end, rather like in H. P. Lovecraft's story 'The Outsider' (1926) (and in both cases, the revelation of the intolerable truth is connected with a mirror).

Noël Carroll, on the other hand, suggests a rather different formula, not for the horror genre per se, but for the condition of being 'art-horrified' (that is, horrified by something in art as opposed to reality):

I am occurrently art-horrified by monster X, say Dracula, if and only if 1) I am in some state of abnormal, physically felt agitation ... which 2) has been *caused* by a) the thought: that Dracula is a possible being; and by the evaluation thoughts that b) said Dracula has the property of being physically (and perhaps morally and socially) threatening in the ways portrayed in the fiction and that c) said Dracula has the property of being impure, where 3) such thoughts are usually accompanied by the desire to avoid the touch of things like Dracula. (1990, 27)

Carroll clarifies that the monster can be 'impure' in a variety of ways, inclusive enough to admit a psychopathic but non-supernatural human like Norman Bates (Anthony Perkins) or Hannibal Lecter, or a real but implausibly motivated animal like the shark in *Jaws* (ibid., 37). However, these examples are inevitably demoted to a marginal position, a fact that has inspired much criticism (Smuts 2014, 6). We will discuss Carroll's cognitivist approach to horror more in the next chapter. *Angel Heart* would strain to fit under Carroll's definition, not the least because the agitation that a viewer of this film might experience would less involve the depiction of monsters (neither Louis Cyphre nor Harry Angel seems quite 'impure' in the sense Carroll intends) and more the entire unwholesome universe of the film.

Wood's account, to use Altman's terminology, is more syntactic, since it depends on a broadly defined and infinitely adaptable set of relationships, whereas Carroll's is more semantic, describing the characteristics that a monster must possess. Yet for all their differences, Wood and Carroll agree on something fundamental: the presence of the monster as a definitional feature of a horror film. But

is this necessarily so? A film with a monster in it is not necessarily a horror film: monsters appear in fantasy and science fiction films with equal, perhaps even greater frequency (indeed, the Obscurus in *Fantastic Beasts and Where to Find Them* (2016) is almost a model case of Robin Wood's 'return of the repressed', discussed in the next chapter). And while a range of monsters appear in horror films (vampires, werewolves, demons, giant or otherwise altered animals, possessed people, aliens, etc.), it does not quite follow that all horror films contain monsters: ghost movies strain to be considered monster movies, for example, and the monstrosity of disturbed but biologically normal humans, despite Carroll's attempted justifications, is a bit of a stretch too. As Mark Jancovich notes, 'If there is any feature which all horror texts share, it is probably the position of the victim – the figure under threat' (1992, 118).

This attempt to uncover a 'factor X', a sine qua non characteristic of a given genre, once typical of genre study, has diminished over time. Brigid Cherry (2009) has suggested that we break from the impulse to think of horror as a single, relatively coherent genre, but rather reconceive it as 'an overlapping and evolving set of "conceptual categories" that are in a constant state of flux' (2). She proposes that these categories can include subgenres, often involving a certain monster (vampire, werewolf, demon, etc.), cycles, generic hybrids as well as styles associated with particular studios, filmmakers or national traditions (2–3). Some of these categories may have relatively little resemblance to others. Cherry's approach has much value, and certainly scholarship has increasingly focused on individual sub-types of horror rather than the baggy and perhaps over-inclusive label 'horror film'. And yet, Cherry's proposal still occurs in the context of a book entitled *Horror*; there remains a need on the part of academia, the film industry and the viewing public alike to theorize the master category, however ill-defined, shifting and debatable it may be.

Cores and margins

Another way to approach genres and their relationships to each other is through a core/periphery model. Under this approach, certain works are designated 'more "central" members of the category',

'that creat[e] a prototype effect' (Bordwell 1989, 148). Such a procedure, as Tom Ryall notes, can explain the diversity of a genre and the potential intersection of multiple genres. For instance, *Seven Brides for Seven Brothers* (1954) is both a Western and a musical, but may seem closer to the 'core' of the musical genre than the Western (1998, 355), despite the fact that its frontier setting, more than simply being ornamental, motivates its narrative. The core/periphery model rather resembles the strategy for defining the fantasy genre proposed by Brian Attebery in *The Strategies of Fantasy* (1992). Attebery suggests that fantasy is a 'fuzzy set', defined less by its boundaries than by its centre. The centre, he proposes, is Tolkien's *The Lord of the Rings* (1954–5): 'Tolkien's form of fantasy, for readers in English, is our mental template, and will be until someone else achieves equal recognition with an alternative conception. One way to characterise the genre of fantasy is a set of texts that in some way or other resemble *The Lord of the Rings*' (14). This is not to say that *The Lord of the Rings* is necessarily the greatest work of fantasy, and it clearly is not the first; it is simply, for now, the most typical, the agreed-upon cultural touchstone where fantasy is concerned.

However, it is less clear what work should occupy the central position for the horror genre. In 2004, *BBC News* carried a short item on a mathematical formula that 'scientists' had recently derived for the scariness of horror films. That this project was commissioned by the TV channel Sky One 'to launch a season of scary movies' suggests that it was not fully scientific in nature, but let us take it seriously for a moment. The formula provided was mapped as '(es + u + cs + t) squared + s + (tl + f)/2 + (a + dr + fs)/n + sin x − 1'. That is, '(escalating music + the unknown + chase scenes + sense of being trapped) squared + shock + (true life + fantasy)/2 + (character is alone + in the dark + film setting)/number of characters + blood and guts x − stereotypes'. The article does not make clear how one assigns a numerical value to 'character is alone' or 'escalating music', or at just how stereotypical a stereotype needs to be counted as a demerit. Nor does it explain just what criteria one uses to identify a horror film to begin with (that 'empiricist dilemma' again). Nonetheless, the fact that it borrows from mathematics suggests an attempt to provide at least the appearance of a clear and logical basis for defining and quantifying horror. And its determination of the scariest horror film is *The Shining*.

The Sky One study seems to suggest that we can think of *The Shining* as occupying the same position within the horror genre that *The Lord of the Rings* has for fantasy. At first glance, this makes a certain amount of sense. A film might depart from *The Shining*'s characteristics and still be horror. It just scores lower on this formula. And *The Shining* has plenty of agreed-upon horror staples: a remote location, a chase, strange powers, violent deaths, blurring of dream and reality, an endangered child and so on. But the downsides of this approach are apparent: if one decides to dethrone *The Shining* and replace it with another film, then one would be faced with needing an entirely different formula. Plug in *Halloween* and maybe the remote location becomes less vital and the presence of the Cassandra-like expert starts to look like a definitive characteristic. Put *The Exorcist* or *The Fly* in the centre and maybe radical bodily metamorphosis becomes a key characteristic. Make it *Carrie*, and perhaps social ostracism and the sympathetic monster become central themes. Furthermore, even when consensus could exist on a core work, the nature of the periphery is deliberately vague – just how far does a work have to depart from *The Lord of the Rings*, for example, and in what ways, before it is no longer considered fantasy? And like the empiricist dilemma discussed above, it gives you little space to discuss just *how* and *why* a work came to be the genre's core. An additional problem with the core–periphery model is that what starts as a useful descriptive account of what a genre has traditionally contained can easily degenerate into a contest over 'purity'.

Boundaries and genre hybridity

Compounding the confusions about genre mixing is the fact that genres are significantly less separate than they first appear. Rick Altman notes,

> In the past, genre labels have primarily served critics who preferred strong genres and clear-cut distinctions ... It's as if they were saying: 'If you agree, when we use the term "Western" we'll pledge blindness to the presence of action, adventure, comedy, disasters, drama, gangsterism, melodrama, music, newspapers,

or anything else that might point to another genre. Once the "Western" button is pushed, we agree to disengage all other generic buttons.' (1999, 141)

According to Altman, while critics have tended to prefer clear-cut generic labels, the film industry has tended in the opposite direction. From the perspective of the film studios, any film having multiple genres is desirable insofar as it can be sold several different ways to several different audiences. *Titanic* (1997) is an excellent case in point: a disaster movie that is also a historical romance, it successfully attracted viewers from a variety of different demographics and became a cultural event that seemingly no one, male or female, old or young, could possibly ignore.

To return to Robin Wood's work on defining the horror film, he claims that 'the possibility of extension to other genres' is a strength of his basic formula: 'substitute for "Monster" the term "Indians" … and one has a formula for a large number of classical Westerns' (14). Wood simultaneously tries to separate off horror as a genre with features specific and unique to itself and to suggest that it has qualities that connect it to other genres. There are manifest crossovers between the Western and horror, like *Jesse James Meets Frankenstein's Daughter* (1966), *Billy the Kid vs. Dracula* (1966), *Near Dark* (1987), *Ghost Town* (1988), *From Dusk Till Dawn* (1996) and *Bone Tomahawk* (2015). However, Wood would suggest that the two genres have more basic homology in the relationship they present between civilization and its threatening (yet also fascinating) Other. Indeed, Wood locates affinities with horror in classic Westerns like *The Searchers* (1956) and *Man of the West* (1953) through themes of duality and the mirroring of civilization and savagery (ibid.). Clint Eastwood's *High Plains Drifter* (1973) is an example of a film that is clearly a Western semantically yet operates on horror-aligned syntaxes like disturbed burial and vengeance from beyond the grave. It hints that Eastwood's nameless character is not just the preternaturally talented gunslinger familiar from his films with Sergio Leone, but a ghost or devil.

An exemplary Western–horror hybrid is John Carpenter's *Assault on Precinct 13*. Carpenter loved Westerns and always wanted to make them – in fact, he earlier wrote, scored and edited the Oscar-winning

short *The Resurrection of Broncho Billy* (1970), about a Western-obsessed young man living in the present day. *Assault on Precinct 13* borrows syntaxes from Westerns, especially Howard Hawks's *Rio Bravo* (1959), for a story about a police precinct in Los Angeles under siege by a gang. In post-frontier America, it finds a new space of isolation and danger in the desolation of the inner city. And yet *Assault* also draws on the horror film in the construction of the gang: a silent, largely undifferentiated horde of singularly motivated and merciless monsters, owing as much to Romero's living dead as to the rampaging 'Indians' of a classical Western, and illustrating points of contact between these genres (the Reavers in Joss Whedon's *Serenity* (2005) function similarly). Authorship plays a role too: if Carpenter did not become a director principally associated with horror and science fiction – if his next film had not been *Halloween* but *Blood River*, the screenplay he wrote for John Wayne (later filmed as a 1991 TV movie starring Wilford Brimley) – we might be more inclined to discount *Assault*'s horror elements.

So with what other genres does horror mix? The list of horror's generic crossovers is extensive. There is action horror (*Van Helsing* (2004), the *Underworld* films (2003–2017), the *Blade* trilogy (1998–2004)) and the horror musical (*The Rocky Horror Picture Show* (1975), *Phantom of the Opera* (2004), *Repo! The Genetic Opera* (2008)). Romance provides an interesting case; the phrase 'romantic horror' makes one think of *Bram Stoker's Dracula* or perhaps even the *Twilight* franchise, both films that have had their status as horror challenged due to audience preconceptions (see Chapter 6). But a great many classical horror films have romantic subplots. They are often weak and seemingly superfluous (except in films like *Mad Love* or *The Raven* (1935), where an impossible love motivates the villain), but are still next to obligatory.[1] *Doctor X* and *Mystery of the Wax Museum* are both hybrids of horror and the newspaper comedy common in the 1930s; the closing moments of both feature successful marriage proposals, coming more or less out of the blue.

[1] Compare Neale's observation that in the classical era 'nearly all Hollywood's films were hybrids insofar as they tended to combine one type of generic plot, a romance plot, with others' (1990, 57).

Similarly, *The Brute Man* ends with the implication of a romance between two characters that have not met till that scene. Nor is romance foreign to post-classical horror; few would argue that, for instance, Cronenberg's *The Fly* is 'debased' by the centrality of the tragic romance of Seth Brundle (Jeff Goldblum) and Veronica Quaife (Geena Davis).

Horror has undeniably also treaded on erotica and pornography at least as far back as the sadomasochistic nude scenes of films like Christensen's *Häxan* and Esper's *Maniac*. One thinks too of the salacious Hammer films of the 1970s, the notorious lesbian sex scene in *The Hunger* (1983), the nudity throughout the films of Jean Rollin, the topless scenes commonplace in the first slasher cycle or later exploitation items like *Cheerleader Massacre* (2003) and *Zombie Strippers* (2008), among many other examples. On the reverse side, pornographic films have been borrowing from horror images and themes at least since the stag film *Nude in Dracula's Castle* (1950). Dracula alone has given rise to *Dracula (The Dirty Old Man)* (1970), *Suckula* (1973), *Dragula* (1973), *Sexcula* (1974), *Spermula* (1976), *Dracula Sucks* (1978), *Ejacula* (1992), *Gayracula* (1983), *Dracula Exotica* (1980) and *Emmanuelle vs. Dracula* (2004). There have been parodies like *Dr. Jeckel and Ms. Hide* (1993), *The Bare Wench Project* (2000), *Porn of the Dead* (2006), *The Texas Vibrator Massacre* (2008) and *A Wet Dream on Elm Street* (2011); 2011 saw two different pornographic remakes of *Halloween*: *Halloween XXX Porn Parody* (by Smash Pictures) and *Official Halloween Parody* (by Zero Tolerance). These spoofs work much like mainstream genre mixing in attempting to appeal to multiple audiences simultaneously. There are also interesting links between 1970s horror and the 'porno chic' period, including shared personnel like Herschell Gordon Lewis, Wes Craven and Sean S. Cunningham, and the cycle of 1970s hardcore horror films like *Widow Blue* (1970), *Zodiac Rapist* (1971), *Come Deadly* (1974) and *Wet Wilderness* (1976) may not be that far removed from comparatively mainstream items like *Maniac* (1980) or *The Last House on the Left*. It is perhaps telling that when performers known from pornography, both soft and hard, cross over to 'mainstream' film acting, it is often in horror (Frank Lincoln in *The Last House on the Left*, the Collinson sisters in *Twins of Evil*, Marilyn Chambers in *Rabid*, Barbi Benton in *X-Ray* (1981), Traci Lords in *Not of This Earth* (1988),

Sasha Gray in *Smash Cut* (2009), *Would You Rather* (2012), etc.).[2] Linda Williams's influential exploration of the triadic relationship of horror, melodrama and pornography will be discussed in Chapter 5.

It is tempting to say that horror's boundaries have historically been closest to science fiction and fantasy, though such an assertion overstates the historical stability of all three of these genres. The very term 'science fiction', for instance, only became widespread in the 1930s, right around the same time as 'horror'. Science run amok is a staple of both genres, and both have come to claim Mary Shelley's *Frankenstein*, as well as Robert Louis Stevenson's *The Strange Case of Dr. Jekyll and Mr. Hyde* and H. G. Wells's *The Invisible Man* (1897) and *The Island of Dr. Moreau*, as seminal texts. In film, *Metropolis*, made before the line between science fiction and horror was clear, contributed substantially to the developing conventions of both genres. There is a significant overlap between the genres, to the degree that in 1967 Carlos Clarens thought it natural to discuss them together, and some horror fans trace their interest in the genre to science fiction programmes like *Doctor Who* (1963–) (Cherry 1999, 105–6). However, we would tend to agree that *Interview with the Vampire* is not science fiction and that *Interstellar* (2014) is not horror, even if plenty of films can be described as having qualities of both genres. So what precisely is the difference?

Vivian Sobchack notes the close relationship of these genres and argues that their difference comes down to an emphasis: 'The horror film is primarily concerned with the individual in conflict with society or with some extension of himself, the SF film with society and its institutions in conflict with each other or with some alien other' (2004b, 29–30). She goes on to suggest that both genres involve chaos, but in horror it stems from disruptions to moral order where science fiction highlights disruptions to the social order (30). Nonetheless, Sobchack admits that individual films often stymie these distinctions, especially the alien invasion and 'creature feature' films of the 1950s and thereafter. Sobchack also suggests a difference in emotion and attitude between the two genres, with horror as passionate and science fiction as dispassionate: 'Terror is replaced

[2] For a discussion of the cases of Chambers and Gray, see Moreland (2015).

by wonder' (38). Later she asserts that 'the horror film evokes fear, the SF film interest' (43).

Under this definition, it seems possible to claim films like *Village of the Damned* (1960), *Alien* (1979),[3] *Invasion of the Body Snatchers* or *Event Horizon* (1997) for horror, despite their science fiction elements (spaceships, aliens, etc.). Though we tend not to think of it as horror film, *Star Trek: First Contact* (1996) makes for an evener mix under Sobchack's terms. It develops the Borg along horror lines reminiscent of the *Alien* films or even *Tetsuo* (1989) and transforms the USS *Enterprise* into a horrific landscape; further, Alice Krige's Borg Queen echoes her performance as another inhuman seductress, Anna Mobray in *Ghost Story* (1981). Meanwhile, the planetside plotline is drawn along more typical science fiction lines, with the wonder and new optimism experienced by Zefram Cochrane (James Cromwell) cuing the audience's matching reaction. Yet the almost Cartesian distinction drawn by Sobchack has implications in terms of class and taste, reinforcing the narrative of science fiction being an elevated, cerebral genre of the mind and horror being a visceral, low genre of the body (Bould 2014, 156). Categories of cultural taste often seem to underwrite generic distinctions; this is perhaps most obviously the case in the divide between science fiction and fantasy (Suvin 1972).

Though the label 'dark fantasy' is predominantly a literary one, fantasy film also proves coterminous with horror in a number of ways. Georges Méliès's films in particular testify to these genres' shared heritage, and the work of contemporary auteurs like Guillermo del Toro and Tim Burton may be best located along their boundaries. Peter Jackson's *The Lord of the Rings* films (2001–2003) are full of echoes of the cheerfully gruesome horror films from his early career (the Army of the Dead bear a striking resemblance to the ghosts in *The Frighteners* (1996)) and Jackson is often at his best, as with Nazgûl, Shelob, Gothmog and other monstrous figures, when drawing upon horror imagery. Sam Raimi's *Army of Darkness* more obviously transports splatter-horror conventions into high fantasy's stock quasi-medieval setting. More recently, *Dracula Untold* (2014) situates its

[3]See Jancovich (2000) for a discussion of the debates over *Alien* as a horror or science fiction film (27).

loose interpretation of the historical Vlad the Impaler within not only or even principally the conventions of the vampire film, but rather those of action-driven fantasy; *Game of Thrones* (2011–) alumni Art Parkinson and Charles Dance seem to have been cast to borrow some of that program's cultural respectability as well.

Somewhat less examined is the overlap between horror and detective fiction.[4] Historically, both genres trace back in literature to Edgar Allan Poe, and as we have seen, the classical horror film and film noir were deeply enmeshed as inheritors of German expressionist personnel and stylistics. Let us return to the example of *Angel Heart*. To what genre does it belong? It follows the plot structure of a detective film based around the investigation of a past crime and the eventual disclosure of the criminal's identity, albeit this time with a supernatural twist and a general lack of the catharsis we find in detective stories as the culprit is found out and punished. In a classical sense, it is a tragedy of sorts, borrowing heavily from Sophocles's *Oedipus Rex*, the classic tale of a man unwittingly investigating himself (Cyphre even quotes the blind seer Tiresias: 'How terrible is wisdom if it brings no profit to the wise'); *Oedipus Rex* has also been regarded as an ur-detective work (Scaggs 2005, 9–14). The film's major twist depends on a set of narratorial conventions from the detective genre being observed and then subverted. Detective films depend on the close management of viewer information, and generally the audience learns new facts as the detective does, its perspective closely allied to his/hers (mostly his); it is thus surprising to learn of Harry's faulty perspective, that he was up to things that eluded his/our notice. *Angel Heart* makes unequivocal its horror elements, and dips into stock horror imagery to do so: Cyphre's eyes even turn yellow and inhuman at one point during his final confrontation with Harry/Johnny.

The image of a descending elevator recurs in seemingly non-diegetic intercuts through the latter portions of *Angel Heart*, and speaks to its generic hybridity. It echoes the ending of *The Maltese Falcon* (1941), in which Brigitte O'Shaughnessy (Mary Astor) is taken away from her crimes. The bars of the elevator cast a shadow over her

[4]See Magistrale and Polger (1999), Meehan (2011) and Leeder (2012).

FIGURE 4.1 *Louis Cyphre (Robert de Niro) reveals his Devilish true nature in* Angel Heart *(1987).*

face, visualizing her status as a prisoner, and the elevator descends, an image of fate and damnation. But where the infernal descent in *The Maltese Falcon* is figurative, *Angel Heart* underscores its literalism with the film's final exchange: 'You'll burn for this.' 'I know. In Hell.'

Further, the film's very last scene does something odd that suggests a generic shift of a different sort. Epiphany has a young son and claims she was impregnated by the gods during a voodoo ritual: 'It was the best fuck I ever had.' But is it possible that the father was actually the Devil? In the final scene, where Harry turns himself in to the police for the murder of Epiphany, the boy is brought in by two detectives and seems completely unresponsive to the presence of his mother's corpse. He looks at Harry confrontationally with the same yellow eyes we previously saw on Cyphre. Could it allude to the line 'He has his father's eyes' in *Rosemary's Baby*? Is the boy the Antichrist? Is there a barely-alluded-to apocalyptic plot transpiring in *Angel Heart*'s margins, relatively removed from the saga of Johnny Favorite and Harry Angel? This revelation, however fleetingly, places the film firmly within the generic syntaxes of the horror film.

The original trailer suggests that the film was sold as much as anything on its generic hybridity. A deep voiced narrator intones: '*The Exorcist*: the possession of the human soul. *Chinatown* [1974]: the mystery of the human mind. And now ...' The film was sold not only

FIGURE 4.2 *A mysterious closing image from* Angel Heart *(1987).*

as successor to both of those famous films, but as a merger of their sensibilities. In the trailer that follows, the noise of a beating heart comes in and out over a series of clips that emphasize violence and mystery, but also imply supernatural horror. The final voiceover, 'Harry Angel has been hired to search for the truth. Pray he doesn't find it,' alludes to 'Pray for Rosemary's baby,' the tagline for *Rosemary's Baby*. Snatches of dialogue include lines like, 'The Prince of Darkness protects the powerful,' 'The flesh is weak. Only the soul is immortal,' and even the already-quoted 'Burn in hell' exchange. The film was clearly sold as much as anything on its hybridity. I would argue that *Angel Heart* is both a film noir–style detective film and a horror film, existing in a clear field of reference with both, and indeed works to illustrate the commensurability of these two genres.

Horror (and) comedy

On 3 November 1996, Roger Ebert's 'Movie Answer Man' column contained this letter from Rob Wolejsza of Astoria, New York:

> Recently, I attended a screening of *The Exorcist* at Radio City Music Hall. Although I enjoyed the film, I noticed that the intensity

seemed to be lacking, thanks to the audience, which laughed and applauded at the most inopportune moments (i.e., the vomit scene and during the climactic exorcism itself). They even managed to giggle when x-rays of Regan's brain flashed on the screen! Admittedly, there were a few lighter moments, but it seemed as though every ten minutes something tickled the audience. *The Exorcist* is not your run-of-the-mill horror flick; it borders on the spiritual at times and is hardly worthy of snickering. (n.p.)

This letter is interesting in that it positions laughter as the disrespectful response of an audience facing a transcendent work ('not your run-of-the-mill horror flick'). The letter goes on to place the blame on *Pulp Fiction* (1994) and *Trainspotting* (1996) for 'using violence and shock for humour', resulting in a dumbed-down slate of filmgoers who 'can't differentiate serious chills from purposely outrageous situations'. The rhetoric here constructs *The Exorcist* as some sort of 'pure horror' to which laughter is more or less anathema, and if any viewer receives it otherwise, that is because he or she has a problem.

But genres are not pure, and neither are audience reactions. Whatever intellectual distaste we might have towards those filmgoers who are inclined to laugh at *The Exorcist*, we cannot deny the authenticity of their reaction. But why do they laugh? Ebert offers two explanations: '(1) laughter is a common reaction among those too touched or embarrassed to reveal true emotion, and (2) unsophisticated audiences consider any sign that a movie is dated (period dialog, references, clothes) to be a laugh cue' (n.p.). Both explanations construe the laughing audience members as 'bad spectators' whose reactions are illegitimate, symptomatic of their own inadequacies. But need this be the case? Novelist Craig Shaw Gardiner notes that an exquisitely mounted horror scene like the 'bus' sequence in *Cat People* can inspire audience laughter, but that this is the laughter of relief and surprise (94); essentially this is the same as Ebert's first explanation, only less negatively expressed. Many times have I observed my students laughing after being profoundly affected by a horror sequence, especially one from a movie that seems to be too old for them to take seriously (say, *Dead of Night* or *Eyes Without a Face*), perhaps as a strategy to regain subjectivity endangered by the film's shocks. In particular, I recall a screening of *The Exorcist* where

certain viewers laughed uncontrollably at the crucifix masturbation scene, but it was clearly not derisive laughter, but a reaction to the scene's audacity (all the more impactful when found in such an 'old' film). Perhaps the same was true of *The Exorcist*'s audience at Radio City Music Hall. Or maybe this was a cinephile audience laughing at the arrival of favourite moments. Or maybe these viewers were only familiar with parodies of *The Exorcist*, present in works as far-flung as *Beetlejuice* (1988), *Look Who's Talking* (1989), *Repossessed* (1990) and *Toy Story* (1995), and inevitably filtering the original through those works.

I close this discussion of horror and its relationship to other genres with comedy because it seems to be the genre that horror is most afraid of. Or, more precisely, *criticism* on horror has often been distinctly phobic towards comedy. Rather like Wolejsza's policing of audience reactions, comedy in horror – and the generic hybrid 'horror comedy' – has either been ignored or outright rejected, sometimes in terms verging on contempt. In his Altman-influenced study of the vampire film, Tim Kane excludes all discussion of vampire comedies on this basis that 'the lead character ... must be softened and made sympathetic in order for the comedy to work. This bypasses much of the syntax built into the genre, replacing it with a parody of the vampire syntax or borrowed syntax from the genre of comedy' (13). The implication, then, is that a comedy's vampire ('softened', defanged) is less of a vampire and that a vampire comedy is less of a vampire film. In *A New History of Horror*, David Pirie revised his earlier assertion that *The Abominable Dr. Phibes* (1971) was 'the worst horror film made in England since 1945' on the basis that 'it is not really in any sense a horror movie at all' (165) ... that its high camp tone excludes it and similar films from the genre altogether. Asserts Pirie, 'There is little point in bracketing these films as with the horror genre at all. When the tone swings as far into comedy as this, they are something else' (166). He insists that 'seriousness' in the overall story and the delivery of thrills confirm a film's status within the horror genre and that the inclusion of comedy endangers it.

One is reminded of Altman's observation that critics prefer generic purity that is often not rewarded by an examination of genre films themselves. But it is also noteworthy that nothing, no kind of genre mixing, seems to threaten the 'purity' of horror like comedy. Some

horror is deadly serious, certainly, but just as many horror films have been calculated to evoke laughter alongside chills and screams. We have already discussed the importance of *The Cat and the Canary* and the serio-comedic 'old, dark house' tradition, and probably the most beloved Universal classic, *Bride of Frankenstein*, holds that status in part because of its tongue-in-cheek tone. Even the 1931 *Dracula*, largely dour and serious, contains a few brief moments of comic relief, courtesy (tellingly enough) of its few working class characters. And as we have seen, *Boo!* not only poked fun at the emerging conventions of horror films, but also may have played a role in cementing them in the public's mind; likewise the play (1939) and film (1944) *Arsenic and Old Lace* are dark comedies with the plot point of a gangster being accidentally surgically altered to look like Frankenstein's monster (on the stage, Karloff played the part). It is also significant that the revival of classic horror in the 1950s was achieved in part thanks to the presence of wisecracking, irreverent horror revue hosts. The 1970s and 1980s saw the emergence of directors like Joe Dante, John Landis, Sam Raimi and Stuart Gordon, many raised on the television revue format, who often mixed horror elements with comedy; Gordon has observed, 'You'll never find an audience that wants to laugh more than a horror audience' (qtd. in Carroll 1999, 146).

Scholarship has also sometimes acknowledged links between horror and comedy. William Paul's book *Laughing Screaming: Modern Hollywood Horror and Comedy* (1994) explores the 'gross out' tradition as a point of contact between horror and comedy, uniting films as seemingly diverse as *Animal House* (1978), *Porky's* (1981), *Fast Times at Ridgemont High* (1982), *The Exorcist, The Shining* and *Poltergeist*. Isabel Cristina Pinedo notes the presence of humour in many horror films, and particularly notes the perverse dinner scene in *The Texas Chain Saw Massacre* as a paradigm of horror and comedy elements complementing each other (48). Matt Hills notes that cognitive theories of horror (see Chapter 5) have a tendency to 'focus on emotions such as fear and disgust – by assuming that horror's sole *raison d'être* is to scare or horrify' that leaves them ill-equipped to discuss 'the importance of comedy within horror texts' (2005, 22).

Clearly the incorporation of comedy into a horror film does not necessarily mean that it forsakes its status as horror. But what about

parodies or spoofs – films that not only incorporate comedy, but actively
strive to produce comedy by poking fun at the genre's conventions?
Perhaps supporting Cherry's understanding horror as a linked family
of sub-categories, horror parodies have generally targeted particular
subgenres, like the vampire film (*Love at First Bite* (1979), *Dracula:
Dead and Loving It* (1994), *Vampires Suck* (2010), *What We Do in
the Shadows* (2014)), slasher film (*Student Bodies* (1981), *Slumber
Party Massacre, Popcorn* (1991), *Scary Movie* (2000)), haunted house
movie (*Scary Movie 2* (2001), *A Haunted House* (2013)), possession
film (*Repossessed*), Frankenstein film (*Young Frankenstein* (1974)),
among others. Some models of genre evolution have identified a
genre's turn to parody with exhaustion: the point at which a genre
can no longer be taken seriously and is fit only for ridicule. This trend
certainly can play out within individual franchises: *A Nightmare on Elm
Street* and *Child's Play* become substantially jokier over time, their
lead monsters transforming from largely silent figures of menace to
wisecracking comedians. However, such a model would have a hard
time taking account of the zombie film, where the overt comedies
(*Shaun of the Dead* (2004), *Zombieland* (2009)) are only marginally
broader than some definitive works like Romero's *Dawn of the Dead*.

Probably the ur-example of a parody apparently terminating
a production cycle is *Abbott and Costello Meet Frankenstein*. It is
tempting to dismiss it as a cynical attempt by Universal to boost
two flagging properties at once, the comedy team of Lou Abbott
and Bud Costello and the monster franchise. Abbott and Costello
tangle with the Wolf Man (Lon Chaney Jr.), Dracula (Béla Lugosi) and
Frankenstein's monster (Glenn Strange) (in each case, the veteran
actors are playing the role for the last time). Yet one can argue that
Abbott and Costello Meet Frankenstein amplifies a comic thread in
the previous *Frankenstein* films, constituting 'a porous continuation
rather than radical departure from its precedents. … Its use of humour
hyperbolises and unleashes tensions that manifest themselves
as mere glimpses in the earlier "straight" horror renditions of the
Frankensteinian narrative' (Picart 2003, 14). On its own terms, the
film is quite successful: the settings are atmospheric, the monsters
are played relatively straight and the slapstick is often hilarious.
Certain sequences, such as when Wilbur (Costello) leaves, re-enters
and again leaves a room, oblivious to the fact that the Wolf Man is

stalking him, carefully exploit resemblances between the staging of horror and comedy in terms of tension and timing.

Yet horror and comedy can also be placed in proximity to each other in a deliberately less commensurable fashion. Takashi Miike's *Audition* plays as a romantic comedy for about half its length. Middle-aged widower Shigeharu Aoyama (Ryo Ishibashi) wants to meet women but lacks confidence. His friend sets up a mock audition process where women think they are trying out for movie roles but actually Aoyama is in search of a wife. He fixates on Asami Yamazaki (Eihi Shiina), a charming if vaguely troubled young woman. While we recognize that Aoyama is acting deceitfully, we expect to eventually be able to forgive his transgressions because we sense that he's basically a decent man. But then the tone of the film changes sharply, as it transpires that because of sexual abuse as a child, Asami is a serial killer for whom violence and love are inseparably linked. The sexism and objectification of women in the first half is thrown into sharp relief with unspeakable violence and brutality as she dismembers and tortures Aoyama. Few would call *Audition* a horror–comedy film, precisely because conventions of the two genres are assembled in such a way that renders them seemingly immiscible.

Sitting elsewhere on this spectrum is *Vamps* (2012). A bit of a *Clueless* (1995) reunion with director Amy Heckerling, actors Alicia Silverstone and Wallace Shawn and numerous behind-the-scenes personnel, its shares a bright, cheerful look and breezy feel with most of Heckerling's films. It tells the story of two vampires, Goody (Silverstone) and Stacy (Krysten Ritter), who abstain from human blood in favour of that of rats, rather like Louis in *Interview with the Vampire*, and who are so gentle that they cannot do violence even when directly compelled to do so. We meet another vampire, Vadim (Justin Kirk), who does prey on humans, but he is a comic foreigner prone to silly malapropisms and never successfully kills anyone thanks to Goody and Stacy's interventions. *Vamps*'s version of Dracula, Vlad Tepish (Malcolm McDowell) – wearing a six-pointed pendant like the one Lugosi wore in *Dracula* – is a genial old Eastern European expat who boasts that he has 'abstained from the blood of *Homo sapiens* for 362 years'. Tepish sublimates his taste for blood into knitting and cooking, and leads an AA-style support group for fellow abstinent vampires. In an early scene, Goody is overcome by bloodlust when a

coke-snorting clubber has a nosebleed and snakes her tongue in one of his nostrils and out the other, a disgusting moment of horror-tinged body comedy, but she restrains herself and it goes no further. One might be inclined to exclude *Vamps* from the horror film altogether, since most of the horror conventions it contains are deliberately twisted into light comedy. In fact, Goody's opening narrative tells us, 'Normally, this would be one of those tales of gore and homicidal urges, but I've always looked on the bright side.'

However, there is another vampire who evokes horror themes more readily. This is Cisserus (Sigourney Weaver), the vampire who made Goody and Stacy. She is a figure of monstrous consumption, whose insatiable appetite for designer clothes is matched by her need for sex and blood. Early in the film she casually murders a pizza guy (Taylor Negron, reprising his role in Heckerling's *Fast Times at Ridgemont High*); the murder is depicted with her shadow descending on him in an homage to *Nosferatu*, followed by a startling cut to a close-up of his severed head. This gruesomeness pales, however, when compared to a later scene when Cisserus, after a rejection by a Spanish pop star deflates her fragile self-image as a master of seduction, kills everyone in a Chinese restaurant. Goody and Stacy find her amid a sea of corpses, wallowing in drunken self-pity with blood on her lips, spouting self-help clichés like, 'Just because you overdid it one day doesn't mean you have to be bad all weekend.' Cisserus remains partially within a comedy idiom even as she shows her true nature as a terrifying and monstrous vampire. The display of violence and gore within this largely bloodless vampire comedy is striking, since this irruption of horror, however momentary, seems alien to *Vamp*'s comic world.

Horror studies would do well not to ignore the relationship between the genres of comedy and horror. It may even be that 'horror comedy' is on its way to being a genre of its own, relatively unpinned from its parent genres, in parallel to the 'romantic comedy', which now exists in the public's mind as a robust set of conventions, rather than necessarily as a hybrid of 'romance' and 'comedy'. In recent years, films like *Jack Brooks: Monster Slayer* (2007), *Tucker and Dale vs. Evil* (2010), *Hell Baby* (2013) and *Krampus* (2015) have all been sold not as horror films with some comedy, nor particularly as horror-themed comedies, but as falling within the recognizable parameters of the horror comedy.

5

Mind and Body:
The 'Why?' of Horror

In a 2003 episode of the *Star Trek* series *Enterprise* ('Horizon'), the Vulcan science officer Sub-Commander T'Pol (Jolene Blalock) reluctantly consents to attending a shipboard screening of the first Universal *Frankenstein* film. Asked about her impressions afterwards, she says, 'I don't understand why humans would feel compelled to frighten themselves.' The closest parallel on Vulcan is a discipline known as *tarul-etek*. But in true Vulcan form, *tarul-etek* is an instrumental practice, using disturbing imagery to test emotional resistance, not entertainment. Perhaps more interesting is the fact that none of the humans around T'Pol can justify the appeal of horror, only offering the stumbling explanation that it 'gets the heart pumping', as if the genre's appeal were wholly physiological in nature.

In October 2016, *Glamour* ran an article by Abigail McCoy about her incredulities concerning the horror genre. Rather like T'Pol, McCoy wonders, 'Why do people want to be scared? What is good about that?', before offering the sweeping claim that 'feeling scared is always, always a negative experience, and I don't think it's even the kind with a silver lining' (n.p.). Her cursory Google research suggests that the release of endorphins by the experience of fear and anxiety may be responsible, but she rejects that explanation and seeks no others. McCoy concludes with, 'Sorry, horror film enthusiasts, but I'm no closer to understanding you. Call me if you want to see something a little more positive at the box office' (n.p.). I doubt many phone calls

will be forthcoming, and it is particularly galling that the article begins with a lack of understanding and ends with a lack of understanding, with only cursory and insincere attempts at empathy in between. However, McCoy's article does help illustrate a significant point: explaining the appeal, the pleasure, of horror has proved difficult for many. So we ask, why? Why does the horror genre exist? What drives viewers to want to see material that scares them, or is it that which brings viewers to the horror genre at all?

Feeding the alligators

Even characters in horror movies reflect on the strangeness of horror movies. The obscure Staten Island-shot slasher film *He Knows You're Alone* (1980) is perhaps most notable for the debut of Tom Hanks. Hanks plays the small role of Elliot, who is neither murdered nor the murderer, but rather the date of a secondary character. His most substantial scene takes place at an amusement park, where, after lamenting the lack of a roller coaster, he offers some thoughts on horror itself. 'Most people do, actually … I mean like to be scared,' he says:

> It's something primal, something basic. Horror movies and the roller coasters and the house of horror ride. … You can face death without any real fear of dying. It's safe. You can leave the movie or get off the ride with a vicarious thrill and feeling that you've just conquered death. One hell of a first class rush.

Elliot expresses an interest in the psychology of fear, wondering why so many people who saw *Psycho* were afraid to shower afterwards. When told that Amy (Caitlin O'Heaney) fears she is being stalked, he asks, 'Is he a big man?' At her affirmative response, he says, 'Definitely sexual.' He also asserts that Amy won't see him while with them: 'The hallucination will only manifest when you're alone.'

Elliot's authority is swiftly undermined when he admits that he's only taken an Intro to Psych class, and he is certainly wrong to dismiss Amy's stalker as a hallucination. But he also provides an internal commentary on the audience's own taste for horror – one

that seems calculated to forgive it, to defend it as psychologically healthy and even necessary. The year after, Stephen King offered a similar explanation for horror's purpose in his non-fiction book *Danse Macabre* (1981):

> The mythic horror movie, like the sick joke, has a dirty job to do. It deliberately appeals to the worst in us. It is morbidity unchained, our most base instincts let free, our nastiest fantasies realised ... and it all happens, fittingly enough, in the dark. ... I like to see the most aggressive of them – *Dawn of the Dead*, for instance – as lifting a trapdoor in the civilised forebrain and throwing a basket of raw meat to the hungry alligators swimming around in that subterranean river beneath. (19)

King's explanation is consistent with the notion that people watch horror films to serve unconscious needs that cannot be satisfied in civilized life. By this logic, horror is inherently conservative, working to secure the continued repression of socially unacceptable impulses.

In another horror film of the early 1980s, *The Entity,* psychiatrist Dr Phil Sneiderman (Ron Silver) finds himself dealing with Carla Moran (Barbara Hershey), a young single mother of three who believes that she is being repeatedly raped and brutalized by an immensely strong, unseen man. Sneiderman is a compassionate physician but is limited by his professional ken. Believing Carla to be suffering from a powerful hallucination, he thinks that they will find an answer in the realm of 'Early psychological development. Emotional development.' When Carla asks what that means, he says: 'Well, the general idea is that certain phases of our life never really die. They continue to exist within us. All of us. You, me, everybody. And they affect us the rest of our lives. For certain reasons, they come back. Sometimes they come back with a vengeance.' Sneiderman, within a horror film, is offering a theorization that applies to the horror film – that it is a consequence of the return of something only partially repressed.

Later, Sneiderman shows Carla a book filled with historical depictions of demons, werewolves and other monsters. These beings did not exist, Sneiderman says, but people saw them anyway.

Why? 'It was a way of expressing something frightening to them.' Sneiderman goes on:

> Let's say a man who wanted to be good had a desire for his neighbour's wife. He knows it's wrong, he feels terrible about it but the desire is growing and growing. Desire can be a frightening and powerful sensation. How does he deal with it? He invents a creature. An evil, ugly, evil-tempered creature, which is just a picture of his own desire.

Compare Freud's assertion that 'the Middle Ages quite consistently ascribed all such maladies [as epilepsy and madness] to the influence of demons, and in this their psychology was almost correct' (243-4) – fighting demons was actually an inchoate form of psychotherapy. Sneiderman's theory is that Carla's attacker is a manifestation of her own psychosis, specifically the sexual repression that Carla suffers from as a consequence of her repressive, authoritarian and possible abusive upbringing and her unacknowledged feelings of desire for her own son. In Sneiderman's assessment, the Entity is, like the creature made out of Dr Morbius's incestuous desires for his daughter in *Forbidden Planet*, a 'monster from the id' (and similarly invisible). However, Sneiderman, like Elliot, is wrong, or at least his explanation is incomplete, since his professional perspective confines him, like so many cinematic psychologists, to non-supernatural explanations in a genre where the supernatural is frequently real.

FIGURE 5.1 *Dr Sneiderman (Ron Silver) psychoanalyses Carla Moran (Barbara Hershey) in* The Entity *(1982).*

As *He Knows You're Alone* and *The Entity* demonstrate, horror is very often tinged with psychoanalysis. German expressionism was saturated in the context of Freud's theories, with the putative Dr Caligari ultimately revealed as a kindly doctor, the film ending hopefully with his declaration that he now understands his patient's mania and how to cure it. Quite in contrast, *Dead of Night* presents its psychiatrist, Dr Van Straaten (Frederick Valt), as a character who disastrously misunderstands the nature of the case before him. At least he is not actively villainous, unlike many of horror's psychiatrists and psychotherapists: Hannibal Lecter, Dr Louis Judd in *Cat People*, Dr Emil Breton (William Finley) in *Sisters*, Dr Hal Raglan (Oliver Reed) in *The Brood* and Dr Robert Elliott (Michael Caine) in *Dressed to Kill* (1980) represent only a few. In *Invasion of the Body Snatchers*, the psychiatrist Dan Kauffman (Larry Gates) attributes the strange events in Santa Mira to 'mass hysteria' and dissuades the main characters from investigating them further; he is not just wrong but a pod person himself, actively spreading disinformation. A semi-exception can be granted for Dr Fred Richmond (Simon Oakland) in *Psycho*, though his role is simply explanatory. Richmond's expertise is beyond question, with Sheriff Chambers (John McIntire) declaring, 'If anybody gets any answers, it'll be the psychiatrist,' and he delivers a lengthy expository lecture on the origins and nature of Norman Bates's pathology. Yet many viewers have been perplexed by that sequence of *Psycho*, since Richmond seems so smug and cold, quite unlike such benevolent psychiatrist types as Dr Luther (Lee J. Cobb) in *The Three Faces of Eve* (1957). The strangeness of his performance seems calculated to undermine the authority of his explanations.

Then there are those psychiatrists who become heroic monster-fighters only by stepping outside of their professional role. One is the troubled Father Damien Karras (Jason Miller) in *The Exorcist*, a Jesuit priest trained as a psychiatrist. He is initially reluctant to perform an exorcism, holding that they haven't been performed since we learnt about 'mental illness, paranoia schizophrenia … all the things they taught me in Harvard'. Only slowly does Karras become convinced that Regan truly is possessed by a demon and that fighting it means rediscovering his faith and tacitly abandoning his psychiatric training.

Perhaps the more obvious example is Dr Sam Loomis (Donald Pleasence) in *Halloween*. He repeatedly identifies himself as Michael Myers's doctor, but has long since abandoned any notion of helping him; instead, Loomis wants only to stop him, with lethal force if necessary. After revealing to Sheriff Brackett (Charles Cyphers) that he carries a concealed gun, Loomis says, 'You must think me a very sinister doctor' – indeed. *Halloween*'s psychiatric contexts are fairly extensive: Carpenter's inspirations include Hervey Cleckley's book *The Mask of Sanity* (1941), which popularized the concept of psychopathy, as well as a visit to a mental ward while he was a student at the University of Western Kentucky. Furthermore, the Oedipal implications of the opening scene are hard to overlook (*Halloween* reworks *Psycho* quite consciously). But in tending towards a paradigmatic, mythical middle-American setting drawn from urban legends, *Halloween* undercuts any attempt at psychological precision. Realizing the uselessness of psychiatry in *Halloween*'s world (or realizing, as Hutchings suggests, 'that he is in a horror film' (2004, 62)), Loomis operates outside or even runs counter to his professional identity, making him less a shrink than a dragonslayer.

It is striking how often psychiatry is undermined in a genre with such heavily psychiatric roots. Yet many have argued that horror's relationship to psychoanalysis goes deeper than content or even influence: that horror is the psychoanalytic genre par excellence, that it is not only amenable to being read through psychoanalysis, but does the work of psychoanalysis in plumbing and potentially purging the deepest and darkest recesses of our unconscious minds. The remainder of this chapter will survey major psychoanalytic theories of horror and the cognitivist and affect-themed counter-theories that emerged later, in part against them.[1]

[1] This chapter cannot cover all psychoanalytic approaches to horror; see Dumas (2014) for a useful overview. The considerable influence of Freud disciple Jacques Lacan on film theory means that most strands of psychoanalytic horror theory have Lacanian influences; see Brottman (2005, 107–38) for an explicitly Lacanian approach to horror. Iaccino (1994) provides a rarer Jungian approach. Studies of horror and national trauma (see Lowenstein (2005), Blake (2008)) generally have a psychoanalytic underpinning as well.

The return of the repressed

Robin Wood's aforementioned essay 'An Introduction to the American Horror Film,' probably the most read and cited work of horror film scholarship, begins by acknowledging the confluence of Marx and Freud around the theme of repression. Distinct from the more overt oppression, repression (surplus repression, to be precise), has a normalizing effect on its subjects, making us '(if it works) into monogamous heterosexual bourgeois patriarchal capitalists' (8). But that which is repressed does not vanish, but grows charged with subterranean power, awaiting its return in a new form. Repression, Wood tells us, is also inseparable from the notion of 'the Other': 'that which bourgeois ideology cannot recognise or accept but must deal with … in one of two ways: either by annihilating it, or by rendering it safe and assimilating it' (9). From these two concepts Wood derives his conception of the monster, a figure of Otherness that represents the return of the repressed. All of those things that our society represses (including female sexuality, the proletariat, other cultures and ethnicities, alternative ideologies, alternate sexual orientations, children) represent possible incarnations of the monster in horror. Wood proposes that the 'true subject of the horror genre is the struggle for recognition of all that our civilization *re*presses or *op*presses: its re-emergence dramatised' (10).

Freud-influenced scholars other than Wood have also approached horror through the return of the repressed (see, for example, Judith Halberstam's reading of *Frankenstein* and of gothic fiction more broadly through repression (esp. 28–52)), but Wood's remains the standard reading. As Matt Hills notes, much of Wood's rhetorical strategy means using psychoanalytic concepts to justify horror as a worthy object of study: 'Repression is used to conceptually elevate the horror genre as a timeless re-enactment of psychological processes, while surplus repression is used to elevate horror to the timely status of a grand cultural-political struggle' (2005, 52).

For Wood, we sympathize with the monster, or at least we should, since it has the powers to overthrow bourgeois society that most of us can only crave. Horror films, for Wood, possess revolutionary potential. *King Kong* is an excellent example. Whatever Kong might

represent, repression (sexual, racial, political/economic, the animal, etc.) is the common denominator. Kong, like Karloff's version of Frankenstein's monster, is a classic sympathetic monster, possessing recognizable emotions and with readily understandable motivations, and generally harmless unless confronted. Kong is huge and strong; he possesses all the powers of repression unleashed, and takes out his anger on the core of civilization, because (so Wood's argument would hold) we unconsciously crave its destruction. He is repeatedly restrained: by the stockade fence on Skull Island, by chains in Manhattan. And he always breaks free. In fact, in the theatre he manages to break his chains with comical ease. It is similar to the moment in *Bride of Frankenstein*, when the monster is imprisoned in the town jail and breaks out even as his jailer is assuring the townsfolk that the situation is now safe; in both cases, audiences are apt to sympathize with the monster breaking free of its literal chains, perhaps because we wish to break through the invisible ideological chains that shackle us all.

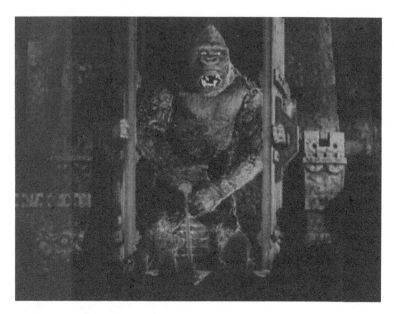

FIGURE 5.2 *The repressed ape breaks free in* King Kong *(1933).*

But Kong dies, and so, however temporarily, does Frankenstein's monster. An obvious difficulty Wood faces is the fact that most horror films end with the monster's destruction, often accomplished by those very bourgeois forces it is arrayed against. Wood attempts to deal with this problem by dividing horror films sharply into two wings, one progressive and one reactionary. The first obliges the audience to side with the monster and see the value in normality's disruption, and the second does the opposite and supports rather than undermines normality (the critic, of course, is in the ultimate position of arbitrating between the two). A major marker of the reactionary horror film, says Wood, is 'the designation of the monster as simply evil' (23); he locates *Shivers*,[2] *Alien* and *Halloween* in this category. His positioning of Carpenter's film is peculiar (and admittedly, Wood notes it as a mixed case) since in many ways, Michael Myers seems like a textbook case of the return of the repressed, his baffling resilience to all forms of attack becoming completely explicable when seen through this lens. Yet Wood reads him as 'the instrument of Puritan vengeance and repression rather than the embodiment of what Puritanism repressed' (218) instead, which belies the fact that he makes fools of the police and other figures of traditional authority; also, while Michael certainly kills sexually active teenagers, his major target is a virgin. Peter Hutchings notes that sometimes a given monster can be read either as progressive and reactionary, or as both at the same time (2004, 38); Michael Myers is surely a richer and even a scarier monster, for being available to both readings simultaneously.

The Uncanny

Another psychoanalytic concept that has found a key place in horror theory stems from Freud's 1919 essay 'The "Uncanny"'; largely ignored for decades, this piece reached particular prominence in cultural and critical theory in the 1990s (Jay (1998), 157–64;

[2]Wood's rather narrow reading of Cronenberg has been much criticized (for example, see Shaviro (145–6)). For a semi-defence of Wood's critique of Cronenberg, see MacInnis (2012).

Masschelein (2011)). Building on (and somewhat rejecting) the early work of psychologists Ernst Jentsch and Otto Rank, Freud defines the uncanny as 'that class of frightening which leads back to what is known of old and long familiar' (220). He writes, 'This uncanny is in reality nothing new or alien, but something which is familiar and old-established in the mind but has become alienated from it only through a process of repression' (241). It represents holdovers of beliefs from infancy or from 'primitive man' that have lingered in the unconscious mind but become twisted into something frightening:

> We – or our primitive forefathers – once believed that these possibilities were realities, and were convinced that they actually happened. Nowadays we no longer believe in them, we have *surmounted* these modes of thought; but we do not feel quite sure of our new beliefs, and the old ones still exist within us ready to seize upon any conformation. (247)

Near the beginning of the essay, Freud explores the etymology of the German word 'unheimlich', often translated as 'uncanny' but literally meaning 'unhomely', though sometimes with the meaning of 'hidden' or 'secret'. Freud notes that 'unheimlich' contains 'heimlich, homely, and argues unheimlich should be regarded not as the pure opposite of heimlich but rather as something that paradoxically resembles it. So the uncanny is not simply that which is frightening, but rather that which is frightening because it is familiar, or put differently, because it contains qualities of familiarity and strangeness. Typically uncanny themes that Freud raises include doubles, reflections, shadows, 'the omnipotence of thoughts' (237) – the anxiety that one might accidentally cause things to happen by wishing for them – as well as automata and waxwork figures that blur the lines between animate and inanimate (though Freud rather dismisses these uncanny themes; they are sometimes characterized as a 'Jentschian uncanny' instead), déjà vu, eerie repetitions, detached body parts and dead bodies. These are, of course, all tempting horror movie themes.

Take mirrors for example. Freud gives an example from his own life, about being in a train car and turning into the washing-cabinet and thinking he sees a person who has accidentally entered his

compartment. It turns out to be his own reflection. Says Freud, 'I can still recollect that I thoroughly disliked his appearance,' which he proposes may be 'a vestigial reaction which feels the "double" to be something uncanny' (248). Mirrors play roles in many a horror film. It is not uncommon for the sudden recognition of a character's reflection to serve as jolt moment, shocking the characters and the audience at the same time. Memorable examples occur late in *Psycho* and early in *The Haunting*, both times mise en scène using the presence of mirrors in a creepy and unfamiliar house to suddenly alter the perceived landscape of the location. *Poltergeist* and *Stir of Echoes* (1999) both have sequences in which a character hallucinates his own bodily disintegration in a mirror. Then there are horror films where mirrors are themselves haunted objects, or gateways to some sort of netherworld: *Phantom of the Opera*, *House* (1986), *Mirror, Mirror, Amityville: A New Generation* (1993), *Into the Mirror, Mirrors, Oculus* and so on. Maybe the greatest example is the 'Haunted Mirror' segment of *Dead of Night*, when Peter Cortland (Ralph Michael) grows increasingly obsessed with an antique mirror that shows him another time and place, seeing himself vanishing into its world, until his personality is subsumed by its mad and cruel previous owner. The subtlest uncanny use of mirrors might be in *The Shining*, where a good portion of a scene between Jack and Wendy (Shelley Duvall) plays out in a mirror image; this is evident only if we notice that the lettering on Jack's shirt is inverted. It is perhaps no surprise to learn that Kubrick and his screenwriter Diane Johnson read Freud's essay as part of their research (see Luckhurst 2013).

Though Freud draws numerous literary sources into his argument, most notably E. T. A. Hoffman's 'The Sand-man', there is only one reference to the cinema, in a footnote where Freud references *The Student of Prague*. He does not make it clear that it is a film, says nothing about any of its cinematic qualities and attributes it to its screenwriter, the well-known German writer Hanns Heinz Ewers. Rank, however, was very interested in cinema, even suggesting, 'It may perhaps turn out that cinematography, which in numerous ways reminds us of the dream-work, can also express certain psychological facts and relationships ... in such clear and conspicuous imagery that it facilitates our understanding of them' (4). As Nicholas Royle notes, 'Film haunts Freud's work' (76), and it would only be a small

FIGURE 5.3 *The haunted mirror in* Dead of Night *(1945).*

FIGURE 5.4 *A mirror image in Kubrick's* The Shining *(1980).*

exaggeration to say that horror film haunts him as much as he haunts the horror film.

Also of interest is Terry Castle's work on the 'invention of the uncanny,' a process she locates in the late eighteenth century: 'The very psychic and cultural transformations that led to the subsequent glorification of the period as an age of reason or enlightenment ... also produced, like a kind of toxic side effect, a new human experience of strangeness, anxiety, bafflement, and intellectual impasse' (9). Castle links this process to the phantasmagoria, the gloomy and ghost-filled proto-cinematic shows pioneered in France in the 1890s. She shows how the very word 'Phantasmagoria' came to change from describing this external display to

> the phantasmic imagery of the mind. This metaphoric shift be speaks ... a very significant transformation in the human consciousness over the past two centuries ... the spectralization or 'ghostifying' of mental space Thus in everyday conversation we affirm that our brains are filled with ghostly shapes and images, that we 'see' figures and scenes in our minds, that we are 'haunted' by our thoughts. (141–3)

In short, the chasing of ghosts and demons out of the world leads them to take up residence in human consciousness itself, and the emergence of the Gothic literature that provides so much of the horror film's ancestry is linked to this reconfiguration of the supernatural. Castle argues that our experience of the uncanny is a consequence of that process, and, via the phantasmagoria, the 'cinematic', broadly defined, has an important role in that transition.

Abjection

Another important psychoanalytic concept to find a major place in horror theoy is abjection. Much thinking on abjection within horror studies traces back to the Bulgarian French scholar and novelist Julia Kristeva. Kristeva's work is founded in Lacanian psychoanalysis, especially Jacques Lacan's theories about the acquisition on

subjectivity by the developing child. The 'abject' can be anything that troubles the lines between subjectivity and objectivity, between self and the world. Writes Kristeva, the abject is 'the place where "I" am not, the place where meaning collapses' (22). She associates it with urine and faeces (which start with self but become other), food (which does the opposite), sex, and the ultimate figure of abjection: the corpse: 'If dung signifies the other side of the border, the place where I am not and which permits me to be, the corpse, the most sickening of wastes, is a border that has encroached upon everything. It is no longer I who expel, "I" is expelled' (4). The abject is horrifying, but it is also fascinating, precisely because it fails to respect 'borders, positions, rules' (ibid.).

It has been suggested that horror films act as 'a kind of modern defilement rite in which all that threatens the symbolic, all that is of the Other, is separated out and subordinated to the paternal law' (Grant 2004, 179) – an innately conservative process that serves to perpetuate the patriarchal status quo. Yet they suggest a venue for feminist resistance as well. In *The Monstrous Feminine: Film, Feminism, Psychoanalysis* (1993), Barbara Creed proposes that horror film is abject in three ways. First, it frequently depicts abject substances like corpses, blood, vomit, etc., in a way that is simultaneously horrifying and pleasurable. Second, its monsters are frequently constructed along abject lines, as figures that cross borders and combine properties of apparent opposites (human and inhuman, good and evil, alive and dead, male and female). The third, of greatest interest to Creed, has to do with the construction of mothers in horror (10–1). Kristeva argues that we all need to push the mother away in order to attain subjectivity, and this process is at the root of the abject construction of women's bodies; Creed extrapolates that female monsters are consistently associated with reproductive functions, but that this 'monstrous feminine' can take on a number of different aspects. *Alien*, *The Exorcist*, *The Brood*, *Shivers*, *The Hunger* and *Carrie* make up her case studies. She argues that

> the central ideological project of the popular horror film [is] purification of the abject through a descent into the foundations of the symbolic construct. The horror film attempts to bring about

a confrontation with the abject (the corpse, bodily wastes, the monstrous feminine) in order finally to eject the abject and redraw the boundaries between the human and non-human. As a modern form of defilement rite, the horror film attempts to separate out the symbolic order from all that threatens its stability, particularly the mother and all that her universe signifies. (14)

On a superficial level, the horror film is the misogynistic product of a misogynistic society. But at the same time, Creed holds out a space of resistance, where feminine monsters can be recaptured for feminist purposes, born of their very abjection.

The final girl: Sadistic or masochistic, castrated or castrating?

We have already noted Carol Clover's influential formulation of 'the Final Girl', also a concept drawn from psychoanalysis. The prototypical Final Girl is Laurie Strode in *Halloween*, the shy virgin who is smart and resourceful enough to battle Michael Myers to a standstill (if not necessarily to kill him). The question is why the slasher film, the prime market of which is putatively teenage boys, stars equivalent girls, and apparently sexless ones at that (often the only young female not to be seen naked);[3] sometimes, as with Laurie, this apparent gender ambiguity is marked with a boyish name. There are a number of arguments, the most fundamental of which appeals to the ancient tradition of the damsel in distress. 'Angry displays of force may belong to the male, but crying, cowering, screaming, fainting, begging for mercy belong to the female,' writes Clover. 'Abject terror, in short, is gendered female' (51).

This description usually suits the inevitable other female victims in a slasher film, but less so the Final Girl. While she may go through

[3]The objection applies that Laurie, while apparently (but not explicitly) virginal, is actually is not sexless and craves romance with boys her age, but is simply a 'late bloomer' relative to her outgoing friends.

FIGURE 5.5 *The archetypical 'Final Girl', Laurie Strode (Jamie Lee Curtis) in* Halloween *(1978)*.

fits of hysterics, she also must inevitably recover her wits to battle the killer. As Clover writes, the fact that slasher film rests on the willingness and even eagerness 'of the male viewer to throw in his emotional lot, if only temporarily, with not only a woman but a woman in fear and pain ... would. seem to suggest that he has a vicarious stake in that fear and pain' (61). To explain this phenomenon, Clover argues that the Final Girl is a phallicized female, 'a congenial double for the adolescent male – she is feminine enough to act out in a gratifying way ... the terrors and masochistic pleasures of the underlying fantasy, but not so feminine as to disturb the structures of male competence and sexuality' (241). For Clover, the Final Girl is the phallic woman of Freudian theory. By wielding a wide array of phallic weapons, perhaps by 'reversing the gaze' (245) by looking for the killer herself, she actually becomes a comforting figure, one who allays genital anxiety on the part of the boys in the audience. Slasher films, Clover argues, 'either eliminate the woman (earlier victims) or reconstitute her as masculine' (239).

It is here that Creed squarely departs with Clover:

The slasher film does not, as Clover suggests, simply 'eliminate the woman'. Specific victims may disappear, but the place of one victim is taken by another ... Nor do these films seek to resolve castration anxiety ... The slasher film actively seeks to arouse castration anxiety in relation to the issue of whether or not woman

is castrated. It does this primarily by representing women in the twin roles of castrated and castrator, and it is the latter image that dominates the ending in almost all of these films. (127)

Creed also rightly points out that, for all of the boyish names of Final Girls noted by Clover (51), there are as many or more feminine ones (like Nancy in *A Nightmare on Elm Street*). Nor, Creed contends, does representing a heroine as resourceful, intelligent and dangerous mean that 'she should be seen as a pseudo man' (127) as Clover holds.[4] Despite the fact that Clover acknowledges that the Final Girl's attack on the killer might be violent indeed – 'His eyes may be put out, his hand severed, his body impaled or shot, his belly gashed or his genitals sliced away or bitten off' (115) – Clover does not characterize the Final Girl as castrating. Creed draws a clear separation between the phallic woman and the *femme castratrice*, 'the former ultimately representing a comforting phantasy of sexual sameness, and the latter a terrifying phantasy of sexual difference' (158), with the latter constituting the proper category for the Final Girl. The *femme castratrice* is a subset of Creed's conception of the monstrous-feminine, where she takes Freud to task for considering a woman castrated but failing to consider her castrating (114–17). Clover follows Freud's lead in speaking of woman as lacking, suggesting that the symbolic phallicization of the Final Girl perhaps flows, 'from the horror of lack on the part of audience and maker' (245), a position Creed denies.

In Creed's interpretation, when the mind of a man gives a woman a penis, it is a protective reaction disavowing not the woman's castration, but rather the existence of the most horrific image in the masculine

[4]Vera Dika actually takes the opposite view to Clover, arguing for Laurie Strode of Halloween as a 'traditional female' in the patriarchal vein, as evidenced by her virginity and her maternal characterization – 'She incorporates a man's set of values, applies them to traditional women's roles, and is sexually passive' (47), as opposed to her sexually active friends, whom Dika views as parodies of feminist 'types' and therefore more masculine, especially Annie (Nancy Loomis), who wears a man's shirt through most of the film (in contrast, Laurie spends some of the film wearing an apron).

unconscious, the toothy and all-devouring *vagina dentata*. Creed sees the *vagina dentata* as commonplace within the horror film:

> In films like *Jaws*, *Tremors* [1990], *Alien* and *Aliens* [1984], where the monster is a devouring creature, victims are ripped apart and eaten alive. When the monster is a psychopath, victims are cut, dismembered, decapitated. Instruments of death are usually knives. ... Close-ups shots of gaping jaws, sharp teeth and bloodied lips play on the spectator's fears of bloody incorporation. (Creed 1993, 107)

The knife wielded by the Final Girl, then, may not be not phallic so much as a displacement of the vaginal teeth. When the Final Girl unleashes her barrage against the killer, the teenaged boys of the audience are actually identifying with the castrator.

In Robert Hiltzik's slasher film *Sleepaway Camp* (1983), the killer and the Final Girl collapse into one. Thirteen-year-old Angela (Felissa Rose) is shy and virginal, just like most Final Girls, opening up only in the company of a nice boy she meets at camp. Murders accumulate in true slasher style, and the film's final revelation is that Angela is not only the killer but also actually a boy, 'transformed' into a girl by her insane aunt. Angela's final action is to strip with her unfortunate boyfriend and to then behead him. The film closes with a genuinely shocking shot of Angela standing fully naked and snarling madly, her face smeared with blood, now completely feral. Angela actually seems to correspond to both Clover's and Creed's competing interpretations of the Final Girl: per Clover, she is castrated, her maleness suppressed, the penis that we see in the film's final scene uselessly remaining. Where Clover interprets Laurie Strode et al. to be 'false boys,' Angela is a literal false boy. But she is also a *castratrice* of the guilty and the innocent alike.[5] Even though we eventually come to see her true monstrosity, we retain some sympathy for her, since she too is a victim of her aunt (perhaps closer to Creed's monstrous mother archetype). She demonstrates a possible space of coexistence between Clover's and Creed's interpretations of the Final Girl.

[5]See *Teeth* (2007) for a literal version of the *vagina dentata* in action on screen.

FIGURE 5.6 *The climax of* Sleepaway Camp *(1983).*

Enter the body

Clover and Creed contributed two of the most significant and influential works of feminist horror theory. The third is Linda Williams's essay 'Film Bodies: Gender, Genre and Excess' (1991). Williams is interested in exploring the appeal of horror, especially of the gross-out variety. She links gross-out horror to pornography and to melodrama, the 'weepie.' These genres are united by displays of excess, 'the spectacle of a body caught in the grip of intense sensation or emotion' (4). What separates these 'female body genres' from other body genres like comedy, Williams argues, is that the audience is encouraged to react in a manner identical to the body on the screen, through displays of arousal, sadness and fear. Each is implicitly measured successful by how strong of a bodily reaction it induces. And each hinges on the image of 'a "sexually saturated" female body' (6).

These three genres themselves are separated by their presumed audiences and the types of perversion they invoke: 'active men' for pornography, 'passive women' for the weepie, and horror 'aimed at adolescents careening wildly between the two masculine and feminine poles' (ibid.). Where pornography is sadistic in character, melodrama is masochistic, and following Clover, Williams identifies

horror as wavering wildly between the two, as identification shifts between the killer and the Final Girl (6–7). But none of these is as sharply delineated as this division suggests, and Williams acknowledges a diversifying audience for all of those films, as well as the potential of a viewer to make multiple points of identification simultaneously (8). In sum, Williams argues that all of these genres function to satisfy unconscious perversions.

Part of the influence of Williams's essay lies with the increased importance of the body and of embodied audience reactions to the study of horror and of film genres more broadly. It demonstrates that such approaches can be made through psychoanalysis, but increasingly horror scholars would turn away from psychoanalysis, sometimes critiquing existing psychoanalytic approaches as flawed or inadequate in the process (for two examples, see Prince (2004) and Turvey (2004)). Broadly speaking, this interest in embodiment corresponded with the decline of psychoanalytic film theory more generally, as the curiously disembodied spectator of Laura Mulvey or Christian Metz slowly changed to an embodied viewer whose emotional and visceral reactions became increasingly important.

Where horror has always been a body of the genre, horror films from the 1970s on more obviously foregrounded embodiment, and scholarship was obliged to respond. In 1984, Phillip Brophy suggested that 'the contemporary horror film tends to play not so much on a fear of death but of one's own body, of how one controls and relates to it' (8). Similarly, Linda Badley suggests that

> horror has become a fantastic 'body language' for our culture in which a person's self-concept is images of the body. In the ongoing crisis of identity in which the gendered, binary subject of Eurocentric bourgeois patriarch (in particular, the Freudian psychoanalytic model of the self) is undergoing deconstruction, horror joined with other discourses of the body to provide a language for imagining the self in transformation, re-gendered, and regenerated or even as an absence of lack. (3)

For Badley and like-minded critics, these visceral films become critical works of their own, violently insisting on the reinstatement of the suppressed body.

From cognitivism to affect

Cognitive film theory sought to overturn the understanding of a spectator as motivated by unconscious drivers in favour of a rational one whose reactions can be understood rationally. The quintessential cognitivist work on horror is Noël Carroll's *The Philosophy of Horror, or Paradoxes of the Heart* (1990). As we have discussed already, he developed a complex formula for what he calls 'art-horror' based around the monster and ideas about interstitiality and impurity; Carroll's consumer of horror is motivated largely by curiosity about and fascination with the monster, its origins and nature. Carroll's book is an important one but was roundly critiqued. Other cognitivist approaches to the horror film followed (notably Grodal 1999; Freeland 2002), each different in their details but sharing the basic premise of a rational, active spectator (for a useful overview, see Smuts 2014).

Hills notes the following assumptions underpinning cognitive approaches to the horror genre: '(i) emotion is theoretically defined as being "object directed" because it is cognitively evaluated, and (ii) emotion is defined as being "occurrent," that is, occurring at a given moment rather than lingering like a mood or disposition' (2005, 24). He objects to the former on the basis that horror often produces 'objectless states of anxiety' as well, and the latter on the basis that horror can indeed produce longer-term emotional effects, like 'a saturated affective experience of anticipation, with specific "emotions" occurring in relation to this affective mood'. Hills also notes that cognitive approaches seem to negate the complex ways that horror establishes mood or ambience through film form (ibid., 25).[6] He proposes the need for affective theories of horror that '[oblige] us to consider that art-horror is not solely concerned with cognitively framed emotions' (31) and which also take as central, rather than dismiss as secondary, embodied reactions to the genre.

Various scholarly works have taken up that challenge, accompanying what has been called the 'sensorial turn' or 'affective turn'. It is both a reaction against both the 'linguistic turn' that dominated much of the

[6]For a strong critique of Carroll in particular, see Brinkema (133–7).

twentieth-century thought and the subsequent 'visual' or 'pictorial turn' that emphasized vision and the image (see Mitchell 1994). Film Studies increasingly turned to the body as well (for a few examples among many, see Marks 2000, Sobchack 2004a and Ince 2011), so it is natural that horror scholarship should find this a productive area of inquiry. A significant early work was Steven Shaviro's *The Cinematic Body* (1993), which makes a case study of horror films as an affective genre. In particular, Shaviro's work on Cronenberg, whom he sees as 'a literalist of the body' and whose films he argues 'display the body in its crude, primordial materiality', and 'thereby deny the postmodern myth of textual or signifying autonomy' (128), would anticipate many later affective readings of horror.

Anna Powell's *Deleuze and Horror Film* (2005), rather like Hills the same year, argues that 'theories of representation and narrative structure neglect the primacy of corporeal affect, and although there has been some exploratory work with horror film spectatorship, the affective dynamic of the films has so far been downplayed' (2). Her book commences with a chapter-length critique of psychoanalysis and argument for 'schizoanalytic film theory' extrapolated from the works of Gilles Deleuze. Powell is interested in explicating Deleuze's theories through horror films, and provides a useful glossary of Deleuzean concepts, often explained using horror examples.

Other works followed, including Julian Hanich's *Cinematic Emotion in Horror Films and Thrillers: The Aesthetic Paradox of Pleasurable Fear* (2010), Angela Ndalianis's *The Horror Sensorium: Media and the Senses* (2012), Larrie Dudenhoeffer's *Embodiment and Horror Cinema* (2014) and Xavier Aldana Reyes's *Horror Film and Affect: Towards a Corporeal Model of Viewership* (2016), as well as parts of Eugenie Brinkema's *The Forms of the Affects* (2014). It is clear that the expansion of affect horror theory that Hills called for in 2005 has arrived; it is less clear if this will attain the near-dominance that psychoanalytic horror theory held for so long. While I do not want to overstate the similarities between these books and their authors, they broadly share an implicit or explicit rejection of psychoanalysis, as well as concerns with some combination of embodiment, affect, emotion, spectatorship and horror, and especially how horror's conventional aesthetics work to provoke audience reactions.

Many of these books foreground relatively recent horror films: Aldana Reyes's focus is on twenty-first-century horror films, especially those of the torture porn cycle, Ndalianis focuses on 'New Horror' in a range of media, and most others skew late. Is it because these films are more affective, or do more to foreground the issues of affection, or is it because we have lost touch with whatever affective qualities classical horror might have had on its viewers?

It is certainly the case that horror can often lose its affective abilities over time. In the first *The Simpsons* Halloween episode ('Treehouse of Horror', 1990), Bart Simpson, unmoved by a recital of Poe's 'The Raven', remarks on how tame '*Friday the 13th, Part I*' looks from the vantage of a decade later. But the mechanism for this 'dating' process remains poorly theorized. Aldana Reyes suggests that 'although films may lose their affective powers as they age, this is not so much a result of a change in our interaction with films as of the development of new and more verisimilitudinous cinematic techniques, as well as our acquaintance with the genre and cinema more generally' (18). In other words, horror can eventually lose its affective qualities either because its special effects, makeup, etc. look less believable than contemporary works (contemporary to whenever the viewer's moment may be) and/or because of overfamiliarity rendering once-disturbing conventions rote and predictable.

These explanations do not entirely satisfy me, in part because later techniques are not necessarily more verisimilitudinous (more advanced special effects sometimes resonate as less realistic than simpler ones) and also because conventions need not become ineffective due to their familiarity. Indeed, a recent audience study on *Alien* demonstrates the notorious 'chest-burster' scene retains its effectiveness even when viewed many times and even when considered analytically (Barker et al. 2016, 78–100). However, it is reasonable to suggest that the cinematic stylistics ancillary to the shocks themselves that may appear dated prevent audience immersion in the work and thus limit potential affect; when *The Exorcist* was rereleased in 1998, the British Board of Film Classification revised its classification from the initial X certification to 18 on the explicit basis that it 'no longer had the same impact as it did 25 years ago'. But here again, a certain kind of cultural training and familiarity is in play. When I teach classical horror, the students often

remark that the films get more frightening as the course proceeds. But it is probably less that the films are intrinsically scarier than that the students' increasing familiarity with, say, Universal horror films of the 1930s make them increasingly open to finding their affective qualities resonate. Moments like the unmasking in *The Phantom of the Opera* and Graf Orlak emerging from his coffin in *Nosferatu* were clearly powerfully affective to their original audiences. Yet it becomes that much more difficult to understand that quality because of our own temporal limitations.

Why horror? Why not horror?

Let us return to our opening question: Why horror? As Tom Hanks's Elliot puts it in *He Knows You're Alone*, 'People pay to be scared. When you think about it, it's really ridiculous.' Perhaps so, but we are often a ridiculous species. Psychoanalysis can provide a range of answers, tied to unconscious drives and desires of one kind or another. Cognitive studies insists that the answer lies in the workings of rational minds, and the affective turn proposes that we should find our answers within emotional and embodied reactions. No single answer emerges as definitive, and nor should it: it may be desirable not to generalize, and there may be as many possible motivations as there are viewers of the horror film. But I wish to end with a less asked question: Why is going to a horror film wanting to be scared intrinsically stranger than going to a melodrama to be moved to tears? Aaron Smuts places both within a super-category called 'the paradox of painful art' (7), and yet horror seems to inspire more reflection, and more moral consternation, than those works aimed at provoking sadness or despair. Why?

6

Horror's Audiences, Critics and Censors

Another important question is 'who?' Who sees horror films, and what attracts them to the genre? Much of the scholarship in the previous chapter, whether psychoanalytic, cognitive or affective, assumes a largely standardized viewer of the horror film who reacts in a standardized fashion, the study of which need not require recourse to actual viewers, actual audiences. The growing field of Audience Studies aims to test a lot of the major claims film theory has made about the audience. In place of the standardized and essentially passive viewer of classical film theory, it seeks to understand the actual habits of actual viewers. So who are they?

There is always a danger of overgeneralizing when speaking of audiences. We have seen that horror is a diverse genre, composed of films that sometimes bear scant resemblance to each other. So too are its fans: What overlap would there be in the audiences for an art house piece like *The Addiction*, a gore film like *Blood Feast* (1963) and a Gothic romance like *Crimson Peak* (2015)? In fact, as we shall see, disagreements among horror fans often revolve around the constitution of 'real' or 'authentic' horror and the 'authentic' fan who consumes it. Viewing context is also important. Whether one views a horror film in a movie theatre, at home alone, in a classroom, a screening at an art gallery, at a teenage sleepover, or on a smartphone while riding public transit changes the experience of a film and our conception of an 'audience'.

Horror is perhaps the film genre most prone to drawing reflexive attention to the audience itself. While it is possible to have a Western

in which a character watches a Western (*The Grey Fox* (1982) is one), horror films in which characters discuss, consume or even make horror films are legion.[1] Reflexive humour surfaces early on. Take the Monogram Lugosi vehicle *Voodoo Man* (1944). Its protagonist is a Hollywood screenwriter who in the last scene, turns in a script called *Voodoo Man* based on his recent experiences. When asked to recommend an actor for the villain, he says, 'Why don't you try to get that actor Béla Lugosi? It's right up his alley.' From *How to Make a Monster* (1958) to *The Tingler to Madhouse* (1974) to *Demons* (1985) to *Fright Night to Anguish* (1987) to *In the Mouth of Madness* (1994) to *Scream* to *Shadow of a Vampire* (2000) to *Spliced* (2002) to *Behind the Mask* to *The Cabin in the Woods*, and many more, horror has always been prone to think about itself and about its audiences. It behoves scholarship to do the same.

Pathologized audiences, victimized audiences

At times, horror's viewers have been disparaged as immoral, and even demonized. A great example is Roger Ebert's 1980 review of *I Spit on Your Grave*, which says relatively little about the film and quite a lot about its audience. Ebert begins by noting the venue: 'It is a movie so sick, reprehensible and contemptible that I can hardly believe it's playing in respectable theatres ... but it is.' He describes seeing the film at 11.20 am on a Monday, facing a crowd that was not just large but 'profoundly disturbing ... the people who were sitting around me on Monday morning made it easy for me to know what they were thinking. They talked out loud. And if they seriously believed the things they were saying, they were vicarious sex criminals' (n.p.). A big 'if' indeed, with the odd implication that it is possible to be a real vicarious criminal to a fictional crime.

[1]And not just horror films, either; take the scene at the Théâtre du Grand-Guignol near the beginning of *Mad Love*. For a treatment of the theatricality of horror, see Loiselle (2012).

Ebert describes witnessing laughing and cheering. He notes a middle-aged, white-haired man greeting the film's interminable rape scenes with cries of 'That was a good one!', 'That'll show her!' and 'I've seen some good ones, but this is the best!' He also notes a woman in the audience who praises the heroine's revenge killings, shouting, 'Cut him up, sister!', but wonders if she was appalled by the protracted rape scene needed to set up her vengeance. He places considerable focus on condemning not only the film itself, but its exhibitors and viewers, noting that he left the film 'feeling unclean, depressed and ashamed' (n.p.).

Ebert spoke again about this screening in the 'Women and Danger' episode of *Sneak Previews* in 1980, using some of the same language. His partner Gene Siskel also noted with disgust that he saw couples on dates at *I Spit on Your Grave*, before seguing into expressing concern about audience members imitating the behaviour of the characters – an implication that he thinks those women were in danger from their dates. It has at times been claimed that horror films have inspired terrible real-life crimes. *Scream* became a key example, with purported copycat cases, including the 1998 murder of Rita Castillo in Lynwood, California (by her own son and nephew), the 2001 murder of Belgian teen Alisson Cambier by neighbour Thierry Jaradin, and the 2006 murder of Cassie Jo Stoddart in Pocatello, Idaho. In the latter, the two teenage killers shut off the power, wore masks and stalked her before stabbing her twenty-nine times. Other serial killer movies like *Halloween*, *The Silence of the Lambs*, *American Psycho* and *Saw* have been accused of inspiring crimes, but so have supernatural-themed films like *The Exorcist* (the murder of James Horgan in Ireland in 1973), *Interview with a Vampire* (the attempted murder of Lisa Stellwagen in San Francisco in 1994), *Child's Play* (1988) (Tasmanian spree killer Martin Bryant), *Child's Play 3* (1991) (the UK murders of James Bulger and Suzanne Capper) and *Warlock* (1989) (in La Ronge, Saskatchewan in 1995, a gruesome case of child murder and cannibalism by a fourteen-year-old boy).[2] Nor are such alleged copycat incidents unique to

[2]My thanks to numerous members of the 'Horror Studies SIG' Facebook group for helping me assemble this list.

post-classical horror films: in 1928, a man named Robert Williams murdered a woman in London's Hyde Park and attributed his crime to Lon Chaney's *London After Midnight*. And yet killers have also apparently been triggered by very different media texts: Charles Manson by *The Beatles* (1968, aka the 'White Album') and German serial killer Heinrich Pommerenke by Cecil B. DeMille's *The Ten Commandments* (1956).

Negative reviews of horror movies have accused their audiences of potential monstrosity themselves. The early Hammer horror releases included a facetious call for a 'SO' rating for 'Sadists Only' for *The Curse of Frankenstein* (qtd. in Hutchings 1993, 6), the characterization of *The Revenge of Frankenstein* (1958) as 'a vulgar, stupid, nasty and intolerable business; a crude sort of entertainment for a crude sort of audience' (qtd. in Petley 2002, 37), as well as the decidedly gendered assertion that 'only the saddest of simpletons, one feels, could ever get a really satisfying frisson. For the rest of us they have just become a rather eccentric and specialized form of light entertainment, and possibly a useful means of escape for a housewife harrowed by shopping' (qtd. ibid., 38). In his review of *Halloween*, Jonathan Rosenbaum wondered what makes admiring such a film 'superior to fondling Nazi war relics?' (8–9). Jonathan Lake Crane references a 1992 issue of *Cosmopolitan* that warns women off approaching single men in the horror section of a video store. Such a man, the article promises, inevitably has 'questionable feelings about women. Whether buried deep or overtly expressed in his words and actions, his misogynistic tendencies make him a man to avoid' (1994, 18) – shades of Siskel's worries about seeing dates watching *I Spit on Your Grave*. Matt Hills notes that certain theories of horror and audienceship also tend to pathologize the horror viewer, either by suggesting that horror's audiences are already anxious and on edge and seek media matching that state, or that horror's audiences 'are all somehow traumatised and seeking to "escape" from "real-life" horrors' (2005, 30–1).

Other studies have examined the potential of horror films not to inspire violent acts but to serve as a kind of violence against their audiences, to traumatize them, enough to create lasting neuroses, phobias and even post-traumatic stress disorder (Bozzuto 1975; Mathai 1983; Simon and Silveira 1994; Cantor 2004). The most at risk

are those with undeveloped or compromised abilities to contextualize the media images that they encounter, especially children.

'Think of the children'!: Children and youths as audiences of horror

The accepted (though now frequently challenged) wisdom is that horror film audiences are generally young, especially young males. But how young is too young? Child spectatorship has been a particular flashpoint for debates over the horror film: Julian Petley notes the capacity of 'the spectre of children watching horror videos' to 'upset a certain traditional ideology of "childhood"' (2011, 27). In 1967, Vincent Price appeared on the American talk show *The Mike Douglas Show* alongside Fredric Wertham, the psychiatrist most famous for his crusade against violence, sex and shock in horror comics in the 1950s. Price defended his horror films as harmless escapism, but Wertham accused him of having 'done incalculable harm to America's children' (Zinoman 2011, 18–20).

The idea of children and youths watching horror films has attracted the lion's share of moral consternation and motivated calls for regulation. At least since the 1930s, studies of cinema spectatorship have been concerned with the effects of frightening imagery on young viewers (Blumer 1933; Preston 1941; Mayer 1972), generally arguing that horror proved 'detrimental to the general health' (Preston 1941, 168). Of the 1930s, Sarah Smith notes that 'the innate threat of horror films was their combination of sex, violence and the supernatural, which broke taboos, challenged Christian values and subverted the social order' (57–8). Annette Kuhn has explored how the British Board of Film Censors fell under public pressure in the early 1930s to more tightly regulate children's access to the new Hollywood cycle that would soon be called 'horror films'. In 1932, it unveiled the 'H' rating for 'horrific', which declared horrific content, but did not actually prohibit children's attendance until 1937. Writes Kuhn, 'It seems reasonable to conclude that the purpose of launching the "H" label was mainly to forestall further troublesome complaints from the public and from pressure groups, and so to protect film producers and

exhibitors, as well as the BBFC itself' (330). As we have seen, these acts of censorship led, however indirectly, to increased reticence to produce horror movies in Hollywood. Most notable, Kuhn argues, is that this move reflects a shift in thinking about child audiences as 'an audience apart with needs of its own, a group whose film going ... should be segregated from that of adult audiences' (331).[3]

The child and youth audiences of horror films are significant as it is society's attitude towards them that generally determines how horror is policed and censored. Mark Kermode notes that the arrival of the adults-only 'X' certification in Britain 'continued to treat adults as little more than advanced children' (2002, 11), unable to make their own decisions and requiring the protection of state- or industry-sanctioned moral arbiters. The 'video nasty' saga in Britain was a product of an increasing wave of moral panic involving gory and sexual films and their circulation on the largely unregulated medium of video. Key 'nasties' included *The Last House on the Left, The Evil Dead, I Spit on Your Grave, The Driller Killer* (1979) and *The Burning* (1981). These films were blamed for all manner of immoral activities, especially among children. A public campaign spearheaded by Mary Whitehouse of the National Viewers' and Listeners' Association led to legislation designed to 'protect' children from these 'obscene' films. Kate Egan notes the tendency of pro-censorship rhetoric to construct the child as 'sinister consumer and trader' (2007, 90–1), scarcely less monstrous than horror films' own evil children. The battle over the souls of children is waged through stories, 'where traditional, healthy stories of the state and insular nation are pitted ... against a wave of new, diseased and commercial ones' (ibid., 94).[4] One unexpected effect of this ban was that 'British horror fandom of the 1980s and 1990s seems largely to have been founded on the obtaining, usually by nefarious means, of uncertificated and uncut video versions of banned horror films' (Hutchings 2004, 92).

Later studies have been less overtly condemnatory towards children and youth's consumption of horror, seeking more to

[3]For more, see Barker (1994).
[4]Horror films targeted specifically at children are thus a peculiar category (e.g. *Monster House* (2006), *Coraline* (2009) and *ParaNorman* (2012)); see Lester (2016).

understand it than to condemn it (e.g. Moss 1993; Buckingham 1995 (esp. 95–138), Johnston 1995; Jerslev 2008; Howard and MacGillivray 2014). The 1996 collection *Horror Films: Current Research on Audience Preferences and Reactions* overwhelmingly focuses on youth reception of the slasher film. For example, Dolf Zillmann and James B. Weaver III examine horror films through gender-socialization theory, arguing that they constitute a space where young males and females can attend together and practice traditional gender roles, the boys performing bravery and the girls performing anxiety and vulnerability. Their experiment had young participants of opposite genders watch *Friday the 13th, Part III* (1982) together and found that both genders rated the experience as more enjoyable when they both displayed the 'proper' reactions: the male participants found it less enjoyable when the girl failed to display distress, and the female participants were dismayed when the boys failed to demonstrate mastery of their fear. Zillmann and Weaver suggest that 'excitatory habituation' eventually diminishes the intensity of horror films' effects on their spectators, so that with sufficient practice, everyone will be able to play the appropriate roles. In Zillmann and Weaver's research, horror films emerge less as a potentially traumatic and perverting force for young people than as an engine for cultural conformity and the naturalization of prescribed gender roles.

Gender, sexuality and audiences

Perhaps the most pernicious misconception about horror's audiences is that they are overwhelmingly male. For two consecutive years at Carleton University (2012/3), I ran a week long 'mini-course' where local high school students came to campus for a taste of university life. I called my course 'Monster Mash: A History of Horror'. The first year, the gender parity was perfect: ten girls and ten boys. The second year, however, the numbers were quite different: eighteen girls and two boys. Showing that this girl contingent was more than purely anecdotal, various scholars have identified large and important female audiences for horror. Scholars including Linda Williams (1984), Rhona Berenstein (1996), Isabella Cristina Pinedo (1997), Brigid Cherry (1999a,b) and Aalya Ahmad (2013) have variously attempted

to understand female horror audiences, even as mass discourses so often diminish them into traumatized girlfriends covering their eyes (or worse, potential victims of sadistic violence).

Berenstein's work on classical horror is the most historical, finding a more complex set of gender dynamics than is generally supposed both in the films themselves and their audiences. She writes:

> Whatever it did to its audience, classic horror did it with flair and, above all, with an attention to conventional gender roles as both powerful social identities and compelling modes of cultural performance. Male and female spectators were offered a range of publicity, exhibition, and critical discourses that invited them alternately to act in line with traditional gender mores and to act out unconventional gender roles. (137)

Berenstein's analysis of reviews and promotional materials from the 1930s makes it clear that not only were women part of the audience of horror films, but that they were consciously sold to by the studios, in ways both subtle and manifest (60–87).

Brigid Cherry's 1999 Ph.D. dissertation provided a large-scale quantitative study of female horror viewership in the UK, while simultaneously responding to existing scholarship on women viewers of horror. Writes Cherry, scholarship had tended to '[construct] the spectatrix as refusing to look, implying that female pleasure is an immasculated collusion with the oppressive male gaze and male violence towards women … this has only recently begun to be challenged' (1999a, 47). Her study reveals female horror fans as an 'invisible audience', less likely to be present at theatrical screenings and favouring home viewings on video or television instead (ibid., 82–3), predominantly watching films alone. Cherry's research indicates that women tend to favour certain types of horror films, notably vampire films and supernatural horror, while many actively disliked slasher films (ibid., 87–8), and that women tended not to rank gore and special effects very highly in terms of what appeals to them about horror, often placing more value on subtle, psychological elements of horror (ibid., 118–19). Though Cherry found her initial speculation that female horror fans enjoy horror as a 'form of feminist revenge fantasy on men' (ibid., 205) to be largely unsupported, she

did find that they enjoy strong female roles and were often critical of misogynistic portrayals, but also often defended the genre against charges of wholesale misogyny.

Queer audiences of horror have also been studied (see Scales 2015), as well as queer representations within horror. Though identifiably gay characters in movies are often victims (like the two stereotypical gay antique dealers killed early in *Blacula*), the queer-coding of monsters has invited much criticism in recent decades: as Harry Benshoff writes, 'Horror stories and monster movies, perhaps more than any other genre, actively invoke queer readings' (1997, 6).[5] Cryptic queer representations have been located in horror films like *Bride of Frankenstein*, *Dracula's Daughter* and *Werewolf of London* (1935), *Blood of Dracula* and *A Nightmare on Elm Street 2: Freddy's Revenge* (1985); later films, including *Curse of the Queerwolf* (1987), *Kondom des Grauens/Killer Condom* (1996), *HellBent* (2004), *L. A. Zombie* (2010) and the 'I Was a Teenage Werebear' segment of *Chillerama*, are examples of horror films designed specifically for LGBT audiences. Lesbianism and horror is a significant topic in its own right, especially the connection between lesbians and vampires that dates back at least to Coleridge's 1800 poem 'Christabel' and J. Sheridan Le Fanu's oft-adapted novella *Carmilla* (1872); vampire films of various levels of explicitness, ranging from *Dracula's Daughter* to *Blood and Roses* to *Vampyros Lesbos* to *The Hunger* to Jordan Hall's web series *Carmilla* (2014–6), have offered a space of lesbian representation.[6] Somewhat similarly, Patricia White (1991) reads *The Haunting* as a haunted house film of tremendous resonance to lesbian spectators and which represents lesbian desire as invisible and 'ghostly'.

Horror fandoms

Fan or Fandom Studies has been one of the breakthrough fields of recent decades (Hills 2002; Sandvoss 2005). Its status is confirmed by

[5] See also Saunders (1998), Spadoni (2010), Benshoff (2012).
[6] For a useful overview, see Weiss (2014).

the 2012 debut of *The Journal of Fandom Studies*, the inaugural issue of which was devoted to horror fandom. It is increasingly the case that our understanding of the parameters of the genre and of its significance is shaped not only by the industry and by critics and academia, but also by audiences themselves, and in particular the 'specialist audiences' constituted by fandoms. Perhaps the 'general cinemagoer', whomever that might be, might see a horror film occasionally, say, when it is especially well reviewed, or if a favourite actor is in the cast, or when it is built into an 'unmissable' cultural event. Horror blockbusters like *House of Wax*, *The Exorcist* and *The Sixth Sense* clearly owe their status to appealing to more than just 'horror fans', and sometimes the specialist and general audiences are disconnected altogether; the 1999 remake of *The Haunting* did good business despite many horror fans denouncing it as a defilement of the beloved original.

The 'Monster Culture' of the 1950s and 1960s, triggered by the release of Universal's back catalogue on television, is probably the most studied era of horror fandom, at least prior to the digital age. As Skal writes,

> in Monster Culture, the participatory rituals surrounding the movies were every bit as important as the films themselves. The rites included the shared witnessing of the antics of horror hosts; an explosion of fan magazines that were read, reread, and traded among the cognoscenti; and even the creation of plastic model effigies. (2001, 266–7)

In *Matinee*, Joe Dante – a lifelong horror buff who in his youth served as the reviews editor for the fan magazine *Castle of Dracula* – pays loving tribute to this era. Its young protagonist Gene (Simon Fenton) is a navy brat with a collection of treasured fan magazines and an encyclopaedic knowledge of the horror genre, and who regards Vincent Price as one of his few consistent friends. *Matinee* is a good example of how horror fans-turned-filmmakers address their audiences in a knowing fashion; writes Mark Kermode, 'More than any other genre, horror movies play to and feed upon the knowledgeability of their fans' (50).

Matinee presents a positive, almost utopian conception of horror fandom, which gives Gene the resources to handle a time of personal

and national stress (his father is on one of the blockade ships during the Cuban Missile Crisis). It came out a year after Henry Jenkins's *Textual Poachers: Television Fans and Participatory Culture* (1992) largely inaugurated fan studies as an academic field, often positioning the 'fan' as a figure of resistance and not simply a mindless consumer. A later wave of theory would complicate the valorization of the fan as a figure opposed to 'mainstream culture', positioning fans rather as 'agents of maintaining social and cultural systems of classification and thus existing hierarchies' (Gray, Sandvoss and Harrington 2007, 6; for an approach specific to vampire fandoms, see Williamson 2005, 97–118).[7] Kermode uses the example of *The Evil Dead* to show how individual films can play differently to different audiences precisely because of that level of insider knowledge. Sam Raimi's film faced censorship in the UK and ended up on the video nasty list, becoming one of the most mentioned films during that controversy due to its violence and gore. Kermode notes that,

> to the uninitiated viewer, *The Evil Dead* was a grueling horror picture in which bodies were mercilessly hacked to pieces. To erudite horror fans, it was *The Three Stooges* with latex and ketchup standing in for custard pies, a knockabout romp in which everything is cranked up to eleven, and in which pain and suffering play no part. (52)

Kermode keenly observes the potentially massive disconnections between how fan and non-fan audiences will receive a text. However, there is a danger in assuming one and only one standardized reaction on the part of horror fans, obscuring how fandom serves as a site of discourse and debate. As Jancovich notes, 'Struggles over the definition of horror as a genre take place between horror fans as much as they do between those who define themselves as pro- and anti-horror' (26).

[7]Writes Jancovich, 'the term "average movie goer" is ... an extremely slippery one that operates to conflate a small fan culture with the conformist mass and so produce a clear sense of distinction between the authentic subcultural self and the inauthentic mass cultural other' (2002, 313).

Perhaps we should speak of horror 'fandoms', potentially as stratified and diverse as the genre itself. What fans conceive of as horror movies, even great horror movies, is often somewhat removed from conventional definitions. Jancovich notes that fan magazines like *Fear* and *Fangoria* have often needed to justify the inclusion of films of debatable genre affiliation, with fan letters challenging the presence of films like *Alien, Jurassic Park* (1993) or *Shogun Assassins* (1980) (2000, 27–8). In the aforementioned study of female horror fans, Cherry notes a wide and sometimes baffling range of films listed as their favourite horror films, including high-fantasy films like *Jason and the Argonauts* (1963), *Legend* (1985) and *The Beastmaster* (1982), war films like *Apocalypse Now* (1979) and *First Blood* (1982), and auteur-driven art films like Pier Paolo Pasolini's *Salò: 120 Days of Sodom* (1975) and Todd Haynes's *Superstar: The Karen Carpenter Story* (1987). Fans even named the supernatural baseball drama *Field of Dreams* (1989) and Laurence Olivier's *Richard III* (1955) (1999a, 92) as favourite horror films. These choices illustrate genres' uncertain boundaries, but also the ability of any individual audience member to receive a film in imaginative and idiosyncratic ways.

What activities constitute horror fandom? Writes Rick Altman, 'While genre fandom sometimes involves ... actual face to face contact, genre buffs more commonly imagine themselves communing with absent like-minded fans' (1999, 160). Traditional artefacts of horror fandom of this abstract type included fan-oriented magazines and newsletters (Sanjek 1990; Conrich 2004b) and model kits (Rehak 2012), fan art, fan films and trailers (Booth 2012), and ultimately digital venues like webpages, newsgroups, message boards, chat rooms and social media (Cherry 2010; Tompkins 2014). Horror conventions, film festivals and comparable events represent the more flesh-and-blood manifestation of horror fandom (Hills 2010). Strata of horror fandom might focus on individual horror stars (for instance, see Egan's work on Ingrid Pitt (2013)), or certain cycles, eras or national traditions of horror (see Tsutsui 2004, esp. 141–75 for notes on *Godzilla* fandom), sometimes with a disparaging attitude towards mainstream, contemporary horror. It is in these narrower focuses that 'subcultural capital' comes into play.

Building on the work of the French sociologist Pierre Bourdieu in her study of underground dance cultures in the UK, Sarah Thornton

coined the term 'subcultural capital' to describe that which 'confers status on its owner in the eyes of the relevant beholder ... Just as books and paintings display cultural capital in the family home, so subcultural capital is objectified in the form of fashionable haircuts and well-assembled record collections' (1995, 11). Subcultural capital is, by nature, defined against the mainstream and is based on rarity and obscurity. Thornton's concept has been adapted to other subcultures, including horror fandom, and even appears within films themselves. Take the scene in *The Lost Boys* (1987) where young Sam (Corey Haim) first meets brothers Edgar and Alan Frog (Corey Feldman and Jamison Newlander) in a comic book store. Sam's ostentatious *Miami Vice*-esque wardrobe draws the derision of the Frog brothers, draped in Vietnam-chic (a Rambo-esque headband, a military jacket and dog tags).[8] Sam ignores Alan calling him a 'fashion victim' and swiftly performs subcultural capital by declaring that he owns a copy of a rare Batman comic and is in search of others, criticizing the filing system and namedropping obscure DC Comics character Lori Lemaris. Edgar asks 'Where are you from, Krypton?', simultaneously acknowledging Sam's credibility as a comic book fan and commenting on the 'alienness' of his clothing and manner. Regardless of this scene's accuracy, within *The Lost Boys*'s verisimilitude Sam's display of subcultural capital impresses the Frog brothers sufficiently to look past his wardrobe. They thus initiate him into another kind of subcultural knowledge from which he was previously excluded, but which soon proves critically important: vampire lore.

So what constitutes subcultural capital in the context of horror fandoms? Hills suggests that it can reside in 'a fan's collection of uncut *giallo* films or "video nasties," or [be] embodied in the same fan's knowledge of horror films and auteurs', and might be displayed by relevant T-shirts at conventions or festivals (2010, 89). There are elements of subcultural capital because they mean relatively little, or might even be causes for disparagement, by non-fans. Personal contact with fan-favourite directors and stars can also be levied as subcultural capital (as I can impress certain people with the fact that I have interviewed John Carpenter and Roger Corman). The overall

[8]Both aesthetics are implicitly deployed against the film's punk-styled vampires.

FIGURE 6.1 *Subcultures intersect in the comic book store in* The Lost Boys *(1987).*

function is loosely hierarchical, aimed at separating the 'true' or 'serious' fans from the rest.

Cult horror films

A related but distinct area of academic scrutiny is the 'cult film'. Put simply, 'cultists' are fans but not all fans are cultists, since a cult is more narrowly focused on individual films than on a broader genre. Cultists may in fact seek to distance the cult object from any genre ('*The Wicker Man* is no more or less a horror film than *Performance* [1970] is a gangster film or *A Clockwork Orange* [1971] science fiction' (Smith 2010, 89)); *Room 237*'s theories about *The Shining* invoke the horror and the haunted house film only to describe Kubrick's transcendence of them. While cults have attached themselves to films far from the horror genre (think of *Casablanca* (1943), *Harold and Maude* (1971), *This Is Spinal Tap* (1984), *The Big Lebowski* (1998) or *The Room* (2003)), it is also the case, as Ernest Mathijs and Jamie Sexton (2011) put it, that 'the term "cult" is probably at its most mobile, and in the most danger of being over-used, when it is discussed in relation to the horror genre' (194).[9] In the 1960s

[9]See also O'Toole (1979), Everman (1993), Paszylk (2009).

and 1970s, independent films that circulated in non-standard ways attracted countercultural audiences, among them *Carnival of Souls* (1963), *Night of the Living Dead, Last House on the Left* and *The Texas Chain Saw Massacre*. 'Without elaborate publicity campaigns, and distributed outside regular markets, they shocked audiences because they appeared out of nowhere, at matinees, inner city theaters, on the midnight movie circuit, and on college campuses' (ibid., 196).

Mathijs and Sexton propose a set of characteristics of horror films that attract cult followings, including the presence of a memorable monster, and a tendency towards reflexivity and hybridity: 'the self-conscious ways in which horror films … comment upon their own status as horror' (200). They suggest that the horror films most likely to generate cult followings are perceived as unvarnished and relatively lacking in reflexivity (like *Night of the Living Dead* or *Henry: Portrait of a Serial Killer* (1986)) or as full of reflexivity – put differently, either hyper-serious or avowedly unserious. Perhaps the ultimate example of the latter is *The Rocky Horror Picture Show*. This much-studied cult favourite (Austin 1981; Weinstock 2008) cheerfully straddles generic lines but is more rarely discussed with reference to the horror film than to science fiction or the musical.

Sometimes cults are regional. In Winnipeg, Manitoba, there was and to some degree remains a sizeable following for Brian de Palma's *The Phantom of the Paradise* (1974), a musical reworking of *The Phantom of the Opera* with a contemporary setting. The film ran for four and a half months in the Garrick Theatre during the frigid winter of 1974–5, attracting a proto-*Rocky Horror* ritual audience that led to the film locally out-grossing *Jaws*. The soundtrack sold 20,000 copies, and when the film's lead actor, Paul Williams, played a concert in Winnipeg in June 1975, he was mobbed like a Beatle. Decades later, Winnipeg would host Phantompalooza, an annual fan convention.[10]

It is also the case that cultists of a given film linked with the horror genre can profess little knowledge of or experience with the genre itself. In a study of fans of the *Ginger Snaps* trilogy (2000, 2004, 2004) conducted by Martin Barker, Ernest Mathijs and Xavier Mendik,

[10]See http://www.phantomoftheparadise.ca/ for an exploration of the Winnipeg *Phantom* phenomenon.

fans were far less likely to correlate loving the film with a general love for the horror genre than with appreciating *Ginger Snaps*' own specific themes (20). Elsewhere, Mathijs and Sexton describe how 'the cult status of *Ginger Snaps* largely lies with how it links cultists from various cultural communities (horror, Goth, Lesbian, feminist) around an affective catch-phrase ("morbid sisters") that allows the building or facilitating of bridges between each of these communes' (22). So it is certainly the case that fans of a cult horror film need not be fans of 'horror' more broadly.

Cult value is often attached to horror films of the 'so bad it's good' variety, where audience responses straddle derision of poor special effects, stilted performances, etc. and veneration of low-budget filmmakers who managed to produce memorable films in absence of resources or apparent talent. In 1995, Jeffrey Sconce proposed the term 'paracinema' to describe those marginal genres of films well outside the bounds of 'legitimate' cinema, including some kinds of horror films like splatter films and the works of 'trash auteurs' like Edward D. Wood, Jr., Dwain Esper, Lucio Fulci and Herschell Gordon Lewis. Sconce sees

FIGURE 6.2 *The sisters at the centre of* Ginger Snaps *(2000).*

the valorization of paracinema as a strategy of counter-taste deployed against the safeness and blandness of Hollywood's prestige products: 'a pitched battle between a guerrilla band of cult film viewers and an elite cadre of would-be cinematic tastemakers' (372). Paracinema, Sconce argues, is largely separate to middlebrow tastes but allies more strongly with high art and the avant-garde in recognition of its transgressive aesthetic and even political sensibilities. Jancovich has noted a danger in this approach as well, in its tendency to construct 'a clear sense of distinction between the authentic subcultural self and the inauthentic mass cultural other' (2002, 313).

Debating horror

Horror fans can have very different priorities. Some value subtlety and suggestion, some gore and excess (Jancovich 2002b, 152). Individual films have proved flashpoints for fan debate as to their value and importance to the horror genre or even their status as 'legitimate' horror films (those films that successfully harness subcultural capital). Such values are often shaped by advertising and reviews. Jancovich has examined how *The Silence of the Lambs* was promoted as a well-made thriller, an auteur piece by Jonathan Demme and a star vehicle for Jodie Foster, carefully distancing it from the horror genre (ibid.). Similarly, Thomas Austin studied the promotion and reception of *Bram Stoker's Dracula*, which was 'variously advertised, reviewed and consumed as the latest creation of an auteur [Francis Ford Coppola], a star vehicle (for any of four stars), an adaptation of a literary 'classic', as horror, art film or romance, or as a mixture of these genres' (114). It was thus calculated to serve different audiences simultaneously, but Austin also found that self-identified horror fans often rejected *Bram Stoker's Dracula* as a mainstreamed and thus neutered version of the horror film, as a handsome but unfrightening film (135–6). He also found that female audiences, somewhat corroborating Cherry's findings, were more likely to express fondness for the sympathetic portrayal of Dracula and to enjoy the emphasis on emotion, romance and eroticism. Therefore, the case that the rejection of *Bram Stoker's Dracula* as 'impure' or 'illegitimate' horror is linked to the devaluation of the traditionally feminized and romanticized mass culture.

FIGURE 6.3 *Romance competes with horror in* Bram Stoker's Dracula *(1992).*

Scream also provided a flashpoint for debates about horror. Certainly, *Scream* courted horror fans with its sympathetic portrayals of horror fans like Randy (Jamie Kennedy) and its web of intertextuality with previous films. However, as Matt Hills notes, it avoids alienating other audiences and so does not 'presuppose "underground" fan knowledge' (2005, 187). Though it certainly rewards subcultural capital on the part of audience members able to recognize a reference to *Suspiria* or *I Spit on Your Grave*, *Scream* also attracted a broad crossover audience, including younger viewers not especially familiar with *Halloween* and its ilk. As Jancovich has noted, some hardcore horror fans actively opposed and disparaged *Scream* and its following with 'us and them' rhetoric, positioning it as inauthentic horror and its fans as inauthentic horror fans. The *Scream* franchise was dismissed as 'trendy horror', with one fan writing, 'They've demeaned you enough, slapping the label of the genre you love on epic tales featuring scantily clad, barely legal teen starlets' (qtd. in Jancovich 2000c, 30), another trace of that strategy of de-legitimation through feminization. Such rhetoric both unifies and stratifies: it '[addresses] like-minded fans but, in the process, it denigrates and Others those fans that it denies as authentic and so presents its tastes as inherently superior to them' (ibid.).

As we have seen, the emergence of the 'splat pack' in the 2000s and to some extent the international popularity of Asian horror in the same period were a reaction against *Scream* and the resultant neo-slasher cycle. Both filmmakers and marketers rallied subcultural capital to market to horror fans displeased with the state of the genre and searching for 'authentic' iterations of horror as a reaction against the neo-slasher's position as the ostensible face of the horror film. In an interview promoting *Cabin Fever* (2002), his first feature, Eli Roth railed against what he saw as deceptive and cowardly mislabelling of horror films:

> God I hate it when they do that – these marketing people who make up terms to avoid calling something a horror movie because, after all, horror movies don't win Oscars, right? That's something that they figured out with *Silence of the Lambs* – it's not a horror movie, it's a violent thriller. It's bullshit is what it is. Thrillers are smart – horror movies are from Mars, but thrillers are *Hitchcockian* – you call *Misery* [1990] a 'thriller' and Kathy Bates goes home with an Oscar. Then you have *28 Days Later* and Danny Boyle comes out and calls it a 'viral thriller' – what the fuck's a 'viral thriller?' Dude, you steal the last third of your fucking movie from *Day of the Dead* and the rest of the film from *Day of the Triffids* [1962], and it's *not* a horror movie? That's spitting in my face. (n.p., original emphasis)

With fan-style personal language (the apparent mismarketing of *28 Days Later* framed as a personal affront), Roth articulates the accurate claim that horror films are not generally available to middlebrow prestige as represented by the Academy Awards, as well as condemning the dalliances in horror of a 'legitimate' director like Boyle as insincere. At the same time as he excoriates these 'mislabelled' films, he indicates that the neo-stalker-dominated contemporary horror genre is worth distancing oneself from: 'All the same, I have a little sympathy. I mean, why would you align yourself with *I Know What You Did Last Summer* and *Valentine* and shit like that … or whatever horrible teenybopper stuff carted out there as "horror" now for 14-year-old girls' (n.p.). Roth casually ties the 'bad object' of the neo-slasher to youth and femininity, implicitly

positioning himself as a suitably masculine and subcultural capital-possessing alternative.

More recently, *The Cabin in the Woods* inspired similar debates. In 2014, *Slayage: The Journal of Whedon Studies*, devoted to the works of Joss Whedon, published a special issue on *The Cabin in the Woods*. Its editors ask of the film:

> Is it a deconstruction of a horror genre in a state of crisis? Is it a fractured film, caught between the auteurist sensibilities of Whedon and the straightforward directorial approach of [director Drew] Goddard? Is it a satire of media excesses and reality TV game shows? Is it a straightforward splatter-comedy? (Woofter and Stokes n.p.)

A number of the essays in this issue address the question of *The Cabin in the Woods*'s attitudes towards the horror film and its fans. In its conscious commentary on the state of the genre, it exemplifies the 'rhetoric of crisis' (Hantke 2007) that response to an apparent post-millennial dearth of (especially American) horror films of value, while staging a commentary on a repetitive, creatively bankrupt and even immoral genre. Whedon referred to *The Cabin in the Woods* as a 'loving hate letter' to horror films:

> Drew and I are enormous horror fans but we both lamented the trend in torture porn and dumbing down with character falling more and more into stereotypes. Take the ad campaign for a movie called *Captivity* [2007], where the billboard showed basically kidnap, torture and execution, in that order. That encapsulated the way I felt horror movies were going: they were becoming this extremely nihilistic and misogynistic exercise in just trying to upset you, as opposed to trying to scare you. The classics that Drew and I went back to – the Carpenters, the *Nightmares* – it seemed they had a different intent: it was not strictly about shock value. (qtd. in Nelson n.p.)

From their position as fan-filmmakers, Whedon and Godard propose to save horror from itself. Like the 'splat pack' filmmakers, they position the horror of the 1970s and 1980s as an authentic form

of horror, a kind of paradise lost, but ironically they are defining it specifically against the splat pack's own emulations of it.

This is not a new strategy. An earlier deliberately fan-allied reflexive horror film, *Fright Night*, was also a deliberate throwback to a 'lost' mode of horror film, this time the vampire film, which positioned itself against newer, revisionist works. Director Tom Holland particularly objected to the arty reworking of vampire lore in Tony Scott's *The Hunger*: 'It was godawful, because it was a picture ashamed of its genre. It didn't use the word vampire once. I wanted to bring it back' (qtd. in Leeder 2009, 192). As noted in Chapter 3, *Fright Night* also explicitly condemns the slasher film. In Holland's case, however, the vanished mode lay with Universal and especially Hammer's vampire films. It is hard to overlook the fact that in both cases, the 'authentic' version of horror aligns roughly with the filmmakers' own youths.

While *The Cabin in the Woods* was generally well received, some fans want to expel it from the horror genre altogether. In October 2015, more than three years after the film's release, The A.V. Club ran an article called, 'Is *the Cabin in the Woods* a Horror Movie?' featuring the duelling perspectives of Becca James and Alex McCown-Levy. James's is the dissenting voice: though identifying herself as a huge horror fan ('if it is horror, I will watch it'), she wants to exclude the film as horror because it is too calculated for comedy. Rather than the balance *Scream* achieves (*Scream*'s own controversial fan reception effaced), she argues that

[*The Cabin in the Woods*] got very close to *Scary Movie* territory for me, focusing almost solely on the humour and forgetting the horror. In the same way a magic trick loses its ability to amaze once the secret is revealed, *The Cabin In The Woods* lost its ability to be actual horror when it stripped away all suspense. So, go ahead and file this under some other genre and I'm fine with it; still largely disinterested, but fine. (n.p.)

As we have seen, nothing seems to endanger horror's status as horror as much as comedy. Against James's critique, McCown-Levy defends the film as not only a horror film, but as an excellent one. It is a useful illustration of how the spaces of fan interaction prove venues for debate, but that debate often is aimed at reshaping the

genre itself through implicit or explicit appeals to 'legitimacy' or 'authenticity', often related to a sense of generic purity.[11]

Also of interest is 'anti-fandom', the passionate and vocal dislike of certain properties and their fans. In horror, the obvious example is the *Twilight* franchise and its adherents. Though many insist that these are, despite featuring stock horror monsters like vampires and werewolves, not horror films, the reaction of anti-fans is not simple lack of interest but vocal hatred. Victoria Godwin notes that 'anti-fans position *Twilight* fans as hysterical, out-of-control female or feminised Others', while simultaneously holding that 'vampires who exhibit romantic behaviours are not "real" vampires and thus not worthy of inclusion in horror genres perceived as masculine' (94; see also Bode 2010; Sheffield and Merlo 2010). Such policing of 'legitimate' vampires is nothing new: in their time, the novels of Anne Rice's *Vampire Chronicles* were criticized along similar lines, as was, as we have seen, *Bram Stoker's Dracula*.[12] Again, the rhetoric of 'purity' and 'authenticity', here defined against the 'inauthentic' *Twilight* phenomenon, with decidedly gendered assumptions underlying these categories of taste.

An obvious historical feature of horror fandom is cyclicality, with similar debates being staged and restaged, simply with different objects (*Bram Stoker's Dracula* to *Twilight*, *Scream* to *The Cabin in the Woods*, and with the mixed reception of *The Witch* reflecting dozens of other arty, restrained horror films). It is also clear that fans and the discourses that they create can no longer be safely ignored by either the film industry or by scholarship that they constitute a recognized block of power in the process of making meaning.

[11]More recently, see Coffman (2016) for a critique of 'horror's gatekeepers' and their opposition to films like *The Babadook, It Follows, Crimson Peak* and especially the then-newly released *The Witch*.

[12]In *John Carpenter's Vampires* (1998), mercenary vampire killer Jack Crow (James Woods) explains that 'real' vampires are 'not romantic. It's not like they're a bunch of fags hopping around in rented formal wear, seducing everybody in sight with cheesy Euro-trash accents. Forget whatever you've seen in the movies.' The then-recent adaptation of *Interview with the Vampire* is the most obvious target against which the film defines its thoroughly monstrous vampires.

7

Shocking and Spooky Sounds

In *Theory of the Film* (1949), the Hungarian film theorist Béla Balázs relates an amusing anecdote that illustrates how any film can be read as horror film, based on the cultural training or lack thereof possessed by an audience member. It concerns a girl raised on a Siberian collective farm, who while intelligent and well educated has never seen a motion picture. She is visiting her urban cousins in Moscow and is left alone at the theatre. When she comes home pale and grim, her cousins ask her how she liked the film:

> She could scarcely be induced to answer, so overwhelmed was she by the sights she had seen. At last she said:
> 'Oh it was horrible, horrible! I can't understand why they allow such dreadful things to be shown here in Moscow!'
> 'Why, what was so horrible then?'
> 'Human beings were torn to pieces and the heads thrown one way and the bodies the other and the hands somewhere else again.' (34–5)

The point of this fictitious tale is that, for Balázs, cinematic conventions are the result of a certain visual training, and without them, the conventions of the close-ups elude the Russian peasant girl and she interprets the cinema as a sick horror show. It is a similar anecdote to the more familiar tale of the bourgeois Parisians, who paid to see moving pictures exhibited for the first time in 1895 being

transformed into panicking savages by the appearance of a train heading towards the camera. Whether or not this really happened is in some ways immaterial; its persistence reflects how early cinema's spectators are often understood as being possessed by what Laura Mulvey calls a technological uncanny: 'the sense of uncertainty and disorientation which has always accompanied a new technology that is not yet fully understood' (27). The sense of unease and outright shock constitutes the complementary double of the reception of early cinema as a new technological wonder that delivered on the promise of moving pictures.

Cinema, which hovers between animate and inanimate status and provides infinitely repeatable doubled images of the world, seems to contain bottomless uncanny potential. It is thus subject to what has been called the 'technological uncanny', a phrase that plays on the psychoanalytic conception of the uncanny or unheimlich, as discussed in Chapter 5. As Mulvey notes, this sense of the technological uncanny diminishes with familiarity, especially since most cinematic practices have sought to minimize it. But just as Freud's uncanny resides in familiarity, this technological uncanny remains as a buried property of the medium that a filmmaker can foreground and exploit – and horror filmmakers do this more conspicuously than others. It has been suggested that horror may be 'intentionally or unintentionally, the most self-reflexive of cinematic genres' (Clover 1992, 168), in part because of that willingness to refer to its own formal properties and exploit them for shock or unease. Put differently, the fact that horror's audiences often expect less-than-absolute immersion within narrative allows a horror film a certain latitude for stylistic ostentation and reflexive commentary that would be less natural in other genres. The following three chapters explore this process with three technological dimensions of cinema: sound, colour and the digital.

Sound matters

Peter Strickland's *Berberian Sound Studio* (2012) starts with the arrival in Italy of a meek English sound engineer, Gilderoy (Toby Jones), to do

postproduction work on a film called *The Equestrian Vortex*. Only once he reaches Italy does he realize that it is a violent *giallo*, though the director, Francesco (Cosimo Fusco), refuses to use the word 'horror' to describe it. Gilderoy reluctantly complies with his tasks. Many watermelons are stabbed and smashed to approximate damage to the human body, many women scream voluminously into microphones and boiling water substitutes for the sound of sizzling human flesh. *Berberian Sound Studio* is set in the 1970s and Strickland's camera lovingly studies the analogue sound technologies; the innards of the cinematic apparatus are on display in place of actual guts. We only get clues about what *The Equestrian Vortex* is about – like Argento's *Suspiria*, it has something to do with evil witches. Haunting female voices fill the soundtrack, and we get hints of violence and misogyny both within the film and on the part of its makers, especially the perverse Francesco.

In the middle of the film, a disgruntled actress turns against the production and destroys all of her voiceover work, forcing them to recruit a new actress to replace her and trapping the increasingly unhinged Gilderoy in the work. Gilderoy suffers what appears to be a mental breakdown, seeing himself within a fragile, decaying filmstrip while a discordant sound mix plays. We then seem to enter an alternate reality, where Gilderoy speaks fluent Italian, and he appears to be both an actor in the film and its sound editor. By the end, the film mires the viewer in confusion and mystery about what is real and what is dreamt or hallucinated, rather like *Mulholland Dr.* (2001) or *The Cabinet of Dr. Caligari*: is Gilderoy insane? Does the entire story unfold in his head? Has he fallen under a witch's curse through his work on the movie? Have multiple, parallel universes intersected? These ambiguities are related to sound's own indeterminacies. *Berberian Sound Studio* joins *The Conversation* (1974) and *Blow Out* (1981) in the select company of films that reflexively foreground sound production and the practice of listening, and it does so to provide a commentary on the uncanny and terrifying potential of film sound. One of its striking features is that we never see anything of *The Equestrian Vortex* (though we do see Gilderoy and other characters watching it, their faces bathed in red from the screen), and can only imagine the horrific imagery these sounds are meant to accompany. Rather than comforting us, the lack of visuals

increases the film's sense of unease. *Berberian Sound Studio* is in the select group of horror films that can almost be said to include no violence – no violent imagery, that is, because its soundscape is disturbing in spite of the lack of accompanying horrific imagery. Or perhaps, *because* of the lack thereof.

Berberian Sound Studio is an opaque, almost unclassifiable film. Its major value to the purposes of this chapter lies in how it foregrounds horror's status as an audiovisual genre. Film scholars generally divide film sounds into three categories: voice, music and sound effects. We also distinguish between diegetic sounds (those purporting to originate from within the film's world) and non-diegetic sounds (those not originating from within the film's world, like mood music or 'Voice of God' narration). These types of film sound are all highly relevant to horror, and, as this chapter will suggest, horror has a particular tendency to undermine the distinctions between them. The significance of sound to horror arguably even predates the introduction of sound technology to cinema in the late 1920s. Silent cinema is a misnomer for a couple of reasons. Films were rarely exhibited in complete silence, but were rather accompanied either by a lecturer/barker explaining the content (especially early on) or by music, ranging from a single tinkling pianist to a full orchestra. In addition, characters could hear even if the audiences could not, and it is surprisingly common to see characters in silent films react to sound cues. Take the end of *Nosferatu*, for example: the image of a crowing cock cues the reaction shot of Graf Orlak rising from feeding on Ellen. We cannot hear it, but the vampire presumably can, and we read the slow realization of his impending demise on his face in part because of the 'sound' that preceded it.

Silent directors also explored using superimpositions to represent sound in silence. Notably, in *Strike* (1925), Sergei Eisenstein superimposed an accordion over an early sequence to develop a sense of musicality (80). Paul Leni tried something similar in *The Cat and the Canary*, using superimpositions to represent someone knocking at a door and the chiming of a clock (Natale 2015, 70). In a ghost film (albeit one in which the ghosts prove to be the products of psychology and trickery rather than 'legitimately' supernatural), this aesthetic inevitably reaches back to the heritage of superimposition effects in spirit photography and other attempts to visualize ghosts as

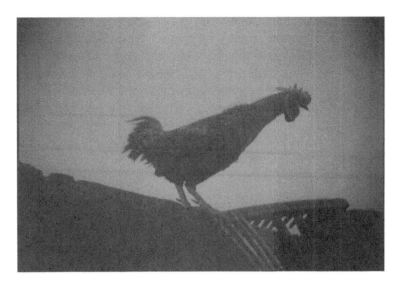

FIGURE 7.1 *The cock crows at the end of* Nosferatu *(1922).*

airy, half-present figures simultaneously present and absent on the level of image.

And is it not the same with sound? Is sound not simultaneously present and absent from the image, much the same as a superimposition? As Salomé Voegelin writes,

> Sounds are like ghosts. They slink around the visual object, moving in on it from all directions, forming its contours and content in a formless breeze. The spectre of sound unsettles the idea of visual stability and involves us as listeners in the production of an invisible world. (12)[1]

The uncanny potential of sound is something that cinema has generally tried to manage and minimize. Fitzhugh Green's 1929 book celebrating the arrival of sound in cinema bore the name *The Film Finds Its Tongue*, promoting the narrative that, for the previous three

[1] The ultimate exploration of the sound-as-ghost paradigm may be the British TV movie *The Stone Tape* (1972), written by Nigel Kneale.

decades, film had been inadequate, crippled and incomplete without sound. But spectators told a different tale: Robert Spadoni's study of reviews of early sound films suggests that the actors seemed 'distinctly *less* alive than before' (2007, 22). Indeed, the early sound era are replete with thin, reedy sound mixes and a clumsy balance of sound effects, music and voices, as the industry worked through the teething problems of the transition; while these qualities are the subject for mockery in *Singin' in the Rain* (1952), they only add to the fascination of these horror films. I sometimes do an exercise in class showing the early sequence of Renfield arriving in Castle Dracula and meeting his host at the beginning of the 1931 *Dracula*s – both the English-language version and the Spanish-language equivalent, shot at night on the same sets. The differences between the two are famously striking, but one element that students tend to latch onto is sound. The sound mix in the Spanish version is much richer and more layered: howling wolves, creaking doors and the voices are clearer and warmer. In both films, the doors in Castle Dracula open and close on their own, but the Spanish version makes it more apparent by synchronizing the motion with a creaky sound effect. But my students are always of mixed opinion as to which is better: the comparative rich and layered soundscape of the Spanish-language film or the thin, hollow soundscape of the English-language one? Both are effective in their own way, but the English-language film better showcases the uncanny potential of film sound, in part because of its own inadequacies.

Many other Golden Age horror films make fascinating use of sound. The opening sequence of *Frankenstein* has almost no dialogue and gains much of its effectiveness from sound effects: the wind whistling through the cemetery, and the thud of a shovelful of dirt landing on top of a coffin. Spadoni reports that 'this moment impressed the *Variety* reviewer, who called it the film's "Shudder no 1"' (2007, 101), and it obviously had sufficient impact as to be explicitly recalled in Lord Byron's (Gavin Gordon) recap of the first film at the beginning of *Bride of Frankenstein*. The uncertain, awkward sound environments of classic horror films constitute a large part of their lasting effectiveness. Take the opening of *The Mummy*. Three Egyptologists discuss a newly unearthed mummy, their voices crisp with a slight echo appropriate to the enclosed setting. Eventually the

overeager young assistant, Ralph Norton (Bramwell Fletcher), is left alone with the newly unearthed Scroll of Thoth. We hear only a few minor sound effects as he removes and unrolls it, and then reads its contents aloud. The sequence of the mummy Imhotep's (Boris Karloff) awakening is tantalizingly silent. Norton begins translating the forbidden scroll, and the camera pans left to emphasize Imhotep, and right back to Norton. It tracks in closer to Norton as he begins mouthing the words, but no sounds emerge. The silent repetition seems to be enough, however, as the film cuts to a close-up of Imhotep, slowly opening his eyes, and then tilts down to show us his arms beginning to rouse. We see Imhotep's hand reach out to grab the Scroll of Thoth, and then follow Norton's bewildered reaction as he sees what's happening. His delayed cry of shock shatters the silence, and we see no more of Imhotep in this sequence. Norton begins laughing maniacally, and the camera pans the room to catch Imhotep's bandages trailing him as he leaves the room. Norton's laughter comes close to hyperventilation before the other characters return to the scene. 'He went for a little walk!' Norton says between spells of laughter as they question him. 'You should have seen his face!' The combination of the still, silent ambience of the scene and Norton's eruption into mad, echoing cries and laughs makes the sequence sublimely creepy, even though we catch only brief glimpses of the animate mummy.

Let us turn to a less examined Golden Age horror film: 1933's *Supernatural*. It was Victor Halperin's studio (Paramount) follow-up to the successful independent *White Zombie*, and like that film, its soundscape alternates between stifling silences and repurposed classical pieces, often coordinated with the film's imagery with surreal looseness. The film begins with a montage sequence concerning the capture, trial and impending execution of serial strangler Ruth Rogen (Vivienne Osborne). A set of dissolves, superimpositions and interspersed newspaper headlines relates this backstory, accompanied both by music and, critically, by a set of voiceovers from the cackling, unrepentant Rogen (sometimes but not always simultaneous with her image). Subsequently, Dr Houston (H. B. Warner) visits the warden with his theory that once Rogen is killed, her malignant spirit might possess others to commit similar crimes, and wants to bombard her corpse with 'nitrogenic rays' to test this thesis.

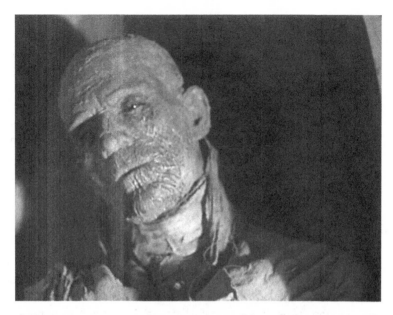

FIGURE 7.2 *Imhotep (Boris Karloff) wakes in* The Mummy *(1932).*

Meanwhile, the rich heir John Courtney has died at the age of twenty-four, and his twin sister, Roma (Carole Lombard), becomes the target of Rogen's old associate, a fake spiritualist named Paul Bavian (Alan Dinehart). We first see Roma after John's funeral, and his superimposed face (a ghost? A memory?) fills the half of the frame opposite to her. This appearance is briefly underscored by a sonic phenomenon that we might call the 'ghost noise', associated with the presence of supernatural beings throughout the film: high-pitched electronic tonalities with a resonant, shimmering effect. Musically speaking, its effect resembles tremolo, which for centuries has been a stock device for creating suspense; in Carl Maria von Weber's opera *Der Freischütz* uses it during the 'Wolf's Glen Scene' specifically to suggest the presence of the supernatural.[2] It is unlike anything else in the film's audio world, an

[2]Thanks to Daniel Sheridan for this insight, and to Paul Jasen, Michael Baker, Randolph Jordan and Benjamin Wright for their helpful thoughts on the ghost noise.

alien 'sound from beyond the grave'. Paradoxically, the sound seems non-diegetic insofar as no character demonstrates any awareness of it, but diegetic insofar as it heralds the presence of beings that are active, if invisible, parts of the story world. It is the aural equivalent to and often accompanies the superimposed images of ghosts throughout the film that similarly are for the eyes of the audience only (John's ghost seems to be constantly breaking the fourth wall and gazing out at the audience), echoing the already noted superimposition-sound link from the silent era. K. J. Donnelly writes, 'Since the advent of synchronised sound, non-diegetic music has graced films as a spectral presence, one that sits uncomfortably with the mimetic "realism" of the on-screen world constructed in mainstream cinema' (8); *Supernatural* provides a useful example. The ghost noise tests the representational conventions of cinematic sound in several ways, standing at the juncture of music and sound effects and of diegetic and non-diegetic sound.

The ghost noise may also allude to the key role of audio phenomena in the history of spiritualism. As Steven Connors notes, 'The members of the séance would see much less than they would touch, taste, smell and, most importantly, *hear*' (208, original emphasis). Preparing his sitters, Bavian even likens himself to sound technology: 'Hostility affects me the same as static affects radio reception.' Commercial radio was also a relatively new technology in 1933, one fraught with supernatural implications (Sconce 2000, 59–91), and its availability to spiritualist rhetoric was consistent with the spiritualists' embrace of technologies in the previous century (notably, telegraphy and photography).

The grieving Roma plays an amateur record that she and John made together when they were younger, the voice of a dead man preserved through technology providing a sideways nod to the return of the dead throughout the film. Soon, she encounters his voice again, or a facsimile of it, at Bavian's séance. Before she arrives, however, we see him rig tricks in his room, including hidden projectors, panels and chimes, as well as a 'levitating' trumpet hanging from the ceiling. At the séance, a ghostly version of John's face appears (actually a plaster death mask Bavian secretly made from John's corpse), the trumpet lowers and Roma hears a purported message from John.

It is really a faked recording, its hollow, faraway sound functioning to convince its listeners that it is voice from beyond the grave.

But if Bavian's mediumship is fake, within *Supernatural*, the ghosts are nonetheless real, and a non-diegetic sound, the ghost noise, marks the difference between the phony and genuine manifestations. At the second séance, Bavian provides the music himself, playing a piano, but its sound competes with the ghost noise on the soundtrack as the real ghost of Ruth Rogen begins to possess Roma during the fake séance. From here, Rogen seeks revenge on Bavian, a former accomplice who betrayed her to the police, and is prepared to kill Roma in the process. Dr Houston and Roma's fiancé, Grant (Randolph Scott), try to track them down, aided by directions from the ghost of John (once again accompanied by the ghost noise). The vengeful Rogen, with her distinctive mad laugh cackling out of Roma's mouth, struggles with Bavian on her yacht and chases him out onto the rigging. We see the superimposed figure of Rogen leave Roma's body. Ropes move around Bavian's neck and he falls to his death, even while the disembodied cackle continues on the soundtrack. Is it audible only to Bavian, or is it an extra-diegetic element for the benefit of the audience? Impossible to say, but the laugh loops and loops back on itself like a jumping needle on a record, spookily foregrounding the recordedness of film sound. The laughter grows fainter and fainter as we see a silhouette of Bavian's dangling corpse, presumably because Roma's spirit is dispelled with the completion of her revenge.

Like many early sound-era horror films, *Supernatural*'s soundscape, at turns clumsy and eerie, is nonetheless attentive to the genre's possibilities for manipulating sound and image and their relationship to harness the uncanny. The separation of body and voice is alluded to in so many ways: John's recorded voice on the record Roma plays, the voice fakery during the séance, Rogen's cackle on the soundtrack. The film ends with a more playful twist on ghostly manifestations, as we hear the ghost noise return as the superimposed head of John conjures a wind to flip an issue of *Vanity Fair* advertising honeymoons in Bermuda, which dissolves into an image of Grant and Roma kissing romantically. The forced united-the-heterosexual-couple happy ending so common in Golden Age horror films is here accomplished by a sort of *spiritus ex machina*. The presentation of John as a benevolent

spectre, however, seems like a strained attempt to nullify the uncanny impact of Ruth Rogen and the 'possessing' aspect of film sound that she implies.

A Rocky marriage: Sound fidelity and infidelity

Rene Thoreau Bruckner refers to the relationship of cinematic sound and image as a marriage, but notes that it is always a rocky one (104) based around the idea of sync: the idea that the sounds and image come from the same place at the same time. It is such within the classical narrative cinema: in other cinematic traditions, notably avant-garde cinema, the relationship of sound and image can be very different, but the classical style insists on a domesticated sound, implicitly secondary to the image. Breaching this relationship has a variety of potential effects. These can be humorous, as in *Singin' in the Rain*, where the ill-fated premier of the film-within-a-film *The Dueling Cavalier* includes the sync breaking down so that the leading lady and the villain appear to speak each other's lines ('Yes, yes, yes!' 'No, no, no!'). Or they can simply be perplexing, disorienting. In horror, however, such breaches in sync can be used to create eerie and disturbing effects that threaten to reveal the uncanny subtexts of the image–sound relationship.

Similar effects apply to another key concept in film sound: sound fidelity. David Bordwell and Kristin Thompson define fidelity as 'whether the sound is faithful to the source as we conceive it' (283). The term does not describe the *actual* source of the sound. A character's voice may be overdubbed during ADR (additional dialogue replacement) in postproduction either by the same actor or by a different one, and sound effects are frequently 'play' by completely different sounds (like the use of coconuts for horse hoof steps, famously lampooned in *Monty Python and the Holy Grail* (1976)) or fully synthetized. But none of these techniques violate sound fidelity so long as we are not conscious of the 'false' origins of the sounds but accept them as convincing. We are not accustomed to films reminding us of the arbitrariness of the relationship between

cinematic images and sounds, and questions of truth, authenticity and ontology lurk around questions of audio fakery. Early audiences of sound films were obsessed with questions of aural authenticity. Nataša Durovicová argues that the advent of sound brought with it a new uncertainty of the relationship of body and voice, raising questions like:

> Is the relationship between a body and its voice qualitatively different from that between, say, a body and a leg? And from there, is the metaphysical conduit to the truth with which voice is imbued in most cultures, its privileged resonance with an inner 'self', something that the medium must take into account in its representation? (86)

Durovicová describes an audience ready to interrogate any technologically accomplished incongruity between performance and performer. Though audiences surely become more comfortable with voice faking over time (witness the late Marni Nixon's visible (?) career as a voice-double for actresses like Deborah Kerr, Audrey Hepburn and Natalie Wood), we largely remain committed to the notion of sound *fidelity* – that every noise the film presents as diegetic, whatever its actual providence, should correspond naturally to an apparent source in the cinematic world.

Horror films often denaturalize this relationship of image and sound, body and voice, to create uncanny effects. Violations of the conventions of sound fidelity can also be terrifying. *The Exorcist* is a great example, with the deep and raspy voice of the (initially uncredited) older actress Mercedes McCambridge unleashing a torrent of blasphemies and vulgarities from the mouth of twelve-year-old Linda Blair. Or take the moment in *The Legend of Hell House* (1973) when Florence Tanner (Pamela Franklin) is being comforted by fellow spirit medium Ben Fischer (Roddy McDowall) after experiencing torments at the hands of the unseen, ghostly torturer Emeric Belasco. At Fischer's statement that 'he can't stop me', Tanner's whole demeanour suddenly changes and she sits bolt upright. 'Who the hell do you think you are, you bastard?' comes a deep, distorted male voice from her mouth. This brief moment of possession is startling in part because of the breech of the

conventions of sound fidelity. Previously, Tanner, a devoutly religious spiritualist, quoted Ezek. 3.27: 'I will open thy mouth, and thou shalt say to them: Thus saith the Lord,' yet her desire to act as a vessel for God's voice is perverted as she becomes an unwilling mouthpiece for the devilish Belasco.[3]

Throughout *The Legend of Hell House*, Belasco functions as a good example of what Michel Chion dubbed the *acousmêtre*: a voice that is heard as part of the cinematic environment but not connected to a body on the screen, thus attaining an impression of omnipresence and disembodiment. *Acousmêtre* do not breech the marriage of image and sound so much as invert it – they prioritize sound by situating it above the level of image, and this has uncanny potential since we expect the opposite. Writes Chion, 'The powers [of the *acousmêtre*] are four: the ability to be everywhere, to see all, to know all, and to have complete power'; acoustmêtric forces include 'the voices of invisible ghosts who move about wherever the action goes, and from whom nothing can be hidden' (Chion 1999, 24–5). Key examples include the Wizard in *The Wizard of Oz* (1939), Dr Mabuse in *The Testament of Dr. Mabuse* (1932) and Mother in *Psycho*, all of whom are eventually subject to what Chion calls de-acousmatization, where the voice is eventually pinned to a fragile, conquerable body on the screen – 'Pay no attention to the man behind the curtain!'[4]

So it is with Belasco in *The Legend of Hell House*, at least to a degree. He appears purely disembodied and invisible throughout the film, a cruel and capricious monster of a spirit. Subtle sound effect, low whispers and unnerving electronic noises suggest his presence throughout the film, but we hear him speak only on two occasions: on a phonographic record of his voice and when he possesses Tanner. His body, we are told, was never uncovered when the rest of his household was found dead decades earlier. At the film's climax, however, the surviving characters uncover his corpse in a lead-shielded tomb at the heart of Hell House. Belasco had it preserved

[3]For more on *The Legend of Hell House*, see Leeder (2014b).
[4]In *Poltergeist*, Carol Anne (Heather O'Rourke), whose voice is heard but her body not seen to her parents' consternation, is an unusual case where the *acousmêtre* is a victim rather than a villain.

before his death so it sits staring blankly at the protagonists as they penetrate his inner sanctum, a brandy in his hand. The corpse looks ready to speak (an impression bolstered by the fact that it is 'played' by the familiar British actor Michael Gough) but sits silently. Without the sound cues associated with Belasco's ghostly presence, we know him to be, finally, *dead*.

Halloween, I have argued (Leeder 2014a, 48–50), reverses the de-acousmatization process outlined by Chion. The film plays effectively with the materiality and immateriality of Michael Myers throughout. In numerous scenes, Laurie appears to glimpse him only to find him gone (across the street from her classroom, peeking out from behind a hedge, standing amid the clothesline in her backyard). Is he there or isn't he? Throughout the film he is associated with two sets of sounds, one diegetic (the heavy breathing from behind the mask, which at one point is even mistaken for a clichéd obscene phone call) and one non-diegetic (John Carpenter's famous electronic score, driven by drones and ostinati). The latter, especially, works to construct Michael's presence in shots and scenes from which he is physically absent. For example, when Laurie sees him outside of her bedroom window, the music bursts onto the soundtrack at the instant he appears on the screen, but continues well after he is gone to underscore Laurie's puzzlement and anxiety. In the seemingly incidental subsequent scene where Laurie walks down the street and watches children trick-or-treating while waiting to be picked up by Annie (Nancy Loomis), the nervous ostinato on the score tells us that Laurie is still dwelling on her sightings of Michael, or perhaps even that he is still watching her from some unknown vantage. Scholars like K. J. Donnelly (2005) and Isabella van Elferen (2012) have discussed the haunting quality of non-diegetic film music, with Donnelly noting how in *Night of the Demon*, 'the appearance of a gigantic demon is anticipated by the noisy, rattling music … which does not merely signify its presence, it *is* its presence' (93, original emphasis). It is much the same with Michael, and since the music occupies a level above narrative, the omnipresence of his musical dimension helps locate him as unstoppable and unkillable, since his presence fails to stay confined to his physical body.

Michael's embodied presence on the screen is subject to damage – from knives, knitting needles, bullets – but not permanently. Like the

prototypical slasher film villain that he is, he does not die when a normal human would, but always comes back, and his returns are always accompanied by music. When Dr Loomis peers over the balcony looking for Michael, the score punctuates Michael's absence, or rather substitutes for his body on screen. The film then shows a set of tableau-like views of different locations around Haddonfield, ending with the Myers house where it all began fifteen years prior. Neither Michael nor any other human figure appears in the sequence, but two aural elements, the score and Michael's heavy breathing, give him presence in absence. He is gone from the screen, but through sound the film tells us that he is not gone. On the contrary, he may be in any of the places visualized on the screen, or all of them. The obliteration of his image on the screen has made him a diffuse, omnipresent and unstoppable presence. The traditional relationship of sound and image has been inverted. Michael Myers has become *acousmêtre*.

Ventriloquism: Voice and body

One tradition of horror that consistently plays on violations of sound fidelity is the ventriloquist movie. While plenty of ventriloquist dummies are not particularly terrifying (it is difficult, though hardly impossible, to be afraid of Edgar Bergen's Charlie McCarthy or Jimmy Nelson's Farfel the Dog), they have been available to horror from early on. Ventriloquist acts are based around the ambiguous externalization of the ventriloquist's body into the dummy and the game of trying to catch the ventriloquist in the act of voice throwing. But when the hierarchy of body and voice ruptures, uncanny potential emerges. Spadoni notes that early viewers of sound film had not yet naturalized the coexistence of image and sounds, but that rather, 'viewers were keenly aware of synchronization as a technological trick, as most patrons who go to see a ventriloquist take pleasure in knowing that the act is an illusion. And this was when the sense of human figures in sound films as "speaking effigies" … was as strong as it ever would be' (2007, 37). Spadoni discusses two ventriloquist films of sound's first years, *The Great Gabbo* (1929) and the second version of *The Unholy Three*, but we will turn to a work made later,

when audiences were somewhat more acclimated to image/sound synchronization.

The final segment *Dead of Night* features Michael Redgrave as Maxwell Frere, an accomplished ventriloquist with a dummy named Hugo Fitch. Their nightclub act presents Hugo as a strutting bully who humiliates Frere at every turn and hints that he may break up their act soon. Fellow ventriloquist Sylvester Kee (Hartley Power) sees their dynamic as unhealthy, and indeed Frere is positioned as a kind of brutalized spouse. Invited to visit Frere's dressing room after the show, Kee hears Hugo's distinctive high-pitched voice welcoming him and then finds the dummy lying inert in an empty room. But Frere is nowhere in sight: Where is the voice coming from? At this point Hugo is a variation on the *acousmêtre*: there is a body and a voice, but just how does one relate to the other? Kee remarks that Mr Frere 'can't be very far away', but when Frere comes through the dressing room door, he seems surprised to find Kee there. What was the source of Hugo's voice? Kee tells Frere, 'I'd sure like to know how you pulled that gag', but Frere seems uncomprehending. Even if we accept that Frere has a split personality manifesting through Hugo, it's not clear how he could have been doing Hugo's voice from another room. Later, Frere attempts to murder Kee after Hugo mysteriously turns up in Kee's room. Dr Van Straaten, the psychiatrist who narrates the sequence, proposes that the deranged Frere unconsciously planted Hugo there to fuel his own paranoid delusions, yet even the hyper-materialist Van Straaten cannot entirely discount supernatural explanations.

But the segment's eeriest moment is still to come. Van Straaten decides to give Hugo back to the imprisoned Frere and the two sides of his personality argue over which of them is the murderer. Taunted beyond his limit, Frere smashes the dummy apart, but the elimination of the body seems to free the voice. When Van Straaten and Kee later visit his jail cell, Frere's mouth opens and Hugo's voice croaks forth: 'Why hello, Sylvester. I've been waiting for you.' Frere's mouth is wide open as he says it, creating the visual impression that his body is not the source of this voice any longer, but merely a piece of equipment. The effect is transcendently creepy because of the violation of the conventions of sound fidelity and the inverted hierarchy it implies – just as Hugo's previously externalized voice has taken residence in

Frere's body – and it echoes chillingly over the dissolve transitioning back to the frame narrative. Few sound effects in all of cinema history are more chilling, not only because the scenario is a creepy and disturbing one, but because it reveals the fragility of the relationship of cinematic sound and image. The troubled 'marriage' of Maxwell Frere and Hugo, in which Frere is supposed to be the source of the voice but ends up having his voice entirely usurped and eliminated, allegorize all of the perils of image/voice synchronization at the heart of sound cinema.

Dead of Night was not the first ventriloquist/possession narrative, and the availability of the ventriloquist's dummy to horror themes would continue in other places: the 1964 episode of *The Twilight Zone* called 'The Dummy', *Magic* (1978), *Dead Silence* (2007) and even as the Batman villain 'the Ventriloquist', introduced in 1988 (Arnold Wesker – like Frere, a weak man cowed by his bullying puppet[5]). It also manifests in Jodie Foster's *The Beaver* (2011), as suicidal executive Walter Black (Mel Gibson) gains a new lease on life by communicating through a beaver hand puppet, only to find the beaver increasingly dominating his personality. While hardly a horror film, *The Beaver* is a (psychological) possession tale, and the finale where Black chops off his own arm to excise the Beaver's influence shows how closely it relates to horrific ventriloquist narratives. This story works especially well on screen, perhaps, because it foregrounds the fact that all film voices are ventriloquized, with disembodied voices only so conventionally linked to the ghostly images they seem to inhabit. Ventriloquism has proved an ideal topic through which to explore the technological uncanny.

Silence is golden

In 1920, German critic Carlo Mierenoff wrote, 'When the [live] music stops, things become frightening, ghostly, eerie' (qtd. in Alford

[5]Wesker was killed in James Robinson's *Face the Face* arc (2006) and was replaced by a new ventriloquist, a woman named Peyton Riley. She also operates Scarface, another variation of the detachment of the voice from the body.

2015, 86); one of sound's uses has been to domesticate cinema and efface its uncanny potential. Sound films paradoxically gained the ability to be silent – to be conspicuously silent, which horror films often exploit. Here again, *Dead of Night* provides a great example during its first episode. The segment tells the story of race car driver Hugh Grainger (Anthony Baird), hospitalized after an accident on the track. We see him resting in his hospital room late at night. The radio plays, and a clock on his bedside table ticks away. The radio suddenly drops off the soundtrack, and he reacts in puzzlement. Grainger's attention goes to the light fluttering of the curtains, and we (and he?) hear what seems to be the sound of a motor vehicle zooming by, an auditory reminder of his accident, or perhaps a portent of another accident yet to come. Suddenly, the clock also stops ticking. The room, and the film, are now completely, eerily silent. He stands and walks to the window, casting a huge shadow on the curtains. He draws open the curtains, and we cut to a reverse shot from outside the window. The day is now inexplicably sunny, and birds chirp on the soundtrack. This bright and cheerful environment feels unnatural, however, since we know that it is supposed to be night. We follow his eyeline downward and the reverse shot shows us an anachronistic Victorian hearse parked across the street. Immediately, loud, dark and overbearing music comes onto the soundtrack, cuing us to his sense of dread at the *wrongness* of this portent. Grainger recoils, and the camera tracks in on the hearse driver, who perversely says, 'Just room for one inside, sir,' and nods backwards towards the coffin behind him. Here again, the soundscape feels unnatural, since the spatial dynamics of the sequence suggest that Grainger should be unable to hear the driver at this distance. Almost somnambulistically, he turns away from the window; the loud non-diegetic score drops off suddenly as he sits down on his bed. As Grainger rubs his head, the sound of a ticking clock returns, and then the radio. He looks up at the curtain, which now looks out on a dark street. His vision is over, and its status as a subjective sequence that represents a break from the film's normal representational mode is signalled in a variety of ways (lighting included – his shadow is cast onto the curtains by a strong off-screen light source that vanishes by the end of the sequence).

A similar example appears in the haunting low-budget American independent horror film *Carnival of Souls*. Anticipating *The Sixth*

Sense, *Carnival of Souls* ends with the twist that the protagonist, Mary (Candace Hilligoss), has been dead since the opening scene. There are sequences throughout that seem to represent her increasing, if unconscious, realization of this fact. At one point, Mary is shopping in a local clothes store and suddenly finds herself in complete silence. Initially, everyday sounds fill the environment, including a low rumble of voices and a dinging bell from an unseen cash register, and these become noticeable only when they disappear.[6] An eerie, non-diegetic organ comes onto the soundtrack (Mary is an organist), and while there are still sound effects when she interacts with objects (opening a door, taking a dress off a hanger), there are otherwise no sounds of the world around her, and she cannot interact with any of the people. Mary even watches a road crew with a jackhammer on the street but she, and we, hear nothing. She wanders through this hollow landscape, until the organ drops off and the singing of birds and the sound of wind through trees signal the end of her experience. The sequence derives its effectiveness from its willingness to leech away those barely perceived elements that construct the average film's sound environment for effect.

James Wan's *Dead Silence*, a supernatural riff on horror's ventriloquism narrative, achieves a set of unusual effects through sound. The film concerns a ventriloquist dummy haunted by the soul of murderess Mary Shaw, who ripped her victims' tongues out. The film's opening murder resembles the sequences we have discussed from *Dead of Night* and *Carnival of Souls* as all sounds, both diegetic and non-diegetic, drop off, achieving the dead silence of the title; the camera lingers on a boiling, but inexplicably silent, kettle to underscore the point. Lightning flashes but we hear no accompanying thunder; the woman breathes visibly but no sound is heard. Slowly, as she approaches the form sitting on her bed, an eerie, apparently non-diegetic squeal creeps onto the soundtrack. She reaches forward, the object bursts and the soundtrack explodes into a welter of noise, a confusing mixture of flapping sheets, metallic sounds and her cries.

[6]The previous year, *The Innocents* similarly dropped off incidental noises of nature before Miss Giddens's first sighting of Peter Quint (Jason Wyngarde).

FIGURE 7.3 *Mary (Candace Hilligoss) reacts to the sudden silence of her environment in* Carnival of Souls *(1962)*.

The silence effect does not last long but the contrast created by the vacillation in levels of volume achieves a striking effect.

Assaultive sound

Horror films need not use sound for subtle, uncanny effects. Rather, it can be used to affect audiences in direct and visceral ways. Take a moment near the beginning of the science fiction/horror film *Event Horizon*. Haunted by the memory of his dead wife and horrific nightmares, Dr Weir (Sam Neill) picks up a straight razor. He looks at a sink, where water drops sound unusually loud, and we wonder if he is contemplating suicide. He holds the razor to his throat and runs it over his stubble, and the sound of the razor bridges to the much similar but much louder sound of Venetian blinds being quickly raised. We are intellectually surprised as we realize that it is not the sound of the razor we are hearing, but more importantly, we are unnerved by

the sheer assaultive quality of the sound (as well as being anchored in Weir's traumatized and, we shall learn, demon-haunted psyche). It makes us as jittery and unstable as Weir himself, and *Event Horizon*'s soundscape continues to deliver such shocks as much through sound as through image.

Horror's tendency towards these startle effects is nothing new. One of the most famous was in Lewton's *Cat People*, accompanying the scene often described as the first 'jump scene' in cinema history. Alice Moore is being followed on a New York street by her jealous romantic rival Irena Dubrovna, who may or may not have the ability to transform into a panther. The film crosscuts between the two women. The scene is dialogue free, but we initially hear two sets of footfalls, clacking on the concrete. Then the one set of footfalls drops from the soundtrack altogether, the film cuts back to Irena ceasing at the same time. Has she given up the chase, or has she turned into a panther, now stalking Alice silently? The suspense builds and builds with Alice's tension, and finally a loud sound comes onto the soundtrack, just before a bus pulls unexpectedly into the frame. Was it the sound of the bus or the snarl of a panther? The interplay of silence and sudden volume, as well as the ambiguity inherent to sounds not connected to a visible source, makes the scene so effective.

Many scenes in many films have replicated *Cat People*'s slow build to a jump scare (or tried to): Peter Hutchings lists the visit to the attic in *The Exorcist* and the last scene of *Carrie* as key examples (135–6), and one can find other examples in the majority of horror films made, especially in the United States, in recent decades. James Wan's films for Blumhouse Pictures represent good examples. *The Conjuring* ends by showing the audience the film's suspect music box apparently triggering at its own accord. We watch its spiral mirror turn, its creepy tune playing lightly against the silence of the Warrens' gallery of unhallowed artefacts, and the camera pushes into the music box's mirror swirling until it fills the screen. Because we are looking at a reflection of the Warrens' haunted treasure room, we expect to see something move in the reflection and are primed to react. Yet this expectation isn't delivered upon; instead, the film cuts to black. But this cut is accompanied by a loud, thumping noise with no apparent source, which we were not expecting, so we react to that, instead. A cheap trick, perhaps, but it is still enough to make us jump.

Assaultive sounds need not be loud. In *Get Out*, the key sound effect is very quiet and simple: a spoon tinkling against the edges of a teacup. It is the post-hypnotic suggestion left in the mind of André (Daniel Kaluuya) by Missy (Catherine Keener) that incapacitates him, plunging his conscious mind into the liminal 'sunken place' that allows others to control his body. Intriguingly, even though it is generally accompanied (or synced) with the visual of a teacup being stirred (even on a television set), we know that it is indeed the sound itself that matters: André is able to escape its effects by plugging his ears. The de-synchronization or 'divorce' of sound and image thus plays in *Get Out* as resistant and triumphant, much in contrast to the possession/ventriloquism of black bodies by white elites and their voices throughout the film.

We will conclude with a film that pulls together many of the themes discussed in this chapter: *The Entity*. This unsettling film – purportedly fact based – involves single mother Carla Moran being raped repeatedly by an immensely strong, invisible man, whose nature and motivations are never truly explained. She allies herself first with a medical doctor who regards the Entity as a hallucinatory expression of her childhood traumas (as discussed in Chapter 5), and then with a group of parapsychologists who try to subject the Entity to scientific scrutiny and contain it in a block of liquid helium. Neither attempt is successful.

The Entity is a disturbing film that makes full use of cinema's powers to upset (it contains countless canted or 'Dutch' angles, their 'unlevel' quality building to emphasize Carla's mental state). The Entity is one of cinema's most completely acousmêtric villains; rather than having a hidden body, like Emeric Belasco's, it simply has none, and thus cannot be fought by any conventional means. The Entity's presence is extensively constituted by sound. The attacks on Carla are accompanied by a repetitive thud-thud-thud suggestive of violent sex: we will call it 'Entity noise'. Created by composer Charles Bernstein, it is low and bassy, with the kind of percussive drive associated with industrial music. Like the 'ghost noise' from *Supernatural* or the sound cues associated with Michael Myers in *Halloween,* it represents a sonic strategy for representing the Entity's presence in the diegetic world despite its almost complete lack of visual representation.

A similar sound effect appeared in a Canadian film of a few years previous, *The Changeling*. There, composer John Russell (George C. Scott) moves into a huge old house to help overcome the death of his wife and child. The house is haunted, however, and he hears a repetitive, metallic clanging noise at regular intervals. It is eventually revealed that the ghost is that of a disabled child, drowned in a bathtub by his father, and the haunting sound is that of his struggling feet clanging against the side of the tub. *The Changeling* thus follows a conventional structure: a mysterious sound is heard with no attachment to anything on the screen, but it is eventually pinned down to the level of image (akin to de-acousmatization), and loses its unnerving power at that point. *The Entity* provides no similar explanation, and its sounds are ultimately more disturbing because of that sourcelessness.

The Entity's first attack starts similarly to the race car driver's experience in *Dead of Night*. Carla lies in her bed reading, while a clock ticks on the soundtrack. The camera lingers on some objects on the bedside and they tremble visibly and audibly. We follow several nervous reaction shots as Carla (an Angelino and thus primed to expect earthquakes) observes these tremors. She sniffs the air (we later learn that the Entity is accompanied by a foul smell) and shudders at sudden coldness. The tremors become more intense and louder, and objects begin to fall onto the floor. Then a tracking shot moves towards Carla (the Entity's POV?) and the thudding Entity noise joins the cacophony. She gets her children together and out of the house, and only when they reach their car does the noise subside. But she has forgotten the car keys and re-enters the house. The soundtrack now features a high-pitched electronic piece, reminiscent of some of the mood music in *Halloween*, that scores her nervous examination of the now-quiet house. She looks back at the bedroom door and sees it trembling as if being bashed from the other side and the Entity noise reappears on the soundtrack as she flees again. She asks her son Billy (David Labiosa), 'Did you hear it?' as they drive away, and he replies, 'Hear what?' From the beginning, the Entity is associated with and even constituted by sound. The Entity's numerous attacks vary, but the Entity noise remains a consistent element.

The question of whether characters can or cannot hear these mysterious noises is revived when Carla and her family return to

the house. We first hear an unexplained metallic noise and Carla's two younger daughters agree that they can hear it too. The metallic noise returns, and then the full-fledged Entity noise erupts onto the soundtrack again. Billy goes under the house and finds a pipe that makes a similar noise when he touches it, but Carla does not accept his rationalizations: 'Then who touched it before?' The scene alludes to all of those attempts to debunk the supernatural as a mysterious but ultimately scientifically explicable auditory phenomenon (see Tandy 1998). But is the fact that Carla's daughters can now hear the Entity noise evidence of its objective reality, or of folie à deux (as one doctor later suggests)?

The film plays with sound in subtler ways too. At one point, Carla is staying with friends and lies awake at night. She looks around nervously, and the diegetic noises of the environment are fairly loud on the soundtrack to emphasize her paranoia. We hear distant, howling wind and the sound of clattering blinds, moving doors elsewhere in the house, and other noises, even as a low electronic drone comes onto the soundtrack. A tracking shot slowly moves in on a lamp at the other end of the room, following Carla's POV. The light slowly turns itself on, accompanied by a much louder wind effect on the soundtrack. The light switches off again, and the sound drops back almost to silence as the scene ends. The Entity has demonstrated that it can follow Carla anywhere and work subtly to intimidate her even in her safest moments.

The Entity of Frank de Felitta's source novel is comparatively talkative, but the cinematic version speaks only one line throughout the film, spoken in the film's last scene. *The Entity* has a peculiar ending, where all attempts at containing and defeating the Entity fail, but Carla still manages to stand up to it: 'You can do anything you want to me,' she says, 'you can torture me, kill me, anything. But you can't have me. You cannot touch me. That's mine.' It appears that Carla's standing up to the Entity limits its power, and in the last scene we find her leaving the home where most of the traumatic events happened, even as the Entity displays its presence, slamming a door noisily and speaking a low, rumbling sentence: 'Welcome home, cunt,' even as non-diegetic music tones ominously. The sudden revelation that the Entity can speak comes at its weakest moment, so its turn to linguistic communication is the closest thing it gets

to de-acousmatization. The film ends with a superimposed scroll of words: 'The film you have just seen is a fictionalized account of a true incident that occurred in Los Angeles, California, in October 1976 ... The real Carla Moran is today living in Texas with her children. The attacks, though decreased in both frequency and intensity ... continue.' Presenting these words on the screen locates them in a different realm of linguistic communication than the aural, one implicitly outside of the narrative and thus uncontestable.

This chapter ends with *The Entity* in part because the film makes a superlatively *assaultive* use of sound throughout, with the Entity noise calculated as an attack on the audience paralleling the attacks on Carla. It also solidifies many of the themes of this chapter, including the use of an exaggeratedly artificial sound to signify the presence of supernatural beings, the effective alternation of silence and volume and the lack of synchronization of sound and image as a source of uncanny effects. In fact, a provocative, unpleasant subtext of *The Entity* involves domestic violence: an 'invisible' offence performed by a controlling figure within the house, which Carla finds it difficult to convince people happened at all. The Entity represents the sonic half of the metaphysical marriage of sound and image as an abusive spouse who, while appeased to a degree, is never fully stopped – any more than the uncanny potential of sound is ever fully contained by its domestication in cinema.

8

Colours of Fear

What a challenge it must be to adapt H. P. Lovecraft's short story 'The Colour Out of Space'. Written in 1927, it concerns a meteorite that crashes in a remote part of Massachusetts. It leaves behind a force that contaminates and warps the region, leaving a 'blasted heath' (594) that locals shun. The pollution is described as a 'colour ... [that] was almost impossible to describe; and it was only by analogy that they called it colour at all' and as 'just a colour – but not any colour of our earth or heavens' (598). It corrupts the local flora and fauna, and soon the area crawls with 'chromatic perversion' (602). The colour, we are told, exists outside of the 'known colours of the normal spectrum' (598).

The story is considered one of Lovecraft's masterpieces, and is a particularly strong example of Lovecraft's philosophy of 'cosmic indifferentism':

Lovecraft had created a new kind of horror story by shifting the focus of traditional supernatural dread away from ... man's fears of the devil, the dead and the beast in himself to a new crushing realisation that he and all mankind, far from occupying the centre of the cosmic stage even on earth, are scarcely important enough or long enduring enough to occupy the stage's shabbiest corners. (Campbell 1997, 169)

The scientific sheen to the story fits with Lovecraft's conviction that new developments in science required the end of the homocentric

world view that places mankind and human senses. Of interest to us here is that this indifferentism is located firmly within colour.

In presenting a colour that escapes rationalization and explanation, and which connotes chaos and uncontainability, Lovecraft was surely on to something. Writes philosopher Stephen Melville:

> Colour can also seem bottomlessly resistant to nomination, attaching itself absolutely to its own specificity and the subject on which it has or finds its visibility; even as it also appears subject to endless alteration arising through its juxtaposition with other colours. Subject and objective, physically fixed and culturally constructed, absolutely proper and endlessly displaced, colour can appear as an unthinkable scandal. (45)

Lovecraft's colour is a scandal and something more: mind-boggling, inexplicable, indescribable, destructive. But what did it *look like*? How do you represent it, when the entire point is that it exceeds representations?

Interviewed for the documentary *Lovecraft: Fear of the Unknown* (2008), John Carpenter opines that 'The Colour Out of Space' would make a great film, but states, 'I don't know how you do the colour.' The story has, however, been adapted at least three times. The first, produced by Roger Corman and directed by his frequent art director Daniel Haller, bore the spectacular name *Die, Monster, Die!* (1965). Here, the colour is represented by a kind of dull yet luminous green that is accompanied by a high-pitched drone suggestive of radioactivity. Haller's approach draws upon stock imagery around radiation poisoning, of which Lovecraft's story is curiously prescient. Another version, *The Curse* (1987), is a largely faithful adaptation that downplays the significance of colour.

The third adaptation,[1] a low-budget German production called *Die Farbe* (2010; released in English as *The Colour Out of Space*), does the opposite. As the title might imply, it foregrounds the significance of the colour and addresses the presentational problems of the colour in

[1] At this writing, a new adaptation of *The Colour out of Space* by cult director Richard Stanley has been announced.

a straightforward way: it makes the film entirely black and white, other than the colour. It plays, then, as a kind of anti-*Pleasantville* (1998). In *Pleasantville*, two modern teenagers are sucked into a monochrome family sitcom from the 1950s, and their inadvertent introduction of progressive ideas into this arrested space is represented by black-and-white objects, places and ultimately people blooming into colour. *Die Farbe* tells a similar story reengineered as horror, so that the intrusion of colour into the monochromatic world is not liberating but horrifying and destructive.

Of course, the colour itself – a kind of purple-pink that looks like perverse Pepto-Bismol – is still *a* colour, and as artificial as it looks, it fails to fully convey the otherworldliness of Lovecraft's colour. This was probably inevitable; in practice, the colour on the screen, artificial looking but within the familiar visual spectrum, is just a convenient approximation of the truly otherworldly colour from Lovecraft's pages. All the same, the very construction of colour as dangerous, sickly invaders has a history of its own, as part of what philosopher David Batchelor has termed 'chromophobia'. Bachelor argues that Western thought has consistently devalued colour:

Chromophobia manifests itself in the many and varied attempts to purge colour from culture, to devalue colour, to diminish its significance, to deny its complexity. More specifically: this purging of colour is usually accomplished in one of two ways. In the first, colour is made out to be the property of some 'foreign' body – usually the feminine, the oriental, the primitive, the infantile, the vulgar, the queer or the pathological. In the second, colour is relegated to the realm of the superficial, the supplementary, the inessential or the cosmetic. In the one, colour is regarded as alien and therefore dangerous; in the other, it is perceived merely as a secondary quality of experience, and thus unworthy of serious consideration. (It is typical of prejudices to conflate the sinister and the superficial … Colour is dangerous, or it is trivial, or it is both.) (22–3)

Batchelor notes, however, that chromophobia also shelters a chromophilic aspect: 'Chromophobia and chromophilia are both utterly opposed and rather alike' (71). All those things that are dangerous

about colour inspire fascination and admiration. The construction of colour as chaos and excess in 'The Colour Out of Space' speaks to the intermingling of chromophobic and chromophilic impulses. Colour's availability to horror, as this chapter will explore, seems to stem from the same thing. If colour is not a true property of any object, it becomes a free-floating, spectral force, like Lovecraft's colour out of space, or like the ghostly colours that the narrator of Edward Bulwer-Lytton's 'The Haunted and the Haunters' (1859) encounters: 'At the far end there rose, as from the floor, sparks or globules like bubbles of light, many-coloured – green, yellow, fire-red, azure. Up and down, to and fro, hither, thither, as tiny Will-o'-the-Wisps the sparks moved slow or swift, each at his own caprice' (46). If colour is monstrous, it often becomes what Robin Wood might describe as an attractive monster, a compelling monster, that speaks both to liberation and to the pleasures of excess and intoxication.

Ectoplasmic colour

Unlike sound (and then somewhat debatably), cinema knew no 'conversion to colour' period. Colour has been with cinema from very near to the beginning and its standardization was a gradual, uneven process. Film colour processes are broadly divided into two categories, 'natural colour' and 'applied colour'. 'Natural colour' refers to 'the photographic reproduction of colour through additive or subtractive processes of filtering light into different wavelengths that can be chemically recorded onto a film base and then reproduced into printing and/or projection' (Yumibe 2012, 2). 'Applied colour' refers to 'films coloured manually after the photographic exposure and development of a print, including hand-colouring, tinting, toning and stenciling' (ibid., 2–3). Jacques Aumont noted that early cinema colour 'generally seems to possess an independent material existence, more or less detached from the objects represented in these films' (qtd. in Misek 2010, 122). One thinks of the beautiful early Edison short *Annabelle's Serpentine Dance* (1895), where the hand-painted colour swirls and changes with the movements of the dancer, exquisitely coordinated but also removed, an accompaniment with its own, separate status. Some of the most stunning surviving

examples of early colour have fantastical or supernatural scenarios, like Segundo de Chomón's *The Golden Beetle* (1907), where a magician's conjurations go awry and culminate in a brilliant shower of gold and red.

The most famous natural colour process, Technicolor, was invented in 1916 and improved over the course of decades, culminating in the arrival of full-colour Technicolor in the mid-1930s. To be sure, there were colour films well before *Gone with the Wind* (1939) and *The Wizard of Oz*. But for decades colour connoted 'specialness' – the costliness of colour in terms of money and time meant that it could generally be used only for lavish, expensive projects alongside the heightened colours that Technicolor favoured, meant that for decades, colour was less associated with naturalism than prestige. The year 1965 is roughly when an 'average' picture could be in colour for the first time, or put differently, the use of black and white was generally an artistic rather than financial choice. Up until that time, as well, documentarians worked almost exclusively in black and white, which connoted roughness and realism despite being farther away from the average person's perceptual experience of reality. As Steve Neale notes, even in the 1940s and 1950s, 'colour was still overwhelmingly associated, aesthetically, with spectacle and fantasy' (2006, 19).

Though fully colour horror films were rare (early two-colour Technicolor horror films include *Dr. X* and *Mystery of the Wax Museum*), it was also true that certain uses of colour were coded with the supernatural and horror. One test of full-colour Technicolor done in 1935 had John Barrymore reading the ghost scene from *Hamlet*: 'At first, blue moonlight modeled the actor's face, then when his father's ghost appeared, greenish blue lights, painting Barrymore's face with a forbidding fear' (Higgins 2007, 30). Such uses of colour harken back to the theatre, where coloured light, especially blues and greens, often connoted supernatural. In this case, they probably echo the superstition that spirits affected the colour of lamplight, alluded to in Shakespeare's *Richard III*: 'The lights burn blue' (Act 5, Scene 3).

Film theory's great chromophobe is surely Rudolf Arnheim, the German psychologist whose 1933 book *Film as Art* is still a standard text for film formalism. Arnheim believed that the artistic qualities of film resided in the medium's difference from phenomenal reality, and as such he was a staunch opponent of film sound. He was

similarly negative about colour. In 1935, Arnheim described seeing a Technicolor film for the first time and subsequently having an uncanny sensory experience, where he perceived the colours of the world as transformed into the heightened, unnatural colours of Technicolor:

> After I had seen my first colour film and left the cinema, I had a terrible experience – I saw the world as a colour film. The Alban hills stood, a common soft lilac color behind the chain of dark green pines, topped by an emerald green sky – Everything was blatant in its poisonous color, and presented a chaotic, fiendish, discordant picture. (21)

Like Lovecraft's colour out of space, Arnheim seems to lack specific language to characterize this experience, resorting to adjectives like 'terrible', 'poisonous', 'chaotic', and so on, to explain a kind of unnatural colour that colonizes and distorts phenomenal reality.

Few, one suspects, have ever experienced film colour the way Arnheim claims to have. But the idea that colour was dangerous seems to have been a commonplace one. Notes David Bordwell,

> While Technicolor could play up the spectacular and the artificial, the industry cautioned that colour must not distract from the story ... 'Never use colour for the sake of colour alone', warned a Selznick art director in 1937. 'It is only something which is added to the story, and the story should not be made for the sake of it.' (1985, 355)

Colour needed to be tightly managed because, like sound, it contained potential threats to the coherence of the verisimilar, classical model of cinema.

For a variety of reasons, film colour has been the subject of critical neglect and derision. As Brian Price writes, 'The major stumbling block thus far has concerned the stability of colour as an object (if colour in fact warrants objecthood). The study of colour is especially mired in archival concerns about restoration and fading, not to mention the always elusive search for definitive versions' (3). Furthermore, colour is subjective on the phenomenological level: 'Where most of us with normal vision see a tracking shot the same

way, very few of us see the same colour exactly alike … [colour] itself is something of an illusion, nowhere near as stable as our everyday perceptions of it would indicate' (ibid., 4). Different cultures name and define colours vastly differently and discriminate between shades and tones in incompatible ways, and to compound matters, the interpretative meaning of any individual colour is far from certain. Lovecraft, it seems, was right – except that every colour is as chaotic and indescribable as the colour out of space.

At times, horror films have used these qualities of colour to their advantage. In William Castle's *13 Ghosts*, Cyrus Zorba (Donald Woods) finds a pair of glasses that allow him to see ghosts. He sees a gallery of bright red, transparent ghosts manifest in his basement, and slowly backs away as they explode into a burst of billowing red smoke. They float and dance before him: a skeleton, a floating disembodied head and other sepulchral figures, and then they merge into what seems to be a huge fireball that rushes Cyrus, pinning him against the wall until it pulls back and vanishes. Like Arnheim, this encounter with colour is disorienting and horrifying.[2] The power of the sequence derives from the fact that, like *Die Farbe*, most of the film is black and white. In fact, some releases are entirely in black and white (rather speaking to chromophobic notion of colour as unnecessary and superficial). But for those viewers who saw the film as Castle intended it, *13 Ghosts* provided colour only in the scenes with the ghosts. This was part of the film's gimmick, Illusion-O. Audiences were provided with a 'Ghost Viewer' outfitting with two strips of celluloid, one red and one blue. In the opening sequence (understandably omitted in black-and-white versions), Castle appears addressing the audience in his 'office', flanked by burbling beakers and accompanied by a skeletal secretary. Affecting magical changes to the film around him to switch the blue saturation that undergirds Illusion-O, he explains that if you believe in ghosts, you should look through the red part, and that if you do not believe in ghosts, you should look through the blue. While Castle frames his gimmick in terms of belief, it is really more about bravery versus cowardice; it anticipates the 'Coward's Corner' from his later

[2] See Allison (2005) for Kenneth Anger's occult-influenced uses of colour in *Invocation of My Demon Brother* (1969).

film, *Homicidal*, where frightened audience members were allowed to leave the film and get their money back, provided they spend the remainder of the film standing in 'Coward's Corner'. The film's unique colour gimmick allows the viewer to not only see ghosts (who would go to a movie called *13 Ghosts* not wanting to see ghosts?) but to feel brave while doing it, having made that choice.

In many ways, Illusion-O is quite consistent with Castle's earlier gimmicks. Like the Emergo skeleton of *House on Haunted Hill*, which popped out of the screen to hover over the audience, or the vibrating seats of *The Tingler*, Illusion-O not only involves the audience in the action of the film but blurs the line between screen space and audience space. Throughout the film, captions solicit the spectator to 'Use Viewer' and 'Remove Viewer' when the Illusion-O sequences begin and end, generally when a character does the same. The chromatic version of the film makes the captions seem redundant because the changes in the film's colours, the arrival of the bright blue tinting, ought to be cue enough. Illusion-O is consistent with the property of colour that Yumibe calls 'projective dimensionality', which 'launches shards of colour out to the viewer, placing them within tactile reach ... they seemingly proceed from the surface of the screen toward the viewer' (10). Yumibe locates this property within experimental cinema (Stan Brakhage's *Black Ice* (1994), especially) and early cinema, but one could hardly find a better example than Cyrus Zorba being assaulted by a wall of spectral red in *13 Ghosts*.

Intriguingly, in some of the advertising for *13 Ghosts*, another phrase replaced or accompanied Illusion-O: 'ectoplasmic color'. The word 'ectoplasm' comes from spiritualism and psychical research. It was coined by scientist Charles Richet in 1894 to describe a mysterious substance that putatively oozed from the orifices of mediums, especially noses, mouths, nipples and genitals, seeming to provide material and therefore incontrovertible evidence of spiritual contact.

Ectoplasmic mediumship continued into the twentieth century, but the word went off in different directions. The '80's kids' doubtless associate it with the *Ghostbusters* franchise, where it came to signify the sticky, abject slime left in the wake of abject spectres. It had an odd, subterranean life before its abject revival; for example, in *Topper* (1937) the ghosts need to expend a limited supply of 'ectoplasm' in

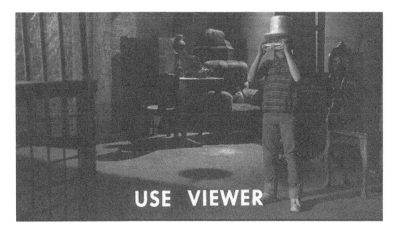

FIGURE 8.1 *Buck (Charles Herbert) dons the ghost viewer in* 13 Ghosts *(1960).*

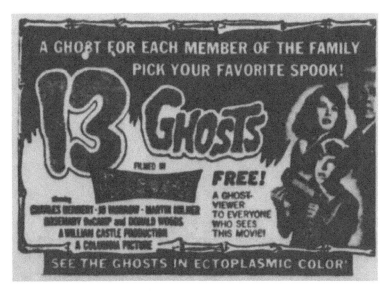

FIGURE 8.2 *An advertisement from* The Sedalia Democrat, *29 September 1960.* 13 Ghosts, *© 1960, renewed 1988 Columbia Pictures Industries, Inc., All Rights Reserved. Courtesy of Columbia Pictures.*

order to become visible, and the 1945 Danny Kaye vehicle *Wonder Man* used the word similarly. Fascinatingly, the term was also apparently used with reference to cinema itself. Karen Beckman notes that the *American Heritage Dictionary* includes as a definition of 'ectoplasm': 'Informal: an image projected onto a movie screen' (78). While empirical examples of this usage seem scarce, critic Parker Tyler wrote in 1945: 'With this power to render the human substance into mere symbolic ectoplasm, the movie camera possesses a perambulation parallel to the movements supposedly initiated in actual *Ghost Land*' (363).

The phrase 'ectoplasmic colour' conjures all of these associations, and in particular cinematic colour's own suppressed ineffability, intangibility and uncontainability (through projective dimensionality). The role it plays in *13 Ghosts*, where the ghosts are not so much *coloured* as they are *colour* itself, is striking but not unique. In fact, for decades horror films had a certain ownership over the technique known as the 'colour insert', moments of colour slipped into a principally monochromatic film, as short as a frame or as long as a scene or two, but always deriving its effectiveness from its difference from the monochromatic world that surrounds it.

Black and white with colour

Colour inserts are by no means unique to horror films. One can construct a long list of examples of films that alternate between chromatic and monochromatic modes. In *The Women* (1939), the ten-minute fashion parade in lustrous Technicolor suggests a brilliant fantasia of consumption. In Eisenstein's *Ivan the Terrible, Part II* (1958), the gorgeously gold-hued colour sequence is also associated with indulgence and excess, but also danger. Hitchcock's *Spellbound* (1945) contains a few frames of bright red when the villainous Dr Murchison (Leo G. Carroll) commits suicide. The ending of Tarkovsky's *Andrei Rublev* (1966) switches to colour to show spectacular images of the real-life Rublev's icons. The supernatural romance *Portrait of Jennie* (1948) shifts through various tints (including green for the film's most mystical sequence) but uses Technicolor only for a climactic view of the eponymous painting; its use of colour echoes the chromatic

views of a more horrific supernatural painting in the 1945 adaptation of *The Picture of Dorian Gray*. In *Shock Corridor* (1962), colour is linked to madness. Of course, in *The Wizard of Oz*, the shift between monochromatic and chromatic film marks the transition between the 'real' world and a fantastic dream world; *A Matter of Life and Death* and *Wings of Desire* (1987) reverse this dynamic, presenting monochromatic landscapes of the hereafter contrasted with a chromatic earthly plane.

But these colour shifts have long played a specific role in horror, related to but distinct from those binaries Misek identifies. One of the most famous colour insert sequences is the *Bal Masqué* sequence in the Lon Chaney-starrer *The Phantom of the Opera*. It used colour in large part in service of prestige; it was a lavish, expensive production where high-class elements meld interestingly with Gothic melodrama (*The Phantom of the Opera* would prove available to such mixing in other ways, as in Andrew Lloyd Webber's musical).[3] As what the intertitles call 'a spectral figure, robed in red', the Phantom is dressed as the Red Death from another great piece of literary chromophobia, Edgar Allan Poe's 'The Masque of the Red Death'. In Poe's story, the Red Death is the embodiment of disease and death's inevitability, shut out by the colour-loving but red-shunning Prince Prospero but making its way into his masquerade nevertheless to claim the souls of the defiant (Roger Corman's film adaptation will figure later in this chapter). The 1925 version of *The Phantom of the Opera* harnesses the same imagery of the unexpected and unwelcome intrusion of bright red into the cinematic world all the more effectively because it marks a break from the film's normal representational mode.

It is perhaps no surprise that red is often horror's most impactful colour. It is maybe for of all cinema. Interviewed by *Cahiers du cinéma* in 1965 about his then-new film *Pierrot le Fou*, Jean-Luc Godard famously answered a comment about how bloody the film is with the cryptic remark, 'Not blood, red.' It is certainly true that the

[3] Joel Schumacher's 2004 adaptation of the Webber musical stages the equivalent sequence, the performance of 'Masquerade', on a staircase reminiscent of the 1925 film, and excludes all colours other than black, white and gold to emphasize the red-clad Phantom's arrival.

FIGURE 8.3 *An intertitle announcing the Phantom's arrival,* Phantom of the Opera *(1925).*

blood in *Pierrot le Fou* is cartoonishly unconvincing, but Godard is likely referring back to that property of projective dimensionality: the idea that colours on the screen have an impact of their own, semi-detached from the objects that they colour. Allan Cameron keenly observes that in horror, the opposite is true: all red on the screen tends to suggest blood (89). He raises the example of *The Shining*, in which the bright red of the bathroom where Jack Torrance (Jack Nicholson) talks with Grady (Philip Stone) echoes the recurring image of blood pouring out an elevator; one might also point to the red tape associated with the spaces where the ghosts manifest in Kiyoshi Kurosawa's 'bloodless' *Pulse*, the red-hooded figure of *Don't Look Now* (1973) and the red paint marks the guilt ('red-handedness') of the town of Lago in *High Plains Drifter*. Red is frequently represented in horror film titles, probably second only to black in terms of frequency (*The Masque of the Red Death, Deep Red, Color Me Blood Red* (1965), *Rose Red* (2002), *Red Dragon, Red Velvet* (2008), *Red Hook* (2009), *The Hills Run Red* (2009), *Red State* (2011), *Red Christmas* (2016), *Crimson Peak*, etc., to say nothing of countless films with 'blood' in their title).

Not all blood reds are made equal. In John Waters's *Serial Mom* (1994), a gore-film-aficionado teen cries, 'I saw blood! And it's brown! Not red like in horror movies, but brown!' According to legend, Tom Savini could not perfect the colour of the fake blood for *Dawn of the Dead*, but George Romero thought that the almost

fluorescent red looked ideal for the film's cartoonish tone. Two years earlier, Martin Scorsese desaturated the colour of the fake blood in *Taxi Driver* (1976) in order to avoid an X-rating (Wickman 2015, n.p.), and *Star Trek VI: The Undiscovered Country* (1991) reputedly made Klingon blood pinkish-purple, which it has never been before or since, in order to avoid an R-rating. The fact that the colour of blood has such implications speaks to how redness pierces through narrative absorption to provide shock and attraction of its own.

In the obscure 1958 independent American horror film *The Return of Dracula*, a late sequence crosscuts between the Count (Francis Lederer) menacing a female victim and the stock scene of a group of men crowding around the female vampire, preparing to stake her. But the staked vampire's scream is accompanied by something new: a flash of bright red blood, redder than red, against her white clothes. It lasts barely a second, and then the film switches back to black and white, as Dracula reacts to his progeny's demise. The splash of colour draws us into Dracula's perspective, cuing us to his heightened psychic awareness. But more importantly, it delivers something new and unexpected, a moment of spectacle and attraction – a flash of blood. As its director, Paul Landres, would later explain, 'Color was not in common use at that time, so what could be more shocking than to suddenly have the rich red color of blood practically come popping off the screen,' an invocation of projective dimensionality (Weaver 1991, 92), an invocation of projective dimensionality.

The Return of Dracula's use of colour is a microcosm of the same transition implied by the more famous Dracula film of 1958, Hammer's *Horror of Dracula*, which takes such a relish in its new freedom to display colour that it wastes no time with its bold introduction. The camera tracks its way through Dracula's crypt, where the engraved name 'DRACULA' is suddenly covered by a shower of blood. Narratively inexplicable, the bloody eruption signals the promise of a new, gorier kind of vampire film. The year prior, *The Curse of Frankenstein* set new standards for onscreen violence and gore with its own colour palette, which also privileged red:

> [It] reveled in redness, from liquids in chemical flasks to the glow of the batteries powered by the cross-rotational discs of the Wimshurst machine to a character's red silk dressing gown or the

red berries in the forest near the Frankenstein chateau, and most horrifyingly of all, the creature's red eye after it has been shot in the face. (Harmes 2015, 7)

Hammer's signature aesthetic, stately and lavish despite limited budgets, was facilitated in part by the inexpensive new photographic processing system Eastmancolor (Heffernan 2014, 43–62).

Castle himself had made significant use of red even before *13 Ghosts*. In the largely monochromatic *The Tingler*, there is a sequence where a deaf-mute named Martha Higgins (Judith Evelyn) is terrified to death by her scheming husband Ollie (Philip Coolidge). She encounters a set of frightful images: A mouldering corpse sits upright and comes at Martha with a knife. A *Cat and the Canary*–style hairy, grasping arm hurls an axe at her. A rocking chair moves by itself. She finds a death certificate for herself with the cause of death listed as 'Fright'. She also encounters a sink where both faucets flow with blood, and then a bathtub fills with blood, out of which a mysterious hand reaches. Martha, as an earlier scene establishes, is so haemophobic that she passes out at the sight of even a small amount of blood. Here, all the blood is red in an otherwise monochromatic film. This use of colour may seem like the least of *The Tingler*'s gamut of gimmicks, but it functions on a couple of levels, appropriate to Castle's typical 'nonseparation between narrative and trickery' (Leeder 2011, 779). The nature of the sludgy black liquid would be unclear if monochromatic, so the colour gimmick works to draw us into Martha's phobic perspective, an appropriate choice in a film so completely themed around fear. It sets the stage for *13 Ghosts*, as well, where shifts in the film's colour register represent shifts in a kind of vision for the audience: in *The Tingler*, an implicit sharing of Martha's haemophobia, and in *13 Ghosts*, a shift into supernatural 'ghost vision' shared by those characters looking through the glasses and exposing an otherwise invisible world.

Colour, excess and intoxication

In the great Belgian vampire film *Daughters of Darkness* (the original French and Belgian titles both translate to *The Red Lips*), Countess

Bathory (Delphine Seyrig) and her new convert Valerie (Danielle Ouimet) kill Valerie's husband, Stefan (John Karlen), with the shards of a shattered punchbowl. We see the blood dripping away, framed like a precious commodity being wasted, an impression heightened by Bathory's chanting of 'The blood, the blood, the blood', as they lock mouths onto his wrists. The film dissolves to an overhead shot where no blood is in sight, but Stefan's dark orange-red bathrobe melds with the slightly deeper red of the carpeting, and the image fades, not to black or to white, but to a wall of red (rather anticipating similar fades in Bergman's *Viskningar och rop/Cries and Whispers* (1973)). *Daughters of Darkness* is among the most lavish and overwhelmingly opulent of all horror films, and this moment draws into the bloodlust, making us share the women's satiation as red crawls up to overwhelm the film itself.

In a way, the moment is an inversion of Martha's encounter with the bloody bathtub in *The Tingler*, since we are not meant to fear blood but rather share in its red allure. The rapturous moment in *Daughters of Darkness* perfectly suits Batchelor's chromophobia/chromophilia: 'Colour is dangerous. It is a drug, a loss of consciousness, a kind of blindness – at least for a moment. Colour requires, or results in, or perhaps just is, a loss of focus, of identity, of self. A loss of mind, a kind of delirium, a kind of madness perhaps' (51). The psychedelic implications of colour described by Aldous Huxley and others manifest in horror films most obviously through the pre-psychedelic dream/ fantasy sequences that became the signatures of Roger Corman's Poe series. Corman says that these sequences

> were shot silent and in black and white. I thought of them as exercises in cinema technique, where we could depart from reality, by using special lenses, surreal sets, gels, and afterwards a lot of optical printing. From a theoretical standpoint, they were pure cinema. (French 2011, 181)

Like some of the other exuberant colour techniques I have referenced, they also tend to be only thinly narratively justified; the Poe films, adapting short stories into feature-length films, are heavily padded, and these sequences are one of the methods of adding screen time. They are fascinating, however, in their own avant-gardism, in their

radical artificiality and their stark difference from the films surrounding them, marked by colour shifts as well as sound cues, changes in film speed and other markers of cinematic alterity. In *The Fall of the House of Usher*, Philip Winthrop (Mark Damon) has a nightmare that alternates between blue, purple and pink, all with superimposed swirling mist. In *The Pit and the Pendulum*, a traumatic, narrated flashback is tinted with purple, and in *The Premature Burial*, a green/ violet miasma roils across the screen as the protagonist hallucinates the title fate. In *The Masque of the Red Death*, the Satanist Juliana (Hazel Court) performs a ritual that causes her to lapse into a green-tinted sadomasochistic nightmare where she is tortured by a demon.

It perhaps goes without saying that the latter is a film obsessed with colour. Separate to Juliana's vision, *The Masque of the Red Death* (with cinematography by Nicholas Roeg, whose later directorial career includes the aforementioned *Don't Look Now*) provides a useful illustration of one way to distinguish between categories of film colour. It contains strikingly coloured objects and settings, including the scarlet costume of the title figure, and the wall paint of the coloured rooms adapted from Poe's story: black, white, purple and yellow (orange in Poe's story; there are also blue, green and violet rooms that the film omits). These are generally lit, per Hollywood norms, with white light. But the stained glass windows in the coloured rooms permit another kind of colour to enter the film's rich colour scheme: coloured light. This is a property of film colour that Richard Misek calls optical colour: 'the colour that results when white light is decomposed into coloured light by means of prisms of coloured filters' (117). Misek notes that Hollywood's colour of choice for light has overwhelmingly been white. Only when sufficiently motivated, as in *Gone with the Wind* when a sunset warrants bright orange light for the first kiss between Scarlett (Vivien Leigh) and Rhett (Clark Gable), are transgressions of this norm permitted (125). *The Masque of the Red Death* also finds occasions to depart from classical lighting conventions. The forbidden Black Room, for instance, has a bright red-stained glass window, which turns the smoke in the room into a hazy, unhealthy-looking brown. As she prepares for her ritual, Juliana's face is subtly tinted red, even though her back is to the window.

A more full-blown use of non-naturalistic optical lighting occurs in the film's climax, as Prince Prospero (Vincent Price) meets the mysterious

figure in red that he mistakes for Satan himself. Prospero confronts him in the Black Room, where he stands next to the red window, so that the image is strikingly double red – red lighting on a red costume. With a wave of his red sleeve, the Red Death infects Prospero's guests with the plague, changing their skin to bloody red, and also causes the lighting scheme to shift. The revellers' bodies move ritualistically, almost mechanically, and the following danse macabre is set against lights that shift in terms of colour and intensity, playing expressively on objects and features – even Price's features, especially as the Red Death reveals that he has Prospero's own face beneath his mask. Fleeing the crowd of his dying merrymakers, Prospero flees back to the Black Room where the Red Death is now an especially luminous red against a black backdrop, and once again, the Red Death's sleeve passing before the camera's gaze signals the transition between life and death.

The melodramatic finale of *The Masque of the Red Death* marks one of horror's most striking uses of optical colour. But it pales next to a later *giallo*, perhaps the only horror film routinely discussed in studies of cinematic colour: Dario Argento's *Suspiria*. Consciously or otherwise, *Suspiria* contains a dash of *The Wizard of Oz*; a young American woman entering a foreign, Technicolor-hued setting, ruled by witches. *Suspiria*'s colour scheme is only part of what makes it one of the most aesthetically striking of horror films. It features gorgeous camerawork with many baroque uses of the zoom, and its score by Goblin is as spooky and unrelenting as that of *Halloween*, working

FIGURE 8.4 *The Red Death in the Black Room,* Masque of the Red Death *(1964).*

similarly to embody the rarely seen villains on the level of film. But its colours are remarkable, including technically:

> [*Suspiria*] would ... be the last ever to be 'dio-transferred': the negative was given to Technicolor who split it into three separate black and white negatives – one for red, one for blue, and one for green. These were then printed one on top of the other to create the vibrant look of the finished film. Argento insisted that Technicolor also use the highest possible contrast to increase the presence of primary colours. (Gracey 2014, 70–1)

Suspiria thus used nearly defunct colour technology, near the end of Technicolor's useful existence, in unusual ways to create a unique look, one so overwhelming that it seems almost impossible to discuss the film without taking it into account.

The film involves the young American dancer Suzy Banyon (Jessica Harper) coming to study at a prestigious ballet academy outside Freiberg, Germany. The exterior of the building is ghastly red, and individual rooms have Poe-echoing names like 'the Yellow Room' and 'the Red Room'. Within the mythology of Argento's 'Three Mothers' Trilogy, the academy was designed by an Italian architect E. Vareli, tasked with designing three strange buildings to house the three witches who secretly control the world. But even more striking than the colour of walls and other objects is the colours of the light, the unearthly tones that bathe so much of the film in unearthly golds, blues, reds and greens. Some of it comes from sunlight reflecting through stained glass, or the film's many lightning bolts, but mostly it has no obvious source.

The lighting in *Suspiria* is so non-naturalistic that we wonder if it is meant to be diegetic at all, since the characters never seem to notice it. The colours frequently elude not only narrative but also scenographic logic. Sometimes the lighting scheme fails to be consistent even within a single scene, as when Suzy stands in her gold-walled, white-lit bathroom and dumps her (she believes drugged) dinner into the toilet, which is somehow bathed in rosy pink light. Writes Misek,

> By creating an environment with a superfluidity of coloured light, [Argento and cinematographer Luciano Tovoli] make it impossible

for the viewer to attach specific motivators to specific colours, freeing themselves to use whatever colour they like whenever they like. Faces are lit in colour even when no stained glass is visible. A shot lit in red is cut together with a counter-shot lit in green. In a red room, lightning flashes green. In a blue room, lightning flashes pink. (142; see also Heller-Nicholas 2015)

In one striking scene, the school's gymnasium is turned into a temporary dorm. At first, the dominant colour is white. The lighting is white and unremarkable; white curtains hang as barriers, the women's nightgowns are largely white and the bed sheets are white. But when the lights are turned out, the environment is suddenly red. Red lighting turns the white curtains bloody, and a discordant soundtrack plays as a crane shot swoops through the gymnasium, suggesting the vantage of an unseen being. As Suzy and fellow student Sarah (Stefania Casini) gossip over their mysterious headmistress (actually the undead witch Helena Markus/Mater Suspiriorum) snoring across the curtain, their faces are bathed in crimson shades.

Whiteness, and white light in particular, plays a curious role in *Suspiria*. The scene where Suzy consults Dr Mandel (Udo Keir) and Dr Milius (Rudolf Schündler) at what appears to be a psychiatric convention starkly contrasts the bulk of the film in aesthetic terms – a brutalist urban setting, natural light and a relatively subdued colour scheme. But it is a brief respite, and the last of the very few scenes taking place outside of the academy. One of the headmistresses, bearing the significant name 'Madame Blanc' (Joan Bennett), is introduced against a background of white windows and wears a light grey outfit. Though Blanc first appears to be more friendly and welcoming than the standoffish Miss Tanner (Alida Valli), she is actually head of the witch coven fronted by the dance school. Her office is one of the few white-dominated rooms in the academy (though frequently transformed by lightning flashes), yet it also contains the primary colours that deliver the film's major reveal. Red, yellow, white and blue irises painted on a wall provide secret access to the coven's inner sanctum. They stand out as some of the few conventionally coloured objects in the environment of the academy, and one of the film's many zooms registers Suzy's thought process in narrowing in on their importance. And they are lit by a relatively white

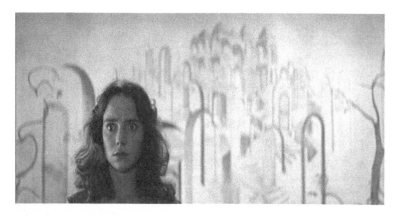

FIGURE 8.5 *Suzy's moment of realization in* Suspiria *(1977).*

spotlight: as Misek notes, 'In *Suspiria*, it is white light and surface colour – not coloured light and optical colour – that is made noticeable by its scarcity' (143).

The revelation scene plays out as Suzy enters the room, a pink light source illuminating the wall behind her. As she scans the environment, the film cuts to outside the house, where a storm is raging, and when we return to Suzy, it is a slightly asymmetrical shot of Suzy against the pink and gold wall, with the significant flowers to the left of her. She walks forward, her face picking up gold hues that emphasize her reaction to seeing a mirror reflect the flowers behind her. Here a lightning strike turns her face and the whole scheme to yellow-green for an instant as she flashes back to the stormy night she arrived at the school – the change in lighting signals realization just as a cartoon light bulb might. Suzy spins backwards and now understands the flowers' significance; she turns the blue iris, and a blue-lit secret door opens for her.

The environment inside is dominated by gold/yellow, and Suzy comes upon the witches' inner sanctum, where Madame Blanc, in black, is leading a witchcraft ceremony and ordering Suzy's death. She beseeches Helena Markus for power, and the moment she raises a chalice to her lips, lightning shifts the colour scheme to purple and blue. Stumbling into Markus's own hideaway, Suzy is framed next to a dayglo peacock with tail feathers coloured with a range of yellow, greens, blues and reds (a striking use of optical lighting here again).

Plucking free one of the feather daggers, Suzy confronts the invisible witch, but a shimmering outline gives her a target to stab at, and seemingly killing *Suspiria*. As with the irises, mastering the colours of her environment finally allows Suzy to penetrate the witches' secrets and overcome them. Suzy flees the burning and collapsing academy to take shelter in the rain (echoing the 'burning house' endings from Corman's Poe series).

Writes Maitland McDonough, 'The consistency of *Suspiria*'s colour strategy, in which the riotous dayglo colours embody the hysterical, hypersensitive world of witchcraft and sorcery, is truly marvelous; it was both rigorously planned and meticulously executed' (140). Yet all this care is in service of an impression of chaos: a world cluttered, overwhelmed with inexplicable, implacable colours. It is a sumptuous, stunning film, its ornate excesses constructing an atmosphere of beautiful oppression. Is it a chromophobic film in Batchelor's sense? Perhaps insofar as colours are associated with environments and characters that ultimately need to be overcome and destroyed (and colour is certainly affiliated with the monstrous-feminine in this film). But as with Lovecraft's colour out of space or Poe's Red Death, chromophobia coexists suggestively with chromophilia, and for the film's many admirers, its rapturous colour environments and its other formal flourishes matter far more than the film's thin plot.

Back to black

Needless to say, few horror films actualize the possibilities of colour quite as fully as *Suspiria*, and many go in the opposite direction. As Cameron notes of contemporary horror films, 'a certain gritty, desaturated look has become a reliable template for films in the genre' (87), downplaying colour's impact in a way that moves against the baroque colours of Argento, Corman or even Castle. Other filmmakers have reverted to monochromatic filmmaking to explore horror's potential. *Die Farbe* is not the only black-and-white Lovecraft adaptation; the H. P. Lovecraft Historical Society has produced two Lovecraft adaptations in vanished styles, *The Call of Cthulhu* (2005) and *The Whisperer in Darkness* (2011). The conceit of these films is that they are made as the stories would have been adapted in the

year of their writing (1926 and 1930, respectively). Both of these very enjoyable films are consequently black and white, and the former is silent (see Corstorphine 2008).

Even blood need not always be red: as Hannibal Lektor (*sic*) (Brian Cox) asks in *Manhunter*, 'Have you ever seen blood in the moonlight? It appears quite black.' For 'moonlight' we might substitute 'monochromatic cinema'. In Val Lewton's *The Leopard Man*, a child is mauled to death outside of a door and we watch blood flow underneath. The thick black blood is such an unexpected sight in a film of its period that it heightens the impact of what is already an intense and difficult scene. It is easy to think of earlier examples of monochromatic blood and gore. In *King Kong*, blood courses from the jaws of the mangled tyrannosaurus and Kong's chest is dabbed with black blood from plane-mounted machinegun fire. In *Psycho*, the blood of Marion (Janet Leigh) (reputedly 'played' by chocolate syrup) swirls down the shower drain. Misek uses blood as an example of 'absent colour', that trace of colour reality that underlies black-and-white images (83); we know it's red, even if we can't see it.

FIGURE 8.6 *Blood leaks under the door in* The Leopard Man *(1943).*

Likewise, we know the colours of the gore that the ghouls munch on in *Night of the Living Dead*, and the newsreel-style black-and-white cinematography gives the film a sense of immediacy and authenticity that colour might have lacked.

Other horror films of recent decades have opted to return to black and white as a stylistic choice. Michael Almereyda's *Nadja* and Abel Ferrara's *The Addiction* are both low-budget vampire film/ art film hybrids with stylish New York settings, the black-and-white helping construct the mood of sophisticated urban malaise. Perhaps following their lead, *A Girl Walks Home Alone at Night* features gorgeous black-and-white cinematography. In contrast, *The Human Centipede II (Full Sequence)'s* use of black and white is anything but elegant and chic (with its own colour inserts). Discussing the emergence of the convention of black and white suggesting pastness, Misek refers to George A. Romero's *Martin* (1977), where 'colour scenes set in the 1970s interlace with black and white flashbacks to the late-nineteenth-century past' (91). This description somewhat understates the complexity of *Martin's* deployment of monochrome cinema, however, since it is not clear if Martin (John Amplas) truly is the immortal vampire he claims to be, or if the intercut 'flashbacks'

FIGURE 8.7 *The monochromatic chic of Elina Löwensohn in* Nadja *(1994).*

are in fact Martin's own self-visualizations, heavily filtered through the visual conventions of black-and-white movies.

A similar but distinct referentiality is at work in Guy Maddin's *Dracula: Pages from a Virgin Diary* (2002), based on a production by the Royal Winnipeg Ballet. Like all of Maddin's films, it recreates the style of vanished modes of cinema as a way of engaging themes of history and memory, and like many of them, it is wordless and largely monochromatic. It too starts with black blood – the stylized image of blood flowing over a map of Western Europe, while an intertitle shouts 'IMMIGRANTS!!' foregrounding the xenophobic subtexts of *Dracula* and so many classic horror stories. However, it has its own colour inserts, especially red, in neck bites and blood dripping from vampires' mouth, in the lining of Dracula's cape and in his eyes, and in the wounds he suffers at the hands of the vampire killers. These are powerful, beautiful, impactful moments which evoke the history of the colour insert in the horror film and deploy it in a new way.

Die Farbe, of course, is largely a black-and-white horror film, too. One wonders if it made the wrong decision, however, in representing the colour out of space at all. Why not just make the entire film monochromatic and thus provide a commentary on the colour's unrepresentability? Perhaps there is no satisfactory strategy for adapting 'The Colour Out of Space', as it is simply beyond cinema's representational reach.

Domesticating colour

William Castle's colour gimmick in *13 Ghosts* takes an interesting turn late in the film when we realize that the ghosts are largely benign. They even act to defeat the film's human villain Benjamin Rush (Martin Milner). Like the child protagonist Buck (Charles Herbert), we are glad to hear that they are still around. We see them reappear one by one, appearing for our eyes like a supernatural curtain call, clearly not existing within the space of the house but superimposed over it. The quality of projective dimensionality seems especially relevant here – colour is not truly contained by the narrative world, but exists on the surface of the screen, or even in a nebulous space between screen

and viewer. Likewise, the film provides an uneasy alliance between chromophobic and chromophilic tendencies, since the coloured ghosts are simultaneously to be shunned and appreciated. In fact, the arc of the increasing acceptance and domestication of the ghosts parallels the diminishing technological uncanny that comes from film colour and new technologies more broadly – yet that uncanny is still only slightly contained and can turn terrifying again at any time.

Finally, Castle reappears to the audience to say, 'If any of you are still not convinced there really are ghosts, take the supernatural viewer home with you and tonight, when you're alone, and your room is in darkness, look through the red part of the viewer … if you dare.' It is an interesting thought: crouching in the darkness and staring through a strip of cellophane, looking for ghosts. What would they look like? Would they appear as bright red, superimposed spectres even in real life, even in darkness? If the ghost viewer were to work as Castle promised, it would be the ultimate case of projective dimensionality, where cinematic colour stubbornly fails to stay contained on the screen.

9

Digital Horrors

In September 2015, the latest viral video to trend online came out of Ireland, purportedly documenting poltergeist activity. Under the name 'REAL Poltergeist Activity Captured in Irish Home!! Must Watch!!' and originally posted on the Facebook page of Ashy Murphy, it garnered more than twelve million YouTube hits in its first four days. It shows a swaying overhead light, objects moving across the room seemingly on their own and kitchen cabinets appearing to open themselves. Immediately the internet set about inspecting it (is that a hidden fishing line? The low quality of the video makes it hard to tell), with some pronouncing it a fake and others taking it as proof positive of the reality of the supernatural.

In a way, it represents nothing new: using photographic technology to try to document the supernatural has been going on since the mid-nineteenth century. The images produced by American photographer William Mumler resulted in a sensational court case in the 1860s, with Mumler being acquitted of fraud because, though the jury was satisfied that such images could be faked, no one had caught him in the act (Jolly 2006; Kaplan 2007; Harvey 2008). His French equivalent, Édouard Buguet, received a year in prison and a stiff fine (Monroe 2002, 180–5). On Halloween 1992, the notorious BBC programme *Ghostwatch* fooled many audiences into thinking that its fictional presentation of supernatural events was real. Featuring famous personalities playing themselves and carefully recreating the conventions of live television, *Ghostwatch* succeeded precisely because of its careful manipulation of the conventions of live television (Leeder 2013), and its tale of the supernatural expanding its reach

through the networked character of modern technology remarkably anticipates the rise of the 'viral'. In the digital age, the numerous ghost-hunting reality programmes (*Most Haunted* (2002–10), *Ghost Hunters* (2002–present), *Celebrity Ghost Hunt* (2012–present), etc.) keep the modern fantasy that ghosts might be documented by recording technologies alive in the popular imagination, while playing on the thin border of fakery and authenticity.

What is striking about the Ashy Murphy video is how much it aesthetically resembles a ghost-hunting TV show, or perhaps even more so, a *Paranormal Activity* film. It has the same tentative, first-person-coded camerawork and rough, grainy quality that, rather than seeming to be a defect, increases the footage's verisimilitude and therefore its impact on a viewer. *Paranormal Activity* is a fictional film, but like *The Blair Witch Project* before it, it rallies an aesthetic associated with documentary realism for supernatural horror. The Murphy video has 'gone viral'. Since the mid-2000s, this infectious parlance reached a level of cultural ubiquity for those videos that (at least putatively) spread unexpectedly and directionlessly through the virtual spaces we occupy online, and out into our homes. Depicting domestic space turned uncanny in part through the process of filming it, it points us to the uncanny subtexts of the digital itself.

Linnie Blake and Xavier Aldana Reyes suggest that there now exists a digital horror that 'exploits its own framing and stylistic devices to offer reflections on contemporary fears, especially those regarding digital technologies themselves. This makes for an exceptionally anxious cinema, preoccupied with the dangers of digital technology' (3). In a sense virtually all cinematic horror is now digital, since digital production and exhibition practices now dominate film production worldwide. But despite the increasing domestication of the digital in recent decades, it can still invoke a profound sense of the technological uncanny. Or perhaps, because of that domestication.

Horror's digital variations

The traditional photochemical techniques used to record images onto film for later replaying are in the process of being replaced by the digital. The speed and extent of this transition are debatable, and

only time will tell whether those filmmakers like Quentin Tarantino, Christopher Nolan and Paul Thomas Anderson who advocate for the continued value of traditional film are stemming the tide or waging a doomed rearguard struggle. Where digital imagery was initially applied only to special effects, it is now present in almost every facet of the filmmaking process: all elements of production, distribution and exhibition. Writes David Bordwell,

> The change isn't simply a matter of new technology, or hardware turning into software. It isn't simply a matter of fancy gear or even the look and sound of images. It involves social processes, the way institutions like filmmaking and film exhibition work. Technology affects relations of power, along with the choices that moviemakers and filmgoers are offered. As films become files, cinema changes in subtle-far-reaching ways ... as moviegoing becomes different, so does our sense of what films are, and have been. (2012, 12)

The effects of the digital on horror are equally far reaching and multifaceted. Whether they constitute an outright break from previous modes of cinema – or even constitute 'the death of cinema', a loss of ontological authenticity and mediumistic identity – is a contentious question and far beyond the scope of this chapter,[1] but I would suggest that the frightening and unfamiliar and uncanny qualities of the digital are linked to it. The digital age has moved the horror genre in several directions at once and, some have suggested, returns us to a technological uncanny largely unseen since cinema's beginnings.

One direction is artistic. An interesting semi-example is the use of decidedly non-digital film in Michael Almereyda's *Nadja*. This baroque art film reworking of *Dracula's Daughter* uses a Pixelvision camera, a children's toy made by Fisher Price that records a grainy, rough image onto audiocassettes, to represent point-of-view shots from the vampire's perspective. It is a curious but effective choice to represent a vampire's enhanced senses, rather than through 'more advanced'

[1] Entries in this debate not otherwise cited here include Batchen (2000), Usai (2001), Belton (2002), Rodowick (2007), Gaudreault and Marion (2015).

FIGURE 9.1 *Pixelvision as vampire vision in* Nadja *(1994).*

digital aesthetics, via an analogue technology that looks crude and primal. It thus simultaneously represents an alternate form of vision and provides a commentary on its unrepresentability. It also stages a quiet commentary on the peculiar state of analogue media in an increasingly digital world, a subject to which we will return.

Long takes, a mainstay of art cinema now easily facilitated by digital filmmaking practices, have a central presence in digital horror films, notably in the *Paranormal Activity* franchise. Rather like the long takes featured in *Bu san/Goodbye Dragon Inn* (2003) or *Loong Boonmee raleuk chat/Uncle Boonmee Who Can Recall His Past Lives* (2011), both ghost films that fit into the art cinema constellation of 'slow cinema' (Wada-Marciano 2015), these digital horror films often encourage viewers to look deeply at static images, attentive to tiny details and changes. Meanwhile, one can go online and stream live feeds of purportedly haunted objects (a doll at www.the-line-up. com or a variety of artefacts owned by the Travelling Museum of the Paranormal and the Occult),[2] for much the same purpose.

[2]Thank you to Kevin Chabot for bringing these examples to my attention.

Another, much more common direction that digital has moved the horror film is towards blockbuster filmmaking (see Abbott 2010). Since the late 1990s, a series of action films have been constructed out of horror staples. An important early example was *The Mummy* (1999), which transformed the Karloff character Imhotep (now played by Arnold Vosloo) into a magically powerful shapeshifter, seemingly capable of anything due to the filmmakers' command of CGI (computer-generated imagery). The previous year, *Blade* (1998) melded vampire and superhero mythologies to considerable success, and was probably the single most important film in motivating the twenty-first-century revival of the superhero blockbuster. In contrast, the attempt at franchise building that was 2004's *Van Helsing*, which recast Stoker's elderly expert as a comparatively youthful nineteenth-century James Bond (played by Hugh Jackman) battling his way through a slate of familiar monsters (Frankenstein's monster, Dracula, Mr Hyde and werewolves), was a disastrous flop. Other blockbuster action/horror properties include the *Underworld, BloodRayne* (2005–2010), *30 Days of Night* (2007, 2010) and *Night Watch* (2004, 2006) series, all driven by CGI-heavy action sequences.

More recently, Universal Pictures has hoped to revive its monster properties in an integrated universe akin to the shared Marvel Films universe. In the November 2014 issue of the *Hollywood Reporter*, Universal Pictures chairman Donna Langley stated: 'We settled upon an idea, which is to take it out of the horror genre, put it more in the action-adventure genre and make it present day, bringing these incredibly rich and complex characters into present day and re-imagine them and reintroduce them to a contemporary audience' (n.p.). Early attempts (*The Wolfman* (2010), *Dracula Untold, The Mummy* (2017)) have done poorly, but Universal is undeterred, convinced it can make a Marvel-style shared universe out of its horror properties. How successful this attempt will prove remains to be seen, but it at least testifies that one profound direction the digital revolution has pushed horror properties is into action blockbuster territory.

Many have seen the influence of CGI on the horror film as a corrosive one. There is no better example than Jan de Bont's 1999 remake of *The Haunting*, directed for DreamWorks with an $80,000,000 budget. Evacuating all of the ambiguity of the original, it locates the force of supernatural villainy in Hugh Crain, represented

as a big floating CGI ghost. Critic Jonathan Romney wrote that 'de Bont's farcical *Haunting* demonstrates the noxious effects of the digital age: there's something inherently unfrightening about pixel generated ectoplasm' (37). For Romney, the problem is not simply that the special effects are poor or misguided, but that they are digital: they lack that indexical trace of reality. Perhaps Romney is reacting in part to the fact that CGI hides visible signs of labour. The 'effects auteurs' of old – from Willis O'Brien and Ray Harryhausen in stop motion and Jack Pierce and Wally Westmore in makeup to 'splatter' specialists like Tom Savini, Rob Bottin, Stan Winston and Dick Smith – had their work clearly and materially displayed on the screen. CGI effaces visible traces of labour and puts us into a different relationship with its technicians.

Horror fans debate the value of CGI, especially decrying the unconvincing monsters of films like *Dagon* (2001) or *I Am Legend* (2007), though the general viewing public does not always share these compunctions; *I Am Legend* and *The Haunting* both made plenty of money. Conversely, horror films that use practical effects are praised by fans for authenticity and fidelity to tradition; the new versions of *The Evil Dead* (2013), *Maniac* (2012) and *The Thing* (2011) largely escaped the scorn heaped on horror remakes in part because of their practical effects work. Ironically, 1990s CGI, especially, now looks older and cruder than many special effects from earlier decades: part of the problem with De Bont's *The Haunting* is that its effects are often representing material objects like bedposts, columns and statues morphing cartoonishly into animation, rather than exploiting CGI's potential for the representation of immateriality.

But CGI has legitimately opened up possibilities for horror, especially in its capacity for visualizing the spectral. Steffen Hantke notes that the standout sequence in Robert Zemeckis's *What Lies Beneath*, in which Norman (Harrison Ford) seems to watch his wife (Michelle Pfeiffer) transform into his murdered mistress (Amber Valetta), works precisely because it is accomplished in what appears to be a single take, achieved with morphing software (2015, 192–5). Indeed, despite the excesses of *The Haunting* remake, the ghost film is a logical place for CGI, since ghosts are most often clean and traceless. The ghosts in Guillermo del Toro's films, including *The Devil's Backbone* and *Crimson Peak*, have an aesthetic that

effectively mixes live action and CG elements effectively, including spectral smoke billowing out of eternal wounds. The spectres of Peter Jackson's *The Frighteners* are another example of effective CG ghosts, precisely because their colourful and spectacular qualities fit the film's tone, even as it sways bizarrely between comedy and horror.

But if digital has inspired blockbuster horror, it has simultaneously had the opposite effect: pushing horror towards small, low-budget projects. Rather than filling the screen with impressive special effects, these exploit the potential of the digital image to convey immediacy and familiarity. The ubiquity of digital recording technologies opens up potential for uncanny horror, especially.

Lost footage, found

Perhaps the most familiar group of straightforwardly digital horror films is the found footage cycle. The name is confusing since the films themselves are not found footage films in the manner of Bruce Conner or Bill Morrison, but rather newly produced footage 'playing' found footage. Other names have been attempted, like Barry Keith Grant's 'verité horror' (2013), denoting its heritage in the observational documentaries that emerged in the 1950s and 1960s, and in particular the faux-documentary style developed by Peter Watkins. Grant rightly points to *Cannibal Holocaust* (1980) and *Man Bites Dog* (1992) as important predecessors (156–7), but the cycle began in earnest with the monumental success of *The Blair Witch Project* in 1999. *The Blair Witch Project* opens with the title card reading:

> In October of 1994, three student filmmakers disappeared in the woods near Burkittsville, Maryland, while shooting a documentary called '*The Blair Witch Project*'. A year later their footage was found.

Thus, we are told that the camera, its footage and its operators are parts of the diegetic world (dynamic that would come to define the found footage film) and that the characters in the film are 'making' the film, too, albeit in ways contrary to their intentions. The remainder

of the film is sixteen-millimetre[3] footage, seemingly unedited, of the three characters entering and becoming lost in the Maryland woods and encountering increasingly shocking – though largely suggestive and ambiguous, events. The film's low budget becomes a virtue, harnessing the realist coding attached to low-grade, handheld camerawork.

While *The Blair Witch Project* had a credited screenwriter and thus declared itself as fiction, many of its paratexts encouraged speculation in the opposite direction. Its website was an exercise in world-building that filled in an intricate history of the Blair Witch and the town of Burkittsville, as well as of the three 'vanished' filmmakers who appear in the film. Even their Internet Movie Database profiles listed them as deceased (Hight 2008, 213). A television mockumentary called 'Curse of the Blair Witch' aired two days before the film opened in July 1999, more than a year after the promotional campaign had begun online; discussion boards and newsgroups were full of discussion of the film's status as fiction or non-fiction (Telotte 2004). *The Blair Witch Project* became a paradigm of clever and successful viral marketing. More than this, some have suggested, it demonstrated the possibilities of cross-platform digital narratives which encourage fans to participate through a variety of formats, and rendering the film 'ancillary to the website, an extension of it' (Grant 2013, 162).

Introducing 2002's *Horror: The Film Reader*, Mark Jancovich noted that '*The Blair Witch Project* increasingly looks like a one-off gimmick rather than the start of a new cycle of horror production' (7). History would prove otherwise, but there was indeed an interesting millennial gap before the found footage format returned in earnest, seemingly to stay. *REC*, *Diary of the Dead* and *Cloverfield* were accompanied by the micro-budgeted *Paranormal Activity*. *Paranormal Activity* concerns a suburban married couple (as in *The Blair Witch Project*, the actors use their own names) documenting the supernatural events in their home with a video camera. In place of the opening title card from *The Blair Witch Project*, *Paranormal Activity* closes with them, again with

[3] *The Blair Witch Project* was shot on film and screened theatrically on thirty-five millimetre; the most strictly 'digital' element of its initial release was its marketing.

dates providing a sense of *verité*-tinged verisimilitude: 'Micah's body was discovered by police on October 11th, 2006. Katie's whereabouts remain unknown.' In both cases, a narrative of the discovery of the footage and distribution is implied as playing out subsequent to the film's diegetic events, suggesting the networked or 'viral' character of modern media.

The kingdom of pixels

Writes Isabella van Elferen, 'Technological transcendency has turned the familiar world into an unhomely place where the borders between technology and nature are no longer clearly defined, where cyberreality has invaded daily life, and where intelligence and agency are not reserved for humans only' (2009, 109). The digital, she argues, has had an uncanny-making influence on our day-to-day lives. Very often, it seems that the uncanniness of new media can be expressed only with recourse to the uncanniness of old media.

One famous instance of the technological uncanny as it applies to early cinema comes from the great Russian writer Maxim Gorky. Gorky attended a screening of the Lumière programme in Nizhni-Novgorod in 1896 and wrote a newspaper review that began:

> Last night I was in the Kingdom of Shadows.
>
> If you only knew how strange it is to be here. It is a world without sound, without colour. Everything there – the earth, the trees, the people, the water and the air – is dipped in monotonous grey. Gray rays of the sun across the grey sky, grey eyes in grey faces, and the leaves of the trees are ashen grey. It is not life but its shadow, not motion but its soundless spectre. (407)

The three-page review deploys supernatural tropes of various kinds to characterize the new and unfamiliar medium. Gorky describes 'the grey silhouettes of the people, as though condemned to eternal silence and cruelly punished by being deprived of all the colours of life, glide noiselessly along the grey ground' (ibid.), and says of the card game in *Partie de Cartes* (1896), 'It seems as if these people

have died and their shadows have been condemned to play cards in silence unto eternity' (408). He speaks of how 'curses and ghosts, the evil spirits have cast entire cities into eternal sleep, come to mind and you feel as though Merlin's vicious trick is being enacted before you' (ibid.).

It is surely the case that, as Ian Christie states, 'we don't have to regard [Gorky] as an objective reporter' (15), but rather should see him as a poet finding suggestive potential in the new medium. It is equally true, however, that Gorky's reactions were not sui generis, however eloquently he may have expressed them. Writes Laura Mulvey:

> It is impossible to see the Lumière films as simple demonstrations of a new technology; every gesture, expression, movement of wind or water is touched with mystery. This is not the mystery of the magic trick but the more disturbing, uncanny sensation of seeing movement fossilized for the first time. This uncanny effect was also vividly present for the cinema's first spectators; the images' silence and lack of colour added to the ghostly atmosphere. (36)

This technological uncanny was suppressed through familiarity, though filmmakers can evoke it still. Mulvey goes on to argue that 'now, after more than a hundred years. ... The phantom-like quality observed by Gorky and his contemporaries returns in force. The inanimate images of the filmstrip not only come alive in projection, but are the ghostly images of the now-dead resurrected into the appearance of life' (2010, 36). Mulvey here refers to the advent of the digital image, which, she argues, makes us all Gorkian spectators again.

Mulvey is building on Lev Manovich's 2001 book *The Language of New Media*. Manovich positioned the digital as a new medium, distinct from photochemical film, which peculiarly also represents a return to the beginning:

> Cinema is the art of the index; it is an attempt to make art out of a footprint. ... The manual construction of images in digital cinema represents a return to the pro-cinematic practices of the nineteenth century, when images were hand-painted and hand-animated. At the turn of the twentieth century, cinema was to delegate these

manual techniques to animation and define itself as a recording medium. As cinema enters the digital age, these techniques are again becoming commonplace in the filmmaking process. Consequently, cinema can no longer be clearly distinguished from animation. It is no longer an indexical media technology but, rather, a subgenre of painting. (Manovich 2001, 246)

Cinema, for Manovich, has lost its traces of reality (the footprint) and now is epically pure and epically unreal. Instead of the kingdom of shadows, we might say, the digital regime is a kingdom without a shadow – like Dracula. For many, including Manovich, this shift is not an occasion for despair but rather something to be accepted, or even celebrated.

Philip Rosen argues that the 'digital utopia' is characterized by '(1) the *practically infinite manipulability* of digital images; (2) *convergence* among diverse image media; and (3) *interactivity*' (318, original emphasis). Digital horror seems prepared to pervert all three into dystopia: manipulability into undecidability, convergence into contagion and interactivity into the insidious workings of digital media on its users. It is interesting to note that around the time when these discourses were being formulated, horror seemed fixated on either the very forms that seemed set to be superseded by the digital (video tapes in the *Ring* and *V/H/S* films, radio waves in *White Noise*, cinema itself in *Playback* (2012) and *The Canal* (2014)), interpretable either as evidence of their consignment to history (the uncanniness that obsolete technology often possesses) or as a fundamental lack of rupture between the analogue and digital regimes.

The early masterpiece of reflexively digital horror was surely Kiyoshi Kurosawa's *Pulse* or *Kairo* from 2001, a philosophical mediation on technology and alienation in the digital era, in which the idea of digital utopia is sharply inverted.[4] Part of the J-horror cycle that included Kurosawa's earlier *Kyua/Cure* (1997) and later *Sabeki/Retribution* (2006), *Pulse* shares with many J-horror films a fixation on technology and its dark, uncanny and potential supernatural implications. Perhaps less shock driven than most J-horror films

[4]For interpretations of *Pulse,* see Jones (2010), Hughes (2011) and Petrovic (2013).

(yet still with plenty of terrifying images), the premise of *Pulse* is that the afterlife has filled to capacity and ghosts are spilling back through the internet, spreading and travelling like data. The question suddenly scrawls across a computer screen: 'Would you like to meet a ghost?' Like so many media before it, the internet promises new contact with the dead. But in *Pulse*, the world of the dead is empty and desolate: 'eternal loneliness', as one spectre claims. And that loneliness is infecting the phenomenal world. Mysterious shadows stalk rooms, a rash of suicides breaks out and people vanish en masse. The ghosts – specifically digital spectres, associated with the sounds of dial-up modems – slowly hollow out Tokyo until it is left a nearly vacant shell, and *Pulse* slides into the apocalypse genre. The networked character of the digital world is its undoing when the 'virus' is death itself.

If *Pulse* engages with Japan's traumatic history, it also makes reference to the contemporary social phenomenon of *hikikomori*, a term coined by Saitō Tamaki that translates roughly as 'seclude oneself'. It describes the social withdrawal of hundreds of thousands of Japanese youths, principally male, 'who shut themselves up in their rooms and avoid face-to-face interaction for six months or longer following acute social or psychological trauma, typically triggered by an event … such as academic failure, bullying, or jilted romance' (Brown 2010, 118). The *hikikomori* are a phenomenon of the digital age, in which mediated communication has become the norm and radical solitude is kept bearable by the endless accessibility of video games, computers, television, music and other digital media. *Pulse* contains numerous hikikomori-evoking images of vague, poorly lit young people at their webcams, looking haggard and defeated, who are explicitly compared to living ghosts. Their joyless existence promises to give way only to a joyless afterlife.

In one of the spookiest scenes in *Pulse*, a character named Harue (Koyuki) watches a grainy webcam footage of a suicide on her computer screen. Suddenly, the image changes to another image, which she recognizes as herself, seen from behind. Harue turns to investigate and sees no source for the image, though it records her every movement. We watch, half looking at the monitor and half cutting away from it, as she walks through a door and turns on a light. Suddenly, we cut to a new perspective, looking at her

through a haze of pixilation, even as a high-pitched drone sounds on the soundtrack. The POV-coded camerawork is a familiar sight in horror (commonplace in slasher films, especially), but in this case it seems an impossible perspective, or at least an invisible one, that is somehow also technological. The camera pans back to the computer screen, now filled with Harue's face, hopping and jumping from place to place with glitches accompanied by an incessant sound effect. Ecstatically declaring 'I'm not alone', she reaches up and grasps something invisible, as we cut between the grainy POV-coded digital footage of her face in close-up and more conventional film footage of the room. Harue seems to vanish, only turning up later on the verge of suicide herself.

Vanishing people leave only inky stains on walls behind, and billowing clouds of ashy black, threatening to pixilate the world, conjure up Hiroshima and Nagasaki imagery. *Pulse* is full of scenarios in which the analogue and digital, reality and simulation, life and death, seem to mingle and become indistinct. There is no transcendence, no utopianism, in this merger. It may even serve as a corrective to or even a parody of those utopian narratives of the digital age, with a dystopia where the manipulability of the digital image is reflected in shadowy parodies of the phenomenal world, and both convergence and interactivity serve the triumph of entropy and nothingness.

FIGURE 9.2 *A digital ghost's eye view of Harue (Koyuki) in* Pulse *(2001).*

In the glitch

The supernatural has long taken up residence in photographic accident, and digital photography continues that tradition. Writes John Potts,

> Whereas early photography produced ghostly shapes in human form in the nineteenth century, the twenty-first century has generated non-human ghostly shaped, expanding the ghost-hunters' lexicon in the process ... Contemporary ghosts ... take on forms – 'orbs' and 'vortexes' – generated by the very technologies used to reveal them. (90)

The mistakes of digital media have taken up their own place in the canon of horror films through their infestation of the found footage horror film.

One distinctive feature of digital horror, especially in the 2010s, is the prominence of the glitch. Rather like the 'found footage' in which it often appears, the term 'glitch' needs to be qualified, since what these films present are generally not actual glitches but simulations thereof, created in postproduction. Rather like the cigarette burns, scratches and decay lines that mark the material character of photochemical film, glitches mark the fallibility of digital media and the fragility of the flow of information on which we now depend. Glitches are hardly unique to horror – Jean-Luc Godard's *Film Socialisme* (2010), much of it shot on camera phones, is full of deliberate visual and auditory glitches – but they have been majorly claimed by the genre. Marc Olivier argues that 'jarring spectacle of data ruins is becoming to the twenty-first century what the crumbling mansion was to Gothic literature of the nineteenth century: the privileged space for confrontations with incompatible systems, nostalgic remnants, and restless revenants' (253), and that the presence of a glitch is dependent on a human observer (261–2). The glitch has become so omnipresent, Olivier shows, that a trailer for the Blu-Ray edition of *The Blair Witch Project* 'has been retrofitted with wildly spiking glitched transitional intertitles' that the original (shot on analogue film) lacked (260).

The glitch is on display from the first moments of the Blumhouse release *Unfriended*. It shows the planetary emblem of Universal Pictures, the film's distributor, pixilating and cracking apart, coordinated with jumps of the familiar theme music that eventually breaks down into cacophonous noise, ultimately turning into a glitch-riddled travesty of the familiar corporate emblem. *Unfriended* provides a clever new twist on traditional horror tropes as filtered through a digital milieu. It has a 'Final Girl' of sorts in Blaire Lily (Shelley Hennig), and especially resembles *Prom Night* or *I Know What You Did Last Summer* in focusing on a group of friends hiding dreadful secrets; it also echoes *The Cat and the Canary*, Agatha Christie's novel and play *And Then There Were None/Ten Little Indians* (1939) and a great many slasher films in isolating a set of characters together in a haunted environment and eliminating them one by one. But this environment is online, and no two of the friends are ever in the same place, except for virtually. The entirety of the film takes place on Blaire's desktop, and unfolds through social media platforms like Facebook, Skype and Chatroulette. Its monster is 'billie227', a mysterious web presence that seems to possess inexplicable powers over internet functions and cannot be 'unfriended' on Facebook. It transpires that billie227[5] is the digital afterlife of Laura Barns, a victim of cyberbullying now taking her revenge on those who actively or passively abetted her demise. 'The glitch just typed!' one character objects as they observe the familiar programmes that facilitate their interaction coopted from within. On a fundamental level, Laura/billie227 is the glitch, the inevitable breakdown of digital media being extrapolated out to the breakdown of the media-saturated circle of friends.

David Crewe notes,

The computer screens we see at the movies are generally simplified to avoid audience confusion. So it's refreshing to see a more realistic depiction of a teenager's desktop [in *Unfriended*]: cluttered with multiple windows, disorganised files and dozens of open browser tabs. *Unfriended* utilises the laptop screen to

[5]The name 'billie' resembles 'Blaire Lily', perhaps disclosing Blaire's role in originating this particular haunting.

add subtle shades of characterization – with small details like the contents of Blaire's Spotify playlist giving us added insight into who she is – and as a rare cinematic representation of 'how we live now'. (80)

In foregrounding the clutteredness and messiness possible in digital environments, *Unfriended* refutes digital media's apparent cleanness and tracelessness and suggests its abject potential. The abject proper makes an unexpected interjection into *Unfriended*'s digital world when we finally see the video that drove Laura Barns to suicide: the image of her unconscious body smeared with her own faeces, uploaded to YouTube without her consent and superimposed with the bright red words: 'Leaky Laura … Kill Urself'. It plays out in multiple windows at once as they fill the screen, suggesting the infinite reproducibility and replayability of digital media, and the fact that the ghost prevents the users from closing them reminds us that in the area of viral media, we can effectively never control or limit the spread of anything. The revelation of the faecal origin of the friends' primal guilt is placed at odds with the digital's (perhaps excessive) cleanliness and purity, though here again the image is being disseminated digitally – as is the image of Laura's corpse following her public suicide, the corpse being, of course, Kristeva's ultimate figure of abjection. Corpses

FIGURE 9.3 *The Universal Pictures logo 'glitchified' in* Unfriended *(2015).*

accumulate in *Unfriended* as the friends suffer increasingly nasty and abject fates (most brutally, Jess (Renee Olstead) with a hair curler down her throat). The apparent abjectlessness of digital imagery is challenged not only by these images, but also by the frequent glitches that distort faces and muffle words, revealing, perhaps, the characters' twisted true natures.

Unfriended also examines the nature of mourning in the digital era and 'digital afterlife' that we now face (Jones 2004; Wright 2014). The process by which Laura stays alive resembles the 'undeath' of social media, which now outlasts its users (one character remarks on still being a Facebook friend of Laura, never having bothered to change the status after Laura's death). Amelia Guimarin (2007) regards MyDeathSpace, a website that preserves the MySpace profiles of deceased users, as a 'phantom archive' that simultaneously preserves the life of the user and testifies to their death. In a way, *Unfriended* tells a classic ghost story of a dead person with 'unfinished business', whose spirit lingers on because she has not been mourned properly. This age-old plotline has simply been transmogrified into a digital environment.

Unfriended is on one level nothing new: a rather moralizing cautionary tale about the dangers of social media. It dips into the roster of time-worn teenage scandals to dredge up cheating, date rape, abortion and so on, but with the additional emphasis on the fact that secrets never stay secret in the digital world. It is on a lineage with countless films about the horrific implications of recording and communication technologies (*Poltergeist*, *Videodrome*, *Demons*, the *Ring* movies, *Ghostwatch*, *TerrorVision* (1986), *The Video Dead* (1987), *Shocker* (1989), etc.), as well as digital-era films that emphasize themes of surveillance and paranoia (*Fear dot Com* (2002), *Stay Alive* (2006), *Disturbia* (2007), *Untraceable* (2008), *Smiley* (2012), *Open Windows* (2014), *Girl House* (2014), *#Horror* (2015), etc.). A curious quality of *Unfriended* is that it seems designed to be viewed on any medium except for home video, where the ability to read the small type that drives much of the narrative is compromised; *Unfriended* particularly rewards being watched on a laptop screen. One can see the film as an exploration of what Scott Bukatman calls 'terminal identity': 'a new subject-position to interface with the global realms of data circulation, a subject that can occupy or intersect the cyberscapes of contemporary

existence' and which involves 'both the end of the subject and a new subjectivity constructed at the computer station or television screen' (9). Where Bukatman is interested in the fleshy interfaces of cyberpunk and its cinematic extrapolations, *Unfriended* suggests that we can find terminal identity in the ghost story, too. Perhaps Laura is the apotheosis of this new configuration of identity, evidently having no objective existence apart from disembodied manifestations through terminals, or so it seems until the film's final moments, which imply a moment of Sadako-like breaching out into the world.

Unfriended was apparently shot in a single take with different cameras on the different actors on different sets, timed carefully to match up. Probably the best point of reference for this practice is Mike Figgis's *Timecode* (2000), a Hollywood-set tale filmed simultaneously on four different digital cameras, staging its own reflexive commentary on the changing medium. Both films work to explore the potential of digital cinema to do things nigh impossible with photochemical film. It will be interesting to see whether *Unfriended* proves to be an interesting one-off or, as *The Blair Witch Project* proved, an originator to a long-standing cycle. Perhaps we will see a long-standing cycle of 'terminal horror' films playing with similar aesthetics.[6]

Analogue echoes

In *Paranormal Activity: The Ghost Dimension* (2015), the found footage aesthetic couples with 3-D to convey the titular spirit world interfacing with our world. The characters find a 1980s camcorder rigged to show the characters supernatural images that elude the naked eye. On a continuum with spirit photography and other attempts to document the supernatural through technology, it works much like the 'ghost viewer' in William Castle's *13 Ghosts* and with a similar reflexive quality. This is especially true in 3D, used almost exclusively to convey supernatural images as subtle as the rippling

[6]Other existing examples include 'The Sick Thing That Happened to Emily When She Was Younger', directed by Joe Swanberg for *V/H/S*, and *The Den* (2013). See McMorran (2015).

fields of distortion that the camera passes through and as manifest as a giant black hand jumping out at the audience. Dialogue reinforces the camcorder's retro novelty ('It's so big!' a child squeals), yet it proves able to achieve what no digital camera can in showing us the titular ghost dimension.

2012's *Playback* also has a supernatural camcorder. The film starts with its glitchy gaze as an unseen figure, marrying the opening of *Halloween* and the glitch Gothic aesthetic, stalks his way through a house. He finds a baby in a crib and begins filming him; the screen turns to static as he does so. Watching the playback, the killer seems to drive his hand into a static-filled television set (rather a reversal of *Videodrome*, with echoes of *Poltergeist* and *Ring*), and then upstairs to claim the camcorder and the baby. Confronted by the police on the house's porch, he lays the baby and the camera both down, before violently stabbing his sister, the baby's mother, to death, but is shot by the police in the process. As the ambulances arrive, we linger on the baby only for that image to glitch out and the footage to begin reversing, triggering a montage that ends with the staticky television again, and for a split second, an image familiar to many students of early and pre-cinema.

Though it is not legible as such yet, it is a frame *Roundhay Garden Scene*, two seconds worth of footage shot by the French inventor Louis Le Prince in 1888, a full seven years before the 'official' debut of cinema by the Lumière brothers in 1895. The film's mythology presents Le Prince as a demonic figure that invented the moving picture camera to steal souls. As video store clerk Wylie (Darryl Mitchell) explains, a movie is 'the exact replica of a living, breathing person. Not a frozen moment like a photograph, but something that moves, something made of light, like a ghost.' The legend, as Wylie tells it, is that Le Prince stole the soul of his son, Adolphe, and continued to possess his descendants down through the ages, and that *Roundhay Garden Scene*, which includes Adolphe, was his method for doing so. Before giving the protagonist Julian (Johnny Pacar) – the baby from the opening sequence, himself an unwitting descendant of Le Prince – a copy of Le Prince's films, Wylie adds that everyone filmed by Le Prince died right afterwards.

Louis Le Prince was indeed a real person, whose overall contribution to the technological history of cinema is still debated (Howells 2006).

Legends do circulate about him, but these involve his mysterious disappearance in 1890 while on a Dijon-Paris train (murdered, some say, to prevent him from patenting his projector). His son, Adolphe, also died tragically in an apparent hunting accident, not 'right after' being filmed as *Playback* implies, but a dozen years later. *Playback* even suggests that Le Prince was the Devil, with Wylie raising *Angel Heart*'s 'Louis Cyphre' as precedent. The film's Le Prince is now an incorporeal menace occupying the body of Quinn (Toby Hemingway), himself possessed by viewing video footage, and looking to migrate to Julian.

In connecting its curse to the history and even prehistory of cinema, *Playback* joins *Paranormal Activity: The Ghost Dimension* and other films including *Ring* and its sequels and remakes, John Carpenter's 'Cigarette Burns' (2005; an episode of *Masters of Horror*), *Sinister* and *The Quiet Ones* in fixating on the very film and video formats that the digital has displaced or at least threatens to displace; *Ouija: Origin of Evil* (2016), set in 1967, even uses digital simulations of 'cigarette burns' as part of its retro aesthetic. In so many of these narratives, the older media contains, accesses or reveals supernatural worlds. There are a number of anachronisms in *Playback*, including the video store itself and Wylie giving Julian a (non-existent) DVD of Le Prince's films (all four of them, adding up to mere seconds of footage?) rather than simply directing him to watch Le Prince's films on YouTube, the first place they have been widely distributed (Lundemo 2009). So it is all the more interesting in its final moments when the curse hops from analogue to digital, with Julian being possessed by Le Prince in *Playback*'s last moments via a video message on a camera phone, displaying Quinn's dying face in morbid close-up. For a second something changes in Quinn's eyes – perhaps an allusion to the legend of a dying man having the last thing he sees imprinted onto them – and from there we see once again the roiling static of a television screen with a few images of *Roundhay Garden Scene* flickering within it. Just as that nebulous thing called 'cinema' has survived migration from format to format, Le Prince, it seems, will do the same. The film thus emphasizes the (here demonic) continuities that underpin a history of technological change (the emphasis on platform migration and emergent 'virality' in *Rings* works similarly).

FIGURE 9.4 *A ghostly transmission in* Playback *(2012).*

Also of interest is the sequence in *The Babadook* where Amelia (Essie Davis) watches television and seems to hallucinate a series of Georges Méliès trick films, including *Un homme de têtes/Four Troublesome Heads* (1898), *Le livre magique/The Magic Book* (1900), *Dislocation mystérieuse/An Extraordinary Dislocation* (1901) and *Le cake-walk infernal/The Cake-Walk Infernal* (1903), along with Segundo de Chomón's haunted hotel film *La maison ensorcelée/The House of Ghosts* (1908). But the images have been altered; for instance, when Méliès's magician pulls open the giant magic book, the Babadook lurks inside it, and dancing girls conjure the Babadook instead of Méliès's Mephisto. These seamless distortions, aged to look as worn and old as the early trick films they invade, were perhaps accomplished digitally but, like the artisanal Babadook book itself, connote a kind of analogue authenticity in a digital world.

In the summer of 2016, Blumhouse began a viral marketing campaign for a mockumentary called *'Fury of the Demon'*, about a (fictional) lost Méliès film called *La Rage du Démon*, purported to cause madness whenever it has been screened (a horrific riff on the myth of the panicking audience of early cinema). Perhaps these narratives featuring analogue hauntings in a digital world is a reaction to the lingering association of analogue technologies with 'authenticity' and 'indexicality', qualities that the digital is often understood to lack. It may prove interesting to place *Fury of the Demon* alongside

. Martin Scorsese's *Hugo* (2011), with its own narrative of tragedy, loss and archival rediscovery attached to Méliès and early cinema, as dark and light tales of analogue authenticity in a digital future. The analogue ability to 'haunt' in these narratives seems closely linked to its materiality and the historicity it suggests, its very obsolescence investing it with potential power.

The persistence of the uncanny

Writes Bukatman, 'Whether Baudrillard calls it *telemetric* culture or science-fiction writers call it the Web, *the Net the Grid, the Matrix*, or, most pervasively, cyberspace, there exists the persuasive recognition that a new and decentred spatiality has arisen that exists parallel to, but outside of, the geographic topography of experiential reality' (105). Authors like Sarah Waters (1997) and Jeffrey Sconce (2000 esp. 167–209) have charted cyberspace's resemblance to nineteenth-century spiritualist fantasies. As I write this chapter, local malls and parks and other public spaces are being stalked, not by the living dead, but by people looking intently at their phones, searching for invisible monsters. *Pokémon Go* seems like the ultimate digital-era reification of that spiritualist commonplace: the existence of an unseen world around us, contactable only through technologized mediumship. Just as spiritualism's extremely positive conception of the afterlife left (officially) little space for the uncanny, so does *Pokémon Go* present its alternate digital sphere as a place for whimsical fun. The line between cyberspace and 'meatspace' has never seemed as thin, and yet the result is greeted as a new recreation activity, albeit with the inevitable conspiracy theories linking *Pokémon Go* to mind control and even occult practices. A similar immersive augmented reality game called *Night Terrors* is being marked to horror fans promises to turn mundane domestic space into nightmarish haunted environments.

Is the digital becoming domesticated? Certainly. But this has been a long process; in 1998, Martin Jay spoke of how 'even the dead are not safe from exploitation, their images revivified to sell soft drinks and shake the hand of Forrest Gump. It is now the height of canniness to market the uncanny' (163). Will it lose the quality of

the 'technological uncanny' in time? Perhaps, but not absolutely. The popular of the Ashy Murphy video and others like it reminds us of just how ready we still are to stare at low-grade digital videos purporting to document the supernatural, ready to indulge videos of domestic space turned chaotic, ready to look for ghosts in the glitch. So just as the uncanny qualities of film sound and colour remain within a horror film's arsenal many decades after the introduction of those technologies, so too is the digital uncanny likely to retain an ability to disquiet its audience for a long time to come.

Bibliography

Abbott, Stacey. 'High Concept Chills and Thrills: The Horror Blockbuster.' In *Horror Zone*. Ed. Ian Conrich. London: I. B. Tauris, 2010. 25–44.

Ahmad, Aalya. 'When the Women Think: Teaching Horror in Women's and Gender Studies.' In *Fear and Learning: Essays on the Pedagogy of Horror*. Eds Aalya Ahmad and Sean Moreland. Jefferson, NC: McFarland Press, 2013. 56–74.

Aldana Reyes, Xavier. *Horror Film and Affect: Towards a Corporeal Model of Viewership*. New York: Routledge, 2016.

Alford, Robert. 'Supernatural Speech: Silent Cinema's Stake in Representing the Impossible.' In *Cinematic Ghosts: Haunting and Spectrality from Silent Cinema to the Digital Era*. Ed. Murray Leeder. New York: Bloomsbury Academic, 2015. 77–94.

Allison, Deborah. 'Magick in Theory and Practice: Ritual Use of Colour in Kenneth Anger's *Invocation of My Demon Brother*.' *Senses of Cinema* 42 (2005): n.p.

Allmer, Patricia, Emily Brick and David Huxley, eds. *European Nightmares: Horror Cinema in Europe Since 1945*. London: Wallflower Press, 2012.

Altman, Rick. 'A Semantic/Syntactic Approach to Film Genre.' *Cinema Journal* 23.3 (Spring 1984): 6–18.

Altman, Rick. *Film/Genre*. London: BFI, 1999.

Ancuta, Katarzyna. 'Global Spectrologies: Contemporary Thai Horror Films and the Globalization of the Supernatural.' *Horror Studies* 2.1 (2011): 131–44.

Anon. '*The Exorcist*.' *British Board of Film Classification*. http://www.bbfc.co.uk/case-studies/exorcist. Accessed 6 August 2016.

Anon. 'Shining named perfect scary movie.' *BBC News*. August 9 2004. http://news.bbc.co.uk/2/hi/entertainment/3537938.stm. Accessed 21 December 2014.

Arnheim, Rudolf. *Film Essays and Criticism*. Madison: University of Wisconsin Press, 1997.

Attebery, Brian. *Strategies of Fantasy*. Bloomington: Indiana University Press, 1992.

Austin, Bruce A. 'Portrait of a Cult Film Audience: *The Rocky Horror Picture Show*.' *Journal of Communication* 31.2 (1981): 43–54.

Austin, Thomas. *Hollywood, Hype and Audiences: Selling and Watching Popular Film in the 1990s*. Manchester: Manchester University Press, 2002.

Badley, Linda. *Film, Horror, and the Body Fantastic*. Westport: Greenwood Press, 1995.

Bailey, Dale. *American Nightmares: The Haunted House Formula in American Popular Fiction*. Bowling Green, OH: Bowling Green State University Popular Press, 1999.

Balázs, Béla. *Theory of the Film: Character and Growth of a New Art*. New York: Dover, 1970.

Barker, Martin, ed. *The Video Nasties: Freedom and Censorship in the Media*. London: Pluto Press, 1984.

Barker, Martin, Kate Egan, Tom Phillips and Sarah Ralph. *Alien Audiences: Remembering and Evaluating a Classic Movie*. Houndmills, Basingstoke and Hants: Palgrave Macmillan, 2016.

Barker, Martin, Ernest Mathijs and Xavier Mendik. 'Menstrual Monsters: The Reception of the *Ginger Snaps* Cult Horror Franchise.' http://citeseerx.ist.psu.edu/viewdoc/download?doi=10.1.1.601.1823&rep=rep1&type=pdf. Accessed 23 August 2016.

Batchelor, David. *Chromophobia*. London: Reaktion, 2001.

Batchen, Geoffrey. 'Ectoplasm: Photography in a Digital Age.' In *Over Exposed: Essays on Contemporary Photography*. Ed. Carol Squiers. New York: The New Press, 2000. 9–23.

Beckman, Karen. *Vanishing Women: Magic, Film, and Feminism*. Durham, NC: Duke University Press, 2003.

Bellin, Joshua David. *Framing Monsters: Fantasy Film and Social Alienation*. Carbondale: Southern Illinois University Press, 2005.

Belton, John. 'Digital Cinema: A False Revolution.' *October* 100 (Spring 2002): 98-114.

Benshoff, Harry M. 'Blaxploitation Horror Films: Generic Reappropriation or Reinscription?' *Cinema Journal* 39.2 (2000): 31–50.

Benshoff, Harry M. *Monsters in the Closet: Homosexuality and the Horror Film*. Manchester: Manchester University Press, 1997.

Benshoff, Harry M. 'Vincent Price and Me: Imagining the Queer Male Diva.' *Camera Obscura* 23.1 (2008): 146–50.

Benshoff, Harry M. '"Way Too Gay to Be Ignored": The Production and Reception of Queer Horror Cinema in the Twenty-First Century.' In *Speaking of Monsters: A Teratological Anthology*. Eds Caroline Joan S. Picart and John Edgar Browning. Houndmills, Basingstoke and Hants: Palgrave Macmillan, 2012. 131–44.

Berenstein, Rhona. *Attack of the Leading Ladies: Gender, Sexuality and Spectatorship*. New York: Columbia University Press, 1996.

Bernard, Mark. *Selling the Splat Pack: The DVD Revolution and the American Horror Film*. Edinburgh: Edinburgh University Press, 2015.

Blake, Linnie. *The Wounds of Nations: Horror Cinema, Historical Trauma and National Identity.* Manchester: Manchester University Press, 2008.

Blake, Linnie and Xavier Aldana Reyes. 'Introduction: Horror in the Digital Age.' *Digital Horror: Haunted Technologies, Network Panic and the Found Footage Phenomenon.* London: I. B. Tauris, 2016. 1–13.

Blumer, Hubert. *Movies and Conduct.* New York: Macmillan, 1933.

Bode, Lisa. 'Transitional Tastes: Teen Girls and Genre in the Critical Reception of *Twilight.' Continuum* 24.5 (2010): 707–19.

Booth, Paul. '*Saw* Fandom and the Transgression of Fan Excess.' In *Transgression 2.0: Media, Culture, and the Politics of a Digital Age.* Eds Ted Gournelos and David J. Gunkel. London: Continuum, 2012. 69–83.

Bordwell, David. *Making Meaning.* Cambridge, MA: Harvard University Press, 1989.

Bordwell, David. *Pandora's Digital Box: Films, Files, and the Future of Movies.* Madison, WI: The Irvington Way Institute Press, 2012.

Bordwell, David, Janet Staiger and Kristin Thompson *The Classical Hollywood Cinema: Film Style & Mode of Production to 1960.* New York: Columbia University Press, 1985.

Bordwell, David and Kristin Thompson. *Film Art: An Introduction* (10th Edition). New York: McGraw-Hill, 2013.

Bottomore, Stephen. 'The Panicking Audience? Early Cinema and the "Train Effect". *Historical Journal of Film, Radio and Television.* 19:2 (1999): 177–216.

Bould, Mark. 'Film.' *The Oxford Handbook of Science Fiction.* Ed. Rob Latham. Oxford: Oxford University Press, 2014. 155–68.

Bozzuto, James C. 'Cinematic Neurosis Following "The Exorcist."' *The Journal of Nervous and Mental Disease* 161.1 (1975): 43–8.

Brinkema, Eugenie. *The Forms of the Affects.* Durham, NC: Duke University Press, 2014.

Brown Steven J. *Tokyo Cyberpunk: Posthumanism in Japanese Visual Culture.* Houndmills, Basingstoke and Hampshire: Palgrave Macmillan, 2010.

Bruckner, Rene Thoreau. 'Bad Sync: Spectral Sound and Retro-Effects in *Portrait of Jennie.'* In *Cinematic Ghosts: Haunting and Spectrality from Silent Cinema to the Digital Era.* Ed. Murray Leeder. New York: Bloomsbury Academic, 2015. 97–114.

Brophy, Phillip. 'Horrality – The Textuality of Contemporary Horror Films.' *Screen* 27:1 (1986): 2–13.

Brottman, Mikita. *High Theory/Low Culture.* Houndmills, Basingstoke and Hampshire: Palgrave Macmillan, 2005.

Brottman, Mikita. *Offensive Films.* Nashville, TN: Vanderbilt University Press, 2005.

Brunas, Michael, John Brunas and Tom Weaver. *Universal Horrors: The Studio's Classic Films, 1931-1946.* London: McFarland, 1990.

Buckingham, David. *Moving Images: Understanding Children's Emotional Response to Television.* Manchester: Manchester University Press, 1996.

Buckland, Warren. *Directed by Stephen Spielberg: Poetics of the Contemporary Hollywood Blockbuster.* New York: Continuum, 2006.

Bukatman, Scott. *Terminal Identity: The Virtual Subject in Post-Modern Science Fiction.* Durham, NC: Duke University Press, 1993.

Bulwer-Lytton, Edward. *The Haunted and the Haunters.* London: Simpkin, Marshall, Hamilton, Kent & Co., 1925.

Butler, Ivan. *Horror in the Cinema.* South Brunswick, NJ: Barnes, 1979.

Cameron, Allan. 'Colour, Embodiment and Dread in *High Tension* and *A Tale of Two Sisters.*' *Horror Studies* 3.1 (2012): 87–103.

Campbell, James. 'Cosmic Indifferentism in the Fiction of H. P. Lovecraft.' In *American Supernatural Fiction from Edith Wharton to the Weird Tales Writers.* Ed. Douglas Robillard. New York: Garland Publishing, 1997.

Cantor, Joanne. '"I'll Never Have a Clown in my House Again": Why Movie Horror Lives On.' *Poetics Today* 25:2 (2004): 283–304.

Castle, Terry. *The Female Thermometer: 18th Century and the Invention of the Uncanny.* New York: Oxford University Press, 1995.

Carroll, Noël. 'Horror and Humor.' *The Journal of Aesthetics and Art Criticism* 57.2 (Spring 1999): 145–60.

Carroll, Noël. *Philosophy of Horror: Or Paradoxes of the Heat.* New York: Routledge, 1990.

Castle, Terry. *The Female Thermometer: 18th Century and the Invention of the Uncanny.* New York: Oxford University Press, 1995.

Castle, William. *Step Right Up! I'm Gonna Scare the Pants off America.* New York: Putnam, 1976.

Cherry, Brigid S. G. 'The Female Horror Audience: Viewing Pleasures and Fan Practices.' University of Sterling, 1999a. Diss.

Cherry, Brigid. *Horror.* New York: Routledge, 2009.

Cherry, Brigid. 'Refusing to Refuse to Look: Female Viewers of the Horror Film.' In *Identifying Hollywood Audiences.* Eds Richard Maltby and Melvin Stokes. London: BFI, 1999b. 187–203.

Cherry, Brigid. 'Stalking the Web: Celebration, Chat and Horror Film Marketing on the Internet.' In *Horror Zone.* Ed. Ian Conrich. London: I. B. Tauris, 2010. 67–86.s

Chion, Michel. *The Voice in Cinema.* New York: Columbia University Press, 1999.

Christie, Ian. *The Last Machine: Early Cinema and the Birth of the Modern World.* London: BBC Educational Developments, 1994.

Christie, Ian. 'The Scandal of *Peeping Tom.*' *Powell, Pressburger and Others.* Ed. Ian Christie. London: BFI, 1978.

Clarens, Carlos. *An Illustrated History of the Horror Films*. New York: Putnam, 1967.

Clover, Carol J. *Men, Women and Chain Saws: Gender in the Modern Horror Film*. Princeton: Princeton University Press, 1992.

Coffman, Jason. 'This is why we can't have nice things: "The Witch" and horror fandom's gatekeepers.' *Medium.com*. 19 February 2016. https://medium.com/cinenation-show/this-is-why-we-can-t-have-nice-things-the-witch-and-horror-fandom-s-gatekeepers-b2c0bb0d8f9a#.prxizx8nj. Accessed 1 August 2016.

Colavito, Jason. *Knowing Fear: Science, Knowledge and the Development of the Horror Genre*. Jefferson, NC: McFarland, 2008.

Coleman, Robin R. Means. *Horror Noire: Blacks in American Horror Films, 1890s to Present*. New York: Routledge, 2011.

Connor, Steven. 'The Machine in the Ghost: Spiritualism, Technology and the "Direct Voice."' *Ghosts: Deconstruction, Psychoanalysis, History*. Eds Peter Buse and Andrew Stott. New York: St. Martin's Press, 1999. 203–25.

Conrich, Ian. 'Before Sound: Universal, Silent Cinema, and the Last of the Horror-Spectaculars.' *The Horror Film*. Ed. Stephen Prince. New Brunswick, NJ: Rutgers University Press, 2004a. 40–57.

Conrich, Ian. 'Killing Time... and Time Again: The Popular Appeal of Carpenter's Horrors and the Impact of *The Thing* and *Halloween*.' In *The Cinema of John Carpenter: The Technique of Terror*. Eds Ian Conrich and David Woods. London: Wallflower, 2004b. 91–106.

Corstorphine, Kevin. 'Filming the Unnameable: The Subversion of Cthulhu.' *Sub/versions: Cultural Status, Genre and Critique*. Eds Pauline MacPherson, Christopher Murray, Gordon Spark and Kevin Corstorphine. Newcastle: Cambridge Scholars Publishing, 2008. 157–64.

Crane, Jonathan Lake. 'Scraping Bottom: Splatter and the Herschell Gordon Lewis Oeuvre.' In *The Horror Film*. Ed: Stephen Prince. New Brunswick, NJ: Rutgers University Press, 2004. 150–66.

Crane, Jonathan Lake. *Terror and Everyday Life: Singular Moments in the History of the Horror Film*. Thousand Cliffs, CA: Sage, 1994.

Creed, Barbara. *The Monstrous-Feminine: Film, Feminism, Psycho-analysis*. New York: Routledge, 1993.

Crewe, David. 'Following Trending Topics: Social Media in Modern Teen Movies.' *Screen Education* 79 (2015): 78–87.

Diffrient, David Scott. 'A Film is Being Beaten: Shock Cut and Material Violence of Horror.' In *Horror Film: Creating and Marketing Fear*. Ed. Steffen Hantke. Jackson: University of Mississippi Press, 2004. 52–83

Dika, Vera. *Games of Terror. Halloween, Friday the 13th, and the Films of the Stalker Cycle*. Rutherford: Associated University Presses, 1990.

Donnelly, K. J. *The Spectre of Sound: Music in Film and Television.* London: BFI, 2005.

Durovicová, Nataša. 'Local Ghosts: Dubbing Bodies in Early Sound Cinema.' In *Film and Its Multiples.* Ed. Anna Antonioni. Udine, Italy: Forum. 2003. 83–98.

Dudenhoeffer, Larrie. *Embodiment and Horror Cinema.* Houndmills, Basingstoke and Hampshire: Palgrave Macmillan, 2014.

Dumas, Chris. 'Horror and Psychoanalysis: An Introductory Primer.' *A Companion to the Horror Film.* Ed. Harry M. Benshoff. Malden, MA: Wiley-Blackwell, 2014. 21–37.

Ebert, Roger. 'The Cabinet of Dr. Caligari.' *RogerEbert.com.* 3 June 2009. http://www.rogerebert.com/reviews/great-movie-the-cabinet-of-dr-caligari-1920. Accessed 8 November 2015.

Ebert, Roger. 'I Spit on Your Grave.' *RogerEbert.com* 16 July 1980. http://www.rogerebert.com/reviews/i-spit-on-your-grave-1980. Accessed 7 August 2016.

Ebert, Roger. 'Movie Answer Man.' *RogerEbert.com* http://rogerebert.suntimes.com/apps/pbcs.dll/article?AID=/19961103/ANSWERMAN/611030305. Accessed 10 January 2013.

Ebert, Roger. *Roger Ebert's Video Companion.* Kansas City: Andrews and McMeel, 1997.

Edelstein, David. 'Now Playing at Your Local Multiplex: Torture Porn.' *New York Magazine.* 6 February 2006. http://nymag.com/movies/features/15622/. Accessed 16 July 2016.

Egan, Kate. 'A *Real* Horror Star: Articulating the Extreme Authenticity of Ingrid Pitt.' *Cult Film Stardom: Offbeat Attractions and Processes of Cultification.* Eds Kate Egan and Sarah Thomas. New York: Palgrave Macmillan, 2013. 212–25.

Egan, Kate. *Trash or Treasure? – Censorship and the Changing Meanings of the Video Nasties.* Manchester: Manchester University Press, 2007.

Eisenstein, Sergei. *The Film Sense.* San Diego: Harvard, 1947.

Eisner, Lotte H. *The Haunted Screen: Expressionism in the German Cinema and the Influence of Max Reinhardt.* Translated by Roger Greaves. Berkley: University of California Press, 2008.

Elder, R. Bruce. *Harmony and Dissent: Film and Avant-Garde Art Movements in the Early Twentieth Century.* Waterloo: Wilfred Laurier University Press, 2008.

Erb, Cynthia Marie. *Tracking King Kong: A Hollywood Icon in World Culture.* Detroit: Wayne State University Press, 2009.

Everman, Welch. *Cult Horror Films.* New York: Citadel Press, 1993.

Flynn, John L. *Cinematic Vampires: The Living Dead on Film and Television, from* The Devil's Castle *(1896)* to *Bram Stoker's Dracula (1992).* Jefferson NC: McFarland, 1992.

Fowkes, Katherine A. 'Melodramatic Specters: Cinema and *The Sixth Sense.* ' In *Spectral American: Phantoms and the National Imagination.*

Ed. Jeffrey Andrew Weinstock. Madison: University of Wisconsin Press, 2004. 185–206.

Freeland, Cynthia. *The Naked and the Undead: Evil and the Appeal of Horror.* Boulder, CO: Westview, 2002.

Freitag, Gina and André Loiselle, eds. *The Canadian Horror Film: Terror of the Soul.* Toronto: University of Toronto Press, 2015.

French, Lawrence. 'California Gothic: The Corman/Haller Collaborations.' In *Roger Corman: Interviews.* Ed. Constantine Nasr. Jackson: University of Mississippi Press, 2011. 169–200.

Freud, Sigmund. 'The "Uncanny".' In *The Standard Edition of the Complete Psychological Works of Sigmund Freud. Vol. XVII* (1917-1919). London: Hogarth, 1964. 219–56.

Gardiner, Craig Shaw. 'Blood and Laughter: The Humor in Horror Film.' In *Cut! Horror Writers on Horror Film.* Ed. Christopher Golden. New York and Berkley, 1992. 91–100.

Gaudreault, André. *Film and Attraction: From Kinematography to Cinema.* Urbana: University of Illinois Press, 2011.

Gaudreault, Émile and Philippe Marion. *The End of Cinema?: A Medium in Crisis in the Digital Age.* New York: Columbia University Press, 2015.

Geraghty, Lincoln and Mark Jancovich. 'Introduction: Generic Canons.' In *The Shifting Definitions of Canons: Essays in Labeling Films, Television Shows and Media.* Eds Lincoln Geraghty and Mark Jancovich. Jefferson, NC: McFarland, 2008. 1–14.

Gifford, Denis. *A Pictorial History of Horror Movies.* London: Hamlyn, 1973.

Goddu, Teresa A. *Gothic America: Narrative, History, and Nation.* New York: Columbia University Press, 1997.

Godwin, Victoria. '*Twilight* Anti-Fans: "Real" Fans and "Real" Vampires.' In *The Twilight Saga: Exploring the Global Phenomenon.* Ed. Claudia Bucciferro. Lanham, MD: Scarecrow, 2014. 93–107.

Gorky, Maxim. 'A review of the Lumière programme at the Nizhni-Novgorod Fair, as printed in the *Nizhegorodski listok,* newspaper, July 4, 1986, and signed "I.M. Pacatus".' Appendix to Jay Leyda, *A History of the Russian and Soviet Film.* London: Unwin House, 1960. 407–9.

Gracey, James. *Dario Argento.* Harpenden, Herts: Kamera Books, 2010.

Grant, Barry Keith. 'Digital Anxiety and the New Verité Horror and SF Film.' *Science Fiction Film and Television* 6.2 (2014): 153–75.

Grant, Barry Keith. 'Introduction'. *Film Genre Reader.* Austin: University of Texas Press, 1986.

Grant, Michael. '"Ultimate Formlessness": Cinema, Horror, and the Limits of Meaning. In *Horror Film and Psychoanalysis: Freud's Worst Nightmare.* Ed. Steven Jay Schneider Cambridge: Cambridge University Press, 2004. 177–87.

Gray, Jonathan, Cornel Sandvoss and C. Lee Harrington, eds. *Fandom: Identities and Culture in a Mediated World.* New York: NYU Press, 2007.

Green, Fitzhugh. *The Film Finds Its Tongue*. New York: Benjamin Blom, Inc., 1971.

Grodal, Torben. *Moving Pictures: A New Theory of Film Genres, Feelings, and Cognition*. Oxford: Clarendon Press, 1997.

Guiley, Rosemary. *The Encyclopedia of Vampires, Werewolves and Other Monsters*. New York: Visionary Living, 2005.

Guimarin, Amelia. 'MyDeathSpace and Cinema: Reconfiguring Life Through Memorials.' *Spectator* 27 (2007): 48–52.

Gunning, Tom. 'The Cinema of Attractions: Early Film, Its Spectator and the Avant-Garde.' In *Early Cinema: Space, Frame, Narrative*. Eds Thomas Elsaesser and Adam Barker. London: British Film Institute, 1990a. 56–62.

Halberstam, Judith. *Skin Shows: Gothic Horror and the Technology of Monsters*.

Hanich, Julian. *Cinematic Emotion in Horror Films and Thrillers: The Aesthetic Paradox of Pleasurable Fear*. New York: Routledge, 2010.

Hantke, Steffen. 'Academic Film Criticism, the Rhetoric of Crisis, and the Current State of American Horror Cinema: Thoughts on Canonicity and Academic Anxiety.' *College Literature* 34.4 (Fall 2007): 191–202.

Hantke, Steffen. '"I See Dead People": Visualizing Ghosts in the American Horror Film Before the Advent of CGI.' In *Cinematic Ghosts: Haunting and Spectrality from Silent Cinema to the Digital Era*. Ed. Murray Leeder. New York: Bloomsbury Academic, 2015. 179–98.

Hardy, Phil. *Horror*. London: Aurum, 1993.

Harmes, Marcus K. *The Curse of Frankenstein*. Leighton Buzzard and Beds: Auteur Press, 2015.

Harvey, John. *Photography and Spirit*. London: Reaktion Books, 2007.

Hart, Adam Charles. 'Millennial Fears: Abject Horror in a Transnational Context.' In *A Companion to the Horror Film*. Ed. Harry M. Benshoff. Malden, MA: Wiley-Blackwell, 2014. 329–44.

Hawkins, Joan. *Cutting Edge: Art-Horror and the Horrific Avant-Garde*. Minneapolis: University of Minnesota Press, 2000.

Heard, Mervyn. *Phantasmagoria: The Secret Life of the Magic Lantern*. Hastings: The Projection Box, 2006.

Heffernan, Kevin. *Ghouls, Gimmick, and Gold: Horror Films and the American Movie Business, 1953-68*. Durham, NC: Duke University Press, 2004.

Heffernan, Kevin. 'Risen from the Vaults: Recent Horror Remakes and the American Film Industry.' In *Merchants of Menace: The Business of Horror Cinema*. Ed. Richard Nowell. London: Bloomsbury Academic, 2014. 61–74.

Heller-Nicholas, Alexandra. *Found Footage Horror Films: Fear and the Appearance of Reality*. Jefferson, NC: McFarland Press, 2014.

Heller-Nicholas, Alexandra. *Suspiria*. Leighton Buzzard, Beds: Auteur Press, 2015.

Henward, Allison S. and Laurie MacGillivray. 'Bricoleurs in Preschool: Girls Poaching Horror Media and Gendered Discourses.' *Gender and Education* 7.26 (2014): 726–42.

Hesiod. *Works and Days, Theogeny and the Shield of Heracles.* Translated by Hugh G. Evelyn-White. Mineola, NY: Dover, 2006.

Higgins, Scott. *Harnessing the Technicolor Rainbow: Color Design in the 1930s.* Austin: University of Texas Press, 2007.

Hight, Craig. 'Mockumentary: A Call to Play.' In *Rethinking Documentary: New Perspectives and Practices.*. Eds Thomas Austin and Wilma De Jong. Maidenhead and Berkshire: Open University Press, 2008. 204–16.

Hills, Matt. 'Attending Horror Film Festivals and Conventions.' In *Horror Zone.* Ed. Ian Conrich. London: I. B. Tauris, 2010. 87–102.

Hills, Matt. 'Cult Movies With and Without Cult Stars: Differentiating Discourses of Stardom.' In *Cult Film Stardom: Offbeat Attractions and Processes of Cultification.* Eds Kate Egan and Sarah Thomas. Houndmills, Basingstoke and Hampshire: Palgrave Macmillan, 2013. 21–36.

Hills, Matt. *Fan Cultures.* New York: Routledge, 2002.

Hills, Matt. 'Hammer 2.0: Legacy, Modernization, and Hammer Horror as a Heritage Brand.' In *Merchants of Menace: The Business of Horror Cinema.* Ed. Richard Nowell. London: Bloomsbury Academic, 2014. 229–49.

Hills, Matt. *The Pleasures of Horror.* London: Continuum, 2005.

Holte, James Craig. *Dracula in the Dark: The Dracula Film Adaptation.* Westport, CT: Greenwood Press, 1997.

Horeck, Tanya and Tina Kendall, eds. *The New Extremism in Cinema: From France to Europe.* Edinburgh: Edinburgh University Press, 2011.

Howells, Richard. 'Louis le Prince: The Body of Evidence.' *Screen* 47.2 (2006): 179–200.

Hughes, Kit. 'Ailing Screens, Viral Video: Cinema's Digital Ghosts in Kiyoshi Kurosawa's *Pulse.*' *Film Criticism* 36.2 (Winter 2011/12): 22–42.

Hutchings, Peter. *Hammer and Beyond: The British Horror Film.* Manchester: Manchester University Press, 1993.

Hutchings, Peter. *The Horror Film.* Harlow: Pearson Longman, 2004.

Iaccino, James F. *Psychological Reflections on Cinematic Terror: Jungian Archetypes in Horror Films.* Westport, CT: Praegar, 1994.

Ince, Kate. 'Bringing Bodies Back In: For a Phenomenological and Psychoanalytic Film Criticism of Embodied Cultural Identity.' *Film-Philosophy* 5.1 (2011): 1–12.

James, Becca and Alex McCown-Levy. 'Is *The Cabin In The Woods* a horror movie?' *The A.V. Club.* 29 October 2015. http://www.avclub.com/article/cabin-woods-horror-movie-227538. Accessed 31 August 2016.

Jancovich, Mark. '"Antique Chiller': Quality, Pretention, and History in the Critical Reception of *The Innocents* and *The Haunting*. ' In *Cinematic Ghosts: Haunting and Spectrality from Silent Cinema to the Digital Era*. Ed. Murray Leeder. New York: Bloomsbury Academic, 2015. 115–28.

Jancovich, Mark. 'Beyond Hammer: The First Run Marked and the Prestige Horror Film in the Early 1960s.' *Palgrave Communications* 3 (2017): 3–14.

Jancovich, Mark. 'Cult Fictions: Cult Movies, Subcultural Capital and the Production of Cultural Distinctions.' *Cultural Studies* 16.2 (2002c): 306–22.

Jancovich, Mark. 'General Introduction.' In *Horror: The Film Reader*. Ed. Mark Jancovich. London: Routledge, 2002a. 1–19.

Jancovich, Mark. 'Genre and the Audience: Genre Classifications and Culture Distinctions in the Mediations of *The Silence of the Lambs*.' In *Horror: The Film Reader*. Ed. Mark Jancovich. London: Routledge, 2002b. 151–61.

Jancovich, Mark. *Horror*. London: B. T. Batsford, 1992.

Jancovich, Mark. 'Horror in the 1940s.' In *A Companion to the Horror Film*. Ed. Harry M. Benshoff. Malden, MA: Wiley-Blackwell, 2014.

Jancovich, Mark. *Rational Fears: American Horror in the 1950s*. Manchester: Manchester University Press, 1996.

Jancovich, Mark. '"A Real Shocker": Authenticity, Genre, and the Struggle for Distinction.' *Continuum: Journal of Media & Cultural Studies* 14.1 (2000): 23–35.

Jancovich, Mark. 'Shadows and Bogeymen: Horror, Stylization and the Critical Reception of Orson Welles during the 1940s.' *Participations: Journal of Audience & Reception Studies* 6.1 (May 2009a): 25–51.

Jancovich, Mark. '"Thrills and Chills": Horror, the Woman's Film, and the Origins of Film Noir.' *New Review of Film and Television Studies* 7.2 (2009b): 157–71.

Jay, Martin. *Cultural Semantics: Keywords of Our Time*. Amherst: University of Massachusetts Press, 1998.

Jenkins, Henry. *Textual Poachers: Television Fans and Preparatory Culture*. New York: Routledge, 1992.

Jerslev, Anne. 'Youth Films: Transforming Genre, Performing Audience.' In *The International Handbook of Children, Media and Culture*. Ed. Drotner Livingstone. Los Angeles: Sage, 2008. 183–95.

Johnston, Deirdre D. 'Adolescents' Motivations for Viewing Graphic Horror.' *Human Communication Research* 21.4 (1995) 522–52.

Jolly, Martyn. *Faces of the Dead: The Belief in Spirit Photography*. London: British Library, 2006.

Jones, Steve. '404 Not Found: The Internet and the Afterlife.' *Omega: The Journal of Death and Dying* 49.1 (2004): 83–88.

Jones, Steve. 'No Pain, No Gain: Strategic Repulsion and *The Human Centipede.*' *Cine-Excess* 1 (2013a): n.p.

Jones, Steve. 'The Technologies of Isolation: Apocalypse and Self in Kurosawa Kiyoshi's *Kairo.*' *Japanese Studies* 30.2 (2010): 185–98.

Jones, Steve. *Torture Porn: Popular Horror after* Saw. Houndmills, Basingstoke and Hants: Palgrave Macmillan, 2013b.

Joyce, Simon. *Victorians in the Rearview Mirror.* Athens: Ohio University Press, 2007.

Kaes, Anton. *Shell Shock Cinema: Weimar Culture and the Wounds of War.* Princeton: Princeton University Press, 2009.

Kane, Tim. *The Changing Vampire of Film and Television: A Critical Study of the Growth of a Genre.* Jefferson, NC: McFarland Press, 2006.

Kaplan, Louis. *The Strange Case of William Mumler, Spirit Photographer.* Minneapolis: Minnesota University Press, 2008.

Kattelman, Beth. '"We Dare You to See This!": Ballyhoo and the 1970s Horror Film'. *Horror Studies* 1.2 (2011): 61–74.

Kermode, Mark. 'I Was a Teenage Horror Fan, Or, "How I Learned to Stop Worrying and Love Linda Blair."' In *Ill Effects: The Media Violence Debate.* Eds Martin Barker and Julian Petley. London: Routledge, 1997. 48–55.

Kermode, Mark. 'The British Censors and the Horror Cinema.' In *British Horror Cinema.* Eds Steve Chibnall and Julian Petley. London: Routledge, 2002. 10–22.

Kerner, Aaron Michael. *Torture Porn in the Wake of 9/11: Horror, Exploitation, and the Cinema of Sensation.* New Brunswick, NJ: 2015.

King, Geoff. *New Hollywood Cinema: An Introduction.* New York: I. B. Tauris, 2002.

King, Stephen. *Danse Macabre.* New York: Berkley Books, 1997.

Kinnard, Roy. *Horror in Silent Films: A Filmography, 1896-1929.* Jefferson, NC: McFarland, 1995.

Kracauer, Siegfried. *From Caligari to Hitler: A Psychological History of the German Film.* Princeton: Princeton University Press, 1947.

Krämer, Peter. *New Hollywood.* New York: Columbia University Press, 2013.

Kristeva, Julia. *The Powers of Horror.* New York: Columbia University Press, 1982.

Lázaro-Reboll, Antonio. *Spanish Horror Film.* Edinburgh: University of Edinburgh Press, 2012.

Lee, Benjamin. 'Did arthouse horror hit The Witch trick mainstream US audiences?' 23 February 2016. https://www.theguardian.com/film/filmblog/2016/feb/23/did-arthouse-horror-hit-the-witch-trick-us-multiplex-audiences. Accessed 2 August 2016.

Leeder, Murray. 'Collective Screams: William Castle and the Gimmick Film.' *Journal of Popular Culture* 44.4 (2011): 774–96.

Leeder, Murray. 'The Fall of the House of Meaning: Between Static and Slime in *Poltergeist.' Irish Journal of Gothic and Horror Studies* 5 (2008): 3–7.

Leeder, Murray. 'Forget Peter Vincent: Nostalgia, Self-Reflexivity and the Genre Past in *Fright Night. ' Journal of Popular Film and Television* 36.4 (2009): 190–99.

Leeder, Murray. 'Ghost-Seeing and Detection in *Stir of Echoes. ' Clues: A Journal of Detection* 30.2 (2012): 76–88.

Leeder, Murray. *Halloween.* Leighton Buzzard, Beds: Auteur Press, 2014a.

Leeder, Murray. 'Humor in the Gimmick Films of William Castle.' In *The Laughing Dead The Horror-Comedy Film from Bride of Frankenstein to Zombieland.* Eds Cynthia J. Miller and A. Bowdoin Van Riper. Lanham, MD: Rowman & Littlefield, 2016, 87–101.

Leeder, Murray. 'Poe/Lovecraft/Corman: The Case of *The Haunted Palace* (1963).' *The Lovecraftian Poe: Essays on Influence, Reception, Interpretation, and Transformation.* Ed. Sean Moreland. Bethlehem, PA: Lehigh University Press, 2017. 163-77.

Leeder, Murray. 'Victorian Science and Spiritualism in The Legend of Hell House.' *Horror Studies* 5.1 (2014b): 31–46.

Lester, Catherine. 'The Children's Horror Film: Characterizing an "Impossible" Subgenre.' *The Velvet Light Trap* 78 (2016): 22–37.

Lim, Bliss Cua. *Translating Time: Cinema, the Fantastic, and Temporal Critique.* Durham: Duke University Press, 2009.

Loiperdinger, Martin. 'Lumière's *Arrival of a Train*: Cinema's Founding Myth.' *The Moving Image* 4.1 (Spring 2004): 89–118.

Loiselle, André. '*Cinéma du Grand Guignol:* Theatricality in the Horror Film.' *Stages of Reality: Theatricality in Cinema.* Eds André Loiselle and Jeremy Maron. Toronto: University of Toronto Press, 2012. 55–80.

Lovecraft, H.P. 'The Colour Out of Space.' In *H.P. Lovecraft: The Complete Fiction.* New York: Barnes & Noble, 2008. 594–616.

Lowenstein, Adam. *Shocking Representation: Historical Trauma, National Cinema, and the Modern Horror Film.* New York: Columbia University Press, 2005.

Lowenstein, Adam. 'Spectacle Horror and *Hostel:* Why Torture Porn Does Not Exist.' *Critical Quarterly* 53.1 (April 2011): 42–60.

Luckhurst, Roger. *The Shining.* London: BFI, 2013.

Lundemo, Trond. 'In the Kingdom of Shadows: Cinematic Movement and Its Digital Ghost'. In *The YouTube Reader.* Eds Pelle Snickars and Patrick Vonderau. Stockholm: National Library of Sweden, 2009. 314–29.

MacInnis, Allan. 'Sex, Science, and the "Female Monstrous": Wood Contra Cronenberg, Revisited.' *Cineaction* 88 (2012): 34–43.

Magistrale, Tony. *Abject Terrors: Surveying the Modern and Postmodern Horror Film.* New York: Peter Lang, 2005.

Magistrale, Tony and Sidney Poger. *Poe's Children: Connections Between Tales of Terror and Detection.* New York: Peter Lang, 1999.

Mangan, Michael. *Performing Dark Arts: A Cultural History of Conjuring.* Bristol: Intellect, 2007.

Manovich, Lev. *The Language of New Media.* Cambridge, MA: MIT Press, 2001.

Marks, Laura. *The Skin of the Film: Intercultural Cinema, Embodiment and the Senses.* Durham, NC: Duke University Press, 2000.

Masschelein, Anneleen. *The Unconcept: The Freudian Uncanny in Late-Twentieth-Century Theory.* Albany: SUNY Press, 2012.

Mathai, John. 'An Acute Anxiety State in an Adolescent Precipitated by Viewing a Horror Movie.' *Journal of Adolescence* 6 (1983): 197–200.

Mathijs, Ernest. *The Cinema of David Cronenberg: From Baron of Blood to Cultural Hero.* London: Wallflower Press, 2008.

Mathijs, Ernest and Jamie Sexton. *Cult Cinema: An Introduction.* Chichester: Wiley-Blackwell, 2011.

Mayer, J.P. *Sociology of Film: Studies and Documents.* New York: Arno Press, 1972.

McCoy, Abigail. 'Do People Actually Enjoy Watching Horror Movies?' *Glamour.com.* 11 October 2016. http://www.glamour.com/story/do-people-actually-enjoy-watching-horror-movies. Accessed 13 October 2016.

McDonough, Maitland. *Broken Mirrors/Broken Minds: The Dark Dreams of Dario Argento.* Minneapolis: University of Minnesota Press, 2010.

McMorran, Connor. 'Horror in the Digital Age.' *Frames Cinema Journal* 8 (2015): n.p.

McRoy, Jay. *Nightmare Japan: Contemporary Japanese Horror Cinema.* Amsterdam: Rodopi, 2008.

Meehan, Paul. *Horror Noir: Where Cinema's Dark Sisters Meets.* Jefferson, NC: McFarland, 2011.

Melton, J. Gordon. *The Vampire Book: The Encyclopedia of the Undead.* Detroit: Visible Ink Press, 2011.

Melville, Stephen. 'Color Has Not Yet Been Named: Objectivity in Deconstruction.' In *Deconstruction and the Visual Arts.* Eds Peter Brunette and Davis Wills. Cambridge: Cambridge University Press, 1994. 33–49.

Middleton, Jason. 'The Subject of Torture: Regarding the Pain of Americans in *Hostel*'. *Cinema Journal* 49.4 (2010): 1–24.

Misek, Richard. *Chromatic Cinema: A History of Screen Color.* Malden, MA: Wiley-Blackwell, 2010.

Mitchell, W. J. T. *Picture Theory.* Chicago: University of Chicago Press, 1994.

Monroe, John Warne. *Laboratories of Faith: Mesmerism, Spiritism and Occultism in Modern France.* Ithaca: Cornell University Press, 2002.

Moreland, Sean. 'Contagious Characters: Cronenberg's *Rabid*, Demarbre's *Smash Cut*, and the Reframing of Porn-Fame.' In *The Canadian Horror Film: Terror of the Soul*. Eds Freitag, Gina and André Loiselle. Toronto: University of Toronto Press, 2015. 249–69.

Moss, Gemma. 'Children Talk Horror Videos: Reading as a Social Performance.' *Australian Journal of Education* 37.2 (1993): 169–81.

Mulvey, Laura. *Death 24x a Second: Stillness and the Moving Image*. London: Reaktion, 2006.

Murphy, Bernice M. '"It's Not That House That's Haunted": Demons, Debt, and the Family in Peril Formula in Recent Horror Cinema.' In *Cinematic Ghosts: Haunting and Spectrality from Silent Cinema to the Digital Era*. Ed. Murray Leeder. New York: Bloomsbury Academic, 2015. 235–51

Natale, Simone. 'Specters of the Mind: Ghosts, Illusion, and Exposure in Paul Leni's *The Cat and the Canary*. ' In *Cinematic Ghosts: Haunting and Spectrality from Silent Cinema to the Digital Era*. Ed. Murray Leeder. New York: Bloomsbury Academic, 2015. 59–76.

Nashawaty, Chris. *Crab Monsters, Teenage Cavemen, and Candy Stripe Nurses: Roger Corman: King of the B-Movie*. New York: Abrams, 2013.

Naylor, Alex. '"A Horror Picture at This Time is a Very Hazardous Undertaking": Did British or American Censorship End the 1930s Horror Cycle?' *The Irish Journal of Gothic and Horror Studies* 9 (2010): n.p.

Ndalianis, Angela. *The Horror Sensorium: Media and the Senses*. Jefferson, NC: McFarland, 2012.

Neale, Steve. 'Questions of Genre.' *Screen* 11.2 (1990): 44–66.

Neale, Steve. 'Technicolor.' In *Color: The Film Reader*. Eds Angela Dalle Vacche and Brian Price. New York: Routledge, 2006. 13–23.

Needham, Gary. 'Playing With Genre: An Introduction to the Italian Giallo.' *Kino-eye* 2:11 (2002): n.p.

Nelson, Andrew Patrick. '*Trick 'r Treat*, *The Cabin in the Woods* and the Defense of Horror's Subcultural Capital: A Genre in Crisis?' *Slayage: The Journal of the Whedon Studies Association* 10.2/11.1 (Fall 2013/ Winter 2014): n.p.

Newman, Kim. *The BFI Companion to Horror*. London: Cassell, 1996.

North, Dan. *Performing Illusions: Cinema, Special Effects and the Virtual Actor*. London: Wallflower, 2008.

Nowell, Richard. *Blood Money: A History of the First Teen Slasher Film Cycle*. New York: Continuum, 2011.

Olivier, Marc. 'Glitch Gothic.' In *Cinematic Ghosts: Haunting and Spectrality from Silent Cinema to the Digital Era*. Ed. Murray Leeder. New York: Bloomsbury Academic, 2015. 253–70.

Olney, Ian. *Euro Horror: Classic European Horror Cinema in Contemporary American Culture*. Bloomington: Indiana University Press, 2013.

O'Sullivan, Michael. 'Enough with the found footage already'. *The Washington Post*, 8 January 2014. https://www.washingtonpost.com/

news/going-out-guide/wp/2014/01/08/enough-with-the-found-footage-already/?utm_term=.2906214172d9. Accessed 17 December 2016.

O'Toole, Lawrence. 'The Cult of Horror.' *Maclean's* 16 July 1979: 46–7, 49–50.

Paszylk, Bartlomiej. *The Pleasure and Pain of Cult Horror Films: An Historical Survey.* Jefferson, NC: McFarland, 2009.

Peary, Danny. *Cult Movies: The Classics, the Sleepers, the Weird and the Wonderful.* New York: Gramercy, 1981.

Peirse, Alison. *After Dracula: The 1930s Horror Film.* London: I. B. Tauris, 2013.

Peirse, Alison and Daniel Martin, eds. *Korean Horror Cinema.* Edinburgh: Edinburgh University Press, 2013.

Petley, Julian. '"A Crude Sort of Entertainment for a Crude Sort of Audience": The British Critics and Horror Cinema.' In *British Horror Cinema.* Eds Steve Chibnall and Julian Petley. London: Routledge, 2002. 23–41.

Petley, Julian. *Film and Video Censorship in Modern Britain.* Edinburgh: University of Edinburgh Press, 2011.

Petrovic, Paul. '"Help Me": Interrogating Capitalism, the Specter of Hiroshima, and the Architectural Uncanny in Kiyoshi Kurosawa's *Pulse.*' In *The Ghostly and the Ghosted in Literature and Film: Spectral Identities.* Eds Lisa B. Kröger and Melanie Anderson. Newark: University of Delaware Press, 2013. 137–53.

Phillips, Kendall R. *Projected Fears: Horror Film and American Culture.* Westport: Praeger, 2005.

Picart, Caroline Joan. *Remaking the Frankenstein Myth on Film: Between Laughter and Horror.* Albany: State University of New York Press, 2003.

Pinedo, Isabel Cristina. *Recreational Terror: Women and the Pleasures of Horror Film Viewing.* Albany: State University of New York Press, 1997.

Pirie, David. *A New Heritage of Horror: The English Gothic Cinema.* London: I. B. Tauris, 2008.

Pierson, Michele. *Special Effects: Still in Search of Wonder.* New York: Columbia University Press, 2002.

Potts, John. 'The Idea of the Ghost.' In *Technologies of Magic: A Cultural Study of Ghosts, Machines and the Uncanny.* Eds John Potts and Edward Scheer. Power Publications: Sydney, 2006. 78–91.

Powell, Anna. *Deleuze and Horror Film.* Edinburgh: Edinburgh University Press, 2005.

Preston, Mary I. 'Children's Reactions to Movie Horrors and Radio Crime.' *Journal of Pediatrics* 19.2 (1941): 147–68.

Price, Brian. 'Introduction.' In *Color: The Film Reader.* Eds Angela Dalle Vacche and Brian Price. New York: Routledge, 2006. 1–9.

Price, Stephen. 'Dread, Taboo, and The Thing: Toward a Social Theory of Horror Film.' In *The Horror Film.* Ed. Stephen Prince. New Brunswick, NJ: Rutgers University Press, 2004. 118–30.

Quandt, James. 'Flesh & Blood: Sex and Violence in Recent French Cinema.' *Artforum* 42.6 (2002): 126–32.

Rank, Otto. *The Double: A Psychoanalytic Study.* Chapel Hill: The University of North Carolina Press, 1971.

Rehak, Bob. 'Materializing Monsters: Aurora Models, Garage Kits and the Object Practices of Horror Fandom.' *Journal of Fandom Studies* 1.1 (2012): 27–45.

Rhodes, Gary D. '*Drakula halála* (1921): The Cinema's First Dracula.' *Horror Studies* 1.1 (2010): 25–47.

Rhodes, Gary D. *Tod Browning's Dracula.* Sheffield: Tomahawk Press, 2014.

Rodowick, D. N. *The Virtual Life of Film.* Cambridge: Harvard University Press, 2007.

Romney, Jonathan. 'The Return of the Shadow.' *The Guardian*, 22 September 1999, 16.

Rosenbaum, Jonathan. '*Halloween.*' *Take One* 7.2 (January 1979): 8–9.

Roth, Eli. Interview by Walter Chaw. 'Cabin Boy: FFC Interviews Eli Roth.' *Film Freak Central.* 14 September 2003. http://www.filmfreak central.net/ffc/2015/07/cabin-boy-ffc-interviews-eli-roth.html. Accessed 1 September 2016.

Royle, Nicholas. *The Uncanny.* Manchester: Manchester University Press, 2003.

Ryall, Tom. 'Genre and Hollywood.' In *The Oxford Guide to Film Studies.* Eds John Hill and Pamela Church Gibson. Oxford: Oxford University Press, 1998. 327–38.

Ryan, Mark. *Terror Australis: Horror Cinema in Australia.* Houndmills, Basingstoke and Hants: Palgrave Macmillan, 2018.

Ryan, Michael and Douglas Kellner. *Camera Politica: The Politics and Ideology of Contemporary Hollywood Film.* Bloomington: Indiana University Press, 1988.

Sahinturk, Zeynep. 'Djinn in the Machine: Technology and Islam in Turkish Horror Film.' In *Digital Horror: Haunted Technologies, Network Panic and the Found Footage Phenomenon.* London: I. B. Tauris, 2016. 95–106.

Sandvoss, Cornel. *Fans: The Mirror of Consumption.* Cambridge: Polity, 2005.

Sanjek, David 'Fan's Notes: The Horror Film Fanzine.' *Literature/Film Quarterly* 18.3 (1990): 150–9.

Saunders, Michael William. *Imps of the Perverse: Gay Monsters in Film.* Westport: Praeger, 1998.

Scaggs, John. *Crime Fiction.* New York: Routledge, 2005.

Scales, Adam Christopher. 'Logging into Horror's Closet: Gay Fans, the Horror Film and Online Culture.' University of East Anglia, 2015. Diss.

Schatz, Thomas. *Hollywood Genres: Formulas, Filmmaking, and the Studio System.* New York: McGraw-Hill, 1981.

Schneider, Steven Jay. 'Kevin Williamson and the Rise of the Neo-Stalker.' *Post-Script* 19.2 (2000): 72–87.

Schneider, Steven Jay. 'Manifestations of the Literary Double in Modern Horror Cinema.' In *Horror Film and Psychoanalysis: Freud's Worst Nightmare*. Ed. Steven Jay Schneider Cambridge: Cambridge University Press, 2004. 106–21

Sconce, Jeffrey. 'Esper: The Renunciator.' In *Defining Cult Movies: The Cultural Politics of Oppositional Taste*. Eds Mark Jancovich, Antonio Lázaro-Reboll, Julian Stringer, Andy Wills. Manchester: Manchester University Press, 2003. 14–34.

Sconce, Jeffrey. *Haunted Media: Electronic Presence from Telegraphy to Television*. Durham, NC: Duke University Press, 2005.

Sconce, Jeffrey. '"Trashing" the Academy: Taste, Excess, and an Emerging Politics of Cinema Style.' *Screen* 36.4 (Winter 1995): 371–93.

Screen, Andrew. 'Ghostwatch.' In *Creeping Flesh: The Horror Fantasy Film Book*. Ed. David Kerekes. Manchester: Headpress/Critical Vision, 2003. 56–63.

Sen, Meheli. *Haunting Bollywood: Gender, Genre, and the Supernatural in Hindi Commercial Cinema*. Austin: University of Texas Press, 2017.

Sexton, Jamie. 'US "Indie-Horror": Critical Reception, Genre Construction, and Suspect Hybridity.' *Cinema Journal* 51.2 (Winter 2012): 67–86.

Shaviro, Steven. *The Cinematic Body*. Minneapolis: University of Minnesota Press, 1993.

Sheffield, Jessica and Elyse Merlo. 'Biting Back: *Twilight* Anti-Fandom and the Rhetoric of Superiority.' In *Bitten by 'Twilight': Youth Culture, Media, and the Vampire Franchise*. Eds Melissa A. Click, Jennifer Steve Aubrey and Elizabeth Behm-Morawitz. New York: Peter Lang, 200. 207–24.

Shin, Chi Yun. 'The Art of Branding: Tartan "Asia Extreme" Films.' *Jump Cut*. 50 (2008): 85–100.

Simon, D. and W. R. Silveira. 'Post-Traumatic Stress Disorder in Children after Television Programmes.' *British Medical Journal* 308.3925 (1994): 389–90.

Skal, David J. *Dark Carnival: The Secret World of Tod Browning, Hollywood's Master of the Macabre*. New York: Anchor Books, 1995.

Skal, David J. *Hollywood Gothic: The Tangled Road of Dracula from Stage to Screen*. New York: Faber and Faber, 2004.

Skal, David J. *The Monster Show: A Cultural History of Horror*. New York: Faber and Faber, 2001.

Skal, David J. and Elias Savada. *Dark Carnival: The Secret World of Tod Browning: Hollywood's Master of the Macabre*. New York: Anchor Books, 1995.

Smith, Angela M. *Hideous Progeny: Disability, Eugenics and Classic Horror Cinema*. New York: Columbia University Press, 2011.

Smith, Justin. *Withnail and Us: Cult Films and Film Cults in British Cinema*. London: I. B. Tauris, 2010.

Smith, Sarah J. *Children, Cinema and Censorship: From Dracula to the Dead End Kids*. London: I. B. Tauris, 2005.

Smith, Steve. 'A Siege Mentality? Forms and Ideology in Carpenter's Early Siege Films.' In *The Cinema of John Carpenter: The Technique of Terror*. London: Wallflower, 2004. 35–48.

Smuts, Aaron. 'Cognitive and Philosophical Approaches to Horror.' In *A Companion to the Horror Film*. Ed. Harry M. Benshoff. Malden, MA: Wiley-Blackwell, 2014. 3–20.

Snelson, Tim. *Phantom Ladies: Hollywood Horror and the Home Front*. New Brunswick, NJ: Rutgers University Press, 2015.

Sobchack, Vivian. *Carnal Thoughts: Embodiment and Moving Image Culture*. Berkeley: University of California Press, 2004a.

Sobchack, Vivian. *Screening Space: The American Science Fiction Film*. 2nd Edition. New Brunswick, NJ: Rutgers University Press, 2004b.

Soister, John T. and Henry Nicolella, with Steve Joyce and Harry H. Long. *American Silent Horror, Science Fiction and Fantasy Feature Films*. Vol. 1. Jefferson, NC: McFarland, 2012.

Spadoni, Robert. 'Strange Botany in *Werewolf of London*. ' *Horror Studies* 1.1 (2010): 49–71.

Spadoni, Robert. *Uncanny Bodies: The Coming of the Sound Film and the Origins of the Horror Genre*. Berkeley: University of California Press, 2007.

Speldewinde, André. '*Targets*.' *Senses of Cinema* 16 (September 2001): n.p. http://sensesofcinema.com/2001/cteq/targets/

Stam, Robert. *Film Theory: An Introduction*. Edinburgh: Blackwell, 2000.

Stuart, Roxana. *Stage Blood: Vampires of the 19th Century Stage*. Bowling Green, OH: Bowling Green State University Popular Press, 1994.

Suvin, Darko. 'On the Poetics of the Science Fiction Genre.' *College English* 34.3 (1972): 372–82.

Tandy, Vic. 'The Ghost in the Machine.' *Journal of the Society for Psychical Research*.

Telotte, J. P. '*The Blair Witch Project* Project: Film and the Internet.' In *Nothing That Is: Millennial Cinema and the Blair Witch Controversies*. Eds Sarah L. Higley and Jeffrey Andrew Weinstock. Detroit: Wayne State University Press, 2004. 37–52.

Telotte, J. P. *Science Fiction Film*. Cambridge: Cambridge University Press, 2001.

Thomas, Ronald R. 'Specters of the Novel: *Dracula* and the Cinematic Afterlife of the Victorian Novel.' In *Victorian Afterlife: Postmodern Culture Rewrites the Nineteenth Century*. Eds John Kucich and Dianne F. Sadoff. Minneapolis: University of Minnesota Press, 2000. 288–310.

Thornton, Sarah. *Club Cultures: Music, Media and Subcultural Capital*. Cambridge: Polity Press, 1995.

Tompkins, Joe. 'Bids for Distinction: The Critical-Industrial Function of the Horror Auteur.' In *Merchants of Menace: The Business of Horror Cinema*. Ed. Richard Nowell. London: Bloomsbury Academic, 2014. 203–14.

Tompkins, Joe. 'Horror 2.0 (On Demand): The Digital Convergence of Horror Film Culture.' *Television & New Media* 15.5 (2014): 413–32.

Tsutsui, William. *Godzilla On My Mind: Fifty Years of the King of the Monsters*. Houndmills, Basingstoke and Hants: Palgrave Macmillan, 2004.

Tudor, Andrew. *Monsters and Mad Scientists: A Cultural History of the Horror Film*. Oxford: Basil Blackwell, 1989.

Tudor, Andrew. *Theories of Film*. London: Secker and Warburg, 1973.

Turvey, Malcolm. 'Philosophical Problems Concerning the Concept of Pleasure in Psychoanalytical Theories of (the Horror) Film.' In *Horror Film and Psychoanalysis: Freud's Worst Nightmare*. Ed. Steven Jay Schneider Cambridge: Cambridge University Press, 2004. 68–83.

Tyler, Parker. 'Supernaturalism in the Movies.' *Theatre Arts* 26.6 (June 1945): 362–9.

Usai, Paolo Cherchi. *The Death of Cinema: History, Cultural Memory and the Digital Dark Age*. London: BFI, 2001.

Valenti, Peter L. 'The Film Blanc: Suggestions for a Variety of Fantasy, 1940-45.' *Journal of Popular Film*. 6.4 (1978): 294–304.

van Elferen, Isabella. 'Dances with Spectres: Theorising the Cybergothic.' *Gothic Studies* 11.1 (2009): 99–112.

van Elferen, Isabella. *Gothic Music: The Sounds of the Uncanny*. Cardiff: University of Wales Press, 2012.

Vatnsdal, Caelum. *They Came from Within*. Second Edition. Winnipeg: ARP Books, 2014.

Voegelin, Salomé. *Sonic Possible Worlds: Hearing the Continuum of Sound*. New York: Bloomsbury, 2014.

Wada-Marciano, Mitsuyo. 'J-Horror: New Media's Impact on Contemporary Japanese Horror Film.' *Canadian Journal of Film Studies* 6.2 (2007): 23–48.

Wada-Marciano, Mitsuyo. 'Showing the Unknowable: *Uncle Boonmee Who Can Recall His Past Lives*.' In *Cinematic Ghosts: Haunting and Spectrality from Silent Cinema to the Digital Era*. Ed. Murray Leeder. New York: Bloomsbury Academic, 2015. 271–89.

Walker, Johnny. *Contemporary British Horror Cinema: Industry, Genre and Society*. Edinburgh: Edinburgh University Press, 2016.

Waters, Sarah. 'Ghosting the Interface: Cyberspace and Spiritualism.' *Science as Culture*. 6.33 (1997): 414–43.

Walton, Saige. 'Baroque Mutants in the 21st Century? Rethinking Genre Through the Superhero.' In *The Contemporary Comic Book Superhero*. Ed. Angela Ndalianis. New York: Routledge, 2009. 86–106.

Weaver, Tom. *Science Fiction Stars and Horror Heroes: Interviews with Actors, Directors, Producers and Writers of the 1940s through 1960s.* Jefferson, NC: McFarland, 1991.

Wee, Valerie. 'The *Scream* Trilogy, "Hyperpostmodernism," and the Late-Nineties Teen Slasher Film.' *Journal of Film and Video.* 57:3 (Fall 2005): 44–61.

Weinstock, Jeffrey Andrew, ed. *Reading* Rocky Horror: The Rocky Horror Picture Show *and Popular Culture.* Houndmills, Basingstoke and Hants: Palgrave Macmillan, 2008.

Weiss, Andrea. 'The Lesbian Vampire Film: A Subgenre of Horror.' In *Dracula's Daughters: The Female Vampire on Film.* Eds Douglas Brode and Leah Deyneka. Lanham, MD: Scarecrow Press, 2014. 21–35.

Wheatley, Helen. *Gothic Television.* Manchester: Manchester University Press, 2006.

White, Patricia. 'Female Spectator, Lesbian Specter: *The Haunting.*' In *Inside/Out: Lesbian Theories, Gay Theories.* Ed. Diane Fuss. New York: Routledge, 1991. 142–72.

Wickman, Forrest. 'A Brief History of Fake Blood.' *Slate.* 22 October 2013. Accessed 17 July 2015. http://www.slate.com/blogs/browbeat/2013/10/22/movie_blood_recipe_and_history_from_hershey_s_to_corn_syrup_and_beyond.html

Williams, Linda. 'Discipline and Fun: *Psycho* and Postmodern Cinema.' In *Reinventing Film Studies.* Eds Christine Gledhill and Linda Williams. London: Arnold, 2000. 351–78.

Williams, Linda. 'Film Bodies: Gender, Genre and Excess.' *Film Quarterly* 44.4 (Summer 1991): 2–13.

Williams, Linda. 'When the Woman Looks.' In *Re-Vision: Essays in Feminist Film Criticism.* Eds Mary Ann Doane, Patricia Mellencamp and Linda Williams. Frederick, MD: American Film Institute, 1984. 83–99.

Williamson, Millie. *The Lure of the Vampire: Gender, Fiction and Fandom from Bram Stoker to Buffy.* London: Wallflower, 2005.

Wolf, Leonard R. *The Annotated Dracula.* New York: C. N. Potter, 1975.

Wood, Robin. 'An Introduction to the American Horror Film.' In *The American Nightmare.* Toronto: Festival of Festivals, 1979. 7–28.

Wood, Robin. *Hollywood From Vietnam to Reagan.* New York: Columbia University Press, 1986.

Woofter, Kristopher and Jasie Stokes. 'Once More into the Woods: An Introduction and Provocation.' *Slayage: The Journal of the Whedon Studies Association* 10.2/11.1 (Fall 2013/Winter 2014): n.p.

Worland, Rick. 'OWI Meets the Monster: Hollywood Horror Films and War Propaganda, 1942 to 1945.' *Cinema Journal* 37.1 (Fall 1997): 47–65.

Wright, Nicola. 'Death and the Internet: The Implications of the Digital Afterlife.'

Yumibe, Joshua. *Moving Color: Early Film, Mass Culture, Modernism.* New Brunswick, NJ: Rutgers University Press, 2012.

Zillmann, Dorf and James B. Weaver III. 'Gender-Socialization Theory of Reactions to Horror.' In *Horror Films: Current Research on Audience Preferences and Reactions.* Mahwah, NJ: Lawrence Eribaum Associates, 1996. 81–101.

Zinoman, Jason. *Shock Value: How a Few Eccentric Outsiders Gave Us Nightmares, Conquered Hollywood and Invented Modern Horror.* New York: Penguin Press, 2011.

Index

#Horror (2015) 227

Abbott and Costello Meet Frankenstein (1948) 32, 41, 109–10
Abby (1974) 58
ABCs of Death, The (2012) 86
abjection 125–7
Abominable Dr. Phibes, The (1971) 108
Academy Awards 21, 25, 33, 55, 59, 61, 70–2, 75, 84, 99, 155
Addiction, The (1995) 85, 137, 207
affect theory 134–5
After Earth (2013) 76
Ahmad, Aalya 143
Aja, Alexandre 82–3
Aldana Reyes, Xavier 134–5, 212
Alien (1979) 103, 121, 126, 130, 135, 146
Aliens (1984) 136
À l'intérieur/Inside (2007) 81
Alligator (1980) 61
Almodóvar, Pedro 82
Altman, Rick 93–4, 108, 146
Altman, Robert 57 n.7
À ma sœur!/Fat Girl (2001) 81
Amazing Mr. X, The (1948) 89
American International Pictures (AIP) 45, 52–3, 56
American Psycho (1999) 71, 139
An American Werewolf in London (1981) 67
Amicus Productions 49, 50

Amirpour, Ana Lily 85
Amityville: A New Generation (1993) 123
Amityville Horror, The (1979) 67–8, 84
Anatomie/Anatomy (2000) 81
Anderson, Paul Thomas 213
Andrei Rublev (1966) 194
Angel (1999–2004) 75
Angel Heart (1987) 89–90, 94–5, 104–6
Anglo-Amalgamated Productions 49–50
Anguish (1987) 138
Animal House (1978) 109
Annabelle (2014) 85
Annabelle 2 (2017) 85
Annabelle's Serpentine Dance (1895) 188
Antichrist (2009) 82
anti-fandom 158
Apocalypse Now (1979) 146
Apollo 18 (2011) 77
Argento, Dario 53, 67, 201–5
Army of Darkness (1992) 69, 103
Arnheim, Rudolf
 Film as Art (1933) 189–90
L'arrivée d'un train en gare de La Ciotat (1896) 5–6
Arsenic and Old Lace (1944) 109
art cinema, horror and 25–6, 51, 81–2, 213–14
Assault on Precinct 13 (1976) 63, 99–100
Asylum (1972) 49

Asylum of Satan (1971) 55
Attebery, Brian
 Strategies of Fantasy, The
 (1992) 97
Atwill, Lionel 23 n.8
*L'auberge ensorcelée/The Be-
 witched Inn* (1897) 18 n.17
Audition (1999). See *Ōdishon*
Audrey Rose (1977) 84
Austin, Thomas 153
Avenging Conscience, The
 (1914) 3, 14
Aumont, Jacques 188

Babadook, The (2014) 81, 85, 88,
 158 n.11, 231
Badley, Linda 132
Bad Taste (1987) 69
Baker, Rick 70
Balázs, Béla
 Theory of the Film (1949) 159
Balcon, Michael 25
Bare Wench Project, The
 (2000) 101
Barker, Clive 69, 73
Barker, Martin 151
Barrymore, John 16–7, 189
Bat, The (1920 play) 17–18
Bat, The (1926) 17
Bat, The (1956) 17
Batchelor, David 187–8, 199, 205
Batman 18, 149, 175
Batoru Rowaiaru/Battle Royale
 (2000) 78
Baudrillard, Jean 232
Bava, Mario 51–2
Beast from 20 000 Fathoms, The
 (1953) 38
Beastmaster, The (1982) 146
Beatles, The
 Beatles, The (1968) 140
Beaumont, Charles 45
Beaver, The (2011) 175
Beckman, Karen 194
Beetlejuice (1988) 108

*Behind the Mask: The Rise
 of Leslie Vernon*
 (2006) 73, 138
Benchley, Peter
 Jaws (1974) 61
Benshoff, Harry M. 145
Benton, Barbi 101
Berberian Sound Studio
 (2012) 160–2
Berenstein, Rhoda 143–4
Bergen, Edgar 173
Bergman, Ingmar 53, 58, 199
Bergman, Ingrid 33
Bernstein, Charles 180
Big Lebowski, The (1998) 150
Billy the Kid vs. Dracula
 (1966) 99
Black Cat, The (1934) 25–6
Black Christmas (1974) 62, 65
Black Christmas (2006) 73
Black Dragons (1942) 34
Black Ice (1994) 192
Black Moon (1934) 25
Blacula (1972) 57, 145
Blade (franchise) 100
Blade (1998) 215
Blair, Linda 170
Blair Witch Project, The (1999) 77,
 212, 217–19, 224, 228
Blake, Linnie 212
Blatty, William Peter 58–9
Blaxploitation 58
Blob (1958), *The* 37
blockbusters, horror and 59, 61,
 68–9, 87, 146, 215–7
Blood and Roses (1960) 145
Blood Feast (1963) 137
Blood of Dracula (1957) 38, 145
Blood on Satan's Claw, The
 (1971) 49
BloodRayne (franchise) 215
Blood River (1991) 100
Blow Out (1981) 161
Blum, Jason 84
Blumhouse Pictures 84–5

Body Snatcher, The (1945) 36, 50
Bogdanovich, Peter 46, 55–6, 57 n.7
Bone Collector, The (1999) 71
Bone Tomahawk (2015) 99
Bonnie and Clyde (1967) 57
Boo! (1932) 22–3, 108
Bordwell, David 169, 190, 213
Bottin, Rob 70, 216
Bourdieu, Pierre 148
Bousman, Darren Lynn 83
Braindead (1992) 69
Bram, Christopher
 Father of Frankenstein (1995) 21
Bram Stoker's Dracula (1992) 71–2, 100, 153, 158
Branagh, Kenneth 72
Breillat, Catherine 81
Bride of Chucky (1998) 73
Bride of Frankenstein (1935) 23–5, 28, 32, 108, 120, 145, 164
Bride of the Monster (1955) 21
Brood, The (1979) 63, 117, 126
Brophy, Phillip 67, 132
Brotherhood of Satan, The (1971) 55
Browning, Tod 14–15, 19, 24
Bruckner, Rene Thoreau 169
Brute Man, The (1946) 32, 101
Bryant, Martin 139
Buffy the Vampire Slayer (1997–2003) 74
Bug (1975) 61
Buguet, Édouard 211
Bukatman, Scott 227–8, 232
Bulwer-Lytton, Edward
 'Haunted and the Haunters, The' (1859) 188
Burning, The (1981) 142
Burnt Offerings (1974) 67
Burton, Tim 103
Bu san/Goodbye Dragon Inn (2003) 214

Butillo, Alexandre 81–2
Butler, Ivan 6
Bwana Devil (1952) 40

Cabin Fever (2002) 155
Cabin in the Woods, The (2012) 75, 138, 156, 158
Das Cabinet des Dr. Caligari/ The Cabinet of Dr. Caligari (1920) 8, 10–1, 14, 18, 26, 161
Le cake-walk infernal/The Cake-Walk Infernal (1903)
Call of Cthulhu, The (2005) 205
Calvaire (2004) 82
Cambier, Alisson 139
Cameron, Allan 196, 205
Cameron, James 46
Campbell, Bruce 70
Canal, The (2014) 221
Candyman (1992) 73
Cannibal Holocaust (1980) 217
Canterville Ghost, The (1944) 33
Captivity (2007) 156
Carmilla (2014–6) 48, 145
Carnival of Souls (1963) 151, 176–7
Carpenter, John 63–6, 69, 83, 99–100, 149, 172, 186, 230
Carradine, John 32
Carrie (1976) 57, 61, 98, 126, 179
Carroll, Noël 95, 133
Carry On (series) 49
Casablanca (1943) 150
Castillo, Rita 139
Castle, Terry 125
Castle, William 41–4, 54, 191–2, 198, 205, 228
Castle of Dracula (magazine) 146
Cat and the Canary, The (1927) 17–18, 41, 108, 198
Cat Creeps, The (1930) 22
Cat People (1942) 35–7, 107, 117, 179
Cattet, Hélène 85

Celebrity Ghost Hunt (2012-present) 212

censorship, horror and 28–9, 52, 141–2. *See also* 'video nasty'

C'era una volta il West/Once Upon a Time in the West (1968) 53

Chakushin Ari/One Missed Call (2003) 78

Chambers, Marilyn 101

Chaney, Lon, Jr. 31–2, 110

Chaney, Lon, Sr. 14–5, 17–18, 20, 140, 195

Changeling, The (1980) 84, 181

Charles of Saxony, Prince 4

Cheerleader Massacre (2003) 101

Cherry, Brigid 96, 143–5, 146

Cherry Falls (2000) 73

Child's Play (1988) 139

Child's Play (franchise) 109

Child's Play 3 (1991) 139

Chillerama (2011) 86, 145

Chinatown (1974) 105

Chion, Michel 171

Christie, Agatha
And Then There Were None . . ./Ten Little Indians (1939) 225

Christie, Ian 220

Chronicle (2014) 77

Circus of Horrors (1960) 49

City Under the Sea (1965) 49 n.50

Clairvoyant, The (1935) 25

Clarens, Carlos 7, 102

Clark, Bob 62

Cleckley, Hervey
Mask of Sanity, The (1941) 118

A Clockwork Orange (1971) 150

Clouzot, Henri-Georges 41

Clover, Carol J. 65, 127–30, 131

Cloverfield (2008) 77, 218

Clown at Midnight, The (1998) 73

Clueless (1995) 111

Coffman, Jason 87

cognitive theory 133–4

Cohen, Larry 57

Coleridge, Samuel Taylor
'Christabel' (1800) 145

Collinson, Madeleine and Mary (the Collinson sisters) 101

Color Me Blood Red (1965) 196

colour, horror and 185–209

Columbia Pictures 25, 31, 34

Combs, Jeffrey 70

Come Deadly (1973) 101

comedy, horror and 106–12

El Conde Dracula (1969) 53

Conjuring, The (2013) 84–5, 179

Conjuring 2, The (2016) 84–5

Conner, Bruce 217

Connors, Steven 167

Conversation, The (1974) 161

Cooper, Merian C. 28

Coppola, Francis Ford 45, 57 n.7, 70–1

Copycat (1995) 71

Coraline (2009) 142 n.3

Corman, Roger 44–6, 56, 149, 186, 195, 199–200, 205

Cosmopolitan (magazine) 140

Court, Hazel 24 n.8

Cox, Brian 71

Crane, Jonathan Lake 140

Craven, Wes 57–8, 63, 66, 73–4, 82–3, 101

Crawford, Joan 43

Creed, Barbara 126–31

Crewe, David 225–6

Crimes of the Future (1970) 62

Crimson Peak (2015) 137, 158 n.11, 196, 216

Cronenberg, David 57, 62–3, 69, 121 n.2

Cruise, Tom 72

Cry Baby Killer, The (1958) 46

Cry of the Banshee (1970) 49 n.50

Cube (1997) 82
cult films 150–3
Cunningham, Sean S. 101
Curse, The (1987) 186
Curse of Frankenstein, The
 (1957) 46–8, 140, 197–8
'Curse of the Blair Witch'
 (1999) 218
Curse of the Cat People, The
 (1944) 36, 50
Curse of the Queerwolf
 (1987) 145
Curse of the Werewolf, The
 (1961) 48
Curtis, Jamie Lee 24 n.8
Curtiz, Michael 25
Cushing, Peter 47–9, 68

Dagon (2001) 216
Dance of the Vampires (1967) 54
Dans ma peau/In My Skin
 (2002) 81
Dante, Joe 4, 43, 67, 82, 146
Dark Eyes of London, The
 (1939) 31
Dark Star (1974) 63
Dark Water (2005) 78
Daughters of Darkness (1971).
 See *Le Rouge aux lèvres*
Daughters of Satan (1972) 55
Dawn of the Dead (1978) 67, 110,
 115, 196
Day of the Dead (1985) 67, 155
Day of the Triffids (1962) 155
Dead of Night (1945) 46, 107, 117,
 123, 174–5, 167, 181
Dead Ringers (1988) 63
Dead Silence (2007) 175, 177–8
de Chomón, Segundo 18 n.17,
 189, 231
Deep Red (1975). See *Profondo
 rosso*
de Felitta, Frank
 Entity, The (1978) 182

Deleuze, Gilles 134
Deliver Us From Evil (2014) 84
del Toro, Guillermo 103, 216–17
Dementia 13 (1963) 46, 71
Demme, Jonathan 46
Demons (1985) 138, 227
Den, The (2013) 228 n.6
de Niro, Robert 72
Denis, Claire 81
De Palma, Brian 57, 61, 151
Dern, Bruce 46
Descent, The (2005) 81
Detective, The (1968) 55
De Van, Marina 81
Devil-Doll, The (1936) 24, 28
*Le Diable au Convent/The Devil in
 a Convent* (1899) 7
Les Diaboliques (1955) 41
Diary of the Dead (2007) 67, 218
Die, Monster, Die! (1965) 186
digital, horror and 211–33
Dika, Vera 129
Dimension Films 73
*Dislocation mystérieuse/An
 Extraordinary Dislocation*
 (1901) 231
Disturbia (2007) 227
Dix, Otto 9
Doctor Who (1963-) 102
Doctor X (1932) 24–5, 100, 189
Død snø/Dead Snow (2009) 81
Donnelly, K.J. 167, 172
Don't Look Now (1973) 196
Dracula (1931, English language
 version) 19–21, 23, 29,
 111, 164
Dracula (1931, Spanish language
 version) 164
Dracula (1958). See *Horror of
 Dracula*
Dracula A.D. 1972 (1972) 48
Dracula: Dead and Loving It
 (1994) 110
Dracula Exotica (1980) 101

Dracula: Pages from a Virgin Diary (2002) 207
Dracula (The Dirty Old Man) (1970) 101
Dracula Untold (2014) 103–4, 215
Dracula's Daughter (1936) 24, 28, 32, 145, 213
Dragula (1973) 101
Drakula halála (1921) 11–12
Dr. Black, Mr. Hyde (1976) 58
DreamWorks 77, 215
Dressed to Kill (1980) 117
Dreyer, Carl Theodor 25
Dr. Giggles (1992) 73
Driller Killer, The (1979) 142
Dr. Jeckel and Ms. Hide (1993) 101
Dr. Jekyll and Mr. Hyde (1920) 16–17
Dr. Jekyll and Mr. Hyde (1931) 25–6, 33
Dr. Jekyll and Mr. Hyde (1941) 33
Dumont, Bruno 81
Durovicová, Nataša 170
du Welz, Fabrice 82

early cinema and horror 5–9
Eastern Promises (2007) 63
Eastwood, Clint 99
Ebert, Roger 11, 66, 106–7, 138–9
Echo, The (2008) 78
Ecologica del delitto/Bay of Blood (1971) 52
Ectoplasm 192–3
Eddy, Nelson 33
Edelstein, David 82
Egan, Kate 142, 148
Eisenstein, Sergei 162, 194
Ejacula (1992) 101
Emmanuelle vs. Dracula (2004) 101
End of Watch (2012) 77

Englund, Robert 66, 70, 73
Entity, The (1982) 68, 84–5, 115–17, 180–3
Esper, Dwain 27, 152
El espinazo del Diablo/The Devil's Backbone (2001) 81, 216
E.T: The Extra-Terrestrial (1982) 69
Evans Robert 55
Event Horizon (1997) 103, 178–9
Evil Dead, The (1981) 69–70, 74, 142, 147
Evil Dead, The (2013) 216
Evil Dead II (1987) 69–70
Ewers, Hanns Heinz 123
Exorcism of Emily Rose, The (2005) 84
Exorcist, The (1973) 57–9, 84, 106–8, 109, 117, 126, 135, 139, 146, 170, 179
Eye, The (2002) 78
Eyes Without a Face (1960). *See Les yeux sans visage*

Fallen Angel (1945) 89
Fall of the House of Usher, The (1928, Epstein film) 26
Fall of the House of Usher, The (1928, Watson film) 26
Fall of the House of Usher, The (1960) 45, 200
Famous Monsters of Filmland (magazine) 44
Fangoria (magazine) 146
fans/fandoms and horror 145–58
Fantastic Beasts and Where to Find Them (2016) 96
fantasy, horror and 103–4
Die Farbe/The Colour Out of Space (2010) 186, 205, 208
Farrow, Mia 55
Fast Times at Ridgemont High (1982) 109, 112

Fear dot Com (2002) 227

Fearless Vampire Killers, or Pardon Me, but Your Teeth Are in My Neck, The (1967). See *Dance of the Vampires*

Fear (magazine) 146

Fellini, Federico 53

female audiences of horror 142–5

Field of Dreams (1989) 146

film blanc 33

film noir 14, 34–5, 89–90, 104–6

Film Socialisme (2010) 224

Final Destination (franchise) 73

Final Girl 65, 74–5, 127–30

First Blood (1982) 146

Florey, Robert 25

Fly, The (1958) 37

Fly, The (1986) 63, 98, 101

Forbidden Planet (1956) 37, 39–40, 116

Foster, Jodie 71, 153, 175

Foster, Suzanne 33

found footage horror 76–7, 217–19

Franco, Jesús 53

Franju, Georges 51

Frankenstein (1910) 3

Frankenstein (1931) 21–3, 29, 113, 164

Frankenstein Meets the Wolf Man (1943) 32, 73

Freaks (1932) 24

Freddy's Dead: The Final Nightmare (1991) 85 n.6

Freddy vs. Jason (2003) 73

Freud, Sigmund 94, 116, 119, 121–5, 129

"Uncanny, *The*" 121–5, 160

Freund, Karl 13, 18, 20, 23–4, 26

Friday the 13ᵗʰ (1980) 65, 72, 135

Friday the 13ᵗʰ (2009) 73

Friday the 13ᵗʰ, Part III (1982) 143

Friends (1994–2004) 73

Frighteners, The (1996) 103, 217

Fright Night (1985) 67, 138, 157

Frogs (1972) 61

From Beyond the Grave (1974) 49

From Dusk Till Dawn (1996) 99

Frontier(s) (2007) 81

La frusta e il corpo/The Whip and the Body (1963) 52

Frye, Dwight 23 n.8

Fukurai, Tomokichi 78

Fulci, Lucio 67, 152

Fulford, Robert 62

Funny Games (1997) 82

Funny Games (2007) 82

Fury of the Demon (2017) 231–2

Game of Thrones (2011-) 103

Ganja and Hess (1973) 58

Garbo, Greta 20–1

Gardiner, Craig Shaw 107

Gatiss, Mark 65

Gayracula (1983) 101

Geheimnisse einer Seele/The Secrets of a Soul (1926) 10

Geller, Sarah Michelle 78

Gens, Xavier 81

Geoul sokeuro (2003) 79, 123

Geraghty, Lincoln 9

German expressionism 8–14, 26, 104

Get Out (2017) 87–8, 180

Ghost (1990) 76

Ghost and Mr. Chicken, The (1966) 67

Ghost Breaker, The (1914) 17

Ghost Breakers, The (1942) 17, 67

Ghostbusters (1984) 67, 192

Ghost Hunters (2002-present) 212

Ghost of Frankenstein (1942) 32

Ghost Story (1981) 103

Ghost Town (1988) 99

Ghostwatch (1992) 84, 211, 227

Ghoul, The (1933) 25

giallo 52–3, 82

Giant Gila Monster, The (1959) 38

Gifford, Denis 5–6

Ginger Snaps (franchise) 81, 151–2

Gin gwai/The Eye (2002) 78

Girl House (2014) 227

A Girl Walks Home Alone at Night (2014) 85, 88

Glamour (magazine) 113–14

Glass, Phillip 73

Glen or Glenda (1953) 21

Goblin (band) 53, 201

Godard, Jean-Luc 195, 224

Goddard, Drew 75, 156

Goddu, Teresa 86

Gods and Monsters (1998) 21

Godwin, Victoria 158

Gojira/Godzilla (1954) 38–9, 77, 148

Golden Beetle, The (1907) 186

Der Golem, wie er in die Welt kam/The Golem: How He Came Into The World (1920) 10–11

Gone with the Wind (1939) 189, 200

Goosebumps (2015) 86

Gordon, Ruth 55

Gordon Stuart 109

Gorilla, The (1927 play) 17

Gorky, Maxim 219–20

Gothika (2002) 76

Gough, Michael 172

Grant, Barry Keith 91–2, 217

Gray, Sasha 102

Great Gabbo, The (1929) 173

Great Train Robbery, The (1903) 6

Green, Fitzhugh
 Film Finds Its Tongue, The (1929) 163–4

Gremlins (1984) 67

Grey Fox, The (1982) 138

Griffith, D. W. 3, 14, 17–8

Grizzly (1976) 61

Grosz, George 9

Grudge, The (2004) 78

Guess Who's Coming to Dinner (1967) 87

Guimarin, Amelia 227

Gunning, Tom 6–7

A Guy Named Joe (1943) 33

Habit (1996) 85

Halberstam, Judith 119

Hall, Charles D. 18

Hall, Jordan 145

Haller, Daniel 186

Halloween (1978) 57, 64–6, 72, 82, 86, 101, 118, 121, 127, 139, 154, 172–3, 201

Halloween (2007) 73

Halloween H20: 20 Years Later (1998) 73

Halloween XXX Porn Parody 101

Halperin, Edward and Victor 26–7, 165

Hammer Film Productions 46–9, 50–1, 53, 94, 101, 140, 157, 197, 198

Hands of Orlac, The (1924). See *Orlacs Hände*

Haneke, Michael 82

Hanks, Tom 114, 136

Hannibal (2001) 71

Hannibal (2013–5) 71

Hannibal Rising (2007) 71

Hantke, Steffen 216

Happy Birthday to Me (1981) 65

Hardy, Robin 50

Harold and Maude (1971) 150

Harper (1966) 89

Harris, Thomas
 Red Dragon (1981) 71
 Silence of the Lambs, The (1988) 70

Harryhausen, Ray 216

Hatton, Rondo 32

Haunted Hotel, The (1907) 17

Haunted House, A (2013) 110

Haunted Palace, The (1963) 45–6

Haunting, The (1963) 50, 85, 123,
 145
Haunting, The (1999) 215–6
Haunting in Connecticut, The
 (2009) 84
Haute Tension/High Tension
 (2003) 82
Hawks, Howard 63
Häxan/Witchcraft Through the
 Ages (1922) 9, 101
Heckerling, Amy 111–12
He Knows You're Alone
 (1980) 114, 136
Hell Baby (2013) 112
HellBent (2004) 145
Hell Night (1981) 65
Hellraiser (1987) 69, 82
Henning, Doug 62
Henry: Portrait of a Serial Killer
 (1986) 151
Hepburn, Audrey 170
Hesiod 19
Hewitt, Jennifer Love 74
High Plains Drifter (1973) 99, 196
Hills, Matt 109, 119, 133–4,
 140, 154
Hills Have Eyes, The (1977) 63
Hills Have Eyes, The (2006) 73,
 82
Hills Run Red, The (2009)
Histoires extraordinaires/Spirits of
 the Dead (1968) 53
A History of Horror (2010) 65
A History of Violence (2005) 63
Hitchcock, Alfred 43–4, 63, 194
Hoffman, E.T.A.
 'Sand-man, The' (1816) 123
Homicidal (1961) 43
Un homme de têtes/Four Trouble-
 some Heads (1898) 231
Honogurai Mizu no soko kara/Dark
 Water (2002) 78
Hooper, Tobe 12, 57, 62, 68, 83
Hopkins, Anthony 71

Horgan, James 139
Horror of Dracula (1958) 12,
 47–8, 197
Horrors of the Black Museum
 (1959) 49–50
Hostel (2005) 82–3
House (1986) 123
House of Dracula (1945) 32
House of Frankenstein (1944) 32
House of Horrors (1946) 32
House of Usher (1960). See The
 Fall of the House of Usher
 (1960)
House of Wax (1953) 20, 40–1,
 146
House on Haunted Hill
 (1959) 41–3, 192
House That Dripped Blood, The
 (1971) 49
Howard, Ron 46
Howling, The (1981) 67
How to Make a Monster
 (1958) 138
H.P. Lovecraft Historical
 Society 205
Hugo (2011) 232
Human Centipede, The (2009) 82
Human Centipede 2 (Full Se-
 quence), The (2011) 82, 207
Hunchback of Notre Dame, The
 (1923) 15, 18
Hunger, The (1983) 101, 126,
 145, 157
Hunger Games, The (franchise) 78
Hutchings, Peter 118, 121, 179
Huxley, Aldous 199

I, Frankenstein (2014) 87
I Am Legend (2007) 216
Ibáñez Serrador, Narciso 53
I Know What You Did Last
 Summer (1997) 73,
 155, 225
I Love Lucy (1951–57) 13

Images (1972) 57 n.7
I Married a Monster from Outer Space (1958) 37
Incredible Shrinking Man, The (1958) 37
Incredibly Strange Creatures Who Stopped Living and Become Mixed Up Zombies!!?, The (1964) 43
independent cinema, horror and 36–7, 41–6, 54–8, 64–7, 74, 76–7, 85, 151, 165, 176–7, 197
Independent Moving Pictures 16
Innocents, The (1961) 50, 177 n.6
Insidious (2010) 84
Interstellar (2014) 102
Interview with the Vampire (1994) 72, 102, 111, 139, 158 n.12
In the Mouth of Madness (1994) 138
Invasion of the Body Snatchers (1956) 37–8, 44, 87, 103, 117
Invisible Man, The (1933) 23, 32
Invisible Man Returns, The (1940) 41
Invocation of My Demon Brother (1969) 191 n.2
Irréversible (2002) 81–2
Island of Lost Souls (1932) 25
Isle of the Dead (1945) 36
I Spit on Your Grave (1978) 66, 138–9, 142, 154
I Spit On Your Grave (2010) 73
It Follows (2014) 86, 88, 158 n.11
It's a Wonderful Life (1946) 33
Ivan the Terrible, Part II (1958) 194
I Walked with a Zombie (1943) 35–7
I Was a Teenage Werewolf (1957) 37, 44

Jack Brooks: Monster Slayer (2007) 112
Jackson, Peter 69, 103, 217
Jackson, Shirley
 Haunting of Hill House, The (1959) 50
James, Becca 157–8
James, Henry
 Turn of the Screw, The (1898) 50
Jancovich, Mark 7, 9, 34, 38, 96, 146–7, 153, 218
Janghwa, Hongryeon/A Tale of Two Sisters (2003)
Der Janus-Kopf (1920) 15
Jaradin, Thierry 139
Jason and the Argonauts (1963) 146
Jason X (2001) 73
Jaws (1975) 57, 61, 95, 130
Jay, Martin 232
Dr. Jeckel and Ms. Hide (1993) 101
Jenkins, Henry 147
Jentsch, Ernst 122
Jesse James Meets Frankenstein's Daughter (1966) 99
'J-Horror' 76, 77–80, 94, 221–2
John Carpenter's Vampires (1998) 158 n.12
Johnson, Dwayne 84
Jonathon (1970) 54
Ju-on (2003) 78
Jurassic Park (1993) 146

Kairo/Pulse (2001) 78, 196, 221–3
Kalifornia (1993) 71
Kane, Tim 108
Karloff, Boris 21–6, 31–2, 36, 41, 45, 56, 66, 109, 120, 165, 215
Kattelman, Beth A. 59
Kaye, Danny 194

Kermode, Mark 142, 146–7
Kerr, Deborah 170
Key & Peele (2012–5) 87
Kill List (2011) 81
King, Stephen
 Danse Macabre (1981) 115
 Shining, The (1977) 67–8
Kingdom of Shadows: The Rise of the Horror Film (1998) 6
King Kong (1933) 27–8, 119–21, 206
King Kong vs. Godzilla (1962) 73
King of the Zombies (1941) 34
Kiss the Girls (1997) 71
Kneale, Nigel 46, 163 n.1
Kondom des Grauens/Killer Condom (1996) 145
Koroshiya Ichi/Ichi the Killer (2001) 78
Krampus (2015) 112
Krige, Alice 103
Kristeva, Julia 125–7
Krueger, Freddy 66, 73
Kubrick, Stanley 67–8, 123
Kuhn, Annette 141–2
Kuroneko (1968) 77
Kurosawa, Kiyoshi 78, 196
Kurutta Ippēji/A Page of Madness (1926) 9
Kusama, Karyn 85
Kwaidan (1964) 77
Kyua/Cure (1997) 221

Lacan, Jacques 125–6
Lady in the Water (2006) 75
Laemmle, Carl 15–16
Lake Mungo (2008) 81
Landis, John 43, 67, 109
Land of the Dead (2005) 67
Landres, Paul 197
Lang, Fritz 13
Langenkamp, Heather 73
Langley, Donna 215
Lansdale, Joe R. 69 n.2
Last Airbender, The (2010) 76

Last House on the Left, The (1972) 57–8, 61, 63, 101, 142, 151
Last House on the Left, The (2009) 73
Last Warning, The (1929) 18
Låt den rätte komma in/Let the Right One In (2008) 81
Laughton, Charles 25
Laugier, Pascal 81
L.A. Zombie (2010) 145
Leatherface (2017) 82
Lecter, Hannibal 71, 95, 117
Lee, Benjamin 86–7
Lee, Christopher 47–9
Lee, Roy 78–9
Le Fanu, Sheridan 12
 Carmilla (1872) 48, 53, 145
Legend (1985) 146
Legend of Hell House, The (1973) 170–2
Legend of the 7 Golden Vampires, The (1974) 48
Leni, Paul 13, 17–8, 162
Leone, Sergio 53, 99
Leopard Man, The (1943) 36, 206
Le Prince, Louis 229–30
Leroux, Gaston
 Phantom of the Opera, The (1911) 15
Der letzte Mann/The Last Laugh (1924) 10
Lewis, Herschell Gordon 68, 101, 152
Lewton, Val 35–7, 206
Lincoln, Frank 101
Little Deaths (2011) 86
Little Shop of Horrors, The (1960) 45
Le livre magique/The Magic Book (1900) 231
Lombard, Carole 27
London After Midnight (1927) 14, 140
Look Who's Talking (1989) 108

Loong Boonmee raleuk chat/Uncle Boonmee Who Recall His Past Lives (2011) 214
Lord of the Rings (series), *The* (2001–3) 103
Lords, Traci 101
Lorre, Peter 23
Lost Boys, The (1987) 149
Love at First Bite (1979) 110
Lovecraft, H.P.
 Case of Charles Dexter Ward, The (1943) 45
 "Colour Out of Space, The" (1927) 185–8, 208
 "Outsider, The" (1926) 95
Lovecraft: Fear of the Unknown (2008) 186
Lugosi, Béla 20–1, 23, 26, 31–2, 34, 41, 66, 110–11, 138
Lumière, Auguste and Louis (the Lumière brothers) 5–6, 219
Lust for a Vampire (1971) 48

Macabre (1958) 41
McCambridge, Mercedes 170
McCoy, Abigail 113
McCown-Levy, Alex 157–8
McDonough, Maitland 205
Macke, August 9
McLean, Greg 83
Maddin, Guy 208
Madhouse (1974) 138
Mad Love (1935) 11, 100, 138 n.1
Magic (1978) 175
Magistrale, Tony 7–8
La maison ensorcelée/The House of Ghosts (1908) 18 n.17, 231
Malkovich, John 72
Malle, Louis 53
Maltese Falcon, The (1941) 104–5
Mamoulian, Rouben 25–6, 33
Man Bites Dog (1992) 217

Manhunter (1986) 71, 206
Maniac (1934) 27, 101
Maniac (1980) 101
Maniac (2012) 216
Manners, David 23
Man of the West (1953) 99
Le Manoir du Diable (1896) 6–8
Manovich, Lev 220–1
Manson, Charles 140
Man They Could Not Hang, The (1939) 31
Man Who Changed His Mind, The (1936) 25
Man Who Laughs, The (1928) 18
Maps to the Stars (2014) 63
Marc, Franz 9
Marceau, Marcel 43
March, Fredric 25
Mark of the Vampire (1935) 24
Martin (1977) 207–8
Martyrs (2008) 81
Marx, Karl 119
Mary Reilly (1996) 72
Mary Shelley's Frankenstein (1994) 72
La maschera del demono/Black Sunday (1960) 52
Mask of Fu Manchu, The (1932) 24
Masque of the Red Death, The (1964) 45, 195, 196, 200–1
Masters of Horror (2005–7) 78
 'Cigarette Burns' (2005) 230
 'Imprint' (2006) 78
Matheson, Richard 45
Matheson, Richard Christian 69 n.2
Mathijs, Ernest 150–2
Matinee (1993) 4, 43, 146–7
A Matter of Life and Death (1946) 33, 195
Maury, Julien 81–2
Méliès, Georges 6–8, 18 n.17, 85, 231–2
Melville, Stephen 186

Mendik, Xavier 151
Mephisto Waltz, The (1971) 55
Messiah of Evil (1973) 85 n.6
Metro-Goldwyn-Meyer
 (MGM) 24, 33
Metropolis (1927) 13, 102
Metz, Christian 132
Miami Vice (1984–90) 149
Mierenoff, Carlo 175–6
Miike, Takashi 77, 80, 111
Mike Douglas Show, The (1961–
 81) 140
Minotaur (2006) 73
Miramax 73–4, 78, 84
Mirror, Mirror (1990) 85 n.6, 123
Mirrors (2008) 78, 82, 123
Misek, Richard 195, 200, 203–4,
 206–7
Misery (1990) 155
Monogram Pictures 32
Monster, The (1922 play) 17
Monster, The (1925) 17
Monster House (2006) 142 n.3
Monty Python and the Holy Grail
 (1976) 169
Morrison, Bill 217
Most Haunted (2002–10) 212
*Et mourir de plaisir (Le sang et
 la rose)/Blood and Roses*
 (1960) 53, 121
Mr. Sardonicus (1961) 43
Mulholland Dr. (2001) 161
Mulvey, Laura 132, 160, 220
Mumler, William 211
Mummy, The (1932) 13, 23,
 164–5
Mummy, The (1999) 215
Mummy, The (2017) 215
Mummy's Ghost, The (1944) 34
Mummy's Hand, The (1940) 23,
 32
Murders in the Rue Morgue
 (1932) 26
Murnau, F.W. 11–12, 15
Murphy, Ashy 211–12, 233

My Bloody Valentine (1981) 65
My Bloody Valentine 3-D
 (2009) 73
Myers, Michael 64–5, 118, 121,
 127, 172–3, 180
Mystery of the Wax Museum
 (1933) 25, 40, 100, 189

Nadja (1994) 85, 207, 213–4
Nakata, Hideo 77–8
Naked Lunch (1991) 63
Naylor, Alex 28
Ndalianis, Angela 134–5
Neale, Steve 100 n.1, 189
Near Dark (1987) 85 n.6, 99
neo-slasher 73–5, 155
Nelson, Jimmy 173
Nemerov, Alexander 26–7
Netflix 77, 86
New French Extremity 81–2
New Hollywood 46, 57
Newman, Kim 7
New Nightmare (1994) 73
Die Nibelungen (1924) 10
Nichols, Mike 72
Nicholson, Jack 46, 72
Night of Terror (1933) 25
Night of the Demon (1957) 46,
 86, 172
Night of the Lepus (1972) 61
Night of the Living Dead
 (1968) 54–5, 57, 61, 67, 76,
 151, 207
Nightmare Alley (1947) 89
A Nightmare on Elm Street
 (1984) 66–7, 72–3, 78, 109,
 129
A Nightmare on Elm Street
 (2010) 73
*A Nightmare on Elm Street
 2: Freddy's Revenge*
 (1985) 145
Night Terrors (game) 232
Night Watch (franchise) 215
Ninotchka (1939) 20

Nixon, Marni 170
Noé, Gaspar 81
Nolan, Christopher 213
Nosferatu, eine Symphonie des
 Grauens (1922) 8, 11–12,
 16, 22, 112, 136, 161
Nosferatu: Phantom der
 Nacht/Nosferatu the
 Vampyre (1979) 10
Not of This Earth (1988) 101
Nowell, Richard 65–6, 83
Nude in Dracula's Castle
 (1950) 101
Nun, The (2017) 85
Nurmi, Maila. See Vampira

Oblong Box, The (1969) 49 n.50
O'Brien, Willis 216
Ochiai, Masayuki 79
Oculus (2013) 84, 123
Ōdishon/Audition (1999) 78, 111
Office of War Intelligence
 (OWI) 33–4
Official Halloween Parody
 (2011) 101
Of Mice and Men (1939) 31–2
Old Dark House, The (1932) 18
Oldman, Gary 71
Olivier, Marc 224
Omen, The (1976) 57, 61
One Exciting Night (1922) 18
One Missed Call (2008) 78
Onibaba (1964) 77
Open Windows (2014) 227
Opera (1987) 53
Orca (1977) 61
El orfanato/The Orphanage
 (2007) 76, 81
Orlacs Hände/The Hands of Orlac
 (1924) 10
Oscars. See Academy Awards
Others, The (2001) 76, 81
Ouija (2014) 84
Ouija: Origin of Evil (2016) 84, 230
Out of the Past (1947) 35

Paramount Pictures 23, 25–6,
 33, 55, 77, 165
Paranormal Activity (2009) 77,
 218–19
Paranormal Activity
 (franchise) 212, 214
Paranormal Activity: The Ghost
 Dimension (2015) 228, 230
ParaNorman (2012) 142 n.3
Partie de Cartes (1896) 219
Party of Five (1994–2000) 73, 74
Passion of the Christ, The
 (2004) 82
Paul, William 109
Peary, Danny 12 n.3
Peele, Jordan 87
Peeping Tom (1960) 49–50
Peirse, Alison 23, 26
Peli, Oren 77
Penalty, The (1920) 14
Performance (1970) 150
Pet Sematary (1989) 85 n.6
Phantom of the Opera, The
 (1925) 15, 18, 123, 136
Phantom of the Opera, The
 (1943) 33
Phantom of the Opera, The
 (1962) 48
Phantom of the Opera, The
 (2004) 100, 195
Phantom of the Paradise, The
 (1974) 151
phantasmagoria 3–4
Pickett, Bobby 'Boris'
 'Monster Mash, The'
 (1962) 44
Picture of Dorian Gray, The
 (1945) 195
La piel que habito/The Skin I Live
 In (2011) 82
Pierce, Jack 18, 21, 216
Pierrot le Fou (1965) 195
Pinedo, Isabel Cristina 109, 143
Piranha (1978) 61, 82
Piranha 3-D (2010) 82

Pirie, David 49, 108
Pit and the Pendulum, The
 (1961) 45, 200
Pitt, Brad 72
Pitt, Ingrid 24 n.8, 148
Pixelvision 213–14
Plan 9 from Outer Space
 (1959) 21, 44
Playback (2012) 221, 229–30
Pleasantville (1998) 187
Poe, Edgar Allan 14, 26, 27, 45,
 49, 104
 'Masque of the Red Death,
 The' (1842) 195, 202, 205
 'Raven, The' (1845) 135
Pokémon Go (game) 232
Polanski, Roman 54–5, 57 n.7
Polidori, John 12
Poltergeist (1982) 68, 78, 84,
 109, 123, 171 n.4, 227, 229
Poltergeist (2015) 86
Pommerenke, Heinrich 139
Pontypool (2008) 81
Popcorn (1991) 109
Porky's (1981) 109
Porn of the Dead (2006) 101
pornography, horror and 101–2
Portrait of Jennie (1948) 194
Potts, John 224
Powell, Anna 134
Powell, Michael 50
Premature Burial, The (1962) 45,
 200
Price, Brian 190
Price, Vincent 40–2, 49, 68, 141
Producers Releasing Corporation
 (PRC) 32
Production Code Administration
 (PCA) 23, 28–9
Profondo rosso/Deep Red
 (1975) 53, 82, 196
Prom Night (1980) 65, 225
Prophecy (1979) 61
Psycho (1960) 43–4, 114, 117–18,
 123, 171, 206

Pulp Fiction (1994) 107
Pulse (2001). *See Kairo*
Pulse (2006) 78
Purge, The (franchise) 84

Quandt, James 81
Quatermass II (1957) 46
Quatermass Experiment, The
 (1953) 46
Quatermass Xperiment, The
 (1955) 46
queerness and horror 145
¿Quién puede matar a un
 niño?/Who Can Kill a Child?
 (1976) 53
Quiet Ones, The (2014) 51, 84, 230

Rabid (1977) 63
Raimi, Sam 69, 109
Rains, Claude 23, 25, 33
Rank, Otto 122
Rare Exports (2010) 81
Raven, The (1935) 45–6
Raven, The (1963) 100
Re-Animator (1985) 69
REC (2007) 77, 81, 218
Red Christmas (2016) 196
Red Dragon (2002) 70, 196
Red Hook (2009) 196
Red State (2011) 196
Red Velvet (2008) 196
Reeves, Keanu 71
Reeves, Michael 49
Rendition (2007) 83
Repossessed (1990) 108, 110
Repo! The Genetic Opera
 (2008) 100
Republic Pictures 32
Repulsion (1965) 54
La residencia/The House That
 Screamed (1969) 53
Resurrection of Broncho Billy, The
 (1970) 99
Return of Dracula (1958), *The* 37
 n.2, 197

Return of the Living Dead, The
 (1985) 67
Return of the Vampire, The
 (1943) 34
Revenge of Frankenstein, The
 (1958) 140
Revenge of the Zombies
 (1943) 34
Revolt of the Zombies (1936) 27
Rice, Anne 158
 Interview with the Vampire
 (1976) 72
Richard III (1955) 146
Richet, Charles 192
Ring (1998) 78, 86, 221, 227,
 229, 230
Ring, The (2002) 78
Rings (2017) 79
Ring Two, The (2005) 78
Ring Virus, The (1999) 78
Rio Bravo (1959) 100
Rite, The (2011) 84
RKO Pictures 27, 35
Roberts, Julia 72
Robertson (Étienne-Gaspard
 Robert) 3
Robinson, James
 Batman: Face the Face (2006)
Robot Chicken (2005) 75–6
Rocky Horror Picture Show, The
 (1975) 100, 151
Roeg, Nicholas 200
Rollin, Jean 53–4, 101
romance, horror and 100–1
Romero, George A. 54, 57, 67, 77,
 83, 100, 110, 196, 207
Romney, Jonathan 216
Room, The (2003) 150
Room 237 (2012) 68, 150
Rosemary's Baby (1968) 36, 43,
 54–5, 57, 76, 105–6
Rosen, Philip 221
Rosenbaum, Jonathan 140
Rosenthal, Rick 66
Rose Red (2002) 196

Roth, Eli 83, 155–6
Le Rouge aux lèvres/Daughters of
 Darkness (1971) 54, 198–9
Roundhay Garden Scene
 (1888) 229, 230
Royle, Nicholas 124
Russo, John 67
Ryder, Winona 71

Sabeki/Retribution (2006) 221
Salem's Lot (1979) 10
Salò: 120 Days of Sodom
 (1975) 146
Satanic Rites of Dracula, The
 (1973) 48
Satan's School for Girls (1973) 55
Savini, Tom 70, 196, 216
Saw (2004) 82–4, 139
Scanners (1981) 63
Scared Stiff (1953) 17, 67
Scary Movie (2000) 72, 73, 110
Scary Movie 2 (2001) 110
Schatten–Eine nächtliche
 Halluzination/Warning
 Shadows (1923) 10
Schatz, Thomas 9
Schoedsack, Ernest B. 27
Schow, David J. 69 n.2
Schröpfer, Johann Georg 3–4
science fiction, horror and
 102–3
Sconce, Jeffrey 152–3, 232
Scorsese, Martin 46, 197, 232
Scott, Randolph 26
Scream (1996) 73–4, 138–9,
 154–5, 157–8
Scream, Blacula, Scream!
 (1973) 58
Searchers, The (1956) 99
Sei donne per l'assassino/Blood
 and Black Lace (1964) 52
Serenity (2005) 100
Serial Mom (1994) 196
Serling, Rod 75
Seven (1995) 71, 82

Seven Brides for Seven Brothers
(1954) 97
Seventh Victim, The (1943) 36
Sexcula (1974) 101
Sexton, Jamie 150–2
Shadow of a Vampire (2000) 138
Shakespeare, William
Hamlet 189
Richard III 189
Shanks (1974) 43
Shaun of the Dead (2004) 110
Shaviro, Steven 134
Shaw Brothers Studio 48
Shelley, Mary
Frankenstein (1818) 102, 119
Shimizu, Takashi 77–8
Shining, The (1980) 67–9, 97–8,
109, 123, 150, 196
Shivers (1976) 62, 121, 126
Shock Corridor (1962) 195
Shocker (1989) 227
'Shock Theater' 44
Shogun Assassins (1980) 146
Shutter (2004) 78
Shutter (2008) 78
Shyamalan, M. Night 75–7
Sigaw (2004) 78
Signs (2002) 75
Silence of the Lambs, The
(1991) 70–1, 82, 139, 153,
155
Simpsons, The (1989-) 135
Sinatra, Frank 55
*La Sindrome di Stendhal/The
Stendhal Syndrome*
(1996) 53
Singin' in the Rain (1952) 164, 169
Sinister (franchise) 84
Sinister (2012) 84, 230
Siskel, Gene 66, 139, 140
Sisters (1973) 57, 117
Six, Tom 82
Sixth Sense, The (1999) 75–6,
146, 176–7
Skal, David J. 22, 146

slasher film 62, 64–7, 72–5, 110,
127–30
Sleepaway Camp (1983) 130
Slumber Party Massacre
(1983) 85 n.6, 110
Smash Cut (2009) 102
Smiley (2012) 227
Smith, Dick 216
Smuts, Aaron 136
Sneak Previews (1975–96) 66,
139
Snelson, Tim 34
Sobchack, Vivian 102–3
Son of Dracula (1943) 32
Son of Frankenstein (1939) 29,
31
'Son of Shock' 44
Sophocles
Oedipus Rex 104
Sorcerers, The (1967) 49
Soska, Jen and Sylvia 85
sound, horror and 159–83
Spadoni, Rob 164, 173
Spasojević, Srđjan 82
Spellbound (1945) 194
Spermula (1976) 101
Spielberg, Steven 57 n.7, 61,
69, 77
spirit photography 162, 221, 228
splatter film 69–70, 103, 152,
216
splatterpunk 69 n.2
Spliced (2002) 138
Split (2017) 76
Srpski film/A Serbian Film
(2010) 82
Stagecoach (1939) 44, 93
Stanley, Richard 186 n.1
*Star Trek VI: The Undiscovered
Country* (1991) 197
Star Trek: Enterprise (2001–5)
113
Star Trek: First Contact
(1996) 103
Star Trek (franchise) 70

Star Trek: Nemesis (2002) 12 n.3
Star Wars: Episode 1: The Phantom Menace (1999) 75
Stay Alive (2006) 227
Steckler, Ray Dennis 43
Steele, Barbara 24 n.8
Stellwagen, Lisa 139
Stepford Wives, The (1975) 87
Stereo (1969) 62
Stevenson, Robert Louis
 Strange Case of Dr. Jekyll and Mr. Hyde, The (1886) 15–6, 102
Stir of Echoes (1999) 123
Stoddard, Cassie Jo 139
Stoker, Bram
 Dracula (1897) 8, 11–12, 22, 71–2
Stone Tape, The (1972) 163 n.1
Strait-Jacket (1964) 43
Street, Sarah 141
Strike (1925)
Student Bodies (1981) 110
Der Student von Prag/The Student of Prague (1913) 3
subcultural capital 148–50
Subspecies (1991) 12 n.3
Suckula (1973) 101
Supernatural (1933) 26–7, 165–9
Superstar: The Karen Carpenter Story (1987) 146
Survival of the Dead (2009) 67
Suspiria (1977) 53, 154, 201–5
Suzuki, Koji
 Ring (1991) 78

Tales from the Crypt (1972) 49
Tales of Terror (1962) 45
Tarantino, Quentin 83, 213
Tarantula (1955) 38
Targets (1968) 56, 58
Taxi Driver (1976) 197
technological uncanny 159–60, 209, 212–13, 219–21, 232–3
Telotte, J.P. 92

Ten Commandments, The (1956) 139
Terror, The (1963) 45–6, 56
Terror Train (1980) 65
TerrorVision (1986) 227
Testament of Dr. Mabuse, The (1932) 171
Tetsuo (1989) 103
Texas Chain Saw Massacre, The (1974) 57, 62, 109, 151
Texas Chainsaw Massacre, The (1986) 62
Texas Chainsaw Massacre, The (2003) 73
Texas Vibrator Massacre, The (2008) 101
Thanhauser Company 16
Them! (1954) 37
Thing, The (1982) 69
Thing, The (2011) 216
Thing from Another World, The (1951) 37
13 Ghosts (1960) 43, 191–4, 198, 208–9, 228
30 Days of Night (franchise) 215
This Is Spinal Tap (1984) 150
Thompson, Kristin 169
Thornton, Sarah 148–9
3-D film 40, 228–9
Three Faces of Eve, The (1957) 117
Tigon British Film Productions 49
Timecode (2000) 228
Tingler, The (1959) 41–2, 138, 192, 198–9
Titanic (1997) 99
Todd, Tony 73
Tolkien, J. R. R.
 Lord of the Rings, The (1954–5) 97–8
Tomb of Ligeia, The (1964) 45
Tomei (franchise) 78
Tooth Fairy (2010) 84
Topper (1937) 293
Torture Garden (1967) 49
torture porn 82–3

To the Devil a Daughter (1976) 55
Touch of Satan, The (1971) 55
Tourneur, Jacques 35, 46
Tower of London (1939) 41
Tower of London (1962) 46
Toy Story (1995) 108
Tracy, Spencer 33
Trainspotting (1996) 107
Travelling Museum of the Paranormal and the Occult 214
Tremors (1990) 130
Trick 'r Treat (2007) 86
Trouble Every Day (2001) 81
Truly Madly Deeply (1990) 85
Tucker and Dale vs. Evil (2010) 112
Tudor, Andrew 56–7, 92
Turner, Lana 33
Tutankhamun 23
28 Days Later (2002) 67, 81, 155
Twentynine Palms (2003) 81
Twilight (franchise) 87, 100, 158
Twilight Zone, The (1959–64)
 'Dummy, The' (1964) 175
 'Monsters are Due on Maple Street, The' (1960) 39
Twins of Evil (1971) 48, 101
Twixt (2011) 71
Two Faces of Dr. Jekyll, The (1960) 48
Tyler, Parker 194

L'uccello dalle piume di cristallo/The Bird with Crystal Plumage (1970) 53
Ulmer, Edgar G. 25–6
Unbreakable (2000) 75
uncanny (Freudian concept) 121–5. See also technological uncanny
Uncle Josh in a Spooky Hotel (1900) 18 n.17
Underworld (franchise) 100, 215
Unfriended (2015) 84, 225–8
Unholy Three, The (1925) 15

Unholy Three, The (1930) 15, 174
Uninvited, The (1944) 33, 68
Uninvited, The (2009) 78
Universal Pictures 15–24, 28–9, 31–4, 41, 44, 46, 48, 52, 61, 94, 109, 110, 113, 136, 146, 157, 215, 225
Unknown, The (1927) 14
Untraceable (2008) 227
Urban Legend (franchise) 74
Vadim, Roger 53
Valentine (2000) 73, 155
Vampira (Maila Nurmi) 44
Le vampire (1945) 22 n.7
Vampire Circus (1972) 48
Vampire Lovers, The (1971) 48
La vampire Nue/The Nude Vampire (1970) 54
Vampires Suck (2010) 110
Vamps (2012) 111–12
Vampyr: Der Traum des Allan Gray (1932) 25–6
Vampyros Lesbos (1970) 53, 145
van Elferen, Isabella 172, 219
Van Helsing (2004) 100, 215
van Sloane, Edward 23
Vargtimmen/The Hour of the Wolf (1968) 53
Variety (magazine) 164
Vault of Horror, The (1973) 49
Veidt, Conrad 10, 18
ventriloquism 173–5
V/H/S (2012) 77, 228 n.6
V/H/S (franchise) 85–6, 221
Video Dead, The (1987) 227
Videodrome (1983) 63, 78, 227
'video nasty' 66, 69, 142
Village, The (2004) 75
Village of the Damned (1960) 103
Visit, The (2015) 76–7
Viskningar och rop/Cries and Whispers (1973) 199
Vogelin, Salomé 163

Le Viol du Vampire/The Rape of the Vampire (1968) 53–4
von Trier, Lars 82
von Wangenheim, Gustav 22
von Weber, Carla Maria
 Der Freischütz (1821) 166
Voodoo Man (1944) 138
Vuckovic, Jovanka 85

Das Wachsfigurenkabinett/ Waxworks (1924) 10–1, 13
Wada-Marciano, Mitsuyo 80
Walking Dead, The (1936) 25, 28
Walking Dead, The (franchise) 67
Wan, James 82–4, 177
Warlock (1989) 139
Warner Bros. 24–5, 40
Warning Shadows. See Schatten
Warren, Ed and Lorraine 84
Waters, John 43, 196
Waters, Sarah 232
Watkins, Peter 217
Waxworks (1924). *See Das Wachsfigurenkabinett*
Wayne, John 100
Weaver, James B. 143
Welles, Orson 34
Wells, H.G.
 Invisible Man, The (1897) 23, 102
 Island of Dr. Moreau, The (1896) 25, 102
Werewolf of London (1935) 145
Wertham, Fredric 141
Westerns, horror and 99–100
Westmore, Wally 216
West of Zanzibar (1928) 15
A Wet Dream on Elm Street (2011) 101
Wet Wilderness (1976) 101
Whale, James 21
Whannel, Leigh 83

What Lies Beneath (2000) 76, 216
What We Do in the Shadows (2014) 12 n.3, 110
Whedon, Joss 75, 100, 156–7
When a Stranger Calls (1979) 62
When a Stranger Calls (2006) 73
When the Lights Went Out (2012) 84
Whiplash (2014) 84
Whisperer in Darkness, The (2011) 205
White, Patricia 145
White Noise (2005) 76, 221
White Zombie (1932) 26, 165
Wicker Man, The (1973) 50–1, 150
Widow Blue (1970) 101
Wild Angels, The (1966) 56
Willard (1971) 61
Williams, Linda 102, 131–2, 143
Williams, Paul 151
Williams, Robert 140
Williamson, Kevin 73–4
Wings of Desire (1987) 195
Winston, Stan 70, 216
Wise, Robert 50
Wishmaster (1997) 73
Witch, The (2015) 86–7, 88, 158
Witchfinder General (1968) 49
Wizard of Oz, The (1939) 171, 189, 195, 201
Wolejsza, Rob 106–8
Wolf, Leonard R. 72
Wolf (1994) 72
Wolf Creek (2005) 81
Wolf Man, The (1941) 31
Wolfman, The (2010) 215
Woman in Black, The (2012) 51
Women, The (1939) 104
Wonder Man (1945) 193
Wood, Edward D., Jr. 21, 152

Wood, Natalie 170
Wood, Robin 44, 94–6, 99,
 119–21, 188
Worland, Rick 33–4
Would You Rather (2012) 102
Wray, Fay 23 n.8, 25

X-Ray (1981) 101
XX (2016) 86

Yablans, Irwin 64–5
*Les yeux sans visage/Eyes
 Without a Face* (1960) 51,
 59, 81, 82, 87, 107

Young Frankenstein (1974) 110
You're Next (2011) 73–4
Yumibe, Joshua 192

Zacherly (John Zacherle) 44
Zemeckis, Robert 43, 216
Zero Dark Thirty (2012) 83
Zillmann, Dolf 143
Zodiac Rapist (1971) 101
Zombi 2 (1979) 67
Zombie, Rob 83
Zombieland (2009) 110
Zombie Strippers (2008) 101
Zucco, George 23 n.8